588556

D1374606

THE SCOTT AND LAURIE OKI SERIES IN ASIAN AMERICAN STUDIES

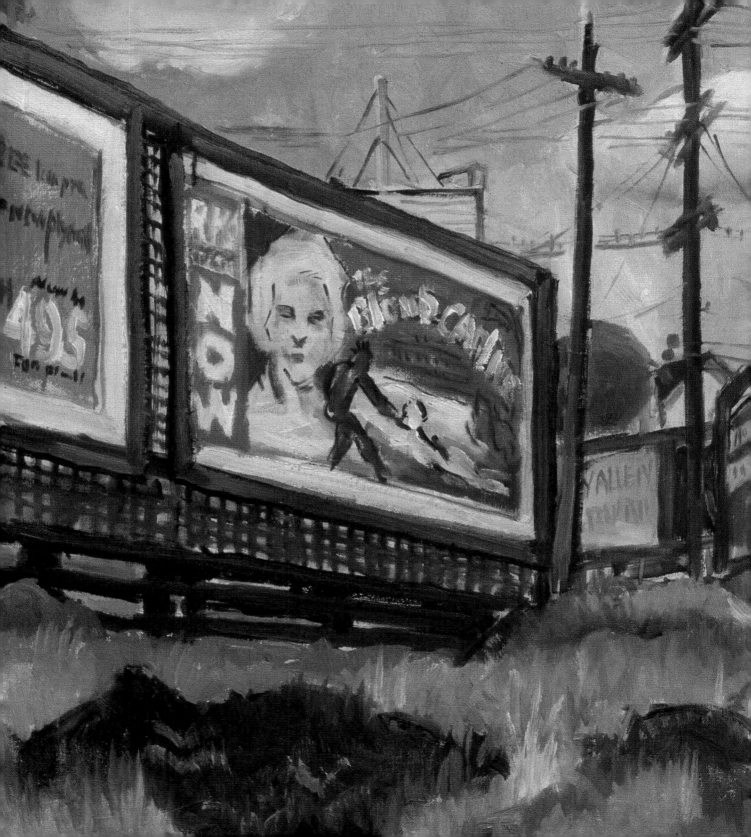

SIGNS *of* HOME

THE PAINTINGS AND WARTIME DIARY OF KAMEKICHI TOKITA

Barbara Johns

FOREWORD BY *Stephen H. Sumida*

UNIVERSITY OF WASHINGTON PRESS
Seattle & London

"Please come with me, traveling bag,
although this is not an ordinary journey."

—Kamekichi Tokita, Diary, December 5, 1942

Signs of Home is published with the assistance of a grant from the Scott and Laurie Oki Endowed Fund for publications in Asian American Studies. A complete list of books in the Oki series can be found at the end of the book.

Generous additional support is provided by Shokichi and Elsie Y. Tokita and Sandy and Ken Tokita.

© 2011 by the University of Washington Press
Printed and bound in China
Design by Thomas Eykemans
16 15 14 13 12 11 5 4 3 2 1

UNIVERSITY OF WASHINGTON PRESS
PO Box 50096, Seattle, WA 98145, USA
www.washington.edu/uwpress

LIBRARY OF CONGRESS
CATALOGING-IN-PUBLICATION DATA
Johns, Barbara.
Signs of home : the paintings and wartime diary of Kamekichi Tokita / Barbara Johns and Kamekichi Tokita ; foreword by Stephen H. Sumida. — 1st ed.
 p. cm. — (Scott and Laurie Oki series in Asian American studies)
Includes bibliographical references and index.
ISBN 978-0-295-99100-9 (hardback : alk. paper)
1. Tokita, Kamekichi, 1897–1948—Criticism and interpretation. 2. Tokita, Kamekichi, 1897–1948—Diaries. 3. Japanese American painters—Diaries. 4. World War, 1939–1945—Personal narratives, Japanese American. I. Tokita, Kamekichi, 1897–1948. II. Title. III. Title: Paintings and wartime diary of Kamekichi Tokita.
ND237.T5755J64 2011
759.13—dc22 2010053508
[B]

The paper used in this publication meets the minimum requirements of American National Standard for Information Sciences—Permanence of Paper for Printed Library Materials, ANSI Z39.48-1984.∞

CONTENTS

FOREWORD

Stephen H. Sumida

"WHEN TOKITA IMMIGRATED IN LATE 1919, he arrived on new shores not only as a citizen of the old world but also as a modern young man of his time."

So begins Barbara Johns's study of an Issei of Seattle who, like many of his generation of immigrants, lived and once thrived in the United States. By choice and commitment, the Issei made their history in an American setting. Insofar as they were from Japan, they were citizens of the "old world" because they were forbidden by U.S. law to become naturalized Americans. Judging not just by Tokita's actions and his life up through the cataclysmic event of Japan's bombing of Pearl Harbor—the event that forever changed Issei relations with their America—Tokita and his fellow Issei travelers, settlers, and adventurers seemed to accept the anti-Asian land laws of the state of Washington and the national proscription against their naturalization as given conditions of their lives, parameters within which they made the decision to immigrate and would live as best they could.

The self-image of the Issei as young and modern—people whose very face and posture are exemplified in Tokita's self-portrait—had to be a bold stance in the face of an American society that saw immi-

grants as barbarians and America as the one nation that could confer modernity upon them. The very idea of immigrants making their own American histories contradicted the practices and ideologies of assimilation and colonialism. Kamekichi Tokita did not come to America to be modernized. He was, we find in this study, already "a modern young man of his time" when he arrived in Seattle in 1919 at the age of twenty-two, and for more than two decades he lived and raised a large family in comfort with this identity.

In his art, Tokita was not merely a student of the modern but was a contributor to the contemporary art scene of Seattle. On the one hand, his business—the Noto Sign Company that he owned with his art colleague Kenjiro Nomura—was concentrated in Nihonmachi (Japantown) and Chinatown, thanks to the two artists' skill in producing gold kanji characters on black fields (although they did also produce signs in English). On the other hand, with their modern realist cityscapes and landscapes, Tokita and Nomura entered competitions and enjoyed growth in their artistic reputations outside their ethnic Japanese (Nikkei) community. Barbara Johns recounts a story about the artist Mark Tobey visiting the two men (30). The younger artist George Tsutakawa recalled that Nomura and Tokita said little during the visit, as though at the feet of the master, even though it was Tobey who wanted to consult them about art. But who knows what they were thinking and what they discussed with each other after Tobey left?

As an artist Tokita may well have learned in Japan how artists such as Vincent van Gogh had devoured the Japanese art of *ukiyo-e*, woodblock prints of "the floating world," and had obsessively copied Japanese prints, trying to translate their aesthetic to the medium of paint. Any number of well-known European and American modernists—and poets such as Ezra Pound—had found inspiration in *ukiyo-e*. James McNeill Whistler was another proponent of this borrowing from Japan. In the South Pacific, Paul Gauguin, who had also caught the European vogue for Japanese art, went totally native and added his primitivist genres of depicting Tahitian and Marquesan subjects to the body of modern art of the West. If Van Gogh, Whistler, and their American

and European contemporaries and Gauguin in the Pacific could be considered creators and not simply borrowers of art, why should not Tokita? His own resource, the culture he came from, was a source itself for modern art of the West and the world. Tokita and Nomura, as well as their fellow artists of the Seattle Camera Club, led by Dr. Kyō Koike, must have felt quite empowered as artists. Not only did they come from a true source of modernity in art but, indeed, like Van Gogh, Whistler, and Gauguin, all Issei came from a nation engaged in building empire, except that the empire of Japan was the world's only one that was not European and white. This in large part may be the meaning of the observation that Kamekichi Tokita arrived and created art in Seattle not in some racially and ethnically delimiting way, but engaged with his contemporary world.

On 7 December 1941 Tokita's self-image clashed with a different view of Nikkei in the eyes of the American public at large. In his diary Tokita comments wistfully that he was, after all, grateful that America allowed him and his fellow Nikkei to run their businesses and support their families. Consequently, in the first months of the war, when it was unclear to the Nikkei of Seattle what was to become of them, he worried that the United States would snatch privileges away from Japanese Americans during World War II. He also reflects on the fact that before Japan bombed Pearl Harbor he was not anxious about his status in America as a resident alien who, though ineligible for citizenship, at least had the protection of his birth nation, Japan, should international conflicts put him, his family, and his community in danger. Now, at the beginning of the war, such danger was at hand and Tokita awakened to newly focused concerns not solely about being a modern family man in a modern world but about race, nationality, and war. Although many facets of his identity during the war are implicit in his diary, in direct terms it can be said that on 7 December Tokita had to seize a realization that he was not a Japanese in America but rather a Japanese American, a person historically connected to Japan who since 1919 has been living and making American history and was now gripped in its currents.

Let us pause, along with Tokita at the moment he begins to write his diary, to recall or to imagine a Japanese American time before the war. Great Nisei writers (those of the first generation born in the United States) have alluded to that time. Though Nisei experiences of the time before the war are unlike Tokita's, they are comparably mythical. In stories, novels, and dramas, by Hisaye Yamamoto, Toshio Mori, Momoko Iko, Wakako Yamauchi, Monica Sone, John Okada, and other Nisei writers of California and Washington, the critical issues before the war are not often centered on race and nationality. In Yamamoto's stories set in the 1930s—"Yoneko's Earthquake" and "Seventeen Syllables," for example—the central conflicts concern misunderstandings between mothers and daughters. Toshio Mori wrote the stories in *Yokohama, California* before the war. In "The Chessmen," Mori tells a story of how a buff young Nisei worker newly hired at a garden nursery unintentionally becomes a threat to an older man, an Issei, who can no longer keep up with the younger in hard physical labor. Racism is not an issue. Momoko Iko's two-act drama *Gold Watch*, set in Wapato, Washington, in 1941–42, contains speeches by both the father and the mother in the Murakami family, addressed to their son, about how they came to settle in the Yakima Valley of the United States. The father, Masu Murakami, tells son Tadao:

> Do you know why I stayed here? I was freer. I could see what
> it was like to be a lumberjack, a fisherman, and anything else
> that came my way. Try it out and forget it. Put a blanket on
> my shoulder and go where I wanted. This land was wide and
> boundless once. Every act still had no name, and every piece
> of land and sky was not spoken for.

To be sure, issues of race and racism do underlie the texts of these Nisei works, particularly because the authors, with the exception of Mori, wrote their stories and plays after the war, after the birth of their awareness of racism against Nikkei. When Japan bombed Pearl Harbor, these issues surfaced powerfully, making the time before the war

seem like a temporary yet irrevocable barrier against the onslaught of history—a mythical, nostalgically a-historical time that older Nikkei refer to as "before the war." And even in the darkest of works among these Nisei writers, John Okada's novel of postwar Seattle, *No-No Boy*, the protagonist Ichiro Yamada recalls a time (that he says he can "no longer remember") when it was all right for his mother to tell him stories of legendary Japanese heroes and when it was all right to be Japanese in America (1976, 15).

With Japan's attack on Pearl Harbor, history crashed into the peaceful life that Kamekichi Tokita and his fellow Issei had made for themselves and that they tried to provide for their families. In the case of the Tokita family, there were Kamekichi and his wife, Haruko, and seven young children during their incarceration in the concentration camp of Minidoka, Idaho. Tokita was forty-four years old when Japan attacked, and on that fateful day he began his diary. To write it appears to have been an unprecedented and decisive act. He was a man so strict and disciplined with his words that a son, Yasuo, cannot recall ever having a direct conversation with his father (39).

Confronting the personal, familial, community, and worldwide historical significances of Japan's bombing of America, on that day Tokita began writing in the mature voice of an Issei about the interplay of facts—that he sought vainly to verify in news reports—and his emotions. The voice of his diary seems to address both himself and his family, as if a conversation among them had been in progress. In the months that follow he writes that he wants to be understood by readers in the future. He discusses his concerns for the Nisei and how they have a right to be regarded and treated as American citizens. Through his writing Tokita paints a picture of what it means for him to be an Issei of Seattle in this historical crisis when their children, the Nisei, must be separated from their parents in their legal identities and the Issei themselves are, even by Tokita's own reckoning, the "enemy alien." It is now a time when he cannot himself control how he is defined. For weeks he notes the condition of his bowels, his meter for his control over his own body being a meter for his and others' control over their lives.

The most stunning passage in the diary occurs on the very first day:

> My heart is full to bursting. In the space of a moment, our
> lives became worthless in this society. Not only have we
> become worthless, we're unwanted. It would be better if we
> didn't exist. (110)

In the process of his swift drop from empowerment to subordination, Tokita experiences a kind of atomization and annihilation of himself, even while he feels that his heart is full. The passage on 7 December continues:

> The cold wind of December did not blow directly on me until
> yesterday. It's now blowing right through me. Even the wind
> doesn't approve of our existence. I feel cold. So cold.
>
> > *Stricken on a journey,*
> > *My dreams go wandering round*
> > *Withered fields.*
>
> This poem comes to my mind. . . . After more than two
> decades, we believed this place had become a second home
> to us. Were we merely travelers on a journey all this time? I
> suppose we were. Or were we really? (110)

Tokita's urgent musings about whether the Issei were settlers or "merely travelers on a journey" become a theme in his journal. On 5 December 1942, in the Minidoka concentration camp of southern Idaho where many Nikkei of Seattle were incarcerated, Tokita writes the poem that is a central expression of a journey at this historical moment: "Please come with me, traveling bag, although this is not an ordinary journey" (215). The poems on themes of journey foreshadow that sense the character Masu in Iko's *Gold Watch* expresses when he speaks of the freedom of putting a blanket, a bedroll, over his shoulder and going where he wanted, the traveling blanket being the stock

possession of the itinerant, migrant Issei worker, the *wataridori*, bird of passage. Tokita's journey evokes the swing music popular among young Nisei in the concentration camps. Lyrics of songs such as "Sentimental Journey" and "Chattanooga Choo Choo" had to be appreciated with a special irony, when these popular songs yearned for returning to a home. In the camps, the Nikkei were going nowhere, at least not at first. Besides, the Nisei knew that they could never return to the American homes they had been forced to leave, without both home and themselves being profoundly altered. At least for a moment in the life of each, the Issei had already experienced dislocation and a sickening moment of anomie when they left Japan, knowing or quickly learning, like the boy in the children's story of Urashima Taro, that once they left Japan, they could never return to the same place, because both Japan and they themselves would be changed by time and circumstances. In World War II, the Issei now doubted again where their homes would be and where they would want their journeys to lead even if they could go on the road. Tokita may be recalling Japanese lore about journeying, for instance the travels recorded in haiku and narratives by Matsuo Bashō. "Fleas, lice, / A horse pissing nearby. / A lodging for the night" foretold the life of a migrant Issei laborer and Tokita's vision of himself as a man on a journey, one day and one night at a time.

By means of a mass "relocation" of the Nikkei, the United States aimed in part to scatter the Japanese of the West Coast across the American landscape so that they would not be able to regroup as a community again. The "relocation" was to have been a Japanese American diaspora, like the scatterings and exiles of the Jews more than two millennia ago, meant to destroy them as a people. A theme of diaspora is implicit within Tokita's thoughts about both journeying (or scattering) and home, or the loss and recovery of a home and of "signs of home," the title of this book.

All the journeys—journeys that begin at home—that are metaphors in Tokita's life (some of them peculiar to Issei like Tokita) took place on "roads taken," to play on Robert Frost's popular poem ("The Road Not Taken," 1916). As members of a community, the Nikkei were

not alone. Kamekichi Tokita did not dwell on what might have been if he had taken that other road, but he took responsibility for his decisions and how they might affect his family now and in the future. There was a spirit in him that scarcely vacillated in spite of the crises he confronted in his days and his diary. For him, the big journeys in life did begin at home, and some ended at home as well. The diaspora failed even while it changed Japanese America and therefore America irrevocably. Tokita, Haruko Tokita, and their family returned to Seattle after the attempt to scatter them as if for their own good. Tokita's art, his diary, his family, and his moral strengths are his legacies.

ACKNOWLEDGMENTS

AS KAMEKICHI TOKITA RECORDED the toll of World War II on him and his fellow Nikkei, he could never have imagined that a book such as this would be published. The creativity and sense of adventure that brought him to the United States, the paintings that had won him a place in the Northwest art community, and the honor and discipline with which he conducted his life and guided his family all seemed to have come to naught. He had lost the fruits of twenty years' work. He, his wife, and their seven children were confined in a desert relocation camp, where, as the years dragged on, there seemed little hope for the future. Indeed, the remainder of his life was short.

This book represents the effort of many people to reclaim his achievements, and it is my honor to be part of it. The retrieval and translation of Tokita's diary began the reclamation, and the visual record of his artwork—although an oeuvre sadly diminished from what he actually produced—provides the evidence of his artistic accomplishment and the basis for an assessment of his place in the region's art history. His family has been central to the effort, and this book would not have happened without them. Shokichi (Shox) Tokita, the artist's eldest son, and his wife, Elsie, shepherded the gathering of Tokita's personal papers. Years later Shox and his nephew Eric Hwang assembled the newly

translated diary into notebook format, which Eric designed with pains-taking care and Shox eventually brought to the University of Washington Press with the assistance of a member of the Press's advisory board, Michael Burnap.

Throughout my work Shox was always ready to answer questions and make introductions, and I am grateful for his help in innumerable ways. Yoshiko Tokita-Schroder has worked with Shox to recover biographical details and contributed many of the photographs to this book. Yasuo, Yuzo, Ken (Masao) and Sandy Tokita, and Goro and Eileen Tokita enriched the story with their own stories. It was an exciting connection when Shox introduced me to Warren Suzuki, Tokita's brother-in-law and the only contemporary of the artist I met. All of them, together with the families of Shizuko Tokita Hashimoto and Mary Yaeko Tokita Namba, opened their homes to me and made paintings available for illustration in this book. Shox and Elsie and Ken and Sandy Tokita gave generous financial support that, together with the Scott and Laurie Oki endowment for Asian American studies, helped make the production of this book possible.

The diary that inspired this publication has had a remarkable odyssey. Sometime after Tokita's death, his widow, Haruko, gave a volume of the diary to Wahei, his brother in Japan, so that he might know something of their wartime experience. Decades later Wahei's daughter, Kakuko Imoto, retrieved the partial diary to inquire about its historical value and then contacted her American cousin Shox. By this time Tokita's personal papers, including the other two volumes of the diary, had been deposited in the Archives of American Art at the Smithsonian Institution, where they were preserved on microfiche. Mrs. Imoto and her sister, Yasuko Norizuki, were able to obtain these two volumes on microfiche by interlibrary loan and recombined them with the volume in Japan. The story of their translation, a joint effort of the Japanese and American cousins, is described in the Preface to the Diary in this book.

My own involvement in the book follows an equally fortuitous course. When I worked at the Seattle Art Museum in the 1980s, part of my job was to construct documentation for works of art in the col-

lection that had little or none. Six paintings by Tokita fell into this category. Eventually I tracked down Shox, and when he and Elsie came to meet me at the museum they carried armloads of personal papers. It was a historian's dream. At that same time I was managing a special undertaking of the Archives of American Art, the Northwest Asian American Artists Project, initiated by the Archives' West Coast regional director, Paul Karlstrom, and we directed the Tokita papers to the Archives. Thanks go to Paul for his leadership in this project and enthusiastic support of the acquisition. Twenty years later, when I contacted the Seattle Art Museum to obtain an image of a Tokita painting for publication, the museum instructed me to seek permission from the Tokita family, and this time I found Shox with the help of the Internet. He showed me a copy of the translated diary—facilitated by the Archives' microfiche copy—and a few months later Pat Soden, director of the University of Washington Press, asked if I would write the biography and art history to frame Tokita's diary. Sometimes life circles around in marvelous ways.

Many people have supported me in this undertaking. Tetsuden Kashima, professor of American Ethnic Studies at the University of Washington, guided me as I delved into Japanese American history. Stephen H. Sumida's work in particularizing and localizing the Issei voice influenced the way I looked at Tokita's art. It is especially fitting that his Foreword begins this book, and I very much appreciate his contribution. Frank Miyamoto and Roger Daniels, distinguished scholars in the field, generously helped shape my understanding of Seattle's Nihonmachi. Tom Ikeda, founder of Denshō, opened its library to me, and Mayumi Tsutakawa and Roger Shimomura suggested valuable contacts and resources.

The translation of Tokita's diary was the motivating force behind this book, and I respectfully acknowledge the work of translators Haruo Takasugi and Naomi Kusunoki-Martin. Naomi answered many questions and generously provided romanized versions of most of the poetry for this publication. Artist Keiko Hara and art historian Michiyo Morioka, both first-generation Japanese Americans, helped me understand

portions of the diary by comparing Tokita's original and edited versions, and I am grateful to them. Michiyo also provided the beautiful translation of Tokita's poem "Orange," published in this book.

Librarians, archivists, and museum professionals at several institutions aided my search for information. Wendy Hurlock-Baker was exceptionally helpful in retrieving images from Tokita's personal papers at the Archives of American Art. Thanks for expert assistance go to Carla Rickerson, Nicolette Bromberg, and their colleagues in Special Collections at the University of Washington Libraries; Robert Fisher at the Wing Luke Museum of the Asian Pacific American Experience; and Jodee Fenton and Carletta Wilson at the Seattle Public Library. David Martin, owner of Martin-Zambito Fine Art and an indefatigable researcher, was generous in sharing information. Margaret Bullock at the Tacoma Art Museum led me through the museum's fine collection of *ukiyo-e* prints. Photographer and historian Paul Dorpat put his sleuthing skills to work in identifying sites represented in Tokita's paintings. In addition to these mentioned, Lowell Bassett of the Seattle Art Museum, Zoe Donnell of the Tacoma Art Museum, and Carolyn Marr of the Museum of History and Industry provided images for publication.

The opportunity to study Tokita's paintings was one of the gifts of this undertaking. My experience of looking is always deepened by artists' insights, and it was a true pleasure to look at the body of Tokita's work with painter Robert C. Jones. Keiko Hara has investigated the work of Sesshū through her own painting and spoke eloquently of its influence on Tokita's painting. Richard Nicol provided new photography of Tokita's paintings, and for that process Peter Malarky, a painter and painting conservator, unframed each with care.

The University of Washington Press has supported this book with steadfast excellence. I am deeply grateful to Pat Soden for inviting my participation; to Beth Fuget, acquisitions editor, for guiding the manuscript to completion with commitment and perseverance; to Marilyn Trueblood, managing editor, for spirited encouragement and support of all kinds during production; and to Tom Eykemans for the thoughtful

design that speaks to Tokita's era. Working alongside the Press, Sigrid Asmus once again edited my work with an expert hand and online conversations that often extended beyond editing. To the academic reviewers, art historian Martha Kingsbury and one who prefers to be unnamed, I extend great thanks for corrections and suggestions from their respective fields, which substantively improved the book.

The Seattle Art Museum has taken the occasion of this book to present an exhibition of paintings by Tokita and his friend and colleague Kenjiro Nomura. I thank especially Chiyo Ishikawa, the museum's deputy director for art, for her early interest and Zora Hutlova Foy for coordinating the planning. The exhibition will open in October 2011 at the Seattle Asian Art Museum, the same galleries where Tokita's work was first hung, and is yet another way in which the book completes a circle of experience.

There is at least one more circle to be drawn, although others may find their own through Tokita's story. The Aleutian battlefront of World War II that Tokita found so compelling is a story I share. My birth-father, a pilot, was killed early in that campaign and I grew up with a sense of the war's continuing human impact. I dedicate my contributions to this book to my mother, Helen Jane Klinger Gleeson (1917–2010), who lived by her own firm code of honor.

As always I thank my husband, Richard Hesik, for standing beside me in this endeavor with utmost patience and encouragement.

Barbara Johns
Seattle, Washington

SIGNS *of* HOME

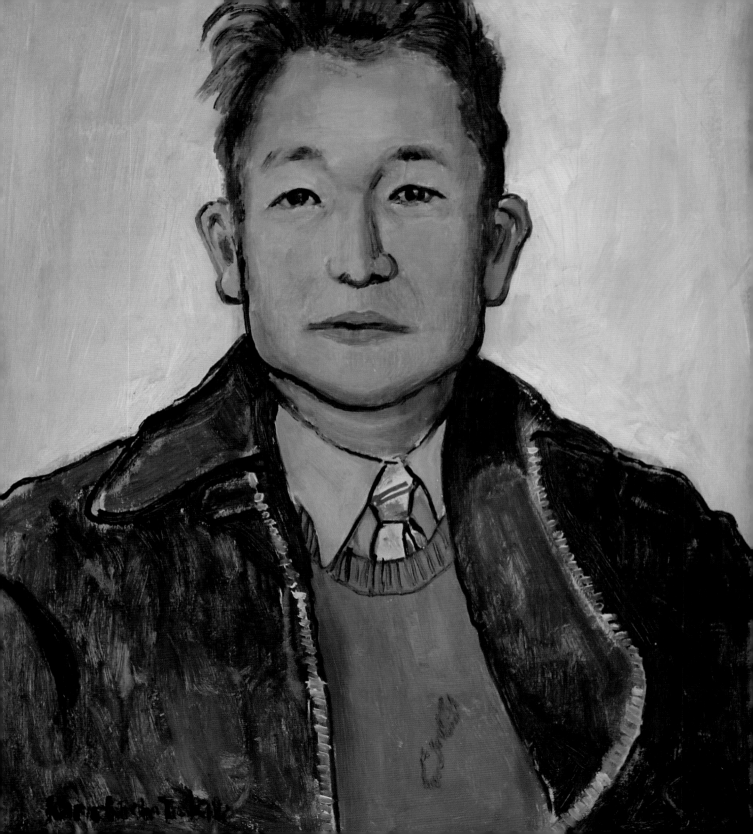

Introduction

THE ARTIST

Barbara Johns

1 *Self-Portrait*, ca. 1936
Oil on canvas
21 × 17 in.
Collection of Shokichi
and Elsie Y. Tokita
Photo: Richard Nicol

THE ARTIST LOOKS SQUARELY AT US. The face is open and minimally shadowed, the eyes are direct, the jaw strongly outlined. The expression is warmed by spicy oranges and browns and enlivened by detail conveying manner and habits—the tie beneath a pullover sweater, the hole burned in the sweater by cigarette ash, the jacket flung casually open. The jacket zipper curves audaciously, each cog in the track a single white brushstroke. Its energetic gesture echoes the strong curve of the jaw and serves as a foil to the smoothly handled, sensitive coloration of the face. The hair is a rusty brown companion to the sweater and jacket, colored more by art than nature. A slight turn of the shoulders suggests even in the formal frontality of the pose that this is a figure full of motion.

Kamekichi Tokita, the artist, was born in Japan in 1897 and came to the United States as a well educated young man of twenty-two. Headed

3

for Chicago, he remained instead in the port city of Seattle and, except during wartime incarceration, made his life there for nearly thirty years. He made a living as a sign painter and a hotel manager, the latter better to support his family in the Depression. He participated fully in Seattle's Japanese American community then dominated by the Issei or immigrant generation, while through the hotel business and his artistic practice he engaged with white individuals and organizations. He was a creative, inquiring person, who found several lasting ways to express his thoughts and experiences—in art, poetry, and a diary. The painting and the writing overlap very little; overall the painting represents a time of creative expansion, the writing a time of intense inner struggle.

Painting was a public practice and the means of expression for which he was known. It was an activity he shared with a handful of artists of Japanese heritage, who were mostly Issei like him. Of the approximately forty extant paintings, most date from 1930 to 1935. The first public display of his work about 1924 was followed by prominent local and national exhibition and recognition until 1938, with one last showing in 1948. The demands of business and his young family effectively stopped his artistic production by the late 1930s. There are no paintings from these years, and only a few during the catastrophic displacement of World War II.

December 7, 1941, brought an abrupt end to the careful balance that Tokita, as well as the Japanese American community as a whole, had constructed between loyalty to the country of his birth and the practicalities of a life committed to the United States. Tokita began a diary that day, vowing to keep it until peace came. Neither he nor anyone around him could imagine that peace would be so long and deadly in coming. Day to day, he described the events, personal stories, fears, rumors, increasing restrictions and regulations, and conflicting news from the battlefront. He did not flinch from describing the emotional turmoil that wracked him personally as events unfolded. The diary is fullest from December 7, 1941, to April 28, 1942, when the Tokita family was forcibly sent to the Puyallup Assembly Center and subsequently to the Minidoka Relocation Center in Idaho, and is discontinuous there-

after. It is a very personal account, particularly in the early months, and provides a unique lens onto the community in which Tokita lived. Perhaps it was his artist's eye that enabled Tokita to see both the telling detail and the big picture and shift his view readily between the two. It is also his artist's sensibility that colors his account of family, friends, and place.

This book brings together two parts: an account of his life and artistic production told in retrospect by an art historian, and his first-person recording of the events around him and his response to them during World War II. Considering the personal reward that Tokita received from painting, the diary contains surprisingly few references to art. The pattern of his creative endeavors is embedded in life events, and the alternation in expressive means reflects their different motivations— the painting socially and personally rewarding, the writing a way to grapple with trial and uncertainty and to seek stabilization within himself. His writing began on a day of global and personal crisis, and once the family left Seattle, he did not resume the diary until they had settled in their final destination with their safety and immediate future secured. As they became more settled and he could devote time to himself, he began to draw, and shortly later to try poetry, which he had first attempted as a young man. With the passing months his diary entries became increasingly intermittent and focused on the war. Only briefly after the war, and only when the family was permanently resettled, did Tokita return to painting.

Readers bring their own interests and may attend to one or the other section of the book, but together the two parts show the complexity and creativity of Tokita's continual adaptation to the changing circumstances of his life. His story is that of a person who proudly bore the values of his country of birth while making a new home in the United States. It is specifically an Issei story in the life he established, the artistic synthesis he sought, his adopted country's betrayal, and the code of honor by which he sustained himself. The journey that Tokita evoked throughout his wartime writings signifies the constructive, values-based path he sought.

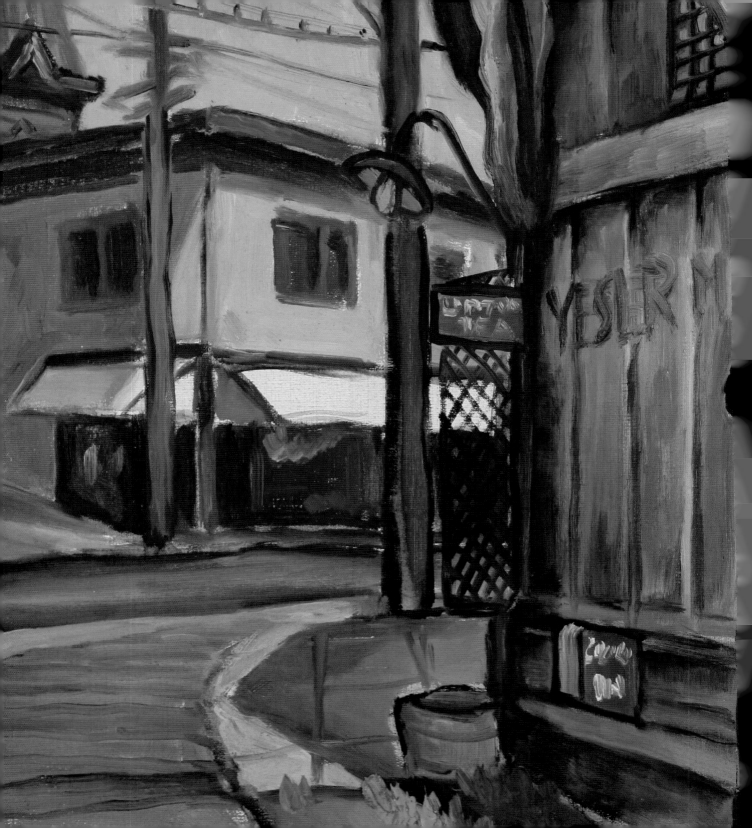

Biography
THE SIGN PAINTER

*After more than two decades, we believed this place
had become a second home to us. Were we merely
travelers on a journey all this time?*
—Tokita, Diary, December 7, 1941

Title unknown
(Yesler Market,
detail), early 1930s
(see fig. 78).

KAMEKICHI TOKITA WAS ISSEI, or first generation Japanese American. Born in Japan, he was reared and came of age in a modernizing country, one steeped in centuries-old, highly elaborated rituals and traditions yet rapidly taking its place among the world's modern powers. During the late Meiji (1868–1912) and early Taishō periods (1912–26) of Tokita's youth, Japan embraced Western learning while adapting it to its own purposes and expression. When Tokita immigrated in late 1919, he arrived on new shores not only as a citizen of the old world but also as a modern young man of his time.

Tokita was born on July 16, 1897, in the thirtieth year of the Meiji emperor, the "Enlightened Rule." In the thirty years preceding his birth, Japan had undergone revolutionary change from a feudal to a rapidly modernizing society; the world he inherited was entirely different from his father's. It had only been forty-four years since American warships had sailed into Edo Bay and the United States had forced a trade treaty with Japan. The 250-year military rule of the Tokugawa period ended in 1868 with the restoration of the emperor, followed by a new political system. Under the Tokugawa feudal structure, the samurai had held the highest position within a rigid class hierarchy, their warrior status symbolized by the sword and a code of honor that valued loyalty and bravery above all else.

Within five years of the establishment of the Meiji reign, the feudal domains of the samurai were abolished, their privileges were revoked, and the government declared all social classes equal. The government began an ambitious program of building modern transportation and communication systems, industrial capacity, and a modern military force. Universal education was mandated. The scientific knowledge of Europe and the United States was considered crucial to Japan's modernization and so, with government encouragement, students began to travel abroad for education, as increasing numbers of Europeans and Americans came to Japan to teach or conduct business. Western art, with its ability to represent the appearance of the physical world, was a part of this learning. Such skills as perspectival drawing and naturalistic modeling were considered an essential part of the scientific study required for rapid industrialization.

Tokita's youth was in the late Meiji years, which were a time of competing interests as Japan sought to determine how much of its past to retain and how to define it. The rapidity of change had brought widespread social and economic dislocation and an accompanying conservative reaction. In an effort to reconcile older Confucian thinking with modernism, an 1890 national educational edict declared loyalty and

filial piety the core values of the country.[1] By the time Tokita reached school age, Japan had fought and won its first two modern wars, the Sino-Japanese War of 1894–95 and the Russo-Japanese War of 1904–05, expanding its political and economic domain and accelerating the pace of industrialization and urbanization. In the cities, the older mercantile class was augmented by the immigration of people from rural areas, producing a middle class of merchants and small businessmen that recreated the system of relationships and responsibility on which village life was based.[2]

Tokita's family origins reflected both Japan's traditional past and its urban modernity. He was born to a family of samurai heritage, in the port city of Shizuoka City in Shizuoka Prefecture.[3] Once home to the first Tokugawa shōgun, Tokugawa Ieyasu, Shizuoka Prefecture was renowned as a tea-growing and exporting region and benefited from the city's large port. His father was Juhei Tokita, born Juhei Ohashi and adopted as a young child by the Tokita family, a traditional practice for a family who had no sons of its own.[4] His mother was Shin Kato Tokita. He was the second of five surviving children and the second son, following an older brother, Wahei. In addition to a shop owned by his family that sold dry tea, Juhei was owner and brewmaster of Uruma Soy Sauce, a small manufacturing business that his eldest son eventually joined.[5] In 1912, when Kamekichi was fourteen, his mother died and for the next six years his father was the sole parent.[6]

The family lived together with the paternal grandparents and was prosperous enough to have servants in the household. In childhood, Tokita learned important lessons in humility, respect, and responsibility from his grandparents. Always pausing before a meal, his grandfather taught him, "You must thank the farmer before you eat, because every grain of rice represents a drop of sweat." When Tokita questioned his grandmother's bargaining with a farmer and a fisherman, she responded angrily to what she saw as his ingratitude and explained the ritualized nature of the exchange, "You wretched boy. We do not buy food from them—but we beg them to sell food for our money."[7] The values learned through these lessons stayed with him throughout

2 Tokita family *mon* or crest. Illustration adapted by Yoshiko Tokita-Schroder.

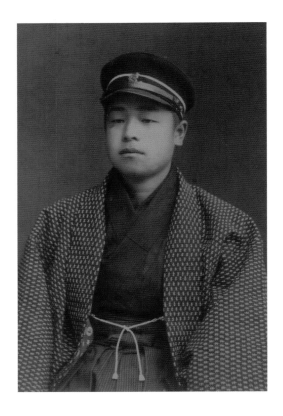

his life. His comfortable, middle-class background would distinguish Tokita from the majority of Issei in the United States, who were farmers and working class.

Tokita attended public schools in Shizuoka City from 1904 to 1915, six years in grammar school and five in high school, graduating with a business degree.[8] Meiji educational policies, which provided universal education for at least six years, closely controlled the schools to ensure that the curriculum included moral education, instilling in students their duty to the emperor, the country, and the family in accordance with national policy. A Western-influenced curriculum was introduced progressively and dominated the more advanced grades. Tokita developed an interest in the English language, and in adulthood could cite European as well as Japanese literary classics

3 Tokita during student years, ca. 1912–15. Courtesy of Yoshiko Tokita-Schroder.

4 Calligraphy by Tokita, December 30, 1924. Courtesy of Ken and Sandra Tokita.

when he occasionally invoked the experiences of literary characters as metaphors for his own life.

Tokita's father expected him to work in the tea business after graduation and arranged a position for him in China. The experience was life-changing, but for reasons other than those his father planned. In China (no record or anecdote tells the location), Tokita discovered a love of art, and spent much of his time learning about traditional Chinese ink painting. In exasperation, his father sent him to Manchuria to sell tea. To his father's dismay, Tokita spent his two years there studying calligraphy and painting with a Chinese teacher.[9] How much business he accomplished is unknown. He learned to be an excellent calligrapher, so good that years later, Katuichi Katayama, an interpreter in Seattle's Nikkei business community, would call him the finest he knew in Japan or the United States.[10]

Tokita had drawn since youth and avidly pursued art as a young adult, and at some point during these years he rebelled against his father by refusing to cut his hair.[11] While others of his modern generation had rebelled in personal and professional ways, nevertheless such disrespect of a father's authority was a provocative assertion of will. Finally his father determined to send him farther away, this time to Chicago, home of a small Japanese immigrant community dating from the 1890s, where he imagined Tokita would find little of artistic interest to distract him.[12] Tokita's brother Wahei was already in the United States, living in Seattle, where for more than a decade he had been working to pay off a debt incurred by their father. Juhei did not want two sons abroad but allowed his younger son to leave on the condition that Wahei return home. Tokita sailed on the direct line from Yokohama to Seattle, destined for Chicago.

SEATTLE

When Tokita landed in Seattle on December 2, 1919, he found a young, aggressive frontier city. Seattle was then home to over 315,000 people, including nearly 8,000 of Japanese ancestry—first-generation immi-

grants and their American-born children.[13] Founded on the waterfront of Puget Sound, Seattle had grown uphill north and east of the tidelands that filled Elliott Bay south of the docks. While Seattle citizens could be proud of downtown's many distinguished buildings, including the famed Smith Tower, the tallest building west of the Mississippi River, the city had only recently grown past its pioneer roots. Nearly all of its buildings dated from the previous thirty years, since the Great Seattle Fire of 1889 had destroyed most of the commercial area. The Klondike gold rush that began in 1897—coincidentally the year of Tokita's birth—solidified the city's development as a major supply port. Railroads steamed into the city from the south, where in 1919 two side-by-side stations anchored the terminals.

On the south edge of downtown near the waterfront and the railroad terminals, a pan-Asian community grew with successive waves of immigrants. A Chinatown, a Japantown, and later, a Filipino community developed in adjacent, tightly packed city blocks. Japantown or Nihonmachi began to develop in response to the increasing pace of immigration by the end of the century, growing north from Dearborn Street until it centered on the slope of South Main Street and Sixth Avenue and extended several blocks up the south side of Yesler Hill

5 Wahei Tokita, Seattle, ca. 1920. Union Station (now King Street Station) and Smith Tower (*left and right*) are in the background. Kamekichi Tokita papers, ca. 1900–48, Archives of American Art, Smithsonian Institution.

6 Kamekichi Tokita, 1920s. Courtesy of Yoshiko Tokita-Schroder.

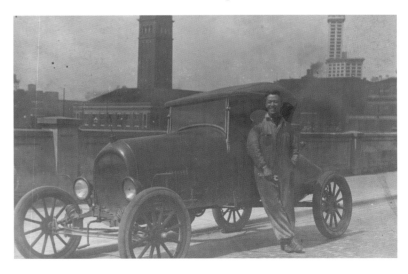

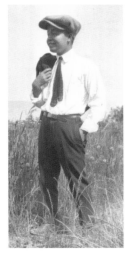

(now First Hill) to James Street. It was hilly terrain, and after Jackson Street was leveled in 1909 during the city's extensive regrading projects, Nihonmachi spread along flatter ground south and eastward. The community was predominately the immigrant generation, the Issei, with a growing number of Nisei, their American-born children. Collectively they were Nikkei, of Japanese ancestry. Here by 1919 were hotels, restaurants, laundries, dry cleaners (called dye works), grocers, newspaper and business offices, and the many kinds of suppliers and professional services needed to provide for a community and cater to a growing white clientele. World War I brought a boom to Seattle's shipbuilding industry, whose influx of workers needing lodging and services spurred a new level of prosperity for Japanese businesses.[14]

Tokita disembarked from the *Suwa Maru* less than a month after the end of World War I, as American nationalism was on the rise. The return of soldiers from active duty meant heated competition for jobs and resources, which refueled a simmering anti-Japanese racism on the West Coast. California, with the largest immigrant population, had long been the hotbed of anti-Asian agitation, first against the Chinese, then the Japanese. The attitude inflamed some in Washington, and in 1919, the year of Tokita's arrival, the Seattle Anti-Japanese League was formed

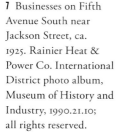

7 Businesses on Fifth Avenue South near Jackson Street, ca. 1925. Rainier Heat & Power Co. International District photo album, Museum of History and Industry, 1990.21.10;

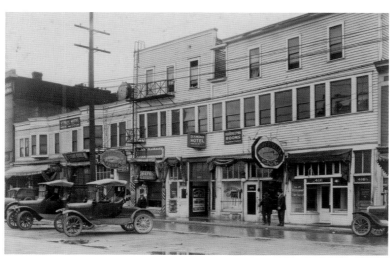

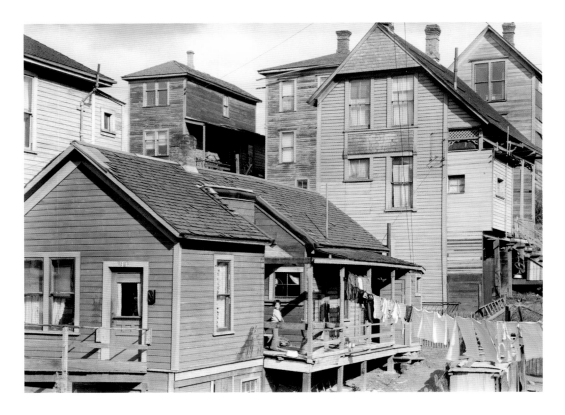

under the leadership of Miller Freeman, a businessman with extensive real estate interests on the east side of Lake Washington. Miller framed his opposition in terms of economics and employment, noting that Issei dominated such Seattle businesses as hotel management. He testified at a Congressional hearing in 1920, "To-day, in my opinion, the Japanese of our country look upon the Pacific coast really as nothing more than a colony of Japan, and the whites as a subject race."[15] A campaign for exclusion intensified, championed by the *Seattle Star* newspaper. In 1921, Washington State followed California's example and passed the Alien Land Law, which prohibited Isseis' ownership of real property, restating and strengthening a provision already in the state constitution.[16]

Tokita reportedly took a fast liking to his new country. Whether his intentions were to settle in the United States or return to Japan,

8 Housing on Yesler Hill (now First Hill), ca. 1930s. Nihonmachi spread several blocks up Yesler Hill as far north as James Street. Special Collections, University of Washington Libraries, UW 531.

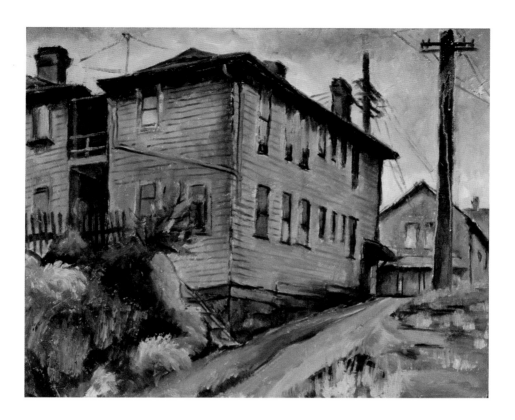

9 *House*, ca. 1930
Oil on canvas
18 15/16 × 23 5/16 in.
Seattle Art Museum,
gift of the artist, 33.228
© Kamekichi Tokita

national as well as local political events during the first years after his arrival severely limited his choices. He soon found himself in the U.S. with no prospect of becoming a naturalized citizen. The U.S. Constitution in 1790 established citizenship for "any alien being a free white person."[17] The Fourteenth Amendment, in 1866, granted citizenship to African Americans and anyone born in the United States but did not address the status of Asian immigrants, who remained without the right of naturalization. Occasionally there had been differing opinions on whether Asians were white, but in 1922 the Supreme Court concluded emphatically in *Ozawa v. United States* that anyone born in Japan and of the "Japanese race," not being Caucasian, was ineligible for citizenship. Under increasing pressure, led by California, Congress passed the Immigration Act of 1924, which effectively

halted immigration from Asia. The law barred immigration by aliens ineligible for citizenship and also required every alien entering the United States to hold a current visa issued by an American consulate, virtually assuring that those who visited Japan could not return to the States. Isseis like Tokita faced a challenging decision: they could return to Japan, where they held rights of citizenship, or they could stay, knowing they could never become citizens of their new home. Tokita decided to stay.

Little is known of Tokita's first years as he made his home in Seattle. Initially he had the companionship and guidance of Wahei, who remained in Seattle for about a year before returning home to Japan. With his enthusiasm for art Tokita must have been quickly drawn to others who shared his interest. He came to the United States with some knowledge of English and in time enrolled in English classes at the Japanese Language School. For the rest of his life, he studied as he read, keeping a notebook and a dictionary at his side to list unfamiliar words and their definitions.[18]

Seattle's Nikkei community flourished in the 1920s as Tokita was becoming established. Washington's Nikkei population was predominately urban, making Seattle a concentrated hub of activity.[19] The core of Nihonmachi was clustered around Sixth and Main within a several-block radius. Downhill at Fifth and Jackson was the Seattle Japanese Association, the largest and most influential organization within the Nikkei community, which shared office space with the Japanese Chamber of Commerce. Within a block to the west were the offices of the most important newspapers, the *North American Times* (*Hokubei Jiji*) and the *Great Northern Daily News* (*Taihoku Nippo*), and, beginning in 1928, the English-language *Japa-*

10 King Street and Sixth Avenue South, ca. 1924. The Japanese Chamber of Commerce was upstairs. Museum of History and Industry, 1990.21.9.

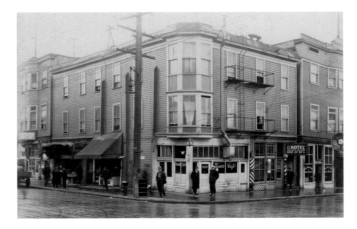

nese American Courier, which was directed to the next generation. Several restaurants around Sixth and Main accommodated groups as large as three hundred people and served as important meeting places, while up the steep slope of Washington Street the Nippon Kan theater was the site of frequent community, political, and cultural gatherings of all kinds. Sixth and Main was also the ceremonial center, where the musicians' platform stood during the annual Bon Odori festival and dancers gathered in the block below.

Nihonmachi was the domain of Issei men, and the Japanese Association was the dominant social, economic, and political organization—the main instrument of the Isseis' authority. It was closely aligned with the Japanese consulate, which promoted excellence in all affairs and

11 *Street Corner*, ca. 1935
Oil on canvas
24 × 30 in.
Collection of Shokichi
and Elsie Y. Tokita
Photo: Richard Nicol

Tokita pictures a different location but a scene remarkably similar to that of fig. 10.

encouraged acculturation.[20] The Association represented up to thirty community groups, and, together with the Japanese Chamber of Commerce, which represented trade-specific groups, brought together the varied community interests. The community was highly organized through this network of professional and social affiliations that were in turn reinforced by a system of mutual obligations that followed established patterns in Japan.[21] It was characterized by a strong middle-class culture of merchants and self-employed businessmen, who, as in Japan, were typically the organizers of community festivals and events. Although there is little record of Tokita's connections, he later noted in his diary that most of the businesses were "known to" him.[22]

Seattle's Nikkei community was also an unusually concentrated educated class. At the community's peak, five Japanese-language newspapers were published in Seattle, along with up to three dozen magazines and weekly papers.[23] Both the newspapers and magazines were filled with opinion and controversy. Artistic activities of many kinds—painting, poetry, music, dance, drama, flower arranging—were formalized, widely practiced means of self-expression among the Issei. Poetry groups flourished, the oldest formed in 1919, and several issued their own magazines.[24] Among the distinguished poets, and the founder of two poetry groups, was Dr. Kyō Koike, a physician and an internationally renowned photographer. The publisher of *The North American Times*, Sumio Arima, had studied painting under John Sloan at the Art Students League in New York before following his father in the newspaper business.[25] Near the corner of Sixth and Main was the small antiques shop of Shigetoshi Horiuchi, who was also the business manager of *The Great Northern Daily News*, the main competitor of *The North American Times*.[26] His personal collection of Japanese art was one of the finest in the country and was celebrated at the Seattle Art Institute.[27] Tokita established himself in this community, where both his physical and personal proximity meant that his acquaintance with at least some of these individuals was inescapable.

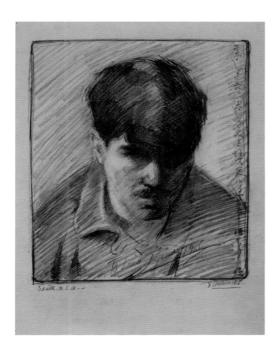

12 Yasushi Tanaka
(1886–1941)
Self-portrait, 1915
Pencil on paper
7 1/2 × 6 1/2 in.
Private collection,
courtesy of Martin-
Zambito Fine Art
Photo: Richard Nicol

BECOMING AN ARTIST

Japanese American painters in Seattle were actively engaged in exhibiting their work to a larger public by the time of Tokita's landing. Five had been included in the Seattle Fine Arts Society's first annual exhibition for Northwest artists in 1914, out of thirty-one exhibiting artists.[28] Another group held semiannual exhibitions in Nihonmachi, naming themselves "Spring and Autumn" for the seasonal program. The *Town Crier*, a weekly magazine of arts and culture, reported on a 1916 exhibition at Fifth and Main streets, "It is in a poorly-lighted store room the walls of which have been carefully covered with a light tan wrapping paper. But one overlooks such things while examining the canvases."[29]

One of those represented was Yasushi Tanaka, who by Tokita's arrival in 1919 was the most prominent among the Issei artists and one of only a handful of artists in the city to make a living from art. He had had one-person exhibitions in Seattle and New York and attracted considerable press. Despite his accomplishment, however, he grew frustrated by the barriers he experienced, especially after having been rejected from the Corcoran Art Gallery's national exhibition of American art because he was not "American," and in 1920 he and his wife moved to Paris. "So, just in time, Paris is waiting for us," he wrote. "My desire is only to be *a* painter, not necessarily an American or a Japanese."[30] Tanaka left Seattle as anti-Japanese nationalism surged in the United States, leading to the legislation that severely restricted his generation. He would be the only artist of Japanese ancestry in Seattle to win such prominence until after World War II, when Paul Horiuchi and George Tsutakawa began their fifteen-year rise to national recognition.

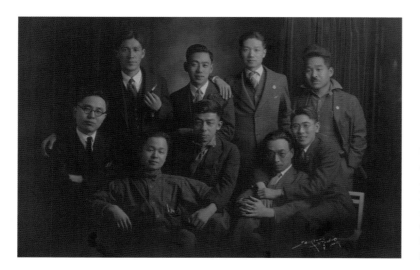

13 Young Issei men, including Tokita (*seated second from left*) and Kenjiro Nomura (*standing second from right*), early 1920s. Jackson Street Studio. Courtesy of Shokichi Tokita.

Early in the 1920s Tokita met Kenjiro Nomura, an immigrant only a year older than he, although with more years' experience in the United States. Nomura became a lifelong friend, who introduced him to oil painting and commercial art. Born in 1896 in Gifu Prefecture, Japan, Nomura was ten when his family immigrated to Tacoma and sixteen when they returned permanently to Japan.[31] He remained in Washington, leaving school to find work, and in 1916, at age twenty, moved to Seattle to work for a Japanese shopkeeper. Within the year he found his way to the painting studio of Dutch émigré artist Fokko Tadama, who had a prominent teaching studio in Seattle and counted a number of Issei among his students and colleagues.[32] As an immigrant himself, of Dutch and Indonesian ancestry, Tadama was perhaps particularly receptive to others negotiating the divide of old and new homelands and cultural difference. From Tadama, Nomura learned the handling of paint media and the fundamentals of the Western tradition: figure drawing, two-point perspective, modeling, and composition. By 1922 he was accomplished enough to have his paintings selected by the jury for the Seattle Fine Art Society's *Annual Exhibition of the Artists of the Pacific Northwest*. Nomura studied in Tadama's studio over a five-year period and passed along to Tokita his lessons in oil painting.[33] In turn, Tokita's knowledge of cal-

ligraphy and traditional ink painting surely must have added a depth of sophistication to the artistic practice and discussions they shared.

Nomura served as a business mentor to Tokita as well. Finding an opportunity to combine painting with income-generating work, Nomura had become an apprentice sign painter, most likely with the sole Japanese American sign painter in Seattle at the time, Burgira Hirayama.[34] In 1922 Nomura and Show Toda, a fellow artist, opened their own business, which they called Noto Sign Company, a combination of their two names.[35] The next year they moved to a storefront at 216 Sixth Avenue South, where the shop would remain for thirteen years. When Toda married and turned to other work in 1928, Tokita became Nomura's partner in the sign business. The name fit the new partnership seamlessly.

Sign-painting became the profession by which Tokita identified himself throughout his life. He and Nomura both lived in the shop until each married, Nomura in 1930 and Tokita in 1932. The shop was located around the corner from Sixth and Main, advantageously close to customers, and after Hirayama's shop closed in 1930 they were the only sign-painting business in the district. They produced gold-leaf script on store windows in Japanese or English and illustrated

14 Nomura and Tokita (*right*) in front of the Noto Sign Company, ca. 1928–36. Kamekichi Tokita papers, ca. 1900–48, Archives of American Art, Smithsonian Institution.

15 Noto Sign Company receipt, ca. 1928–36. Courtesy of Shokichi Tokita.

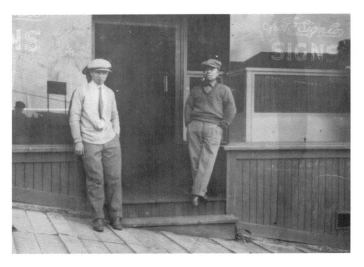

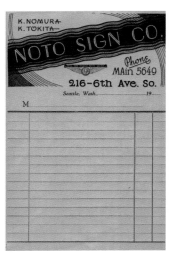

signs for Japanese and Chinese businesses of all kinds. "They did beautiful work," artist George Tsutakawa remembered. "They were doing very good business, and they were also painting backdrops and scenery for the Japanese opera, the Kabuki. The old Japanese [Nippon Kan] theatre was going full swing then."[36]

From its beginning the sign shop served as a creative venue. Tokita and Toda started a notebook of poetry in 1923. Poetry was widely practiced among the educated Issei, and particularly for men of Tokita's generation was one of the few accepted means of expressing emotion.[37] Tokita and Toda chose *tanka*, a traditional poem form of thirty-one syllables, and wrote on the title page, *Hei-i*, "Simplicity." The prologue is a reflection on intent and readership that foretells the reflective character of Tokita's diary.

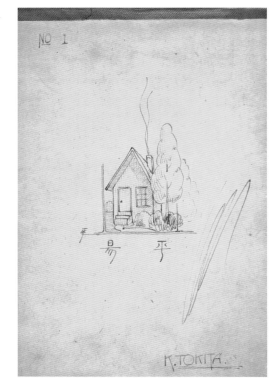

16 Tokita, cover illustration for poetry notebook, 1923. Kamekichi Tokita papers, ca. 1900–48, Archives of American Art, Smithsonian Institution.

We have purchased ten of these notebooks. They feel nicer and smoother to write on than we thought. We would like to keep writing until the last page of the tenth notebook, if possible. Even if the readers may not find it interesting, we intend to relate some impressions that we find memorable.[38]

They filled only part of one notebook (or only a partially filled one remains); some poems are complete, some scratched out in trial and error. The cover design, a house and a tree, is rendered and signed by Tokita in the elegantly simplified, rounded forms of early modernism, indicating that he had already learned the stylized graphic skills of sign-painting. He seems not to have tried poetry again until wartime, when the need for emotional release was acute.

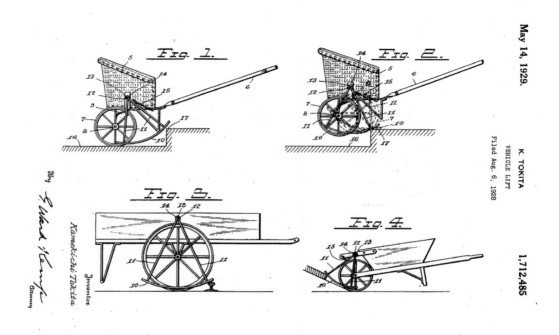

May 14, 1929.

K. TOKITA

VEHICLE LIFT

Filed Aug. 6, 1928

1,712,485

17 Tokita, patent illustration for a vehicle lift, 1928. Patent 1712485, registered 1929, www. freepatentsonline. com/1712485.pdf.

Tokita's creativity is evident in other ways. He registered two patents in the late 1920s, a vehicle lift and a medical syringe. The first, which he submitted in 1928, was a device to raise manually operated vehicles over curbs and other obstacles. Working through patent attorney G. Ward Kemp, he described the invention as providing "levers attached to curved shoes, the levers pivotally attached to the vehicles and which will readily lift the vehicle when moved forward against an obstruction."[39] The medical syringe had a collapsible bag to eliminate air intake. Both patents, along with the effort and expense they entailed, demonstrate his curiosity, imaginative energy, and practicality.

For the next twenty-four years, until Tokita's death, he and Nomura would paint and exhibit alongside one another, their names commonly linked together. It proved a sustaining, mutually supportive artistic

partnership. Noto Sign Company served as their painting studio. The two joined other Nikkei painters on weekend sketching trips, sometimes to the waterfront, on other occasions to the rural Duwamish or Green River valleys, which were extensively farmed by Nikkei families. Afterward they often gathered together at the sign shop to socialize and critique each other's work. Their painting colleagues were a changing group of Nikkei artists, some known and some unknown today. They included Takuichi Fujii, who was among the most prominent in the 1930s but would leave the Northwest, moving to Chicago from Minidoka;[40] Genzo Tomita, who returned to Japan before the war; Shigemitzu Hamada; and Keijiro Miyao. Their group sometimes included a few younger painters, notably Chikamasa Horiuchi, later known as Paul Horiuchi, who visited periodically from Wyoming, and George Tsutakawa, a Kibei, educated in Japan and returned to Seattle in 1927.[41] Years later Tsutakawa recalled how, soon after his return, he and his friend Shiro Miyazaki visited Noto Signs to watch the two older men

18 Sketching trip, ca. 1930–35; Takuichi Fujii (*left*) and Nomura (*right*). Kamekichi Tokita papers, ca. 1900–48, Archives of American Art, Smithsonian Institution.

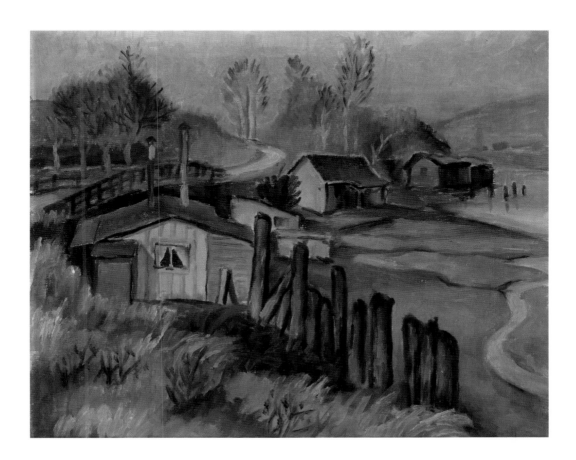

February, ca. 1931
Oil on canvas
17 1/2 × 21 1/2 in.
Collection of Goro
and Eileen Tokita
Photo: Richard Nicol

paint and found inspiration in their example. "[Miyazaki and] I used to drop by after school or weekends. . . . We'd sit there and talk about art, and they were already very much in the art, and they were very knowledgeable. They have studied European art, American art, and they were doing some very fine work."[42] The Nikkei painters provided the core support for Tokita's artistic endeavors.

Tokita also surely knew some of the prominent art photographers in the Japanese community. Many of them belonged to the Seattle Camera Club, which Dr. Koike founded in 1924 and led until its closing in 1929.[43] Tokita, who was beginning to exhibit his own work, cared enough about attending the 1924 annual *Salon of Pictorial Photography*

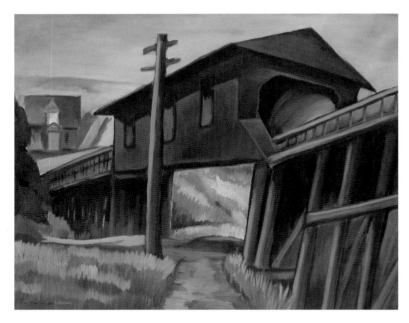

20 Takuichi Fujii
(1892–1964)
Title unknown,
mid-1930s
Oil on canvas
25 × 31 in.
Private collection,
courtesy of Martin-
Zambito Fine Art

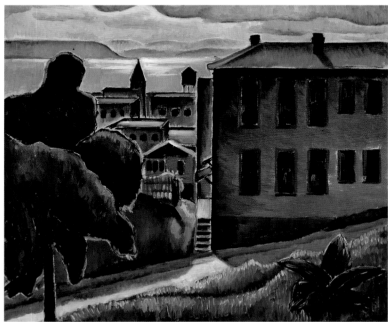

21 Kenjiro Nomura
(1897–1956)
Puget Sound, ca. 1933
Oil on canvas
19 5/8 × 23 3/4 in.
Tacoma Art Museum,
gift of Mr. and Mrs.
Cyril A. Spinola, 1992.8
Photo: Richard Nicol

to save its brochure. Koike promoted the integration of the arts in the club's bimonthly, bilingual newsletter *Notan* (meaning the interaction of light and dark), which published fiction, drama, and art history along with photographic news. Through the newsletter, he encouraged the choice of Seattle city scenes as subjects of art. He made an eloquent appeal in 1925 that evokes the scenes Tokita would paint:

> If you are a stranger who wishes to find some photographic subjects in this city, I am able to guide you. . . . Now follow me and listen:
>
> This is Pioneer Square, the center of the city . . .
>
> Once in an early morning, Mr. T. Morinaga, a member of our Seattle Camera Club, strolled along Second Avenue, and turning back from Columbia Street corner . . . he snapped this building and there was his "Quiet Hour, Seattle" which was published in the *Seattle Times*, Rotogravure Section, and which was accepted by New York Salon recently. One block up Third Avenue and James Street, there is the County-City Building, the south entrance of which gave me my "Sunday Afternoon". . . . Allow me to take you to the nearby bridge over Fourth Avenue at Yesler Way and never say your hasty judgment is not worthy of photographic desire, but remember that one who keenly observes things can find a gem everywhere.[44]

Koike's advocacy of the integration of Japanese and Western art also foreshadowed Tokita's efforts. An article on Japanese art history, which Koike translated and published in *Notan*, concludes, "When we Japanese succeed in mingling Western conception with our own idea, there will appear a new art, free from the peculiarities of both. At least we must advance toward such a result."[45] A decade later Tokita would state his own intent in similar terms.

Although by the nature of their medium the photographers were able to reach an international audience unavailable to the painters, the shared interests of the painters and photographers in Seattle are

striking. The most renowned of the photographers were featured in the *Town Crier* and exhibited at the Seattle Art Institute and the Seattle Art Museum, where Tokita's work was sometimes exhibited at the same time as theirs. The records of their concurrent or successive exhibitions, however, are the only trace of their connection. These activities and many more were part of the vibrant Issei community in which Tokita came of age artistically.

ENTERING THE MAINSTREAM

As Tokita was establishing himself in the new country, the white art community in which he was to make a place began to coalesce. Although Tanaka left Seattle within months of Tokita's arrival, several artists with whom Tokita would one day be connected came to the city around this time. Each was also connected to art institutions that contributed significantly to the city's artistic growth. In 1919 the University of Washington established a new Department of Art and Design and hired the cosmopolitan Ambrose Patterson to teach. Four years later painter and educator Walter Isaacs was hired as the department's first director. Both had firsthand experience of contemporary French painting. Patterson, an Australian, had lived and exhibited in Paris, Brussels, Hawai'i, and California, and, in Paris, exhibited with the Fauves, the radicals of their day; Isaacs, the more conservative by nature, had just completed two years of study and travel in France. Mark Tobey, who would become the most widely recognized, arrived in Seattle in 1922 and soon headed the new art department at the educationally progressive Cornish School. In coming years he would delve deeply into Asian, particularly Japanese, aesthetics and philosophy. He left Seattle in 1931 to teach in England, not to return until 1939, and

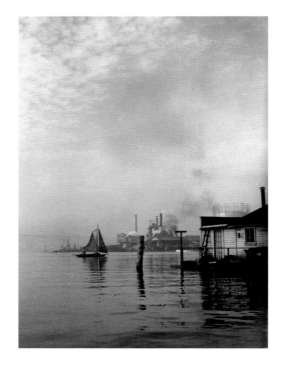

22 Kyō Koike
(1878–1947)
Passage, n.d.
Gelatin silver print
Special Collections,
University of Washington Libraries, UW28786z

23 Title unknown
(Fourth and Washington), 1930
Oil on canvas
17 3/4 × 21 1/2 in.
Collection of Yuzo M.
and Lilly Y. Tokita
Photo: Richard Nicol

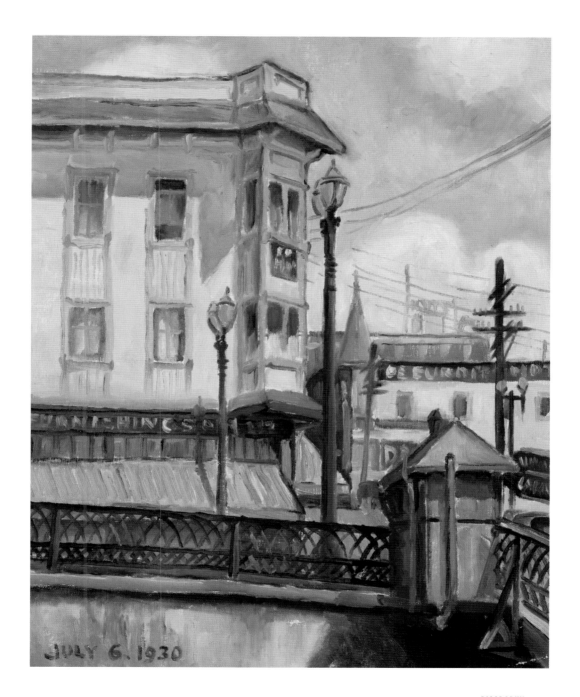

JULY 6. 1930

except for occasional visits was absent from the city for most of the decade of Tokita's greatest activity; yet he, more than any other, was sensitive to the cultural bridge that Tokita and his peers represented. Patterson, Isaacs, and Tobey became anchors of Seattle's fledgling art community, and each would be important to Tokita's mainstream participation.

Kenneth Callahan, a young artist returning to the city of his youth in 1928, was soon acquainted with the older men. By the early 1930s he was beginning to establish both a regional and national record of exhibitions. "Kenneth we saw very often," recalled painter Viola Patterson, Ambrose's wife, "and after he married Margaret [Bundy] Callahan, they were a center. In fact, they were the center." Callahan married Bundy, an editor of the *Town Crier*, in 1930 and assumed her role as the magazine's art columnist; their home soon became a place for animated artists' gatherings. Throughout the 1930s and 1940s Callahan would be the primary voice in articulating a regional vision.

With the exception of formal communications, however, there was limited interaction among the Issei and white artists, for whom Nihon-machi was merely a place of occasional visits and inexpensive meals. Margaret Callahan wrote about exploring the district, but she could do so only as an outsider with a eye for the picturesque.[46] The lack of exchange was compounded by the Isseis' deferential manner. Years later Tsutakawa recalled that even as Tokita and Nomura gained reputation they retained a formal distance. "Mark Tobey wanted to talk to Nomura and Tokita, but they always shut up when they're confronted with a great artist. Because he was regarded as so superior, they were modest. . . . They were immigrants. . . . There was a very strong feeling about this. . . . They have to contain themselves."[47] The Isseis' reticence would have implications in future years, however, when they were largely overlooked as a Northwest style was defined.

The growth of institutional structures to support artists paralleled Tokita's early career. The Seattle Fine Arts Society, by Tokita's time, was the predominant art organization and regularly mounted exhibitions at various downtown quarters. Through its sponsorship of the North-

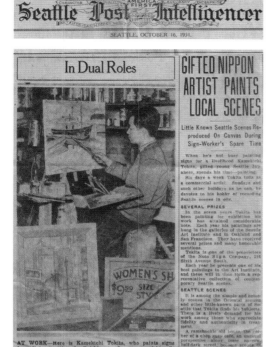

24 Tokita, featured in the *Seattle Post-Intelligencer,* October 16, 1931. Courtesy of Yoshiko Tokita-Schroder

west annual juried exhibitions, the Fine Arts Society, along with its successor organizations—the Seattle Art Institute (1928–33) and the Seattle Art Museum (opened 1933)—was the primary route to mainstream recognition for Issei artists, as it was for all of the artists in the region.

A surge of institutional growth occurred in the prosperous years of the late 1920s and continued into the early 1930s, the years of Tokita's greatest productivity. With a major gift from Horace C. Henry, the University of Washington opened the Henry Gallery in 1927, which provided special exhibition galleries as well as a home for Henry's collection. Walter Isaacs was appointed gallery director; its curator was Halley Savery, an Orientalist by academic training, who had strong connections in contemporary art.

The Seattle Fine Art Society moved into the art gallery Henry had built adjacent to his Capitol Hill home and changed its name to the Seattle Art Institute, shedding the exclusive "society" to signal an expanded public commitment. It acquired its first professional director, John Davis Hatch, Jr. The Institute's president, prominent architect Carl F. Gould, declared its aspiration to emulate the Cleveland Art Institute (now Museum) or Pittsburgh's Carnegie Art Institute.[48] Supporting this growth were numerous new interest groups, so many as to attract notice; "A veritable epidemic of organizations has seized the artistic fraternity," reported the *American Magazine of Art* in a feature about Seattle.[49]

Tokita began exhibiting in the Nihonmachi around 1924, although the first published mention refers to a 1926 exhibition.[50] A reviewer for the *Seattle Times* later wrote, "Tokita is a Seattle artist whose work I saw at the Japanese Commercial Club fully four years ago. Again I see his

work [1930], and again I am struck with the thought that it is strange that this artist has lived here and worked here without Seattle's becoming aware of his ability. He is an admirable painter."[51]

Tokita's entry into the mainstream came two years later at the Independent Salon in summer 1928. The Northwest Annual, which had been held in spring that year, was considered a measure of an artist's and the region's achievement, but what that achievement meant was far from a matter of agreement. When the 1928 jury, comprised of Tobey, new UW art instructor Raymond Hill, and Anna B. Crocker, curator of the Portland Art Association, favored the modernists and omitted some of the longtime exhibitors, a vociferous debate broke out over the selection. In the aftermath of the fury, artists initiated a second, unjuried exhibition that summer, the *First Northwest Independent Salon*, which accepted all applicants and did not limit the number of works shown.[52] Among its three hundred entries was Tokita's urban landscape *Yeslerway*.

The Salon provided Tokita his opportunity. Walter Isaacs took note of Tokita's painting in the Independent Salon and invited him and his Issei colleagues to exhibit at the Henry Gallery that August.[53] The exhibition seems not to have been realized.[54] Tokita's work, however, held the attention of the gallery's curator Halley Savery. In 1932 she invited Tokita, Isaacs, and UW art instructor Raymond Hill to represent the Northwest in a proposed touring exhibition, *The Regional Note in American Painting*, organized by the American Federation of Arts. The Henry Gallery shipped Tokita's painting *Under the Bridge* to Washington, D.C., but once again the exhibition did not come to fruition.[55]

Despite the onset of the Depression, the continued growth of the Seattle Art Institute provided Tokita with opportunities that secured his artistic legacy. In 1931 president of the board Dr. Richard E. Fuller and his mother, Margaret MacTavish Fuller, announced the gift of a new building, to be designed by Carl Gould and constructed in Volunteer Park on Capitol Hill.[56] When the newly named Seattle Art Museum opened in 1933, Fuller assumed the role of director. Fuller

maintained the Seattle Art Institute's active support of artists in the region, as well as its ambitious program of presenting historic and contemporary national and international art. He would be one of Tokita's most important advocates.

HUSBAND AND FATHER

Tokita's life gained a new center with his marriage. Following formal introductions, he married Haruko Suzuki on January 24, 1932. Ten years younger than he, she had been reared in Tokyo and in 1919—coincidentally the same year as Tokita—immigrated to Seattle with her father and stepmother. She had attended the old Main Street School in Nihonmachi, then moved to the new Bailey Gatzert Elementary School when it opened on Twelfth and Weller, and later attended Broadway High School. She lived with her family at the Wilson Hotel on Sixth and Dearborn streets, where her parents were managers, and worked at Shosaku Suyama's produce cart in the public market. Her father had formerly run a dry-cleaning business and in 1927 bought the Wilson

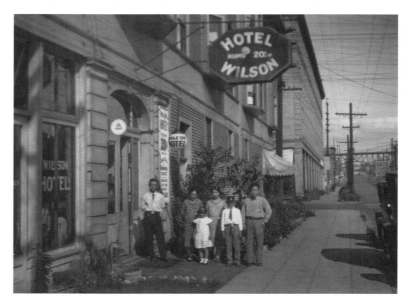

25 Kamekichi Tokita (*far right*) and the Suzuki family—(*from left*) Toshiyuki, Haru, Toyoko, Haruko, and Koike (Warren)—outside the Hotel Wilson, Sixth and Dearborn streets, ca. 1932–34. The Twelfth Street bridge can be seen in the right background. Courtesy of Warren Suzuki.

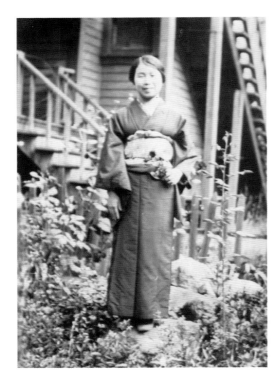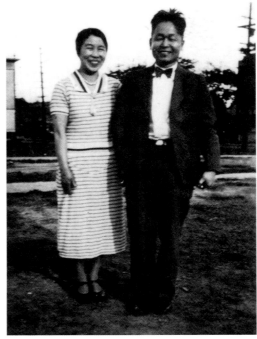

Hotel management from an Issei who was returning to Japan. The hotel had fifty rooms that rented from twenty-five cents a night.

Tokita and his new wife lived in an apartment at Fourteenth and King, a neighborhood that was frequently the subject of his paintings. When they began a family, they moved to larger quarters a mile south of Nihonmachi on Thirteenth Avenue on Beacon Hill. A son, Shokichi, was born in 1934, and the next year, a daughter, Shizuko. Within twelve years, there would be eight children, a growing family that not only increased responsibility but would also bring comfort in difficult times.

The Great Depression hit the Nikkei community particularly hard. As the economy contracted the already marginalized business sector experienced a severe decline. Some people moved to California, where the larger population offered more opportunities; many returned permanently to Japan.

26 Haruko Suzuki Tokita, early 1930s. Kamekichi Tokita papers, ca. 1900–48, Archives of American Art, Smithsonian Institution.

27 Haruko and Kamekichi Tokita, c. 1940. Kamekichi Tokita papers, ca. 1900–48, Archives of American Art, Smithsonian Institution.

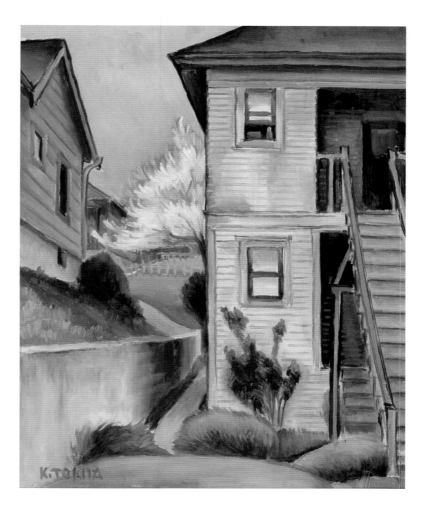

28 *Backyard*, 1934
Oil on canvas
27 × 21 1/2 in.
Seattle Art Museum,
Public Works of Art Project, Washington, 33.231
© Kamekichi Tokita

As the Depression deepened and lingered, Tokita and Nomura were among the top rank of artists employed by the federal Public Works of Art Project (PWAP). Launched in December 1933, the PWAP was a six-month experimental program to employ artists, part of an intensive Civil Works program to employ four million people. The artists were "to be given employment in their own field under conditions calculated not to deflate their inspiration."[57] Conceived and led by painter and businessman Edward Bruce and supported personally by Eleanor Roosevelt,

the program paid artists to produce studio art and site-specific work for publically supported buildings. The project was designed to employ 2,500 unemployed artists and craftspeople and eventually reached more through short-term employment.[58] It was administered through the sixteen regional divisions established by the New Deal. Local representatives within each district selected artists to participate.[59]

Tokita and Nomura were among seventeen in Washington to be chosen for Group I, the highest among three ranks, and the only Nikkei among the sixty Washington artists in the program. They received $38.25 a week.[60] During his employment from February 22 to March 22, Tokita produced six oil paintings, all landscape subjects. The work was gratifying and the salary welcome, and he wrote Bruce urging the program's continuation as it drew to conclusion in April. Bruce replied, "It means much to us here, who have been working on the Project, to know the reaction of the artists and to have them accept the Project in the spirit in which it was set up." Noting that he and others hoped to continue the project in some form, he continued, "Whatever happens,

29 Cadillac Hotel, Second Avenue and Jackson Street, ca. 1937–38. Washington State Archives, Puget Sound Regional Branch.

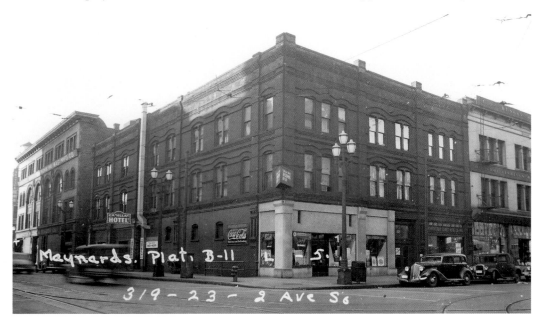

however, we all feel that every artist on the project has . . . helped to create an art consciousness in this country which will have a far reaching effect."[61] Tokita's PWAP employment, however, was for only four weeks, and neither he nor Nomura participated in subsequent WPA programs. They kept the Noto Sign Company open until 1936, when insufficient income forced them to close the shop.

Tokita then became the operator of the Cadillac Hotel. He bought the hotel's management business and its furnishings from Ichitaro Matsuoka, who was among those leaving for California. The Cadillac Hotel, a red-brick building built in 1889, stood on the corner of Second and Jackson streets within two blocks of the train stations and the waterfront. Located outside the heart of Nihonmachi, the Cadillac served the single white men who came through the docks or the railroad. Tokita moved his young family there. Like the many married couples who operated hotels, Tokita and Haruko did the work of the hotel themselves. He kept the books, did maintenance and repairs, and cleaned the public spaces, while Haruko and a helper cleaned the rooms each day.

In becoming a hotel manager, Tokita joined a local industry in which the Issei had been especially successful, even as they were forbidden by law from owning or leasing real property. By the time of his immigration in 1919, Isseis had established a strong foothold in the hotel business, and hotel management soon represented the largest sector among Issei-run businesses. They were able to gain a dominant position, as he later described, by their own labor and frugal operation, which enabled them to charge minimum rates.[62] Tokita noted the number of pensioners dependent upon such hotels, people who would have nowhere to go if the hotels were operated according to typical mainstream practices. Issei dominance of the industry, however, earned them the enmity of some white business leaders and was used against them in arguments for exclusion. In taking over the business in 1936, Tokita knew from his inlaws, the Suzukis, that it provided a steady income. He and his wife were undoubtedly guided by their example and became a strong partnership.

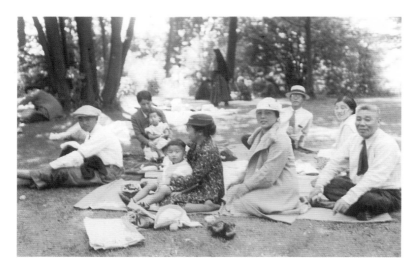

30 Tokita, Suzuki, and Kuromiya families at Lincoln Park, ca. 1937. Haruko Tokita (*left rear*) holds Shizuko; her stepmother, Haru Suzuki (*front*) holds Shokichi; Mr. and Mrs. Shotaro Kuromiya (*seated right*); Manzo Tokita (*rear right*). Courtesy of Warren Suzuki.

Tokita did relatively well in the hotel business. With time, he converted the Cadillac Hotel from single-night stays to a predominately residential hotel, until about two-thirds of the customers were long-term residents, mostly retired laborers who subsisted on Social Security and pensions. The hotel catered to an entirely white clientele, which Tokita came to see as an advantage in broadening his viewpoint beyond the tightly knit Nihonmachi. A precise and disciplined person, he was diligent about maintenance and bookkeeping. "It must be hard to imagine what it's like to run a hotel like mine," he wrote. "I believe people would be surprised how easy it is once they try it."[63] Because of the work he and Haruko did themselves, they realized a healthy margin between expenses and income, enabling them to purchase a car and home appliances such as a refrigerator and a washing machine. With discipline they built a modest bank account, and Tokita made at least one investment in the stock market.[64] He also earned the trust of a number of their long-term residents, who deposited their money with him rather than with a bank.[65]

The family's living quarters at the hotel were carved out of a parlor: they consisted of a kitchen with an eating area, three bedrooms, and a bathroom. The sidewalk outside was the children's playground, where

they were forbidden to cross the street or the fire-station driveway at the other end of the block. Tokita regretted the lack of green spaces for his children to play, and on Sundays he and Haruko took them to parks and playfields. During the next few years, the family grew by three children. Two sons, Yasuo and Yuzo, were born in 1938 and 1939, and a daughter, Yoshiko, in 1940.

Tokita was a strict, demanding father to his children, particularly to his eldest son, Shokichi, whom he expected to uphold the family name and honor. While his discipline was typically Issei, his enforcement was stricter than many others'. The children could never question his orders or decisions. He required them to speak Japanese at home and taught that, as in Japan, all of one's actions reflect upon the family's name. Although he himself was the second rather than the eldest son, as the only one among his siblings to live in the new country he may have placed an extra premium on his son's proper conduct in assuring the family's honor. (He owned a samurai sword, although not the Tokita sword inherited by his older brother, and would pass it along to Shokichi.) He taught his children respect for elders and proper conduct in their presence, and he insisted they follow his rules rather than the more relaxed Americanized ways of their friends. His older children remember that he expressed no affection; indeed, one of them remembers never having had direct communication with him.[66] Their mother was often the communicator and mediator and occasionally implored Tokita to ease a restriction or punishment. And yet in the wartime diary, Tokita describes a tenderness toward his children that demonstrates indisputable love. Two poems reveal the person behind the authority role:

> I was seriously angry with the children then.
> But looking back, my red face was ridiculous.
>
> Sono toki wa, honki ni natte ko wo shikari,
> Sono jibun no kao ga, bakarashiku nari.

With my eyes, I signal to my wife not to smile while
I'm scolding the children;
And my wife looks down to fold the diapers.

Shikari nagara, warau ja nai to me de ieba,
Tsuma utsumuite oshime wo tatamu.[67]

In later years his discipline relaxed somewhat within the large family,
although not for his eldest son.

There were also many good
times together. In extended cir-
cles of friends and community
members, Tokita was relaxed
and jovial. He practiced *kyudō*,
the formalized archery of the
samurai, and took the chil-
dren along to the archery range
on Twelfth and King streets,
where he honed his skills and
participated in tournaments.
The family joined in the festi-
vals and games that were part
of each calendar year for the
Japanese community. They
attended the Bon Odori parade
on Main Street. At Jefferson
Park on Beacon Hill they gath-
ered for the annual Japanese
Language School picnic, which
was attended by the entire
community; people brought
elaborate lunches, exchanged
favorite dishes, and cheered the
children's foot races. They pic-

31 Tokita (left) at *kyudō* practice, 1930s. Courtesy of Shokichi Tokita.

32 Tokita's *kyudō* manual. Kamekichi Tokita papers, ca. 1900–48, Archives of American Art, Smithsonian Institution.

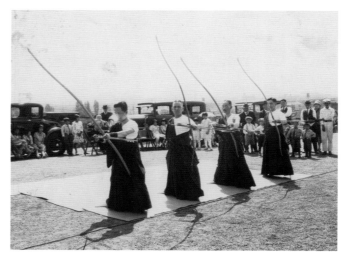

nicked at Lincoln Park on Puget Sound and swam in its warm salt-water pool. As summer turned to fall, they celebrated Halloween and Thanksgiving in American style, and joined in Christmas preparations at the local Maryknoll School, while at home the children awaited Santa Claus. The year's cycle began again with the traditional Japanese New Year. The mix of traditions was characteristic of their adaptation to their American home.

When Shokichi and Shizuko were old enough for school Tokita decided to send them to the Catholic Mission's Maryknoll Grade School. The decision would serve his family in years to come. Each day the Maryknoll pastor, Father Leopold Tibesar, drove the children to and from school at Sixteenth and Jefferson streets, providing safety and supervision that must have appealed to Tokita. At the end of regular school hours, a teacher from the Japanese Language School came to Maryknoll to teach language and the values, conduct, and decorum of Japanese tradition. Throughout Japanese communities on the West Coast, Christian ministries aided immigrants' adaptation to the new country by providing basic human services, and won converts as they did so. The Maryknoll Mission in Seattle, established in 1922, was the first Catholic mission in the United States to serve Japanese immigrants. Father Tibesar, fluent in Japanese after having served in Japan, arrived in Seattle in 1935. He would be an invaluable ally during World War II, negotiating on behalf of Japanese families during the first months after the declaration of war, accompanying families to internment camp, and helping the Tokitas and others resettle after the war.

While Tokita accepted the help of Father Tibesar and the Maryknoll Mission, he did not convert to Catholicism himself.

33 Tokita family at Alki beach in West Seattle, 1941. The children (*left to right*) are Yasuo, Shizuko, Yuzo, Yoshiko, and Shokichi. Courtesy of Yoshiko Tokita-Schroder.

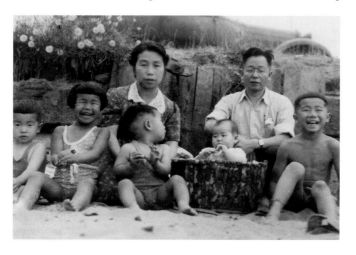

He had been reared Buddhist but held the attitude that all faiths lead to the same goal. During the war he would declare himself and his wife Congregationalists, and the children Catholic.[68] In the uncertainty and despair of wartime he called upon both traditions:

> Not exactly knowing what to pray or wish for,
> Still I kneel silently before God and Buddha every morning.

> Inoru demo negau demo naku asa asa ni,
> Kami to hotoke wo mokushite ogamu.[69]

In time he grew to so greatly admire the values of social justice and service demonstrated by the Catholic Church that at the end of his life he asked that he, Haruko, and his children be baptized.

Business was a more straightforward matter. In addition to managing the hotel, Tokita pursued his sign-painting business. He set up the signs on which he worked in the hotel hallway, which wrapped around a large central staircase with skylights overhead. Although he and Nomura no longer shared a shop, he kept the name Noto Sign Company. Nomura and his wife had struggled to find a viable business as the Depression wore on but reestablished themselves by managing a dry-cleaning shop in the University district. With the purchase of the hotel business, however, Tokita found little time to produce art. He seems to have stopped or nearly stopped painting; no works of art remain from the late 1930s and early 1940s. The demands of two jobs and his young, growing family consumed the time and effort he once devoted to sketching trips and studio

34 Father Leopold Tibesar and Maryknoll Sisters with students, 1941. Shokichi Tokita (*first row, second from right*). Courtesy of Shokichi Tokita.

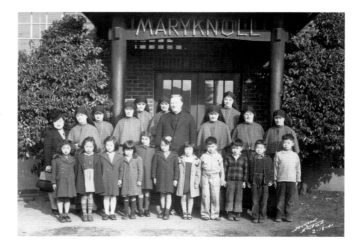

work. Yet several years later, when the war began and the future was in doubt, the promise of new landscapes to paint was his one solace.

WAR AND LAST YEARS

On December 7, 1941, the life Tokita had built collapsed. With Japan's bombing of Pearl Harbor, he and his family and the thousands of Nikkei on the West Coast suddenly looked like the enemy. In the words of author John Okada, "The moment the impact of the words solemnly being transmitted over the several million radios of the nation struck home, everything Japanese and everyone Japanese became despicable."[70] Tokita wrote that evening, "In a moment, we have lost all the value of our existence in this society. Not only have we lost our value, we're unwanted. It would be better if we didn't exist."[71]

Tokita, like many others, understood that their lives would change irreparably. He began keeping a diary that day, vowing to write until peace came. More than an intention to "relate some impressions that we find memorable," as his book of poetry had once been, it became a means of trying to comprehend and interpret the confusion of events that enveloped him. Tokita's public life had been experienced through art and exhibitions, when he produced paintings to display for viewing and critique. By contrast, the diary opened a private side, one where he could put into words the events, relationships, and emotions that were otherwise difficult for an Issei man to express. The practice of diary-writing had been instilled by his Japanese schooling and now he turned to it.

For the five months that the family remained in Seattle, Tokita followed the day-to-day war news, the city's changing defensive measures, and the succession of regulations and orders directed to the Nikkei community. In the early weeks he adapted the hotel to blackout requirements, while needing to cut back on daily maintenance in order to keep up with the changing regulations. He and Haruko discussed the plight of families whose husbands and fathers had been arrested by the FBI in the immediate aftermath of December 7 and offered help to many of them

in the form of moral support, food, and sometimes financial assistance. They guarded their children's activities and found relief from anxiety in their daily care. Throughout the five months, Tokita frequently visited James Sakamoto, a founder of the Japanese American Citizens League (JACL) and the publisher of the *Japanese American Courier*, for news and interpretation of the onslaught of new and often conflicting regulations. Sakamoto, then the key local spokesperson for the JACL, posted the JACL's guidelines for compliance with government officials, along with the JACL's recommendations to demonstrate loyalty to the United States. And always there was discussion of the varying possible fates of the Issei and Nisei.

Tokita suspected from the beginning that he and his Issei compatriots would lose all they had worked for. Working in the United States without the possibility of citizenship, the Issei had devoted their efforts to their children's success in the new country. He revealingly described their customary, low-profile comportment in the white world: "As Issei, we aren't in a position to complain no matter how we are treated in this country. Nevertheless, somehow we can conduct our business and live quietly."[72] The Isseis' social and economic position was threatened not only by strain between the white and Nikkei populations but also within the Nikkei community, where they had held undisputed authority. The arrest of Issei leaders left a vacuum that the Nisei tried of necessity to fill. Wartime circumstances greatly exacerbated the generational differences and began to undermine the Isseis' traditional authority not only in the community but within the family as well.

Throughout January and early February, Tokita shared the view, common among his community, that the U.S. government would hold the Issei, now classified Enemy Aliens, as a particularly threatening population that needed to be isolated. A debate persisted, however, among American policy-makers as well as the Nikkei, about the treatment of American-born citizens of Japanese descent, the Nisei. Franklin D. Roosevelt's Executive Order 9066 of February 19, 1942, was the decisive act. It gave the Secretary of War and his commanders the authority to establish military zones from which "any or all per-

sons may be excluded." Two weeks later, when the army's Lt. General John DeWitt declared the entire West Coast a military zone, it quickly became clear that all Nikkei were subject to the exclusion: Issei, Nisei, and the youngest generation, the Sansei.

Tokita and his wife spent the next weeks sorting, packing, storing, and selling possessions as they uneasily awaited notice of the family's destination. He wrote on March 2, "This afternoon, I removed all of my oil paintings from their frames. I decided to keep fourteen or fifteen paintings. As to the frames, I can discard them if it becomes necessary," and the next day, "We spent the last few days organizing things, dusting my paintings, putting some of my old drawings up on the walls again."[73] Haruko was particularly anxious; she was expecting another baby in early summer. Rumors of their assignment included Missouri, the central or western states of the interior, eastern Washington, the Columbia River Basin, and places south. By early April they knew they would be taken temporarily to Puyallup, Washington, although there was no word of their final destination. In mid-April, as word that their removal date was approaching, Tokita sold the family car for $35, and agreed to sell the hotel business to a friend, Jimmy Minelli, who paid $500 down on the $1,500 price. He described the experience:

> I felt that part of the load on my shoulders had been lifted.
> On my way back [to the hotel], though, I felt as though I was
> a vagabond again because the load on my shoulders was too
> light. That was a strange feeling. . . . Right now, I feel as if my
> clothes have been stripped off by force or something.[74]

He eventually realized only $1,000 on the sale, including the hotel furnishings. The Scavatto family, who ran the Italian restaurant in their building, agreed to store what they left behind and promised to ship several packages once the family was resettled. Having shed all but their most basic possessions, on May 1 the Tokita family of seven stood at the corner of Eighth and Lane, waiting to board a bus to the Western Washington Fairgrounds in Puyallup, thirty miles south of Seattle.

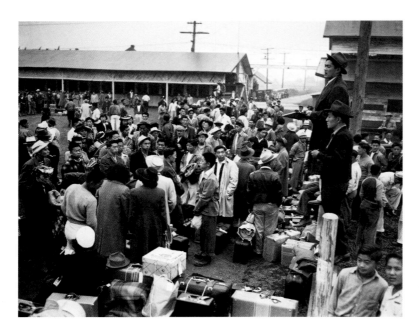

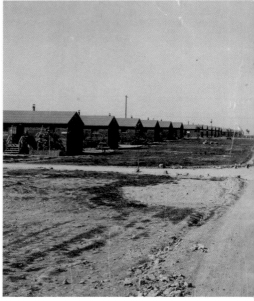

From the first of May until the end of August 1942, the animal stalls and quickly constructed barracks on the fairground were home to the Tokitas and more than seven thousand Nikkei from the Seattle area and Alaska.[75] The Puyallup Assembly Center was an especially confined and crowded site.[76] It was divided by the fairground's layout into four separate sections, with movement among them prohibited, and was surrounded by eight-foot fencing that left little room for circulation, conditions that were described as conducive to "a prison psychosis."[77] The barracks were built directly upon freshly graded fields, with one small window and a windowless door to each unit, and open space between the roof and the walls between the units. The Tokitas were allotted one unit, about twenty feet across. Shokichi was now eight years old; Shizuko, six; Yasuo, four; Yuzo, three; and Yoshiko, a two-year-old toddler. Surrounded by barbed wire and armed military guards, they and all the others stood in long lines for meals, use of bathrooms, and other basic needs. On June 19, Haruko gave birth to a son, Kenneth Masao, the first of the Tokita children to

35 Japanese Americans preparing to leave the Puyallup Assembly Center for relocation centers, Puyallup, June 1942. Seattle Post-Intelligencer Collection, Museum of History and Industry, Seattle, P128078.

36 Barracks at the Minidoka Relocation Center, ca. 1943–45. Wing Luke Museum of the Asian Pacific American Experience, 2006.38.1.50.

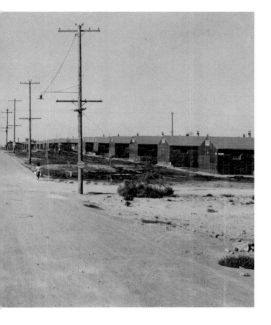

37 Title unknown
(Minidoka water
tower), ca. 1943–45
Oil on Masonite
11 × 14 in.
Collection of Goro
and Eileen Tokita
Photo: Richard Nicol

be born in a hospital rather than at home with a midwife's assistance. In the turmoil of the interim move, Tokita left no diary entries, or they did not survive.

On August 5, the order came for their assignment to Idaho. As the month ended, the Tokitas packed again. They left Puyallup by train on a hot and dusty trip to southeastern Idaho that took three and a half days. "It was desert hot in August," Shokichi recalled many years later, "with the train spewing smoke and cinders that entered into the passenger areas if the windows were open, and unbearably hot if the windows were closed to keep the smoke and cinders out."[78] They arrived in Hunt, Idaho, on September 3 and were transported by bus to the outlying plains, where the new Minidoka Relocation Center was still under construction on 950 acres of a 33,000 acre reserve. Like most other relocation camps, Minidoka was built on arid land designated for reclamation, with the plan for infrastructure and cultivation dependent upon Nikkei labor. Annual temperatures were extreme— from thirty degrees below zero to one hundred four, the War Reloca-

tion Authority reported; frequent dust storms completely obscured vision.[79] There were forty-four sections or blocks, each block with twelve barracks, each barrack with six one-room units. Each block had a mess hall, a recreation hall, and a combined bath and laundry building. Five miles of barbed-wire fence surrounded the area, and eight armed guard towers loomed overhead.[80] The family would be incarcerated there for over three years.

The Tokita family, now with six children from eight-year old Shokichi to infant Masao, moved into a single unit furnished with little more than military-issue cots. After two months they were allotted two adjoining units in another barrack and moved to 38-8-E and F, where they spent the duration of the war. It helped, Tokita thought, that these units were nearer the latrines and communal laundry. They filled one unit with beds and used the other for storage and a workshop. Tokita, along with all the other families, scavenged wood wherever he could to build shelves, benches, and finally, a storage cabinet, a *tansu*. "Everyone needs wood," he wrote in one of his lighter moods. "We were laughing out loud earlier in the mess hall, saying that we feel like stealing whenever we see some wood. We want to make a cupboard or some shelves. There are a lot of things we'd like to make but there's no wood."[81] As cold weather set in they were issued a wood stove, for which they scavenged wood chips and hauled coal. The Scavatto family shipped some of the household goods they had stored and, with time, their raw space took on a homelike character. In December 1943, another baby boy was born, Goro, or "fifth son," the second of their children to be born in incarceration.

With his family's fate determined and safety secured, Tokita resumed his diary within two weeks of their arrival. His entries cover pieces of family life, the regulations and routine of camp, the interpersonal and intergenerational relations of people involuntarily confined together, and evocative descriptions of the new geography. He no longer suffered the debilitating anxiety that had eaten away at him in Seattle, although he remained apprehensive about the course of the war in the Pacific and the interpretation of the news. Increasingly his entries were solely accounts of the war.

He also turned once again to poetry and after gaining confidence left about forty poems with the diary. His first attempts, which he found difficult, tell of loss and uncertainty:

Traveling bag, don't open yourself up too much.

Tabi kaban, ōkina kuchi wa akemai zo.

Please come with me, traveling bag,
 although this is not an ordinary journey.

Ryokō naranedo otomo shitekure tabi kaban.[82]

The journey, family life, and nature are common themes of his poems. Many add a sensory dimension to small incidents in camp and underscore Tokita's use of poetry to maintain a positive spirit.

Intriguing sounds are echoing from somewhere:
The sounds of rice cake being pounded at the mess hall.

Doko yara ni kokoro wo sosoru hibiki ari.
Mochitsuki no oto mesu-hōru kara kuru.[83]

He also left one extended poem, "Orange," an artist's meditation on a world at war (see pages 215–18 of this book).

His first job was as the handyman for Block 38. Although he was offered a job as a sign painter, he did not want to work under a Nisei's supervision and declined; despite the continual assault on his dignity he maintained his sense of order and honor. Eventually, however, Tokita returned to the familiar work of sign painting, and once again he worked alongside his friend Nomura. They were part of a forty-four person crew of cabinetmakers who were responsible for the camp's furnishings and remodeling of buildings and earned sixteen dollars a month. Each day he headed for the maintenance shops at the far end of

camp. Nomura sketched him at work in autumn of 1943, painting the Honor Roll of Nisei in the army.[84]

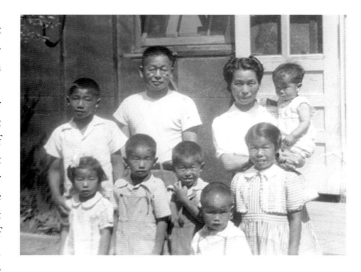

His family, despite their many needs, brought comfort that assuaged the anxiety of these years. During the first weeks at Minidoka, as the war continued to expand and the rhythms of camp life were not yet established, Tokita wrote of his fears and added, "In a way, my family may be more carefree than anybody else because we are so busy with the children day in and day out. For families without children or families with grown-up children, life here may be five to ten times harder and more unbearable than it is for us."[85] Nevertheless, he maintained strict discipline, as he had in Seattle. At dinner, he required the family to sit together at the designated "Tokita" table in the mess hall, rather than letting the older children sit with friends, as others did. He taught Shokichi a stern lesson in not quitting when all of the other boys dropped out of their judo class, and the eight-year-old had to run alone to the class in the dark and bitter cold of winter. He was a vigilant and dedicated father; his rescuing toddler Masao from a pond and carrying young Yoshiko home in a blizzard made indelible impressions on the family. Living in an isolated, segregated community made him concerned for his children's socialization, as reflected in two paired poems:

38 Tokita family at Minidoka, 1945. Children (*left to right*): Shokichi, Yoshiko, Yasuo, Yuzo, Goro, Shizuko, and Kenneth Masao. Courtesy of Yoshiko Tokita-Schroder.

"Is our dog Japanese?" a child asks,
"It's white," my wife replies.

"If you are white, get out!" the child says to the dog.
Alarmed, I take a second look at my four-year-old.

39 Title unknown
(Minidoka barracks
38-8-E-F), ca. 1943–45
Oil on Masonite
11 × 14 in.
Collection of
Yasuo G. Tokita

Kaishi inu Nihonjin ka to ko no toeba.
Hakujin nari to tsuma henji suru.

Hakujin naraba gettauto-da to ko wa ieri,
Yon-sai no kodomo wo imasara ni miru.[86]

Tokita applied his code of honor to all in the camp as well as himself and his family. Its principles had been instilled by his rearing and education in Japan and in his mind endowed the Japanese people as a whole with superior character. It was a code that required proper respect for others, restraint in demeanor, personal discipline, and perseverance in work. He expressed embarrassment when people quarreled over scarce goods, disgust at arrogance and selfishness. "What can we

do to cultivate Japanese awareness in them?" he wrote. He praised their hard work as part of the national character: "It is in Japanese people's nature to work diligently once they have a job to do."[87]

He also watched the generational difference in conduct. While he sometimes admired the Niseis' enthusiasm, as for a camp Christmas party, he disparaged what he considered their lack of discipline. In the interval between Pearl Harbor and the forced removal, he had frequently thought that the events of the war would strengthen the Niseis' discipline and resolve. "I believe the Nisei will grow up to be very strong and distinguished people by overcoming this difficulty," he wrote. "If they can survive this winnowing process, their future will be bright."[88] Now he saw Issei and Nisei giving in to laxity in their attitude and conduct. As for the soldiers fighting for Japan, they were warriors of a special class, their actions recalling samurai virtues. He wrote, as he tried to sort out the news from the Aleutian battlefront, "Such behavior [as quitting] is simply not permissible for Japanese warriors. If you lose your weapon, you bite your enemies if you must, or do anything else to fight on until your last breath, never losing hope of victory until the final moment. That's the Japanese philosophy and that's common sense among Japanese military men."[89]

Tokita followed war news as carefully as was possible. Just as he did in the five-month interim in Seattle, he continued to gather news from several sources, compared them, and tried to sort through the contradictions and reconcile what he heard and believed. He was frustrated that most people had become indifferent to the war after only a month at Minidoka. "I strike up conversations hoping to get more news, but I get disappointed every time," he wrote. "I've decided not to talk about the war any more."[90] He turned instead to his diary and occasional poems.

> While yearning for some noteworthy news,
> All we get is disinformation and it is too hard to find the truth.

> Me no sameru nyūsu bakari wo nozomu koro wa,
> Dema nomi tonde shinsō shirigatashi.[91]

Soon after their arrival in camp he resumed art-making. Within the first month he began drawing, and when they moved into the second unit in Block 38 he unpacked his painting supplies. For the first time in years he had time to paint. He used Masonite rather than the fine-quality linen of former times, and in the Nikkei community's isolation he returned to traditional Japanese subjects alongside his contemporary work. He, Nomura, and Fujii were featured as "three of the best ten painters in Washington" in one of several exhibitions organized at camp.[92]

He found little of interest to paint in camp but the desert was new to him. He found its spare, arid clarity striking and his aesthetic sensibilities unexpectedly heightened. A moonrise over the desert was so floridly colored that he wondered how he could paint it without producing a cliché.[93]

> The rays of the setting sun add deep violet hues
> To the indigo sky, making it appear bottomless.
>
> Konjō no sora tomo miyure yūhi haete,
> Fukasa mo shirenu murasaki tomo miyu.[94]

He found in sagebrush a bonsai-like elegance: "When I took a closer look, I found that sagebrush, despite its small size, has the dignified look of huge trees. Every single one of them has lichen covering its surface. They must be hundreds of years old. . . . I was utterly stunned."[95] He and Shotaro Kuromiya, whose family had picnicked with his in Seattle, searched the desert for greasewood, a material popular at Minidoka for making ornaments and small objects.

More than three years at Minidoka passed. The sense of honor that Tokita maintained had little influence when the camps were closed in late 1945 and their inmates sent home. White resistance to the return of the Nikkeis to the West Coast was widespread and occasionally violent. Frightened by the reports, Tokita and his wife asked to stay at Minidoka until the final closure.[96] As their release approached in November, they searched unsuccessfully for housing in Seattle. They had $500 left of their life's savings for a family of nine, yet even this

was too much for them to qualify for federal assistance.[97] Tokita had been correct in predicting that by the war's end they would be left without anything. Father Tibesar of the Maryknoll Mission arranged for them to live in the Japanese Language School building, meeting them at the train from Idaho to take them there and also arranging the younger children's enrollment at St. Mary's Grade School. They shared the space with twenty-six other families and cooked meals in a communal kitchen. They lived in one school classroom, where their allocation of space and military-issue beds was similar to a single unit at Minidoka. Tokita arranged their beds exactly as they had been at camp, and to create privacy he hung sheets to make a wall between the living and sleeping areas. It was their home for two years. In 1946, their eighth and youngest child, a daughter, Yaeko, was born.

Tokita worked as a sign painter at St. Vincent de Paul, a job that had been secured by Father Tibesar, and again found himself in the company of James Sakamoto, who headed telephone solicitations. He commuted by bus to the facility at the south end of Lake Union. Each day the younger children eagerly awaited his return at the bus stop, when they could always find a small toy from the thrift store in his lunch box. He would lift the youngest onto his shoulders and walk around the block, singing softly and letting thoughts of the day's work drop away.

In early spring 1947, in an effort to rebuild a financial base, the Tokitas bought the management business of the New Lucky Hotel. They did so at Haruko's initiative; Tokita was worn down by the unrelenting defeats. Located on Maynard and Weller streets in Chinatown, the fifty-room hotel was dilapidated and dirty, part residential and part flophouse, where single men still paid twenty-five cents for a night's sleep. Even the children were shocked at the building's run-down condition. But there was a vacant lot next door where the children could play and it represented a new start. Tokita and his wife set up a home on the second floor and began the process of cleaning and repairing. They had seven dollars to their name.

Hardly a half year later, however, Tokita showed signs of illness. Over the coming months he experienced a loss of sight, kidney failure,

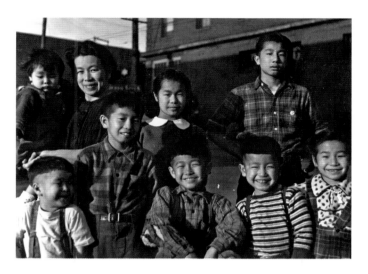

and numbness of the hands and feet, all later understood to be symptoms of advanced diabetes. Following a hospitalization, Haruko ordered a hospital bed for his home care, and as it was delivered on October 7, 1948, he suffered a heart attack and died. He was fifty-one.

At the Seattle Art Museum, the *Annual Exhibition of Northwest Artists* had opened on October 6, and a painting by Tokita hung in the galleries once again. It was the first time since 1936 that his work appeared in an Annual. It served as a memorial. Fellow artist and art writer Kenneth Callahan marked his passing, calling him "one of Seattle's important artists of the local scene."[98]

40 Haruko and children, late 1948. Back row (left to right): Yaeko, held by Haruko, Shizuko, Shokichi; front row: Goro, Yasuo, Yuzo, Masao, and Yoshiko. Courtesy of Yoshiko Tokita-Schroder.

Widowed with eight children, Haruko insisted that all of the children complete school, as their father would have required; all attended college, and five earned undergraduate or advanced degrees. She managed the hotel firmly and single-handedly, relying upon substantial help from the older children and gaining the respect of the hard-worn clientele. At times there was no money. After three years of work, she bought the Fremont Hotel and leased a third, the Baronoff Hotel in Pioneer Square, and in 1955 she bought the Laurel Apartments at Twenty-second and Main. She moved the family to the new neighborhood and with the help of the children managed the four properties herself. In 1957 she realized a dream by buying a beach house near Poulsbo, across Puget Sound from Seattle, where her adult children and their children could gather and play. She continued to work until age eighty and died at eighty-three, having been honored by the Japanese American Citizens League for her perseverance and achievement.[99]

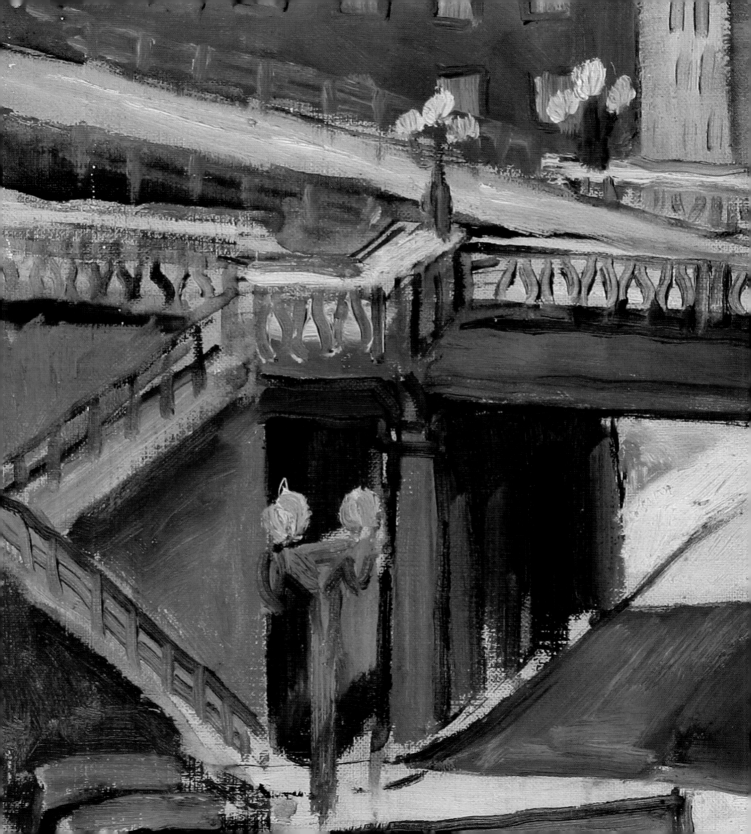

Painting
PICTURING HOME

TOKITA PAINTED STILL LIFES, urban and rural landscapes, and the working waterfront, but it was landscape that most captured his imagination and established his reputation.[1] He painted the urban landscape where he lived and worked—the clapboard houses, the buildings layered with signs, the bridges and viaducts, street corners, and storefronts. This was the Issei domain. To painting skills grounded in Chinese tradition and broadened by Western practices he brought the bicultural perspective of a Japanese immigrant at home in the United States. He was called a painter of the American Scene and his work praised as being "entirely occidental."[2] His paintings, however, offer a more complex picture than these labels suggest.

Tokita's earliest extant paintings dating to 1929 and 1930 show him in full command of his medium. Opportunities opened to him with their public exhibition. In March of 1929 his painting *Autumn* was accepted in the Annual Exhibition at the Oakland Art Gallery, a West Coast regional juried show. The following September three of his paintings were accepted in the Northwest Annual at the Seattle Art Institute. This was to be the first of many exhibitions at the Seattle Art Institute and the Seattle Art Museum, and he began with distinction. His painting *Alley* was awarded the "First Honorable Mention in Oil," the exhibition's second highest recognition at the time. As was customary for prizewinners, he was offered a solo exhibition the next year.

In spring 1930, Tokita exhibited at annuals in both Oakland and San Francisco as well as the Northwest Annual, where his work again was awarded first honorable mention. From 1929 through 1936, he exhibited in all but one Northwest Annual, winning second and third prizes in 1931 and 1933 as the number of awards increased with the Annual's growth. George Tsutakawa recalled the pleasure of seeing such work on display: "I remember walking from Broadway High School to the Seattle Art Institute, just a few blocks up Harvard North. . . . The first time we went there was for the Northwest Annual. In that show several Japanese painters were showing their work: Tokita, Nomura, Fujii, and others, all very good painters who were winning prizes. So that was great encouragement."[3]

Tokita's solo exhibition at the Seattle Art Institute opened on December 9, 1930, to warm praise. Kenneth Callahan, who had just

41 *Alley*, ca. 1929
Oil on canvas
20 1/2 × 16 1/2 in.
Seattle Art Museum, gift of the artist, 33.229.
© Kamekichi Tokita

42 Photograph by Tokita, ca. 1930s. Kamekichi Tokita papers, ca. 1900–48. Archives of American Art, Smithsonian Institution.

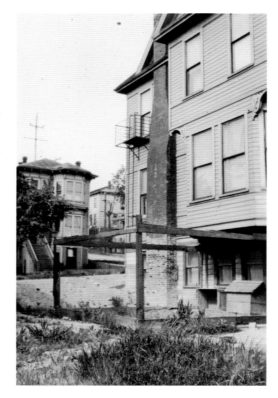

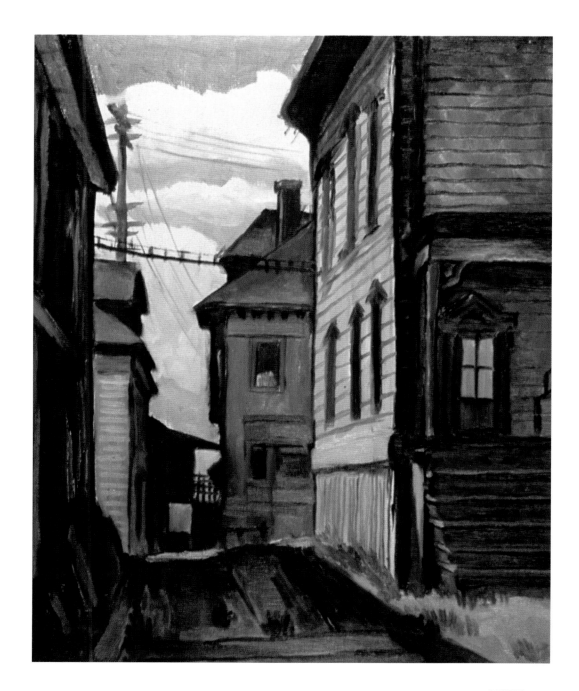

begun writing for the *Town Crier*, hailed the event: "The landscapes and marines of Kamekichi Tokita now on view at the Art Institute make an exhibition that as a whole is consistently as good as any one-man show in Seattle for some time."[4] The *Japanese American Courier* picked up the theme, noting Tokita's show was "lauded by critics as one of the best art exhibits held here this year." "The young artist," it continued, "has an exhibition of some thirty oil and watercolor paintings, which were shown for the first time to the public last Saturday."[5] The *Seattle Times* published a photograph of the artist with his paintings in its Sunday pictorial section, calling Tokita "the prominent Japanese painter."[6] The *Times* noted elsewhere that several paintings had sold. One went to Richard E. Fuller, president of the Art Institute board.[7]

43 Tokita, cover illustration for *Town Crier*, March 19, 1930. Special Collections, University of Washington Libraries, UW26957z.

At the close of the exhibition, Tokita wrote to Fuller offering two paintings, *Alley* and *House*, as donations to the Art Institute (figs. 41 and 9). His paintings were among the first gifts to the nascent collection. "We were quite overwhelmed by your very generous gift to the Art Institute," replied Fuller. "I have always admired your work very greatly; your one man show was one of the most outstanding we have had, and I look forward to again having the privilege of exhibiting your work at some future date."[8] Fuller was a collector of Asian art with deep interest and expertise in the subject, and had worked with Shigetoshi Horiuchi and others to organize a major exhibition of historical Japanese art at the Institute earlier that year. (The exhibition was featured in the *Town Crier* with a cover illustration by Tokita.)[9] His familiarity with Japanese culture and Seattle's Nihonmachi surely contributed to his steadfast support of both Tokita's and Nomura's work. By year-end, Tokita donated a third painting, *Bridge*, and proposed to contribute his best painting each year (fig. 67). "I have no doubt but, that in years to

come, they will have an important historic interest as well as having great artistic merit," replied Fuller in expressing thanks.[10] Tokita would donate five paintings altogether.

STREET SCENES

Nothing remains of Tokita's earliest work. Of the extant paintings, two from 1930 are dated in Japanese, while the others, if they are inscribed at all, are in English. The paintings of 1929 and 1930 firmly establish his style. An untitled urban landscape pictures a working-class neighborhood of the kind Tokita knew firsthand, with its wood-frame houses, trees, and utility poles lining the sidewalk (fig. 44). The palette is neutral—browns, grays, and ochre—punctuated by the skeletal black lines of trees and poles. The vertical accentuation recalls his cover illustration of a house and tree for his youthful book of poetry, but without the sentimentality; instead, the particularities of place and time are carefully observed. No image or action centers the composition; a partial view of a house on the left frames the scene.

Alley displays these characteristics more confidently (fig. 41). Its obliquely cropped houses, their features outlined in black, the upright structures that govern the composition, and its deep central space mark it as a signature work. The volume of the buildings is balanced by the textural detail of clapboard and steps, while the cropping displays the buildings as geometric shapes, equally form and content. The brushwork is painterly, not meant to disappear in illusion. Both paintings are realist in their naturalism and prosaic subject matter, but the emphasis on form and surface, the material and process of painting, placed Tokita among the modernists of his time.

Downtown in and near Japantown is the subject of several paintings from 1930. Here Tokita's cropping and layering of buildings recreates a feeling for the area's wholly built environment, dense enclosure, and compressed use. The buildings and bridges are laced with railings and signs, while utility lines similarly trace across the sky (figs. 23 and 78). All are accented by the vertical uprights of lampposts and utility poles, or occa-

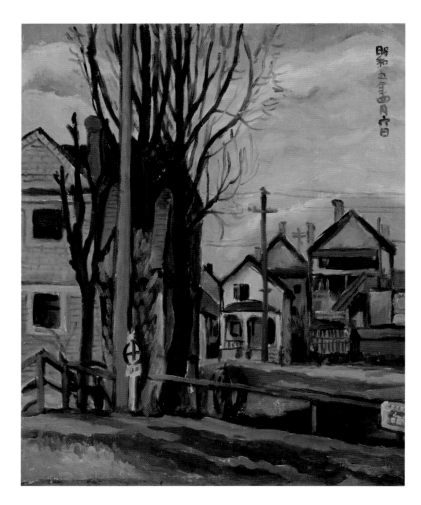

44 Title unknown
(neighborhood), 1930
Oil on canvas
21 1/2 × 18 in.
Collection of Shokichi
and Elsie Y. Tokita
Photo: Richard Nicol

sionally a church tower. The grays and browns are softened by muted rust
orange. A painting of Prefontaine Street is a kaleidoscope of buildings,
posts, and signs, with the City-County Building (now the King County
Courthouse) and Smith Tower in the background (fig. 45).

In Tokita's view, the pedestrian experience shapes the relationship to
place, rather than the grand buildings. Figures are rare in the paintings,
and small if present. He often painted the views from above or below,
or looked at the spaces between buildings, seeing the voids where others

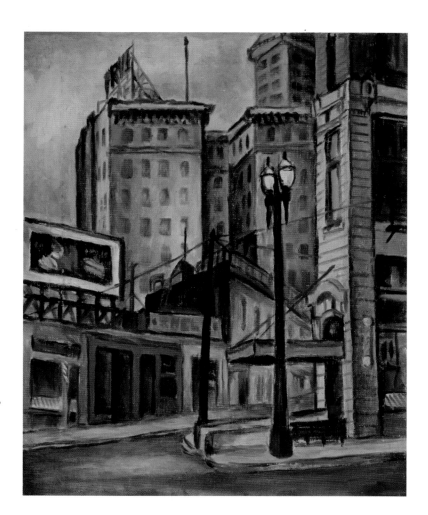

45 Title unknown
(Prefontaine Street), 1930
Oil on canvas
21 × 17 in.
Collection of Yoshiko
Tokita-Schroder and
Jerry Schroder
Photo: Richard Nicol

might redirect their gaze. He sometimes climbed the steep south slope
of Yesler Hill, where the historic Japantown spread uphill above Main
Street and, as Margaret Callahan described, "Impudent small houses
perched on the side of the hill like barnacles on a rock."[11] By the early
1930s the old houses were being razed to make way for a new county
hospital, known today as Harborview, and he was aware of painting
a part of the city that was disappearing.[12] From the hill he sometimes
painted a more distanced, romantic view of the neighborhood below.

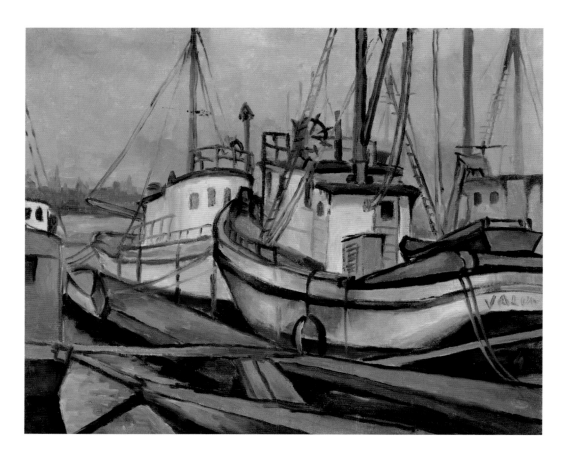

Of the surviving paintings, only four are rural scenes, of which at least two were painted after the war, suggesting that, in saving his work, Tokita's own preference was for urban subjects.

When he painted along the waterfront, Tokita brought the same pedestrian's perspective of compressed and close-up views that he did in city landscapes. His focus was the docked ships and boats, and, like the downtown buildings he painted, these convey the crowded, competing space of their subject. The masts and webs of rigging reiterate the poles and wires of the city, while Tokita's customary black outline defines the forms (figs. 46 and 47). The robust, outlined forms of the boats interlock like puzzle pieces with the planks of a dock or the pillars and

46 Title unknown
(fishing boats), ca. 1930
21 3/4 × 18 in.
Oil on canvas
Collection of Yasuo
G. Tokita

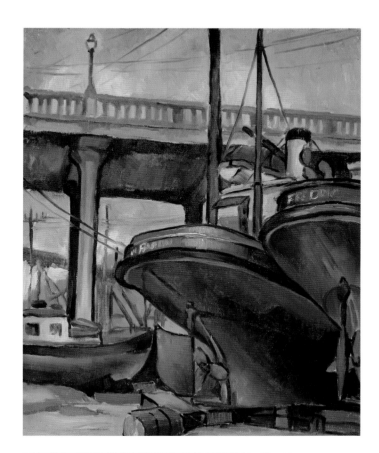

47 Title unknown
(trawlers by Bal-
lard Bridge), 1930
21 × 17 in.
Oil on canvas
Collection of Yoshiko
Tokita-Schroder and
Jerry Schroder
Photo: Richard Nicol

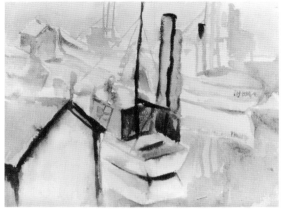

48 Black-and-white
photograph of watercolor
painting, 1930s. Kame-
kichi Tokita papers, ca.
1900–48, Archives of
American Art, Smith-
sonian Institution.

underside of a bridge overhead. In *Bridge*, of 1931, the intricate concrete scaffolding of the structure itself becomes the subject, while the vessels are a detail between the pillars (fig. 68). In several marine watercolors (or possibly *sumi*), Tokita's compositional emphasis is reduced to a few black lines on wet-worked paper, the black strikingly accented on the otherwise liquid rendering. The watercolors remain only as photographs, but the limpid grace of the images makes one wish the originals had survived (fig. 48).

Kenneth Callahan, who had praised Tokita's first one-person exhibition as among the best, elaborated on his description of the paintings. "Tokita . . . draws his subject matter from what he sees and knows in the life about him," he wrote. "He sees and feels the personality of the old weathered buildings, the street corners and alleys falling into decay around Yesler Hill. He is most at home with this type of subject, for which his silvery greys and brick reds are particularly suited. . . . Tokita is undoubtedly the leader of the Japanese painters in Seattle. He has an originality of conception and a palette that is different."[13]

The color sensibility that Callahan praised characterizes all of Tokita's paintings. With Tokita's first Northwest Annual appearance, jury chair Reginald Poland had praised the values in his work, adding that the majority of artists addressed color and composition but that value, the relative lightness or darkness of color, was addressed successfully by only a few.[14] Echoing Poland, Callahan wrote two years later, "Mr. Tokita's work is distinguished by his infallible sense of values," and again named him the leader of the Japanese painters in Seattle.[15] Tokita's favored colors were subdued earth tones ranging from rust, pale tan, and ochre to olive green, a rich and subtle harmony set off by the omnipresent black outline. Orange highlights are common. Closer attention reveals the complexity of the earth tones, as in *Seattle Scene*, where they are inflected with lavender, peach, rose, and pink (fig. 49). His colors reflect the subdued, filtered light of Seattle; its seasonal qualities are as carefully observed as the vernacular detail.

Even more than color, line and composition distinguish Tokita's style. Line defines form, describes surface detail, and structures his

49 *Seattle Scene
(Street)*, 1930
Oil on canvas
19 1/4 × 23 2/4 in.
Collection of Brian,
Ellen, Alex, and Payton
Namba, in memory of
Yaeko Tokita Namba
Photo: Richard Nicol

compositions. While a strong outline was commonly used in modern painting as a means to define form, for Tokita it became an expressive mark. His practice of calligraphy and ink painting surely reinforced his interest in line, while his experience with *sumi*'s wide and subtle range of saturation must similarly have contributed to his sensitivity to value.

Tokita's "originality of conception" lies in the paintings' spatial relationships. His framing of views and cropping of images heightens the contrast between near and far. The prominent use of signage, which is inherently two-dimensional, flattens the image and emphasizes the surface of the canvas. In some, notably *Billboard*, two and three dimensions compete in lively tension with one another (fig. 50). In *Drugstore*,

nearly all elements of the composition are insistently parallel to the pictorial surface, making the painting a study of geometry and the most abstract of Tokita's landscapes (fig. 51).

Photography appears to have significantly influenced Tokita's composition. The cropped images and oblique angles show an unusual freedom in framing views, one that is characteristic of the camera. Modernist invention in photography thrived in the 1920s and 1930s, spurred by the introduction of the small-format, handheld camera. Tokita enjoyed taking photographs himself, knew the work of the Seattle Camera Club, and would have seen a wide range of modernist work at the international photography exhibitions at the Seattle Art Institute

50 *Billboard*, 1932
Oil on canvas
18 15/16 × 23 in.
Seattle Art Museum,
gift of Kamekichi
Tokita, 35.214
© Kamekichi Tokita

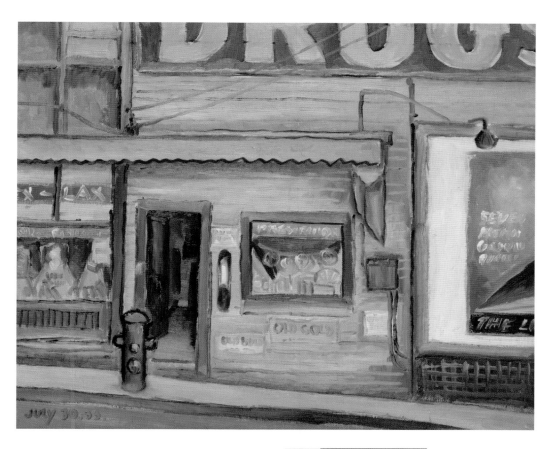

51 *Drugstore*, 1933
Oil on canvas
16 5/8 × 20 1/2 in.
Seattle Art Museum,
gift of the artist, 33.227
© Kamekichi Tokita
Photo: Paul Macapia

52 Walker Evans
(1903–1975)
*Outdoor Advertise-
ments*, 1928–29
Gelatin silver print
8 5/8 × 5 3/4 in.
San Francisco Museum
of Modern Art, Purchase
© Walker Evans
Archive, The Metropoli-
tan Museum of Art

53 Kenjiro Nomura
(1896–1956)
Title unknown, ca. 1933
Oil on canvas
24 × 30 in.
Private collection,
courtesy of Martin-
Zambito Fine Art

Nomura and Tokita
painted the same site
from slightly differ-
ent viewpoints.

and the Seattle Art Museum. Stimulated by experiments of the Euro-
pean avant-garde, contemporary Americans such as Walker Evans and
Edward Steichen capitalized upon the camera's framing and used the
two-dimensionality of signs and words as compositional features (figs.
52 and 67).[16] The cropped framing of *Alley* and *Drugstore* highlights this
camera viewpoint. *Street* takes another angle (fig. 54). Here, like the
camera that frames out peripheral vision, the viewpoint begins on the
rise of a foreground hill, then descends steeply into the sunstruck street,
with no skyline visible. The gas station, whose orange accents fill the
lower left, might be taken for the subject, but Tokita's title calls atten-
tion to the nearly vertical swath of street, which stretches across bold
patterns of shadow and light to the top of the painting.

From about 1933, the palette of Tokita's paintings is deepened and
modulated, with an increasing emphasis on color as a design element.
Street is composed in alternating bands of oranges and olive-gray, a
contrast that is fully exploited in the café pictured in *Street Corner*
(fig. 11). The paintings of the mid-1930s are compositions of color as
much as portrayals of place and indicate his continual expansion of
expressive means.

With these paintings, Tokita claimed his place in American art of his
time. During the 1920s and '30s, his most productive years, the develop-

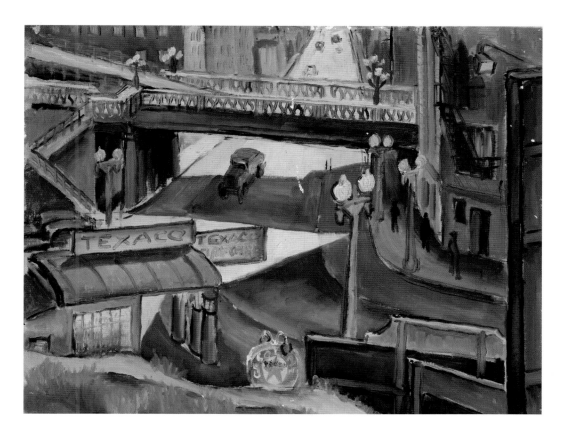

54 *Street*, ca. 1933
Oil on canvas
20 × 24 in.
Collection of Shokichi
and Elsie Y. Tokita
Photo: Richard Nicol

ment of a distinctively American art was a topic of intense discussion. The search for a national art that embodied the character of the place and people had grown since the turn of the century, when New York's Ash Can painters, named for their gritty subject matter and dark palette, pictured working-class and immigrant neighborhoods, in contrast to portrayals of the privileged by their predecessors. Others saw in America the embodiment of a new age, as skyscrapers, electrification, and new modes of transportation and communication reshaped the environment. The quest for an American identity gained momentum with the United States' growing prominence after World War I, when artists were urged to leave behind studio subjects for the vitality of American cities and the countryside. Many returned to places of their youth, searching, as critic

Van Wyck Brooks had urged, for the "usable past."[17] Marsden Hartley, Edward Hopper, and Thomas Hart Benton were among those who had lived in Europe but returned to the States and turned to painting small town and rural America as emblematic of the country's individualistic character. While Hartley found in such subjects the material for a bold expressionist style, others, like Benton, abandoned abstract directions for more accessible representational styles. Benton, together with fellow Midwesterners Grant Wood and John Steuart Curry, produced narrative paintings that celebrated their region's history and ethos and epitomized what by 1930 was called the American Scene.

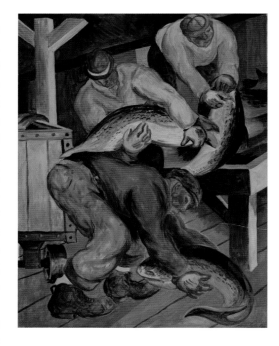

Art that focused on the lives and places of ordinary people was given new urgency by the Depression. The positive portrayal of working-class activities in the context of place was viewed as validation of the American way of life and an antidote to the widespread despair. Local variations of American Scene painting flourished nationwide. Holger Cahill, national director of the Federal Art Project that succeeded the PWAP, argued vehemently for an American art based upon the artist's social context and environment.[18] Government relief programs, which were administered by state and geographic region, each with local administrators and advisors, reinforced the regional emphasis in art. Numerous exhibitions, such as New York City's *First National Exhibition of American Art* in which Tokita, Nomura, and Fujii participated, were selected on a state or regional basis. In her book surveying American art, Martha Candler Cheney held that an artistically informed expressive regionalism was the foundation of an "American art revolution." She cited the prominence of Seattle's Issei painters in describing the multi-ethnic influence on the vitality of a new American art.[19]

Tokita's vernacular subject matter and realist style readily identified his work as belonging to the American Scene—displaying a "flair for 'Americana,' " in one observer's words.[20] Callahan felt impelled to quell any suspicion of foreign habits of seeing at a time when Japan's modern art was broadly considered to be immature relative to Western standards.[21] "There is no apparent oriental influence in his work," he wrote. "The pictures are sympathetic, sincere interpretations of nature as he sees it through occidental eyes."[22] To those who took the paintings literally, Tokita was documenting the parts of the city he knew, although Seattle's modern artists recognized him as one of their own.[23]

In content as well as style, Tokita's work is aligned with a number of modernist concerns. The transformation of the urban environment, with the rapid modernization of cities in the 1920s and the commercialization of American life, was for many progressive artists a subject of celebration or despair. Tokita consistently attends to the signs of this change, evident in the overhead wires criss-crossing streets and the buildings laden with advertising. The tension between tradition and progress that preoccupied a number of artists is implicit in his representation of old buildings that would soon be lost to development, although nothing in his work suggests the moralizing intent often evident in others' work. Most pronounced is the stylistic embrace of photography, evidence of his receptivity to new technology and the new ways of seeing that accompanied it.

Paintings such as *Drugstore* (fig. 51) call to mind those of Edward Hopper, renowned for picturing the vernacular buildings of American cities and towns (fig. 56). More firmly than Tokita's, Hopper's paintings are anchored in formal geometry, often with a horizontal structure crossing the lower picture plane

56 Edward Hopper (1882–1967) *Drug Store*, 1927 Oil on canvas 29 × 40 1/8 in. Museum of Fine Arts, Boston, bequest of John T. Spaulding, 48.564 Photograph © 2011 Museum of Fine Arts, Boston

that can serve either as a barrier or an entry point. The paint is lushly applied and smoothly finished. Light falls across the scene to accentuate the contrast of light and dark, lit and unlit, and creates a sense of interiority and exteriority that is both physical and psychological.

However similar the choice of subject matter, Tokita's work does not show this psychological isolation but instead is grounded in a sense of familiarity. It pictures the territory of the Issei, centered in Nihonmachi and extending to the rural valleys with Nikkei farms, a vibrant but marginalized community. Even the waterfront scenes, some identifiable as the distant Ballard neighborhood, might be considered within the Isseis' sphere, areas at the edge of the port city where people of many nationalities landed and worked. The modesty of the subjects and the subdued character of their representation reflect not only their physical appearance but also the Isseis' manner of adaptation to their home, the need to conduct business on the margins and to "live quietly" that the artist described in his diary.[24] The paintings claim his home in Seattle.

Tokita's paintings of the early 1930s had earned him significant recognition from the Seattle Art Institute, and as the new Seattle Art Museum opened in June 1933, Fuller assumed the role of director.[25] He reaffirmed support for artists in the region, declaring at the opening, "I think that the encouragement of local art is one of the most important functions of any museum. We sincerely hope that the Seattle Art Museum will be an inspiration to local talent and, at the same time, will succeed in bringing their finest achievements to the recognition of the public."[26] He honored Tokita and Nomura specifically in naming them two of only three Artist Life-Members of the museum.[27] He served ex officio on juries of Northwest Annuals and in the 1930s was nearly always a member of regional committees that selected artists to represent Seattle and the Northwest in West Coast or national exhibitions. He held the sole authority for acquisitions.[28] He also employed artists at the museum in the Depression years, chief among them Kenneth Callahan, who served as registrar, exhibition preparator, art writer and publicist, and later, curator. Fuller's patronage was critical in establishing Tokita's institutional legacy.

It is a credit to an artist to be selected for juried exhibitions, but the greater honor is to be singled out for inclusion in focused, selectively organized exhibitions. Within a few months of the museum's opening, Fuller began working with Walter Heil, director of San Francisco's California Palace of the Legion of Honor, to organize an exhibition featuring two artists from each city, *Oil Paintings by Four Japanese of the West Coast*. Tokita and Nomura represented Seattle, and Masuta Narahara and Henry Sugimoto, the Bay Area in the exhibition shown in each city in 1934. Reporting on the exhibition, the *Japanese American Courier* called Tokita and Nomura "the leaders" among West Coast Issei artists.[29] "There are not many Japanese painters of exceptional talent living in America," wrote Larry Cross in his review for the *Seattle Times*, citing Yasuo Kuniyoshi in New York as the best known. "We may well be proud that Seattle should be the home of two Japanese artists of unusual stature, not only in comparison to others of their countrymen in America, but whose work places them importantly among all contemporary painters in this country."[30] By the early-mid 1930s, Tokita and Nomura were consistently among the artists chosen to represent Seattle and the Northwest. They were the only, or nearly the only, Nikkei artists in the national exhibitions in which they participated, an indication of both their ability and their local support.[31]

TOKITA AND NOMURA

Since the early 1920s Tokita and Nomura had worked side by side in the daily business of sign-painting, their studio painting, and in the collegiality of weekend painting trips and the critiques that followed. Nomura had entered the public arena earlier, but Tokita was the first to win acclaim, and by the mid-1930s their painting careers followed a closely parallel path.[32] As often as their names were linked and as similar as their subjects are, their styles are individual. In contrast to Tokita's use of line in both structure and detail, Nomura's paintings employ a rounded, volumetric sense of form defined by shading and atmospheric light (fig. 57). The paintings display clearly constructed pictorial spaces with an ordered

sense of linear perspective. The natural forms of trees, foliage, and clouds are reduced to simplified, crisply outlined shapes, which are layered in depth and create a decorative pattern that emphasizes the painting's flatness even as the picture recedes. The colors are generally brighter than Tokita's, and the palette a balance of warm and cool. Overall an idyllic clarity prevails. Nomura's painting of the same gas-station scene as Tokita's

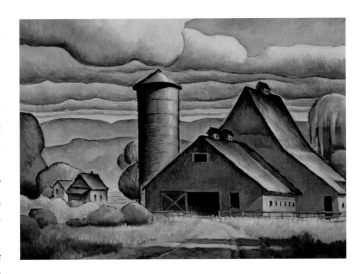

57 Kenjiro Nomura
Red Barns, 1933
Oil on canvas
28 × 36 in.
Seattle Art Museum,
Eugene Fuller Memorial Collection, 33.224
© Kenjiro Nomura

58 *Houses*, 1935
Oil on canvas
27 × 22 in.
Collection of Mark and Lori Hashimoto
Photo: Richard Nicol

Street makes an instructive comparison (figs. 53 and 54). Above the cascading green mounds of the foreground, the downtown buildings recede toward distant mountains. The effect is one of a pleasant urban vista rather than the densely built urban enclosure that Tokita portrays.

Tokita and Nomura were both employed by the Public Works of Art Project in early 1934. The Project presented a unique opportunity for them to concentrate on painting, and Tokita's work around this time reflects Nomura's influence in its attention to surface design (fig. 28). The exchange among colleagues went both ways. Nomura and Fujii, for example, produced nearly identical paintings of a drawbridge with the cropped framing and linear emphasis Tokita favored.[33]

Tokita and Nomura received special recognition from the PWAP when their work was selected for exhibition at the Corcoran Art Gallery in Washington, D.C. The Corcoran exhibition was the second of two national shows organized by PWAP leaders to celebrate the artists' production and the new "art consciousness," the first at the Whitney Museum of American Art in New York and the second in Washington, D.C.[34] They were two of fifteen artists chosen to represent Washington State, and again, they were the only Nikkei in the exhibition. They had the honor of exhibiting in the nation's capitol, in a country that sup-

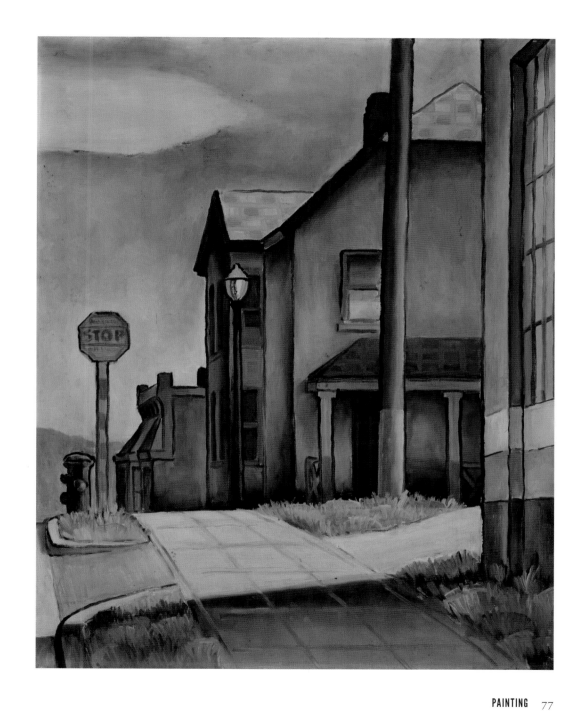

ported their artistic endeavors but would not accept them as citizens, and in a museum that had rejected Tanaka fifteen years earlier for not being American.

When the Project closed in June, the works of art produced in the studio were distributed to publicly supported organizations. Two of Tokita's six paintings were placed with agencies in Washington, D.C., one each in the Seattle Public Library and the Seattle Art Museum, and two in Washington state colleges.[35] For a while, his work could be experienced by far-flung constituencies in the national capitol, the state, and the city.

Several paintings around 1935 display the smooth finish characteristic of Nomura's work and suggest Tokita's continuing investigation of his friend's style. In these, the background is minimized and forms are silhouetted against it, rounded and crisply outlined. Color is closely calibrated and softly shaded. In *Houses*, 1935, which pictures the corner of Twelfth and King streets, the surfaces of the objects are swept clean, and decorative patterning replaces vernacular detail (fig. 58). Similar modeling and polish appear in two paintings of the Twelfth Avenue Bridge, one of Seattle's oldest steel structures and a favorite painting site of Tokita's (fig. 62). Nomura, however, unlike Tokita, by this time had turned attention primarily to rural subjects.

Tokita's still-life paintings from 1934, all originating in the studio, provide a contrast to the external engagement of the city paintings. One includes a baby bottle, signaling the birth of his first child and implying that he had relinquished some of the freedom of his Sunday painting trips; a diaper pin and a child's toy appear in a later watercolor (fig. 60). *Masks*, a unique example, depicts the four masks used in the dance "Fukuyama," which Tokita borrowed from a well-known Seattle dancer and teacher, Fuku Matsuda Nakatani (fig. 59).[36]

THE GROUP OF TWELVE

The year 1935 was a fruitful one for Tokita. In January he again exhibited at the Annual Exhibition of the San Francisco Art Association, which

59 *Masks*, 1934
Oil on canvas
24 × 29 in.
Collection of Ken
and Sandra Tokita

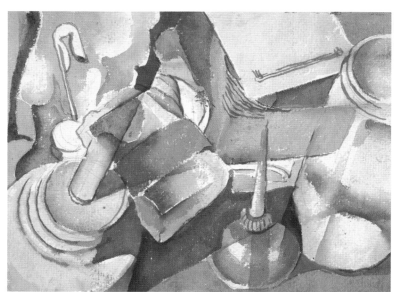

60 Title unknown
(still life), ca. 1935–38
Watercolor on paper
9 × 12 in.
Kamekichi Tokita
papers, ca. 1900–48
Archives of American Art,
Smithsonian Institution

drew artists nationally, in October at the Northwest Annual, and in November at the First Annual Exhibition of the Bay Region Art Association at the Oakland Art Gallery.[37] In December the Seattle Art Museum presented his second one-person exhibition, again to acclaim. Callahan wrote an extensive review for the *Seattle Times*, naming him "this excellent Seattle painter." "Tokita's sense of design and form and volume," he continued, "moves these common themes into [compositional] organizations that are very significant and beautiful."[38] After the opening of the Northwest Annual, Callahan approached Tokita about personally acquiring one of his paintings. He and his wife, Margaret, particularly liked one rejected by the Annual's jurors, *Street Corner*, and proposed a trade. "My finances are not in a state where I can pay the price this canvas should bring—and as I have obtained some paintings by making an exchange with different artists, picture by picture, I am taking the liberty of making this proposal," he wrote Tokita.[39] They traded Callahan's muscular portrayal of fishermen for Tokita's painting of a café storefront (figs. 11 and 55). Margaret Callahan wrote in her journal,

> Kenneth's been trading some pictures lately, and has made a
> good haul. We have a swell one of Tokita's, a Margaret Camf-
> ferman, a Viola Patterson, an Ambrose Patterson of course,
> some good ones of Mark [Tobey] and Morris [Graves], the
> one that [Louis] Bunce gave us, a couple of Earl's [Field], the
> portraits Barney [Nestor] did of Kenneth and me, and we'll
> get one of Nomura's. It's fine to have them. It's like having a
> piece of the person about.[40]

Tokita, Nomura, and Fujii developed a social relationship with the Callahans, and the three called together at the Callahans' house. To Margaret, Tokita was "the pleasant suave artist." These visits stopped, however, by the end of the 1930s as international political tensions heightened along with foreboding at home for what they portended.[41]

Callahan's interest in Tokita's work, together with opportunities provided by Fuller's support, led to Tokita's final artistic affiliation. Callahan

61 Tokita, late 1930s. Courtesy of Yoshiko Tokita-Schroder.

and Ambrose Patterson were among the artists in the fall of 1935 who organized the Group of Twelve, a cooperative gathering of progressive painters.[42] Tokita, Nomura, and Fujii were invited to join. "This group," announced a news article, "is interested in furthering its painting standards and represents the best in painting in the Northwest."[43]

The Group of Twelve began exhibiting in rotating shows at the Penthouse Gallery atop the deco-styled Textile Tower.[44] By spring, the group's work was in demand. An exhibition of paintings by the Group of Twelve at the new Tacoma Art Association (now the Tacoma Art Museum) was so well received that it was followed by a show of their watercolors the next month, and in April their work hung at the Seattle Art Museum. By 1937 the group had expanded to seventeen to include several Oregon and eastern Washington artists.[45] A small catalogue, which included one illustration and a brief statement from each of the original twelve, was self-published by the artists that year, one of the rare documents of art in Seattle in its time.[46] Tokita's elegant *Self-Portrait* of ca. 1936 was probably produced for an exhibition of self-portraits by the Group of Twelve (fig. 1).[47]

Tokita exhibited with the group through 1938, his last public entry. His work was not shown again for a decade except at the Minidoka Relocation Center. In 1948, days before his death, a painting hung once more in the Northwest Annual. It appears to have been submitted by Paul Horiuchi on Tokita's behalf (fig. 62).[48] It appears to have been submitted by Paul Horiuchi on Tokita's behalf (fig. 62). In the war's aftermath Horiuchi had salvaged the painting among donated goods at St. Vincent de Paul.

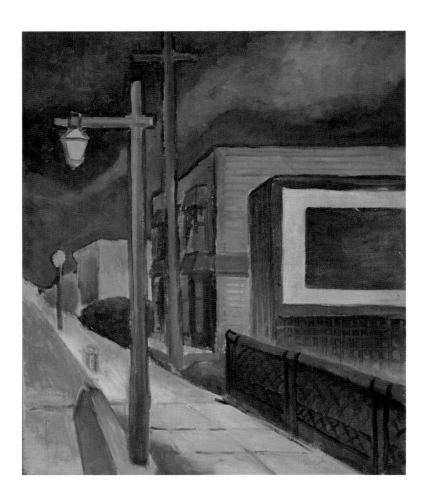

62 *Street* (Twelfth
Avenue bridge),
ca. 1933
Oil on canvas
25 × 21 in.
Collection of Ken
and Sandra Tokita

CÉZANNE AND SESSHŪ

While Tokita's painterly explorations of the mid-1930s were critically
well received, the new, more polished direction was not one he pursued
in his few remaining later paintings. His statement for the Group of
Twelve catalogue describes a deeper purpose, and in it he speaks of
exploring the compositional implications of Western and Eastern picto-
rial space and expressive line. He dated this interest to about 1930.

In the catalogue, Tokita and Nomura stated their intention to meld

Japanese tradition and Western modernism, and—as Tokita states—to position their own work between Sesshū and Cézanne. Their shared values were the product of years of painting and talking together. They address nature as their ultimate aim, and in doing so invoke a Japanese understanding of nature as a single unifying spirit, a continuum parallel to human experience and capable of reflecting or embodying the character of that experience or aspiration. The intent of art is to express nature's essence or mood. "It is the truth in Nature I am after," Fujii wrote for the Group of Twelve, "not the superficial aspects of Nature or man, but the basic truths of the structure of life."[49]

Nomura stated his interest in combining Eastern and Western approaches in terms of a problem of reconciliation:

> My desire in painting is to avoid the conventional art rules, so that I can be free to paint and approach Nature creatively. I have gradually and almost unconsciously been influenced by the work of early Japanese painters. Now realizing this influence, I am consciously trying to utilize those qualities that I want, such as color, line and simplicity of conception, in my own style of painting. Due to the great difference between the Western style of painting and the Japanese, the problem is a very difficult one.[50]

Tokita, however, was explicit about the nature of that reconciliation:

> About seven years ago, I realized the necessity for a greater simplification in my painting. At the same time, my interest grew in the use of expressive line. A resemblance which I saw between the work of Cezanne and the great early master of Japanese painting, Sesshu, made me realize my painting aims were those found in Cezanne and could be developed through the methods used by Sesshu. I am trying to paint the basic truths and realities of Nature through simple, rhythmic, expressive line.[51]

He held up the two artists as models but distinguished between aims and methods. Both the French modernist Paul Cézanne (1839–1906) and Japanese Zen priest Sesshū Tōyō (1420–1506) established new means of structuring pictorial space through the way they represented three-dimensional space on the two-dimensional plane of a painting. Both created a newly disciplined and vigorous representation that emphasized the directness of experience. They worked, however, in very different cultural contexts: Sesshū painted in the centuries-old tradition adapted from China in which the artist followed, and perhaps amplified, preceding masters, while Cézanne painted within the individualistic, iconoclastic artistic practice of modern France.

Tokita had committed himself to art during his study of Chinese painting, but now as he painted in the Western tradition, he was said to have held Cézanne as his "idol."[52] By Tokita's time, Cézanne had become the touchstone of modernism for his deep investigation into the nature of representation (fig. 63). A painting, in the modernist conception, was no longer an illusory window onto reality but was directly apparent as material and process. In aiming to articulate the visual

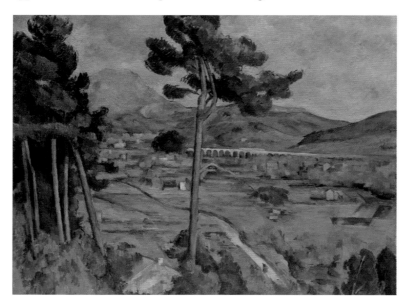

63 Paul Cézanne
(1839–1906)
*Mont Sainte-Victoire
and the Viaduct of the Arc
River Valley*, 1882–85
Oil on canvas
25 3/4 × 32 1/8 in.
The Metropolitan
Museum of Art,
H. O. Havemeyer
Collection, bequest of
Mrs. H. O. Havemeyer,
1929 (29.100.64)
© The Metropolitan
Museum of Art/
Art Resource, New York
Photo: Malcom Varon

perception of three-dimensional form on the flat surface of a canvas, Cézanne produced paintings composed of webs of interlocking planes of color, resulting in a vibrating surface that is at once image and paint, content and abstract form. Tokita kept a copy of Jan Gardner's *Modern French Painters*, which he acquired soon after its publication in 1923, and carefully annotated the chapter on Cézanne. He gave special attention to passages on color, prosaic subject matter, the emotional value of space, and the relative nature of vision.[53] Cézanne's influence appears throughout Tokita's paintings, from the outline that enhances structure and the hatched foreground color to the striking geometry of light in such paintings as *Street* (fig. 53). His investigation of Cézanne's lessons is evident in a watercolor still life, a mélange of household items viewed from above (fig. 60). Here the wedges of light and shadow do more than reveal the objects; they also take on an independent life in the composition so that the picture becomes a lively interplay of planes, color, and line.

While Tokita's aims were modernist, he declared that his methods were influenced by the fifteenth-century paintings of Sesshū. Sesshū excelled in *suiboku-ga* or monochrome ink painting, which had reached a pinnacle of refinement in Chinese landscape painting of the Sung Dynasty (960–1269) and was greatly admired during the Japanese Ashikaga period of Sesshū's time. This was the classical tradition Tokita himself had studied during his two years in Manchuria. Sesshū was a seminal figure in adapting the Chinese style to an indigenous Japanese aesthetic to express the unity with nature sought in Zen (fig. 64). He worked in several different styles, but his major innovation was to shift the poetic, atmospheric space of Chinese-influenced

64 Tōyō Sesshū (1420–1506) *Winter Landscape,* 15th century Hanging scroll, ink on paper H. 18 1/4 in. Tokyo National Museum, TNM Image Archives, source http://TNMArchives.jp

painting to a more concrete, rational, and mass-centered composition. Using dark, vigorous brushstrokes, he composed in blocky planes that step back from the picture plane in parallel succession. The paintings focus on the subject's—and by implication the viewer's—experience.[54] Tokita's work frequently displays the compositional devices found in Sesshū, namely the asymmetry, cropped foreground motifs, and compressed planes of spatial recession, all adapted from Chinese precedent. Most distinctively, the emphasis Tokita gives to line and his appreciation of the balance of line and mass pay homage to the master's example.

Tokita's paintings share aspects of later Japanese art as well, and his personal papers show that he looked at a wide range of historical examples. Many of the formal qualities of Tokita's paintings find parallels in the *ukiyo-e* style that flourished from the seventeenth to nineteenth centuries. It was an urban style that pictured city street life and entertainments and popularized these scenes in widely distributed prints. It capitalized upon the conventions of Japanese art to recast them in a dramatically heightened way. Spatial depth is indicated by intersecting vertical and diagonal lines, a compositional device that Tokita melds with Western perspective. In the palette of the prints' natural dyes, in use until the introduction of chemical dyes, are the low-keyed but richly nuanced color harmonies found also in Tokita's paintings (fig. 65). Here are the orange highlights and black accents, the contrast of olive-green and orange, and the rippling sequence of ochre, rust, and mauve of his street scenes. With the introduction of one-point perspective to Japan, printmakers Katsushika Hokusai and Utagawa Hiroshige produced striking images that contrast closely cropped foreground motifs with dis-

65 Kitagawa Utamaro (1754–1806) *Shizuka of the Tamaya (Tamaya uchi Shizuka, Ikuyo, Isono)*, from the series *Array of Supreme Beauties of the Present Day (Tōji zensei bejin-zoroe)*, ca. 1794 Woodblock print 15 1/8 × 8 3/4 in. Collection of Allan and Mary Kollar, promised gift to the Seattle Art Museum in honor of its 75th anniversary

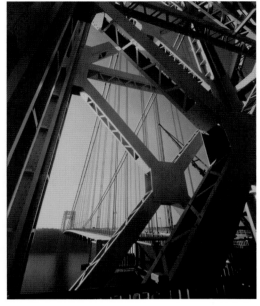

66 Utagawa Hiroshige
(1797–1858)
Suidō Bridge, Suragadai
(Suidōbashi Suragadai)
from the series
One Hundred Views of Edo
(Meisho Edo hyakkei),
1857–58
13 3/8 × 8 15/16 in.
Woodblock print
Tacoma Art Museum,
gift of Mrs. James W. Lyon,
1971.131.6B

67 Edward Steichen
(1879–1973)
George Washington Bridge, 1931
Gelatin silver print
11 × 14 in.
George Eastman House,
International Museum
of Photography and Film,
bequest of Edward Steichen
by direction of
Joanna T. Steichen;
permission of
Joanna T. Steichen

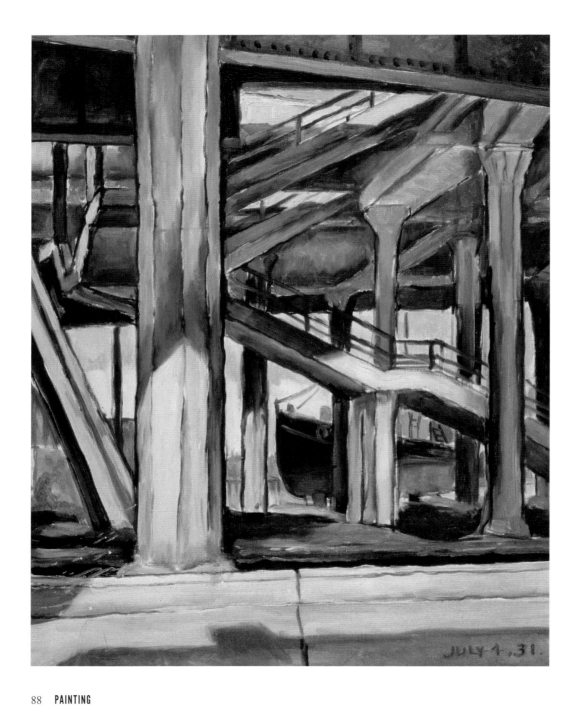

JULY 4, 31.

tant views, employing the same juxtaposition displayed in *Bridge* (figs. 66 and 68).[55] A number of the compositional conventions of *ukiyo-e* are similar to those possible in photography, a phenomenon appreciated by advanced artists of nineteenth-century France, notably Edgar Degas. The parallels must also have appealed to Tokita.

Tokita's personal papers include reproductions of many kinds, a rich and varied visual resource. There are books from China of calligraphy and ink painting, reproductions of Hiroshige's *Fifty-three Stations of the Tōkaidō*, the geisha and genre scenes of *ukiyo-e*, Sōtatsu, Botticelli, Raphael, Cézanne and his contemporary Europeans, and contemporary Japanese painting.[56] Together with his paintings, these tell of Tokita's ongoing inquiry into the commonality and complementary nature of the two traditions.

LAST PAINTINGS

Although Tokita again began drawing and painting within a short time after he arrived at Minidoka, few paintings remain from the war years.[57] His paintings during this time are of two kinds, contemporary Western and traditional Asian, and they separate, rather than combine, these influences.

Four extant paintings depicting Minidoka are composed with clear linear perspective and local color. The desert sunlight bleaches color and casts strong shadows across the buildings, describing a decidedly different environment from Seattle. Like the Seattle paintings, the scenes of Minidoka invoke intimacy of place. Two views of the family's barracks show the garden that Tokita built and tended, and in one a child's wagon rests by the doorstep (fig. 39). A painting of the block's boiler room pictures the place where the Issei men gathered to socialize and is by choice of subject a statement of familiarity (fig. 69). The striking geometry of sunlight and shadow is countered by the carefully articulated piles of coal, stacks of wood, and the facing benches. Here are the details of work and rest that the men knew well and that most specifically identified their place.

68 *Bridge*, 1931
Dated July 4, 31
Oil on canvas
23 1/4 × 19 in.
Seattle Art Museum,
gift of the artist, 33.230
© Kamekichi Tokita

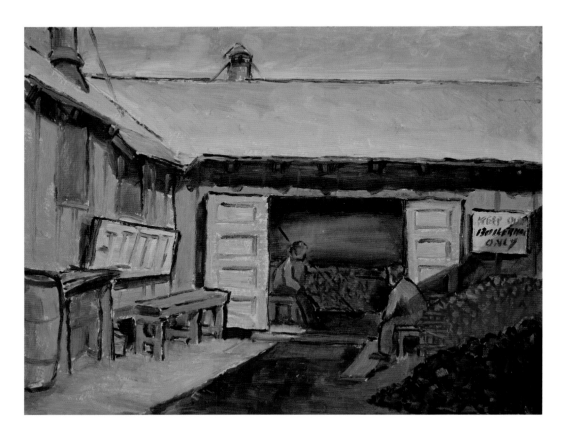

Tokita also returned to traditional Japanese subjects, filling pages with sketches of familiar motifs—landscapes, animals, and figures from the eleventh-century *Tale of Genji*, the eighteenth-century printmaker and painter Utamaro, and a host of others (figs. 70, 71, and 72).[58] He produced several identical paintings of Daruma, the legendary founder of Zen Buddhism, who was said to have faced a wall in meditation for nine years and, by some accounts, cut off his eyelids to prevent himself from sleeping (fig. 73). Tokita inscribed these paintings "Minidoka Mountain-Man," and in doing so he encapsulated his experience as an incarcerated Issei. A Japanese national unable to become an American citizen, he had effectively been denied the validity of his more than twenty years' endeavor in establishing a life in the United States. The

69 Title unknown (Minidoka boiler room), ca. 1943–45
Oil on Masonite
14 × 18 in.
Collection of Yuzo M. and Lilly Y. Tokita
Photo: Richard Nicol

70 Sketch (landscape), ca. 1943–45
Pencil on paper
8 × 5 in.
Kamekichi Tokita papers, ca. 1900–48, Archives of American Art, Smithsonian Institution

71 Sketch (bamboo), ca. 1943–45
Pencil on paper
8 × 5 in.
Kamekichi Tokita papers, ca. 1900–48, Archives of American Art, Smithsonian Institution. Inscribed in Japanese, "Middle of spring"

72 Sketch (figures), ca. 1943–45
Pencil on paper
8 × 9 ½ in.
Kamekichi Tokita papers, ca. 1900–48, Archives of American Art, Smithsonian Institution

paintings suggest that the experience of incarceration required the self-discipline and perseverance exemplified by Daruma.[59]

The postwar years were difficult, and few paintings remain. Two paintings of 1947 show Tokita resuming his exploration of pictorial space and, at least briefly, his weekend sketching trips. Both works have rural subjects, and both employ the orange and gray-green contrast he favored. The earlier one, dated in March, shows a cluster of farm buildings as closely layered planes stepping back in space to blend with the background hills. A black line defines each plane and shading is present but minimal, subordinating volume to surface design (fig. 74). The other painting depicts a dockside cabin, perhaps along the Duwamish River, one of his favorite painting sites (fig. 75). Above the sloping diagonal of the dock, the cabin and a small boat stand in a riotous of mix of spatial relationships. It is dated May 16, 1947, and was his last painting.

LEGACY

Within a few years after the war, several of Seattle's Nikkei artists, all but Nomura younger than Tokita, began to win awards and build reputations, and once again the press began to mention their collective presence.[60] Nomura lived another eight years, developing an abstract calligraphic style that reflected Tobey's influence in Seattle. Tsutakawa and Horiuchi, and for a few years Nomura, participated in the postwar transformation of American art and a Northwest style.[61]

Callahan had been one of Tokita's most consistent supporters and also a persistent advocate for the development of a regional style. In his writings of the 1930s, he praised the increasing number of artists and quality of work represented at the Northwest Annuals and argued passionately on the side of modernism, taking pains to explain its premise and varied expressions to a lay audience. He began to argue as well for an expressive regional modernism grounded in a sense of place. As a Northwest style

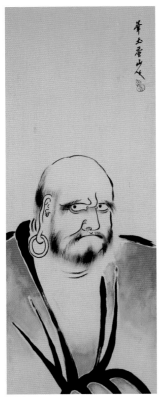

73 *Minidoka Mountain-Man* (Daruma), ca. 1943–43
Oil on Masonite
28 × 12 in.
Collection of Warren and Kanemi Suzuki
Photo: Richard Nicol

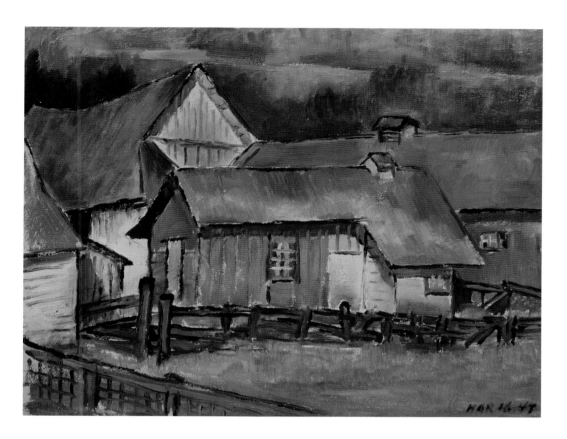

74 Title unknown
(rural landscape), 1947
Oil on Masonite
14 × 18 in.
Collection of Yoshiko
Tokita-Schroder and
Jerry Schroder
Photo: Richard Nicol

came to be defined, many of the qualities he had praised in Tokita's work
were those associated with this emerging artistic identity.

One positive development to come out of the Depression, Callahan
argued, was that artists felt free to explore more personal expressions
because the market for art had disappeared.[62] He praised painters with
individual but disciplined means of expression—those who responded
emotionally to their subject but had a conceptual or theoretical ground-
ing, what he called "intellectual qualities," in their practice.[63] Tokita
and Nomura were among those he regarded most highly. "[Among]
the painters who have attempted to see the Northwest as it really is,
and not as California, the Mediterranean, or Paris, there are the two
Japanese—Nomura and Tokita, with his 'Drug Store' and 'Bridge,' all

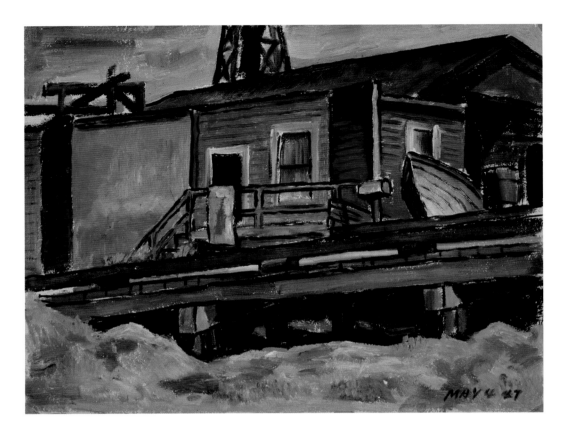

excellent paintings with definite relationship to this region and to the painters as individuals," Callahan wrote in a 1933 review. "They capture much of the real mood of the country, the earthy, vigorous and low-toned character found here." He named several other painters and reiterated for emphasis, "May I add that these paintings are not typical of the Northwest because they depict Northwest scenes, for certainly a huge amount of paint is wasted on landscape in these parts; they reflect it because they capture something of the rugged earthiness and the somber quality. In addition, they are well painted and well organized pictures."[64]

The affiliation of artists within the Group of Twelve increased familiarity among the white and Issei artists. "There was a group of Japanese

75 Title unknown (Duwamish River?), 1947
Oil on Masonite
14 × 18 in.
Collection of Goro and Eileen Tokita
Photo: Richard Nicol

artists," recalled Viola Patterson. "They were all painting in the western manner, none of them painting in the Oriental Japanese tradition, but with sensitivity for color and form, and they were very, very good."[65] The professional relationship gave Callahan a more complex appreciation of the Isseis' artistic intent. Writing in 1937 for the national magazine *Art and Artists of Today*, he referred to them for the first time as Japanese Americans. Rather than ascribing their work to "occidental eyes," as he had formerly, he cited particular Asian influences, while he also acknowledged their experience in the Seattle immigrant community. His statement about them read in full:

> Washington has three important Japanese American painters:
> Kamekichi Tokita, Kenjiro Nomura, and Takuichi Fujii.
> Somewhat associated in style, their art is still individual. The
> quality of line peculiar to Oriental painting is fused with
> their life and associations here. Keen sensitivity to nature and
> its moods is reflected in simple, direct, and solid painting.[66]

As a number of a number of progressive artists moved increasingly from "simple, direct, and solid painting" to varied degrees of abstraction, Seattle in the 1940s became the focus of a newly defined Northwest style. Its development has been well described and analyzed by art historians.[67] It was centered on Tobey, energetically infused by the early success of Morris Graves in New York, and supported by Callahan's steady artistic rise as well as his writing. Its style was markedly influenced by Tobey's interest in calligraphic line, while the tone of spiritual quest was underscored by Graves's abstract statements of existential yearning. Both artists had had firsthand experience in Asia and were deeply influenced by its aesthetics and philosophy. Callahan continued to write and promulgate a regional identity, which he stated most explicitly in a 1946 article for *Artnews*, citing the artists' use of a neutral palette and fragmented line, the emotive power of the region's natural grandeur, and the influence of Asian art and philosophy.[68] The concept would become popularized, particularly with the publication

of a feature in *Life* magazine in 1952, and adapted to a younger generation of artists—among them Tsutakawa and Horiuchi—whose work was sympathetic to these developments.

But in the same 1946 article Callahan also wrote at length about the importance of the Northwest artists' many years of discussions together. He located the beginning of these developments in the early 1930s, the time when Tokita was most active. "Over a period of some fourteen years [the artists] have mulled over such questions as the interrelation of man and nature, the infinite, Picasso and cubism, Chinese painting, and Oriental and Christian philosophies." Despite the social relationship they enjoyed in the mid-1930s, the larger conversation was one in which Tokita and his Issei colleagues had little or no part. The Isseis' separate social worlds, the differences in language, and their personal reticence precluded their engagement. The Northwest artists, Callahan continued, "had long concerned themselves with the ancient culture of the East, which had produced magnificent sculpture, beautiful Sung paintings, and great philosophies. Thus they decided that while the artist on the west coast must look across American to New York and farther still to Europe, he must also direct his gaze across the Pacific to find and understand Asia directly from its source."[69] This discussion and study of Asian sources took place without credit being given to the experience and perspective of the Isseis among them.

If there had been any sense of the older Isseis' influence, it was destroyed by the war. The Issei artists, who had exhibited consistently and with distinction in the Northwest for years, were under military surveillance in relocation camp. From 1942 to 1946, the years in which a regional style was being artic-

76 Kenneth Callahan
Stump Landscape,
ca. 1934–35
Oil on composition board
21 3/4 × 27 1/2 in.
Henry Art Gallery,
University of Washington, gift of Ambrose and
Viola Patterson, 67.29

11 Mark Tobey
(1890–1976)
Farmers' Market, 1941
Opaque watercolor
on paperboard
19 5/8 × 15 5/8 in.
Seattle Art Museum,
Eugene Fuller Memo-
rial Collection, 42.31
© Mark Tobey Estate,
Seattle Art Museum
Photo: Paul Macapia

ulated, they disappeared from the Northwest Annuals and all other exhibitions except those organized inside Minidoka. Despite the years of praise Callahan had bestowed upon Tokita's painting, as well as that of Nomura, Fujii, and others, no trace of them remained in the account of Northwest art that was being written. Despite the intellectual investigation of Asian art and the embrace of the Isseis within the Group of Twelve, there is no recognition of the Isseis' participation. Yet the nuanced neutral palette for which Tokita's work was acclaimed, his search for the expressive line, and his sensitivity to the environment around him surely provided a striking and instructive interpretation to the painters of his time.[70]

Whatever influence his art may have had on other artists, Tokita's originality lies in his Issei perspective. He brought to it artistic skills and a vision honed by his studies of Western and Asian art traditions, and, more fundamentally, an appreciation of nature as the spirit of place. He created a particularized view of place, one realized through the bicultural experience of a Japanese immigrant in Seattle. It was a view with which he was intimately familiar. The scenes in themselves are not picturesque. Like *House* or the untitled painting of Yesler Market, they represent types of buildings and a perspective on them that arises from daily routine, from the habitual walking in a neighborhood and absorbing the look of its mundane details until they take on a familiar narrative (figs. 9, 78). The texture of place is felt in the weathered siding, the worn boardwalk, the drainpipe and rain barrel, the tangle of overhead wires. It is in the pedestrian-level detail, which is set against the massing of buildings that structures the composition. Tokita was a shopkeeper and a sign painter, alert to the life behind facades, the layers of wear, the signals of individualized use. The grayed palette that Callahan praised, the "earthy, vigorous and

low-toned character," was the nature of the place, parsed and enriched by the artist's inflection. Margaret Callahan, by interest and social philosophy sympathetic to Nihonmachi, wrote about walking on Yesler Hill, "Such silly houses! Each with its gingerbread trimmings. . . . Over the basement of one is a sign, 'Japanese Congregational Church,' and we didn't ever know there was such a thing."[71] Tokita needed no exclamation. It was his community.

Tokita left a legacy of paintings that reflects the Issei experience of Seattle and Minidoka. His paintings are scenes of home and community. In this they parallel his diary, which moves readily between Japanese values of honorable conduct and the practicalities of life in the United States, describes the fluency and contradictions in his adaptations to American life, and delineates the ways he established a physical and psychic place. His paintings are also scenes of nature in their penetration of the particularized and emotive character of his environment. They draw upon his Japanese heritage of both modern and traditional Japan, as well as his years viewing American life as a creative newcomer and a cultural outsider. In the hands of an artist, the paintings transform the specifics of site to an enduring expression of time and place. They have been called American Scene paintings, but their viewpoint and aesthetic statement arise from the specificity of the Japanese immigrant experience in the Northwest. Rather than being subsumed by the generalizing label, they make a lasting contribution to its complexity.

78 Title unknown (Yesler Market), early 1930s
Oil on canvas
20 1/2 × 17 in.
Collection of Yuzo M. and Lilly Y. Tokita
Photo: Richard Nicol

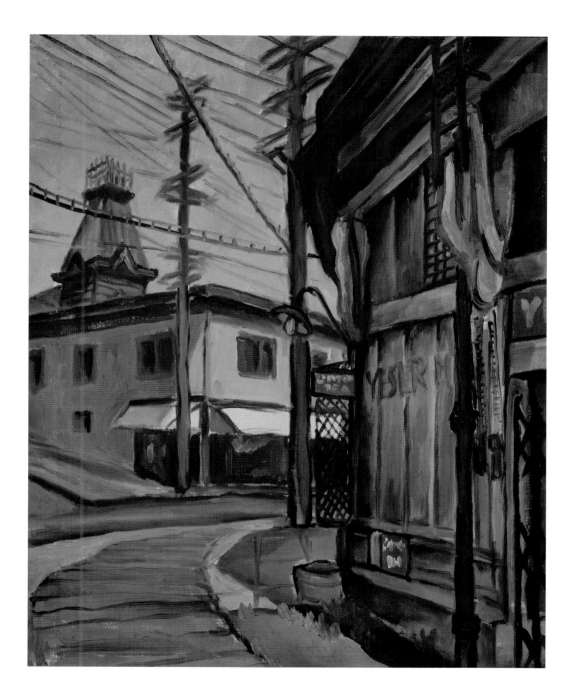

争ひと云ふものは稀事こも
あれば負ける事もあつて
それで初めて慰め戦れるの。
戦争時同じ事い稀つ事戦争
れば、負ける事もあります。
甚慶は楽しみ姜しとは去は
れませんです。
ところが、吾々の様な敵国
稀民は闘争体あるが、稀
はありません。日目で二十
四時向の生活がまるで闘争
と擇ぶ事の姜い生活であり
ますが の様ほ絶対は堂まれ
ません。絶対す稀は姜らか
も金輪負けでは ふ勝ほはの

Preface
TO THE DIARY

Barbara Johns

"MY DIARY BEGINS TODAY. I intend to continue writing until the day peace returns." With these words, Tokita began a project on December 7, 1941, that ultimately filled four hundred and fifty pages in three hand-bound volumes.[1] Two-thirds of the account pertains to events in Seattle from the date of the Pearl Harbor attack to the family's forced removal on the first of May. The diary is discontinuous thereafter, with infrequent entries and months-long gaps. There are no entries during the four months spent in the Puyallup Assembly Center. The account of the Minidoka Relocation Center begins in September 1942 shortly after Tokita's arrival, diminishes in regularity, and stops a year later, then resumes briefly, and ends in July 1944.

As happens with many diaries, the intent and the implied reader of Tokita's writing change over time. He began in the knowledge that

he was living through a catastrophic experience for which a diary was a culturally appropriate place to contain emotion and to try to bring logic to chaotic events. At times he addresses himself, at other times he records data; when he questions his own actions or emotion, it is not so much from self-consciousness as to focus himself on a path of integrity. From the start, he refers to saving news clippings, indicating that he sees the diary as a record. Somewhat later he muses on his purpose and the appropriate tone to use. By the end of March 1942 he seems to have realized the diary would be a future resource. He describes having reviewed, recopied, and sometimes rewritten the preceding entries for greater clarity, showing a new mindfulness of future readers. Whether that audience is his older brother in Japan, his children in their adulthood, or an undefined interested reader is never specified. He kept both versions; they comprise two of the three bound volumes. The translation is based upon his revision, in which he placed the entry written on March 30, 1942, as an introduction.

On the night that Tokita made his first entry the FBI began arresting Issei community leaders. When the United States declared war on Japan on December 8, he and his wife, Haruko, became Enemy Aliens. They were nationals of Japan, a country at war with the United States, the nation in which they lived but had no right to become citizens. He expresses fear for his own family, and writes of his and Haruko's concern for families whose husbands and fathers were missing. That Tokita names his anxiety is symptomatic of its acuteness. His numerous candid references to his digestive process follow the common Asian cultural pattern of describing emotional distress in terms of physical symptoms.[2] These symptoms are especially acute during the first weeks of the war. During one of the occurrences, he confesses that he would be embarrassed if his symptoms had an emotional rather than a physical cause.

Tokita's accounts of the fears, uncertainty, personal situations, and the organized response within the Nikkei community in the months between the bombing of Pearl Harbor and the family's forced removal make this an unusual document among first-person accounts of the

Japanese American relocation. Most such accounts focus on the experience in camps. Throughout the diary he ruminates on differences between his generation and the Nisei generation and the meaning of honor in their common circumstance.

Once at Minidoka, he charges himself with dealing as constructively as possible with the regulations and restrictions, the environmental conditions, and the care of his family. He remarks on the new climate, studying the force and direction of the wind and uncertainly anticipating the first winter. But he also finds pleasure in his first autumn in the interior as he describes the blue of the desert sky, the warmth of midday sun, and the marked seasonal change that reminds him of Japan. Although the specific references to painting are few, he brings an artist's sensitivity to descriptions of the shapes, colors, and scents of the new landscape.

He left a number of poems from the Minidoka years, some incorporated into the diary and others not, which amplify the emotional content of his narrative, as in these reflections on the landscape.

> Even after traveling over so many undulating hills,
> All I can see is an endless horizon.
>
> Uneri kuru kazu aru oka wo koe tardeo.
> Tada tairakana chiheisen nari.
>
> Heaven and earth are howling wildly today,
> It feels like we are being blown by the wind.
>
> Tenchi mina kurui sakebinu kyō no hi wa.
> Kaze no shihai ni okareshi gotoshi.[3]

His first two poems, which he recorded in the diary, are in the form of *haiku*; all others but one are *tanka*.[4] His single long poem, "Orange," undated but presumably written during the war, is published here following the diary.

A notable feature of the diary is Tokita's use of it to track the course of the war. The December 7 attack on Pearl Harbor was part of a broad-based offensive by Japan, which had attacked the Philippines, Malaya, Singapore, Wake Island, Guam, and Midway on the same day in a drive to dismantle American and British power in the Pacific and East Asia. Over the coming months Japan aggressively pursued this policy, achieving a string of military victories and reaching maximum expansion by early August 1942. Tokita follows its invasion of Hong Kong, the Dutch East Indies, Borneo, and the Philippines and also turns periodically to Europe and the home front. While he displays a bias toward Japan, his identification is not entirely with that country. He makes an early reference, for example, to American "citizens" and "us" and in doing so, signals his personal stake in the United States (December 13, 1941). The diary also implies that Tokita was long accustomed to following the news and appreciated its larger context, as when he quickly comprehends the consequences of Japan's destruction of two British battleships (December 10, 1941). Later he refers explicitly to his "extensive knowledge" of history (June 5, 1943).

Although the diary skips from May until September 1942, Tokita's first entry in mid-September makes it evident that he had continued to track the war intently. During his months in Puyallup the war in the Pacific had begun to turn toward the Allies, with an American victory at sea at Midway followed by the U.S. Marines' landing on Guadalcanal and Tulagi in the Solomon Islands. Even as the Americans declared victory at Midway, however, Japan invaded the Aleutian Islands of Alaska. As the diary resumes, the battle for Guadalcanal was at its bloody height, while Japanese and Australian forces fought in New Guinea, and Japanese and British in southeast Asia. Tokita carefully follows the different fronts. As Allied forces slowly gained on Japanese-occupied territory, he expresses exasperation and sometimes depression at American news reports that are contrary to what he believes to be true about Japan. Nevertheless, his aim is to determine the truth about the war's course. As camp life wore into routine, the personal accounts give way to those of the war, and beginning March 31, 1943, the diary

entries focus exclusively on war news. The diary ends on July 20, 1944, with Prime Minister Tōjō's resignation.

The language of the diary is old-style Japanese, which uses more than twice the number of *kanji* or characters as modern Japanese. The modern translation, originally prepared for the Tokita family in Japan and the United States, represents the skills of two translators. Haruo Takasugi, a retired newspaper editor in Japan, translated the diary from old-style to modern Japanese, and Naomi Kusunoki-Martin, born in Japan and now a professional translator in the United States, translated it from modern Japanese to English. The first was the more subjective process, one in which Takasugi had to sort through pages bound out of chronological order and to create consistency where entries were illegible or passages missing. Kusunoki-Martin established a fine balance between contemporary usage and Tokita's formality in the English translation and provided Romanized versions of the *haiku* and *tanka* for this publication. Together they have produced a translation true to the emotional tenor and content of Tokita's text. During the preparation of this book, Michiyo Morioka, also first-generation Japanese American, reviewed portions of Tokita's handwritten diary to clarify the relationship between his first and revised versions and verified numerous details of the original text so that the integrity of his translation could be assured in publication.

The diary has been edited for publication, with every effort made not to disturb Tokita's voice and intent. This published edition represents three-quarters of the original text. Repetitious entries have been deleted, as have numerous extended accounts of the war, several of those verbatim newspaper reports. The entire diary in the original Japanese is part of the Tokita papers at the Archives of American Art, Smithsonian Institution.

WEATHER FORECAST
Washington—Occasional rain today; showers tomorrow; strong to gale southerly winds along coast.

MEAN TEMPERATURES
SEATTLE	48	Los Angeles	63
Portland	48	New York	31
San Francisco	59	Boston	34

Seattle Post=Intelligencer
AMERICA FIRST
MAN-AMERICAN PAPER EVERY... ...THE AMERICAN IDEA...

VOL. CXXI, NO. 97 — Entered as Second-Class Matter at Seattle, Wash. SEATTLE, MONDAY, DECEMBER 8, 1941 TWENTY PAGES HH DAILY 5c, SUNDAY 10c

JAPAN, U. S. AT WAR
104 DIE IN HAWAII RAID; 2 U. S. TRANSPORTS SUNK

All Military Posts In Seattle Region Go on War Basis

By R. B. Bermann

As swiftly and unexpectedly as a bolt from the blue, war came to Seattle yesterday.

What had been just an ordinary sleepy Sunday morning was suddenly transformed into a day of seething activity with the news of Japan's unheralded attack on Hawaii.

Because Seattle is the center of one of the nation's most important defense areas—and it is in the Pacific Northwest that one of the first blows has long been anticipated in the event of war with the Japanese.

Both the army and the navy went on a complete war footing.

Here's the way posts in the Puget Sound area were affected:

FORT LEWIS — Post closed to all but essential visitors, and troops with full war packs began moving out to take up positions at strategic

(Continued on Page B, Column 1)

New Warning On Planes

Rear Admiral C. S. Freeman, commandant of the Thirteenth Naval District, published the following order at 4 o'clock yesterday afternoon:

"All planes flying over naval stations, except air stations, will be regarded as hostile and will be fired upon without warning."

GENERAL TIRE COMPANY. MAIN 4577
Trade worn tires on new GENERALE.
Easy safety on wet streets. 8th & Lenora—Adv.

BRITAIN GETS READY FOR WAR AGAINST JAPS

Parliament Summoned to Meet Today; Churchill's Pledge Of Aid Will Be Fulfilled

By George Lait

LONDON, Dec. 8 (Monday). — (I.N.S.) — As Japan hurled her air and sea forces into unheralded assaults on American and British bases in the Pacific and seized Shanghai, Great Britain early today prepared to declare war jointly and simultaneously with the United States on the Japanese empire.

Both houses of parliament were summoned in emergency session at 3 p. m. today (6 a. m., Seattle time) at which time Prime Minister Winston Churchill is expected to announce that Britain, in concert with the United States, has entered formally into a state of all-out war against Japan.

As Prime Minister Churchill plunged into emergency consultations with the nation's highest military and government leaders after news of the Japanese attacks on Hawaii and the Philippines reached London, the expectation of a British war declaration against Japan, due to be issued to-

(Continued on Page A, Column 8)

Two American Warships Lost In Pearl Harbor

NEW YORK, Dec. 7.—(I.N.S.)—The Japanese aircraft carrier, from which planes presumably operated to attack Pearl Harbor, has been sunk by units of the United States navy, according to unofficial reports circulated in London tonight and reported to New York by CBS. The same unofficial sources said two British cruisers had been sunk at Singapore.

NEW YORK, Dec. 8 (Monday).—(AP)—NBC reported from Manila early today that it had received a reeport that the U. S. transport Gen. Hugh L. Scott, formerly an American President liner, had been sunk about 1,600 miles from Manila.

NBC relayed another report from Manila that the former President Harrison, now a transport which has been sent to China to evacuate Americans, "had been either seized or sunk in the Yangtze River, just south of Shanghai."

SINGAPORE, Dec. 8 (Monday).—(I.N.S.)—Japanese troops have succeeded in landing in Northern Malaya above the Singapore base and are now being engaged in violent fighting, the British Eastern high command announced early today.

HONOLULU, Dec. 7.—(I.N.S.)—Striking with sudden savagery out of the Sunday

(Continued on Page A, Column 8)

TOKYO SAYS AT LEAST ONE AIR CARRIER USED

Formal Declaration of War Follows Attacks on Hawaii; U. S., British Envoys Called

LOS ANGELES, Dec. 7.—(AP)—A Tokyo radio station, in a broadcast picked up by NBC's listening post here tonight, stated that Japan has attacked Hongkong and the Malay States.

(By the Associated Press)
TOKYO, Dec. 8 (Monday).—Japan went to war against the United States and Great Britain today with air and sea attacks against Hawaii followed by a formal declaration of hostilities.

Japanese imperial headquarters announced at 6 a. m. (1 p. m. Sunday, Seattle time) that a state of war existed among these nations in the Western Pacific, as of dawn.

RAIDS REPORTED

Shortly afterwards Domei announced that "naval operations are progressing off Hawaii, with at least one Japanese aircraft carrier in action against Pearl Harbor," the American naval base in the islands.

Japanese bombers were declared

President Drafting Special Message; Cabinet in Session

WASHINGTON, Dec. 7.—(I.N.S.)—President Roosevelt tonight announced that he will personally address a joint session of congress at 12:30 p. m. (9:30 a. m., Seattle time) tomorrow, presumably to request a declaration of war against Japan.

The announcement was made after the President had held a lengthy meeting with his cabinet, and leaders of both houses.

WASHINGTON, Dec. 7.—(AP)—Japan declared war upon the United States today. An electrified nation immediately united for a terrific struggle ahead. President Roosevelt was expected to ask congress for a declaration of war tomorrow.

During the day, Japanese planes bombed Honolulu, Pearl Harbor, and Hickam Field, Hawaii, without warning. In a broadcast from Honolulu, some 350 soldiers were reported dead at Hickam Field, with numerous casualties at the other points of attack.

The war department's first official estimate of deaths was much lower, however. Army chiefs told the White House there were 104 known dead and more than 300 wounded in the army forces. These figures did not include civilian casualties.

Come and get

Diary

Kamekichi Tokita

Translated by Haruo Takasugi and Naomi Kusunoki-Martin

In any conflict, sometimes you win and sometimes you lose.* You prove yourself by winning. War is the same way. Sometimes you win and sometimes you lose. It's probably not true to say there's no joy in battle.

For Enemy Aliens like us, however, there's only a struggle, one that we can never win. Everyday life is nothing but a never-ending struggle without choices. The day will never come when we are completely victorious. Yet we cannot afford to lose, either, for it will be the end for us if we give up. The authorities seized the business licenses from the Japanese residents of Portland early on. Nevertheless people still are struggling to keep their businesses going because they have no other choice.

In battle, people fight for their lives. Once

* In copying and editing his diary in March 1942, Tokita placed this March 30 entry as an introduction.

the battle is over, however, there is at least some time for restful moments; once soldiers brush off the dust of the battlefield, they can admire the flowers, or take a moment to be mesmerized by the moon's beauty. But there's almost no time for us Enemy Aliens to rest. Every single moment of our lives is a battle. It's an endless struggle. The situation doesn't call for great courage or heroism, as would be the case in war, but our spirits are being ground on a whetstone of anxiety day in and day out. Little by little, our spirits are worn away.

Since we're fighting this battle along with our wives and children, we can't give in to pessimism. We can't even allow ourselves to look dismayed. Yet superficial cheerfulness is not enough. Such a mask can easily fall away and reveal our true feelings. We must therefore find some source of hope that we can rely on in order to avoid despair. But what or whom can we turn to? God? Or Buddha?

While in the midst of our struggle, we have to pretend that everything is business as usual. We shouldn't act too defiant, for after all they are our customers. We all feel pressure coming from every direction. Somebody quietly said the other day, "I envy those diplomats and public officials. Although they're trapped in this country just like us, at least they don't have to worry about getting enough food or fear for their lives."[1] We are treated as the enemy, but we still have to keep

our businesses going so we can eat. We have to protect our lives and endure. We must fight this defensive war with no prospect of really winning.

A wealthy man, who was the owner of a dried food store, withdrew a lot of money from his bank when things started to turn ugly between Japan and the United States. As soon as Japan declared war, the FBI raided his store, took him away, and confiscated all of his "suspicious" cash. His wife felt that they lost all their money because she recommended that he withdraw it. She kept repeating "I'm sorry, I'm sorry," over and over until she eventually lost her mind. She would say, "They took all our money. Now we don't have anything left in this house," as she snatched the sweets her son offered to their guests, and hid them away somewhere in the back of her home.

Okuyama-san is the Japanese representative of a trading firm, who was also taken away by the FBI a couple of months ago.[2] However, Mrs. Okuyama was born in the United States, so they were using her name for business transactions and regulations that required citizenship. When the war broke out, Mrs. Okuyama regretted having allowed her name to be used for business purposes. She slowly lost her sanity. About a week ago, we heard that Mrs. Okuyama had been institutionalized. And today's paper (dated March 30) reports that she died from hanging herself in the hospital.

This war also attacks one's physical weaknesses. Some of our people stay in bed suffering from diabetes, and others have had to quit working due to heart problems. Lately, more and more people have become bedridden. I call these victims of the "war disease." Each person's physical condition may have a different name, but they're all caused by the stress brought on by this war. In fact, after we found out that Japan had declared war on December 7th, we all became ill for a few days. Nothing seemed changed and our lives remained the same. How then can I fully describe the anxiety that shook us deep down, in the bottom of our hearts?

Threats to our lives, which might or might not surface; the fear of riots that appeared both unlikely and imminent. . . .[3] No matter how tightly I cinched my belt, I couldn't feel any strength coming from my stomach. Only half due to the chilliness of the December weather, my heart was shivering. Day after day, I felt unpleasantly cold from the waist down. My blood must have lost its ability to warm up my body. I couldn't swallow rice, and even sesame seeds stuck in my throat. My intestines lost their digestive function for several days, and whatever I ate came out unchanged. It was about this time, however, that I began to get used to the continual anxiety we all felt.

1941 (SHOWA 16)

December 7 (Sun.)
10:00 at night.

It rained pretty much throughout November and continued raining in December until yesterday, when the weather became fine. Today turned out to be a fair, sunny day. I felt cheerful and planned to spend this beautiful Sunday in the suburbs fully enjoying the fresh air.

It has been our custom to play Japanese record albums on Sundays. We would play them one after another. We started cleaning our rooms listening to music. After playing seven or eight records, both I and Haruko got too occupied to keep switching albums. So we turned on the radio and kept working.

We noticed something unusual about the radio broadcast. I became concerned about the announcements coming in between the music. When I began paying closer attention, I figured out that there was an order that navy personnel return to their warships immediately. Then they played music again. After a minute or so, there was another announcement. This time, it ordered army personnel to return to base immediately. "Return to your posts immediately," it said. When the announcer said the word "immediately," it had a peculiar sense of urgency. Then they played music again. After a minute of music, there was another announcement.

It said that off-duty policemen should report to headquarters immediately. Something must be terribly wrong.

While we were discussing what this big commotion might be about, there came some astonishing news. Japanese planes were attacking the Philippines. We left the radio on and continued listening intently. As we listened, I noticed something strange. We heard the word "Honolulu" over and over. As the story developed, I found some of the contents questionable. Honolulu can't be in the Philippines—then I suddenly realized. They were talking about Hawai'i, not the Philippines. After a while it became clear to us that Japan had declared war. It also became apparent that Japan had attacked Hawai'i as well as the Philippines. How many times did I listen to the same story over and over again before I clearly understood this fact. I don't know if I should feel ashamed or think it was natural, but I was quite confused. I couldn't gather my wits.

Despite all that, we went over to Haruko's parents because the children were anxious to go someplace. We came home after 4:00. Yoshiko is almost over her cold, but Yuzo is coughing frequently. We may have to use a poultice again tonight.

My diary begins today. I intend to continue writing until the day peace returns. I will keep writing until the day when Japan and the United States shake hands again. I keenly hope that day will come as soon as possible. As I envision the constant torment we will have to face, I see that we will need to be both extraordinarily courageous and patient. It will be a blessing if our family can somehow survive the grave difficulties that lie ahead. I put down my pen to reflect upon the situation. My heart is full to bursting. In a moment, we have lost all the value of our existence in this society. Not only have we lost our value, we're unwanted. It would be better if we didn't exist.

The cold wind of December did not blow directly on me until yesterday. It's now blowing right through me. Even the wind doesn't approve of our existence. I feel cold. So cold.

Stricken on a journey,
My dreams go wandering round
Withered fields.[4]

This poem comes to my mind. "Stricken on a journey" . . . on a journey . . . on a journey. . . . After more than two decades, we believed this place had become a second home to us. Were we merely travelers on a journey all this time? I suppose we were. Or were we really?

December 8 (Mon.)

Coldness crept into my body. As I realized that yesterday was Sunday and today Monday, I was truly surprised. That merely means that night fell and morning followed. But

they say that yesterday was Sunday the 7th, and it turned into the 8th overnight. And on top of that, today was Monday. Even such simple facts are too complicated for me right now. The artificiality of these conventions troubles me. Such things don't have any use to us now. If I force myself to think that yesterday and today are somehow connected, it feels as though about a century has passed between them. So far as I can see and hear from our hotel, yesterday's commotion has subsided and things seem to have calmed down.

I felt absentminded all day. The only thing I did was clean up the hallway of the hotel. From time to time some indefinable weight presses down on the pit of my stomach, which drains all the energy from my entire body. I find it unbearable. Nevertheless, I feel more composed than yesterday. Ordinary people can't make themselves face reality all at once. Unless one is forced by circumstances to admit it's a matter of life or death, one probably can't accept the facts. I try to gather strength around my stomach, telling myself it's a matter of life or death, but it's in vain. The apprehension presses down on the pit of my stomach all the more.

I decided not to listen to the radio at all anymore because I didn't think I could listen to it and maintain my sanity. The radio broadcasts still refer to us as "Japan" or "Japanese," but I tremble to think of how we'll be treated when they begin calling us

"Japs." I just hope we're going to survive this and long for the day when we can return to our normal lives in safety. So long as the local Japanese newspapers last, I'll try to save the articles relating the developments in the war.[5]

December 9 (Tues.)

I think it was before one of Musashi Miyamoto's duels in Matsubara or somewhere that he said, "Respect the gods yet don't rely on gods."[6] This passage has kept crossing my mind the last couple of days.

I really fear the mob mentality. There was a blackout in our area last night. Friedlander's Jewelers downtown forgot to turn off their neon sign and was vandalized. I heard there were a few other similar incidents downtown, too.

The owner of the restaurant on the street corner, a friendly Caucasian lady, visited us this morning to make sure we were okay.[7] She advised us not to have cash in our house. She offered to keep our money in a safe inside her restaurant. That would be one way to deal with the current situation. Even though she is a Caucasian, she came to check on us because she was deeply concerned about our well-being. This is very encouraging. She left a piece of paper with her restaurant's number and her home phone number and told us to call her if anything should happen.

The tone of the radio broadcasts sounded a bit different. I found out that Germany and

Italy had declared war against the United States. Actually at this point, their declaring war against the United States was assumed to be inevitable because the U.S. had begun criticizing Germany and blaming Hitler for all this mess.

Seven at night, the U.S. President issued a proclamation to the nation. Maybe because I was calmer, or maybe because I didn't quite understand his speech, I listened to his proclamation relatively calmly. His speech contained some difficult words here and there, but I listened very intently and found the overall message easy to grasp. In addition, the speech sounded powerful enough to raise the nation's morale.

From the point of view of the United States, I could see that some of his arguments are reasonable. He said that without warning during the last few years, Germany had occupied first Czechoslovakia, then Poland, Belgium, France, and Denmark in succession. Italy took over Ethiopia without warning, and Japan took over Manchuria.

From Japan's or Germany's or Italy's viewpoint, however, each must have its side of the story. If Great Britain and the United States had found a way to provide Japan, Germany, and Italy with an appropriate amount of resources, this war would never have happened. Intelligent people could have resolved these issues by considering the fair distribution of benefits. This is the most fundamental issue. Yet, for the past few years, people from every nation seem to have forgotten all about it, focusing only on fighting. I wish Great Britain and the United States had cared a little more for these three relatively poor countries. Japan, Germany, and Italy have been earnestly trying to get their attention for several years, but Great Britain and the U.S. deliberately shut out their voices and wouldn't listen. That was quite unreasonable. If only there had been a great politician in Great Britain or the U.S. who had figured out a way to supply them with enough resources to live moderately, and to bring about some benefits for their own countries as well, such a big war would have never broken out.

Anyhow, my mind has become somewhat calmer and people in town seem to be coping with the situation. The radio broadcast has returned to a somewhat normal tone that is more pleasant to listen to. With Germany's participation in this war, the United States may have shifted some of its focus away from Japan.

The local Japanese papers will stop delivering temporarily tomorrow. I'm going to miss them.

December 10 (Wed.)

It doesn't feel that cold physically, but I feel unpleasantly chilly from the waist down. Maybe it's because I'm feeling uneasy. It feels as though I'm submerged in cold water up to my waist.

In a large headline, the English paper's morning edition reported that the British battleship *Prince of Wales* and one other battleship were attacked by Japanese planes and went down. I thought Great Britain had only a few battleships in the Far East. If my memory is correct, this bombing must have caused tremendous damage to that nation.

The *North American Times* issued yesterday said that on the 8th there was a huge air raid all over the Philippines.[8] There is a rumor that the Japanese army landed at Luzon. The article said that the Japanese forces were aided by a fifth column consisting of Japanese fishermen. It also said that the Japanese flag was planted both on Wake Island and Guam. (See the paper for details.)

Since they're not delivering the Japanese papers, I went outside to get yesterday's papers. I received them with a sense of gratitude. I really miss having the Japanese papers delivered to our door.

I had three bowel movements today. The condition of my body is returning to normal.

I hear that many stores owned by Japanese have lost business because of the war. Mrs. Hidaka, who works at our hotel, told me about an incident that happened at the restaurant where her husband worked. The restaurant had some Filipino workers. A white person asked one of them, "Are you Japanese or Filipino?" The worker replied, "Filipino, of course. Isn't that obvious?" And they got into a fight, which quickly became a bigger fight involving the three Filipino workers and the white person. The restaurant owner (who is Japanese) got upset and told Mr. Hidaka that he didn't have to come to work anymore because he was going to close his restaurant for awhile. So as of today, Mr. Hidaka isn't working.

The lady from the restaurant on the corner and her sister came to check on us. There are more than 120 Japanese in this city who have been taken into custody. It seems like they are all people we know. Some of the names I heard are as follows:

Hara-sama of Tacoma Hotel
Hayano-sama of Regina Hotel
Nisei lawyers including Okuda-
 sama and Ito-sama

Wholesalers such as Furuya Company, Tsutakawa & Co., and North Coast Importing Company that import Japanese products have had their businesses closed down.[9] Meanwhile, the Japanese newspapers are being printed only with permits, which are issued on a daily basis.

December 11 (Thurs.)

The war broke out just as Mr. Sawada was hospitalized for paralysis-like symptoms. Mrs. Sawada couldn't withdraw any money from the bank to hire a nurse because their

savings in the bank were frozen. The two daughters took temporary leave from school so they could take turns tending their father in the hospital. A telegram was sent to their eldest son in Alaska requesting his prompt return. "What do we do?" asked Mrs. Sawada, who was totally at a loss. "I can lend you some money for the time being," I said. "Your husband doesn't have to know about this." Under the current circumstances, I can't be physically absent from home. The only thing I could do for the Sawada family was to offer some monetary support. Although our money in the bank was frozen, we had some cash on hand we needed for the business.

Haruko is worried about the baby and wants to get some things ready for the delivery. Her due date is late June or July. Since we still have more than half a year to go, I didn't think there was any rush. On the other hand, we're going to have to get those things sooner or later anyway. So I stopped at Gosho Drug Store and purchased some cotton, gauze, vitamins, and cod liver oil.

Gosho-san looked extremely discouraged. Since he was so depressed, it fell to me to cheer him up. I would like to have someone to console me and cheer me up too. By consoling someone else, however, I found myself more at ease. Maybe that's how it works. I realize that I feel better after visiting and comforting other people. With situation as it is now, it may be better for me to go out and comfort other people rather than cowering alone inside the house.

There will be a blackout again tonight from 1:30 a.m. to 8:45 a.m. As a law-abiding resident, I am following this rule.

December 12 (Fri.)

My mind is calm again but a deep anxiety sometimes comes over me. It's an obscure feeling, but when it's over me it shakes me to the very bottom of my heart. It's like an aftershock. Small or big, the magnitude of each aftershock doesn't affect the depth of my anxiety.

Guests have stopped coming to our hotel. We've had one vacancy since yesterday, but we must be very careful now whom we let in. I think we're going to leave it vacant until a familiar customer arrives.

Sakamoto-kun told me this afternoon that we could keep our businesses running by assigning custodians.[10] He also told me to relay this message by phone to others because he couldn't mention it in his newspaper. I asked him where we should go to get official approval after assigning custodians, but he didn't know yet. He promised to make inquiries. I suppose a custodian is essentially a business manager who oversees the entire financial aspect of our business. Sakamoto-kun said that a custodian has to be someone with U.S. citizenship, either a Nisei or a white person.

As of today, Issei are allowed to withdraw savings up to $100 (only from American banks and not from Sumitomo).[11] I heard that Seattle First National Bank on Jackson Street was swarming with people.

The sanctions against monetary dealings with Japanese farmers were also lifted today. At the vegetable market on Western Avenue they are about 80 percent back to the normal level of activity. Seattle gets 80 percent of its vegetables from Japanese farmers and the rest from Italian farmers. The citizens of Seattle have had trouble since the sanctions against Japanese farmers came into effect. That's why they had to ease up on the regulations. Japan says they have taken over both Guam and Wake Island. The United States claims that those islands are still in their hands. The news repeated the story of the U.S. sinking the *Haruna* several times. A headline in the newspaper referred to a battleship going down. I was alarmed, thinking that another battleship had gone down. But as I carefully read the article, I realized the story was by the reporter on board, who was repeating the stories of the *Prince of Wales* and *Repulse*.

According to the radio broadcast, they continue to enforce blackouts in the San Francisco, Los Angeles, and Sacramento areas. In Seattle, however, they are ending the blackout tonight after four nights of enforcing it. I feel so relieved. Everyone's a bit edgy now. Even if it's a guest who fails to observe the blackout, the hotel owner is held responsible. Besides, I'm a Jap. They will definitely blame me for anything that happens. I haven't slept really well the last four nights.

December 13 (Sat.)

I slept in until after 10:00 a.m. As soon as I finished my breakfast, I went over to see Sakamoto-kun. I wanted to discuss the custodian issue he told me about yesterday.

The authorities haven't decided whether they will assign custodians for us or let us choose our own. If they decide that the government will make the selections, that's extra work for them while they are in dire need of manpower. Not to mention the money for wages it's going to cost the government. On the other hand, if they decide to let each of us choose, that's too much freedom. That must be why they have been so indecisive. When I asked Sakamoto-kun if this custodian issue applies only to hotel owners for the time being, he said, "The authorities want to deal with hotel owners first, because that's the largest segment among the Issei Japanese." Somehow, it seems, we can continue our business. The hotel guests are calm and nobody is talking about moving out. Since Seattle was not directly hit by bombs, the whole agitated atmosphere has subsided. It doesn't look like this hotel will be attacked by a mob anytime soon; I feel less threatened as time goes by.

The real oppression is yet to come. But I can rest easier for now. We can't keep worrying about the future. That cycle has no end. "Don't trouble yourself by thinking too much about what tomorrow may bring."[12] This passage came to me. It's perfectly suited to the current situation. I don't know why but I somehow can't help but wear a bitter smile.

The past week has been very peculiar. I can't possibly measure the time in terms of a week, days, or hours. Last Saturday, when there was still peace, seems like the ancient past. Up until then it was like a fairyland where a week controlled the days, and a day controlled the hours. That made our lives then like a fairy tale.

They say the First Lady's speech was aired today, and that she was trying to persuade the nation not to oppress Japanese immigrants. I think the general public's opinion is in tune with her speech. They still have some room in their minds to care about us. The reality of this war hasn't truly hit us all yet. Eventually there will be no time for such consideration of us. When that time comes, the oppression will be hard to bear. I'm not worrying needlessly about the future. I'm talking about a reality that must surely come sooner or later.

December 14 (Sun.)

Since we live in a downtown hotel, I long for fresh air and sunshine. Normally on Sundays, we take the children out to the suburbs unless it's raining. But neither Haruko nor I feel like going out today.

Ever since the war broke out, I find it a bother to walk outside. I don't feel like going out at all unless I have accumulated a few errands that absolutely need to be done. Once I'm out, I take care of things single-mindedly without paying attention to anything else. When I'm done, I run straight home as fast as I can. Nobody has called me "Jap" to my face yet, but the American people's attention bothers me. The more normal the treatment I receive, the more convinced I become that I should stay hidden in some out-of-the-way corner. I'm trying not to stand out.

The *Japanese American Courier* was the first English-language newspaper published by Japanese people in the United States. It's been more than ten years since it was launched. As the name suggests, the newspaper's logo has the Japanese and American flags forming a shield-like design. They felt the need to change their logo, so I drew an illustration with a bald eagle in the background.

Sakamoto-kun is the president of the *Japanese American Courier*. He is blind, having lost his sight over ten years ago. Sakamoto-kun is an extremely energetic person. We used to joke about how wild and unmanageable he would have been if he still had his sight. Since this war began, he has become indispensable to both the Japanese and American communities.[13] In our view,

Sakamoto-kun is a distinguished American citizen born in the United States.

I'm composed once again, but still somewhat apprehensive. What should we do in case of an emergency? This is a question I've asked myself over and over again. We discussed this issue and decided that it would be a good idea to take refuge at the fire station in town should there be an actual emergency. If it's too dangerous to walk on the streets, we will head for the fire station along the rooftops. Or if it isn't that urgent, we could take shelter at Maryknoll School. After we planned a few methods of evacuating depending on the degree of the crisis, I felt fairly relieved.

Teramoto-kun visited me with his wife in the evening. "About the job you got me, my boss tells me that he can probably keep me given the developments so far. But we really don't know how long the current atmosphere will last," he said. "Even if I get fired, I can't blame anybody." Under the circumstances, he would have been better off if he had kept his job at the Washington Hotel. On the other hand, when the situation worsens to the point that he gets fired from his current job, I suppose there's no guarantee that he would have remained employed at the hotel either. Mrs. Teramoto said that her sewing business had enough orders to keep her busy until Christmas. But new orders were not coming in, and the students in her sewing class have stopped coming.

December 15 (Mon.)

Mrs. Hidaka told me that her husband went to a pharmacy run by a Nisei yesterday, only to be locked out. According to her, the store owner didn't even let him through the door and simply said, " I don't do business with Japanese people."

The story was outrageous and I didn't understand the reason behind the store owner's attitude. When I found out it was because the government had prohibited monetary dealings with Japanese, I felt I had to do something about it. All the guests at our hotel are Americans. Yet nobody has refused to pay just because the government set up these new regulations. I became more and more irritated thinking how unreasonable the pharmacy owner was. So I called Jimmy Sakamoto-kun and asked him to upbraid the store owner for his misconduct. I was so upset that I found myself yelling into the phone saying, "Hara of the pharmacy is a total asshole!" Later I suddenly realized how careless I had been. Any Japanese person's phone could be tapped.

Some of the Nisei don't remember the fact that they are the children of Japanese immigrants and claim to be 100 percent American. These same people are scared to death when the government restricts monetary transactions with Japanese. I'm disgusted by how narrow-minded they are.

It may be because the United States has become confident that the mainland is safe,

or because Japan has suggested the lack of such intention, but people seem to be very calm. It almost feels as though things are back to normal. When I look back on December 7, if even a single Japanese plane reached the mainland somewhere on the Pacific coastline and attacked, our fate would have been much more miserable. We may not even have survived. It's also possible that the Japanese navy was ready to attack the U.S. mainland. If Japan decided not to attack even if they could have, it may have been a manifestation of the navy's compassion toward Japanese immigrants like ourselves.

I review the Japanese government's claims printed in the *Post-Intelligencer* very carefully.[14] I compare them with what the American government says to figure out roughly where the truth lies. They say that Wake Island and the Midway are still under the Stars and Stripes. They also say that Japan has been attacking Hong Kong in full force since the 14th. The authorities here tell us that the air fleets from the Dutch East Indies and Australia that have arrived in India are heavily engaged and have already sunk six Japanese transport ships. I wonder if their air fleets actually have been playing such an active role.

looked at myself in the mirror. It was hard to believe that it was me. Definitely different from the way I looked ten days ago. There was no resemblance to my former self that I was used to from the past forty-plus years. It was a different face. Disgusting, vulgar. It looked very old, too. I looked like I had aged about ten years. All dignified features such as self-respect or self-confidence had vanished. I was utterly amazed and looked at myself again. If someone had brought this face from somewhere, presented it to me, and told me it was mine, the humiliation would have been unbearable. I was so disappointed. I thought my face should look a little more dignified after surviving such an ordeal.

According to Jimmy Sakamoto-kun, it won't be necessary to appoint custodians for our businesses. He also said we could now withdraw as much money as we want from the bank. To withdraw cash, however, there are two conditions: one has to present proof that one hasn't traveled abroad since June 17 of last year; and one has to present proof that one's business has no direct ties with Japan. Nevertheless, considering how strict it was in the beginning, this new loosening of regulations may be a sign of hope for the future.

December 16 (Tues.)

I shaved for the first time since I heard the news. I was dumbfounded for a while as I

December 17 (Wed.)

I glanced at the headlines of the paper one of our guests was reading. It read "Menace"

"Singapore" or something like that. It looks like Japan's attack on Singapore and Hong Kong is heavy. Considering how Great Britain has treated Japan for over ten years since the China Incident, the Japanese soldiers must feel as if they are facing their foe. [15] They must be fighting very fiercely.

The morning edition of the *North American Times* reports that the Japanese army landed on Borneo in the midst of a heavy storm. Things seem to be going according to their plans. The situation in the Philippines, on the contrary, is quite unclear. My assumption is that Japan hasn't cared that much about the Philippines from the beginning. To fight with American solders in the Philippines is a waste. That's why they attacked the Philippines as a cover and faked a retreat, while the troops were sent toward Borneo. There may already be some kind of an agreement between Japan and the United States. Or is this just my imagination?

As for our businesses, we no longer face any restrictions or need to obtain any permits as long as bank withdrawals are $1,000 or less a month. We can now withdraw money freely. This is quite a change.

Sakamoto-kun phoned to warn me about con men. A few white men posing as government officials are making the rounds and collecting $3 or $4 as a tax. He told me not to pay because they are swindlers. According to him, these impostors are going around in a light tan medium-sized car with the license number L329. I relayed his message to a few of my acquaintances.

December 19 (Fri.)

As Issei, we aren't in a position to complain no matter how we are treated in this country. Nevertheless, somehow we can conduct our business and live quietly. I feel grateful for that. But my take on the Japan–U.S. war for the past several days may have been a bit too optimistic. It looks like the United States is getting ready to buckle down and really deal with the war. If so, this war is going to last for a long time and we're going to suffer harsher oppression as the war goes on. The current situation has seen some temporary improvement but things could get worse later.

The true challenge is yet to come for Nisei as well as Issei. I believe the Nisei will grow up to be very strong and distinguished people by overcoming this difficulty. The war presents a great opportunity for the younger generation to become disciplined. If they can survive this winnowing process their future will be bright. The Issei are certainly ready to help in any way we can so that the Nisei are able to make it through.

Is this because my body's defenses are down? I'm very sleepy. I think I have a cold too. My stomach is acting funny. I keep dozing off, but I can't sleep when I get in bed. Maybe I'm experiencing a nervous break-

down. After working just a little bit, I feel exhausted. I had diarrhea three times this morning.

December 20 (Sat.)

My stomach trouble has been persisting since morning. I've had seven or eight bowel movements, but my stomach still hurts. If this is caused by a cold, it's a very severe one. I feel like something is pressing hard against my entire abdomen. This reminds me of the intestinal catarrh I suffered in Manchuria a long time ago. I remember how terrible that was. Or have I lost my nerve and not gotten over my anxiety yet? If I'm still panicked, I should feel embarrassed about recording this in my diary.

About two hundred people were taken into custody immediately following the outbreak of the war. The *North American Times* reports that about fifty of them are to be sent from the local immigration office to a CCC camp in Montana.[16] The FBI handles federal government cases, which have nothing to do with the local police force. Why were those people taken into custody to begin with? Are the rest of them going to be released after fifty of them are sent to Montana? Nothing has been made clear to us. The Russian GPU probably works in a similar manner.[17] All we can do is to tremble in the face of the authorities.

They say that the publishing of Japanese newspapers has been suspended in Hawai'i

and Vancouver. I wonder how long our local Japanese papers will last. The paper's report on the situation in Malaya says that the Japanese army has advanced to within 300 miles of Singapore. In the Philippines, the Japanese army landed at Davao and is probably planning to base their naval forces there. The paper also reports that Hong Kong's fall is imminent.

With all of these actions, it's no wonder our guests seem restless. We can feel some of their nervousness. This may be partially because they are now requiring that men between the ages of nineteen and sixty-four register for the draft.

Meanwhile, in the world controlled by months and days, Christmas is approaching each time we turn the pages of the daily calendar. The Christmas break at Maryknoll School starts the day after tomorrow. Their Christmas program will be held tomorrow as usual. I trimmed Shizuko's hair and gave Shokichi a haircut too. Then I went to Tazuma Ten-Cent Store for some Christmas shopping. The store is an example of a business built by Japanese immigrants fair and square. While I was shopping there, I couldn't help feeling depressed wondering how long businesses like this one would survive.

December 21 (Sun.)

Since there was a Christmas program at Maryknoll School, I invited Toyoko, Haru-

ko's little sister, to come along. The program was pared down compared with other years, and there were only three performances altogether. After the final performance, all the children received Christmas presents and went home. It was before 4:00. It's unsafe to walk outside after the sun goes down nowadays. By the time I put the car into the garage and went inside, the streetlights were on.

At night, we wrapped Christmas presents for the five teachers at Maryknoll: four Sisters and Hata-sensei (the Japanese teacher). We will distribute handkerchiefs to the hotel guests. I folded them and Haruko placed them in envelopes with the words "Merry Christmas" and "From the hotel owner" written in English on them. We were amazed how fortunate we were to spend such relaxed hours. We talked about how thankful we were. Thinking about Christmas presents and having time to wrap them made us happy.

Toyoko said both of her parents have been continually angry and irritable lately. They came out to the car when I went to pick up Toyoko. The little chat I had with them confirms Toyoko's story. When I visited my mother-in-law the day before yesterday, Oye-sama of Jackson Furniture Company happened to be there. The three of us had a little talk. We should be grateful as long as we make it through each day safely. It's easy to say and hard to do. But there's no point in becoming irritable like that.

My stomach feels better but I feel very weary around my hipbones . . . painfully weary. But it gets a bit better each time I sleep. Strangely, I always feel sleepy. I can doze off whenever I try. Yet I can't sleep for long. Maybe my nerves are wearing thin. This is the third Sunday since the outbreak of the war. I am filled with emotion. All I want is peace.

How many times have I thought about what to say in a telegram to my big brother in Japan when peace comes? I began thinking about this the day the war started. The moment I start thinking about it, my mind becomes totally occupied with these thoughts. Should I say, *Mina buji* [We are all safe]? No, Japanese content probably won't be allowed until the conclusion of all peace negotiations. So maybe I should say, "Family-Business-Safe."

When I come to my senses, however, I realize it's been just two weeks since the outbreak of war. We still have a very long way to go. I don't know if our lives or business will be secure when the war is over. When I try to face that reality, I feel gloomy and don't know what to say. I am aghast at how silly I'm being!

December 22 (Mon.)

My physical condition is much better. My bowel movements are not loose anymore. I was feeling helpless for those few days when everything I ate went straight through me.

I've heard about stomach flu, but it was more like intestinal flu.

While my intestines were in bad shape, I remembered from time to time that Mitsunari Ishida had stomach trouble after he lost a battle.[18] I don't know why that came to my mind. I must have thought that the way my bowels were out of order was similar to the trouble Mitsunari suffered. While my problem persisted, I didn't even want to eat the dried persimmons that are my favorite. Comparing myself to a brave warlord like Mitsunari, just because we suffer the same problem under similar circumstances, is too arrogant. I feel extremely embarrassed as I write this in the diary. But I assume that even a strong person like Mitsunari couldn't help suffering from stomach troubles, worrying about the future of his family and his followers after losing a battle.

The evening edition of the *Great Northern Daily News* says that the authorities are now issuing license plates to Japanese people. We were just talking about the inconvenience of not being able to drive for a long time. So this decision helps us a great deal. Especially those in the dry-cleaning and grocery business who need their cars for work must be relieved to hear this news.[19] This is indeed great news.

The paper also said that all short-wave functions on radios must be removed. So I asked a Japanese radio repairman to come, and he disconnected something in our radio.

While I was taking care of the radio problem, I decided to buy a used radio for $5.50. I thought the hotel guests must be eager to listen to the news on the radio. I plan to set up this radio in the lobby so that our guests can freely use it.

We got presents ready for the mailman, the garbage men, and the Brothers at Maryknoll.

December 23 (Tues.)

The only thing the children can think of is Christmas. Their only concern is what Santa Claus will bring them. Over lunch, Haruko and I talked about how good it was that we had bought all the presents for them before the incident happened. Otherwise we wouldn't have had enough latitude to get presents ready for the children. Rather, we probably wouldn't even have been in the mood.

The world has become quiet. We have become composed. The hotel guests have all become calm, too. Large-sized headlines in the newspapers occasionally stir us up.

(Postscript: I have written several times that things had become quiet, or things were calm. Now as I read what I wrote, I feel that my mind wasn't in a normal state while I was writing such nonsense.)[20]

July 16, 1940, was the day funds for Germany and Italy were frozen. The treatment of Japanese people is quite different

depending on whether one has traveled to Japan since then or not. Those who haven't been to Japan since then, and haven't been taken into custody as suspects associated with the current incident, have been enjoying generous treatment in all respects. Thanks to such a policy, we can conduct our businesses relatively freely, and are allowed to obtain license plates. There's no restriction on transactions (both withdrawals and deposits) with banks, so long as we follow certain procedures. It doesn't seem like we have any major inconveniences. I feel truly thankful for that.

My physical condition is almost back to normal. But I must still be weak overall because my feet are really cold, and the muscles of my groin are tensed up. It's like I'm afflicted with lumbago. It's very unpleasant. So I sit cross-legged on a couch with my shoes off, and put a blanket folded in quarters over my lap in order to keep warm from the waist down. This feels quite nice. They say there are lot of Japanese people sick and bedridden. I feel sorry for all of them. But I believe everyone will eventually get up with courage and rise above this situation.

December 24 (Wed.)

It's not snowing this year. If it were a regular year, tonight would have been a perfect Christmas Eve. It certainly feels like Christmas. Christmas songs are coming out of the radio, and funny jokes are being told. We put up a Christmas tree in our office, just like every other year. Yet I feel flustered. Or is it just me? The children went to bed before eight expecting that Santa Claus will be coming tonight. Peace reigns over the world in their minds.

Kiyo-chan came over after seven. She had given us gloves for our children, so I had given her *udon* noodles in return. In order to thank me for the noodles, she brought three toys, saying they were given to her by someone last year. I left one out and put the others away. After making sure our children were asleep, we brought out the toys we had purchased and wrapped them suitably for Christmas presents.

Kiyo-chan said that many people will be transferred tonight from the Immigration Office to a camp and that the families of those in custody received a phone call telling them to bring down some warm undergarments. It's not like things are going to be easy for those of us remaining behind, but I can't imagine how horrible they must be feeling as they are being sent to a camp. It's really unbearable to think what it'd be like to leave for a camp tonight and spend all your days there until we regain peace.

May peace return as soon as possible. I wish for a peaceful world where nobody would have much reason to complain about the way things are.

December 25 (Thurs.)

I thought it had been awfully cold since last night, and today turned out to be an unusually clear day. The children are totally absorbed in their Christmas presents. Thanks to that fact, they behaved well without causing much trouble. The winter break for school starts today and lasts until January 5. Since the incident, we hesitate to let the children play openly outside. But they get bored easily if they are confined inside the house all day. I don't know what to do.

Just as soon as the war broke out, I began wondering what I should do in this delicate situation. I didn't know what to do and was completely driven up the wall, but I have an uncontrollable urge to do something. We have very limited freedom, however. So in the beginning, I thought I could help people in need due to the current situation. I thought that was the best I could do. It really wasn't a bad idea at all, plus somebody has to do it. Nevertheless, I own very little. Even if I had dedicated all my assets, that would have been enough to help only one or two people at most. In such a case, it would have been impertinent to say I was helping people. I began wondering what other ways I could make myself useful.

The conclusion I've reached is this: I would like to maintain an attitude that helps all the people I meet feel cheerful, be they Japanese or Americans or any other nationali-

ties. Come to think of it, I have kind of been doing this already without being aware of it. And I have a feeling that this fits perfectly well with my personality. Immediately following the outbreak of war, one lady came to me and said, "A friend of mine visited and complained bitterly about how we were totally victimized by Japan." "That's totally nonsense," I immediately remarked.

December 26 (Fri.)

When I went over to Takano-kun's, he was in extremely low spirits. Strangely, the Japanese living around Jackson Street in Nihonmachi are far more scared than the Japanese like ourselves living in areas mingled with American people. I believe there is a good reason for that. In Japantown all sorts of false rumors are circulated. People are constantly scaring one another with such unfounded rumors. They said, for example, that the owner of Nakamura Grocery was taken into custody. We believed that story. But then he showed up at Maryknoll School for the Christmas program. They also said that the Kumagaya brothers were both taken into custody. I believed they were until today. Takano-kun, who is a relative of the Kumagaya brothers, told me that the elder one was in fact taken into custody but not the younger one.

Another thing about people living in Japantown is that they are enclosed in their own community while living in America.

They don't have much contact with the world outside. So no sooner does a harsh wind from outside blow through than they cringe and tremble. Those who've engaged the American community running dry cleaning, grocery, or hotel businesses, on the other hand, are servicing American customers all day long. We know how to cope with the American community. We are always exposed to the harsh wind blowing on this side. We also benefit directly from kindness shown by thoughtful American people and feel greatly encouraged to know that evil isn't the only thing that resides in the hearts of mankind. People in Japantown, however, do not have an opportunity to directly receive such kindness from their neighbors. They only feel strong pressure from the outside.

December 27 (Sat.)

The newspaper reported that four Nisei were in detention pending trial. Two of them were prominent lawyers in the Japanese American community, Mr. Masuda and Mr. Ito, while the other two were from trading businesses. They are suspected of sabotage. Since Nisei are Americans, all four of them are in jail, unlike Issei, who would be sent to the Immigration Office.

Over two hundred Issei have been arrested, but none of them has yet been released. They are sent to a camp, one group after another. Most of those who are in the office now will be sent to the camp in Montana today. I feel so sorry for them. Those sent to the camps in the early stages of this war are the most unfortunate ones. Statistics published twelve years ago said that the average age of Issei then was about fifty-five or fifty-six. That means almost all of those going to the camps are over sixty. Life in the camps won't be that bad in terms of the material supplies; however, it will be fairly hard on them mentally. I should probably keep track of those who fall in the camps during this war.

On my way home, I stopped by Togo Securities to pay my Manufacturers Life Insurance premium. Togo's Mr. Hosokawa said that he expected no new business coming in for quite a long time. Togo's main business is from hotels, real estate, and houses, so his expectations are well founded. Mr. Hosokawa used to be an energetic person, but he has aged a lot in such a short time.

After coming home, I called Nomura-kun of Stadium Cleaners.[21] Nomura-kun told me that his business hasn't seen much change yet. We talked about how business in general had slowed since the outbreak of war, so it was only natural to have a little less business than before. We also discussed how we'd like to support Sakamoto-kun's JACL relief efforts.

December 28 (Sun.)

The jurisdiction under Lt. General John L. DeWitt, the commander of the Fourth Army,

is now called the Western Theater of Operations. The Western Defense Command and the Fourth Army cover California, Oregon, Washington, Nevada, Idaho, Montana, Arizona, and the U.S. Territory of Alaska. They must be assuming that these areas could potentially become battlefields if worst comes to worst.

The *Great Northern Daily News* had a notice that Japanese, Germans, and Italians in possession of shortwave radios, cameras, and guns have to report them to the police station by 11:00 a.m. on Monday. I'll have to take care of that first thing tomorrow.

Listening to the radio news for half a day on Sunday makes me fed up. I feel like I've listened more than enough. Once I start listening, though, I just can't stop. Some Filipinos have attacked Japanese in America. Two Japanese have been murdered so far. Although the incidents took place in California, we have to be watchful of Filipinos. Fortunately, we don't have any Filipinos or blacks in our hotel. But when the bell rings late at night, we have to be careful when we go out to the office.

December 29 (Mon.)

I went to city hall in the morning to obtain a license plate. They charged me $4.50 for it. In the afternoon, around 2:00, I went to the store that repairs radios and spent slightly more than an hour getting the shortwave

parts removed. I took the removed parts and the radio straight to the police station. They asked me if I had removed them myself. I told them that the radio repair man did it, and the job was okayed. They told me to toss the removed parts into a garbage can at home. They were extremely casual about it. They didn't even take a look at the radio I brought in. While I was there, I deposited two cameras at the station, too.

December 30 (Tues.)

Every errand is taken care of for now, so I feel relaxed. After lunch, I took Shokichi and Shizuko to the garage to put on the new license plate. On our way back, we visited Haruko's parents. I felt reassured because they seemed to be calm today. Since the children wanted to remain at grandmother's to play, I went to Sagamiya to purchase *noshi-mochi* by myself.[22] I also visited Sakamoto-kun to donate $10 for his relief efforts, and told him that I was planning on donating $10 every month. Then I stopped by the barber for the first time in many days before going home.

December 31 (Wed.)

After 6:00 last night, about half of the ceiling paper and some plaster fell down in Room 49. We had a fire going, and the ceiling paper was seven or eight layers thick. The room must have gotten so dry that the ceiling

paper shrunk. We had the same problem in Room 20 a few years ago. Fortunately, I had some plasterboard on hand. So I spent the whole afternoon repairing the damage. As for the ceiling paper, we'll have to wait until summer. If we do it now, in winter, we won't be able to use the fire for warmth for about a week despite the cold weather. With the heater on, they say the paper will dry up too quickly and tear.

At night, I cut up the *noshi-mochi* I bought yesterday. Normally we'd offer *kagami-mochi* to the gods and Buddha, but we can't be too extravagant at a time like this.[23] So we offered sliced *noshi-mochi* instead to the altar for the new year in a move to be more economical in all aspects of our life.

The soldiers fighting under General MacArthur in Manila are being over-whelmed by the enemy coming from both north and south. They are left with no choice but to retreat. According to the newspaper, they retreated about a half-hour drive away from the previous battlefront in the south. On the northern side, they were said to have retreated even further away from the Lingayen Gulf. Today's evening edition reports that the United States may base their Air Force on Kamchatka in the Soviet Union. The newspaper warns that they found signs of a Japanese battleship near Alaska. It also says that Singapore has declared martial law.

Mrs. Kambe received a letter from her husband, who was among the first of some forty of our fellow countrymen sent from here to Fort Missoula in Montana. All the residents of the camp are Japanese. Since self-government is allowed, they elected leaders and formed a committee to make decisions. There are some inconveniences, but they are being treated fairly well. They pitched in to buy a radio. He met some of his old friends that he hadn't seen for many years, and said that the atmosphere there is like a Japanese convention on a national scale. It takes some extra days for a letter to reach its destination because it has to be censored, but the families can send letters and everyday things to those in camp.

1942 (SHOWA 17)

January 1 (Thurs.)

We spent the simplest New Year's Day for 1942. Normally we complain a lot about how the *zoni* turns out, but this year it was the best dish of all. Part of the reason might have been the fact that it was the coldest New Year's Day in recent years. The dishes served today were all made out of ingredients we already had on hand: *kamaboko, kinton, kanten*, oranges in place of Japanese tangerines, *kuromame, kazunoko*, and *nishime*, a little bit of each.[24] Nevertheless, it was enough to create the ambience of New Year's Day.

New Year's Day among ourselves without any guests wasn't bad at all, as things turned out. Only one of the uncles paid us a visit in the afternoon. We didn't have anything to offer him other than some tea and children's snacks. Our talk kept going back to the people who had been taken by the authorities. The newspapers don't report everything, so we have to figure out how many people have been taken by tallying up the number of people we've heard about. It feels like so many people have been arrested. But the actual stories of such incidents we heard directly from someone amount to no more than twenty people.

The FBI seems to be still detaining a few people here and there. We heard that Kiyo-chan's husband, who worked for Mitsubishi's Lumber Department in Seattle, was arrested around 6:00 last night. And his case isn't the only one. The Kawasakis have two children: a five-year-old and a three-year-old. It will be extremely tough on Kiyo-chan to try to make a living with two little children. I talked about her situation with Haruko last night and decided to let her stay free in one of our hotel rooms if she would like to come. I'll tell her about our intentions when I call her tomorrow to express our sympathy. Kiyo-chan is a Nisei born in Vancouver, while Kawasaki-san is from Japan. He is a kind-hearted person.

January 2 (Fri.)

After finishing my breakfast, I immediately called Kiyo-chan. However, she was thinking of going to the Wilson Hotel.[25] After all, Haruko's parents arranged Kiyo-chan's marriage. If that works out for her, so be it. What happened to Kiyo-chan will probably start happening to more people close to us. We'll probably need to take some people into our hotel. It's just a matter of time. Indeed, we really don't know what fate will bring us either.

In general, all of the U.S. businesses operated by Japanese people are suffering the effects of the war. Every single one of them except the hotel business, which hasn't been affected at all due to the big influx of people into town for the expansion of the munitions industry. But the hotel business will eventually feel the pressure, too.

The dentist Higashida called and asked me to come in the afternoon. He has a sign on the brick post at the entrance with his name written in Japanese in a golden color. He asked me to paint over the Japanese letters so that it would read "An American Citizen." What difference does it make to paint over the Japanese letters and write "An American Citizen" instead? But that's just my opinion. I took on this project, removed the sign from the post, and brought it home with me.

(Postscript: I painted over the sign and put it back up. Within a week, the sign was totally vandalized.)

I went home to find out that an order had come in from K. C. W. [Furniture Company] to create a paper sign for their New Year's Inventory Clearance Sale. Of course, they want their sign in English.

January 3 (Sat.)

The JACL formed by the Nisei will start collecting donations and embark on a patriotic movement. From the Issei's perspective, the Nisei are respectable U.S. citizens. They are now trying to serve the country by participating in patriotic movements like the JACL. That is very admirable. It is our duty as Issei to support their efforts. The United States and Japan unfortunately went to war and the Issei have been put in a tough position. Yet that shouldn't stop us from supporting what the Nisei are trying to accomplish or assisting in what the Nisei are trying to do.

Americans are still skeptical when they look at the Nikkei citizens. If the Nisei are discriminated against during as well as after the war, they would have to reconsider things. But the Nisei today are trying to show their loyalty to the United States of America by leading patriotic movements for the country. Hopefully they won't end up being disappointed because of Americans' persistence in discriminating against them. May they be

able to freely fulfill their duties as Americans Please don't let them be disheartened. This is what I want most from the American people.

Even though the Nisei have been brought up in America, I have no doubt that they were born with great attributes, being Japanese descendants. Japanese people living in Japan are faithful to their country. Likewise, I strongly believe that the Nisei living in America are faithful to the United States and will bravely serve their country. Americans, value them and use the right men in the right places. I believe they come from better seed than the descendants of immigrants from any other country.

January 4 (Sun.)

According to today's radio news, the Japanese army that invaded Manila prohibited any Caucasians, regardless of their nationalities, from going outside. Even after living for so many years in the United States, we can't differentiate between Caucasians in terms of race (just like Americans can't differentiate Japanese, Chinese, Filipinos, etc.). So it's understandable that they put all Caucasians in one group and restricted them from going outdoors. But it seems as though Americans now feel it's a war between white people and yellow people. Or it may be America's intention to make this appear to be a race war. One such indication is the radio news. The radio broadcast emphasizes the fact that the

targets of these restrictions include even neutral people like the Spanish, and prohibit all white people from going outside. The radio also says that white people are suffering terrible treatment at the hands of the Japanese. War has happened. That's that. But because of the war, all this propaganda is emerging that says the Japanese are the most barbaric of people. This makes me feel really miserable. Being labeled as social outcasts, as we are now because of this war, is most vexatious and annoying. To look down upon people from the enemy's country to that degree may be even worse, in a sense, than war itself. This kind of propaganda will get into the brains of young people and affect those who are still too young to go to war. That's a more horrifying thought to me than the war.

I think the average American's view of Japanese people boils down to one word, and that is disrespect. Don't underestimate your enemy. Don't take Japan too lightly. These are the phrases we see quite often lately in the newspapers. Yet the writers' contemptuous attitude toward the Japanese people is evident between the lines. Extreme examples are the articles discussing how the United States should deal with Japan after Japan's defeat. Amazingly, all such articles are written by senators and congressmen. I'm just astounded to see how arrogant they are.

Prime Minister Tōjō is warning the nation that Great Britain and the United States are great powers and that the war has just begun.[26]

I can't help thinking of the sheer contrast in the attitudes of the two nations. The Japanese people are as one heart and flesh whereas the United States doesn't seem to have it all together. It makes me worried about this country, yet they may eventually unite.

Teramoto-kun and his wife visited us tonight. Teramoto-kun lost his new job after all. Another person I know is now unemployed. I told Teramoto-kun that they are always welcome at the Cadillac Hotel if they start worrying about how to put bread on the table. Since we run a hotel, I feel it's our responsibility to take care of some of the people who've lost their jobs. We'll try to hang in here as long as we can until we can't hold on any longer.

January 6 (Tues.)

We ran out of oil for our heater yesterday, so I went to Queen City (a fuel store run by a Nisei) to order some. The person who delivered the oil told us about an incident that happened recently. All the hotels have their fifty-gallon oil tanks installed on the second floor. It's customary to pump the oil in from trucks. The store has never experienced any trouble refilling the oil tanks in that manner before. However, when they were pumping in some oil at the Rainier Hotel by extending the hose through the entrance, officers from the fire station objected to the operation. They said that people are not allowed to run

a hose across the street anymore. I wonder if that is one of those cheap tricks meant to oppress people of Japanese ancestry.

When I read the *North American Times* tonight, it said that hotels are required to cover their skylights during the blackout, because hotels still have to keep the lights on in hallways throughout the night. Our Cadillac Hotel has two large skylights (one is about 25 × 8 feet, and another about 20 × 8 feet). Old hotels like ours with large skylights will have a very difficult time covering them up.

Yesterday's evening edition of the *North American Times* also reported that Japanese people in Portland are going to get their business licenses revoked. There was also an article on the city council meeting in Vancouver. It said that one of the agenda items was how they should drive the Japanese away into the back-country. The pressure is coming toward us inch by inch from various directions.

January 9 (Fri.)

I spent all afternoon yesterday calculating and preparing my business tax return, which is due March 15. In the United States, if taxes are filed jointly, a couple has a $1,500 exemption plus a $400 exemption for each dependent child. Since we have five children, our exemption is $2,000 for children and $1,500 for Haruko and me. That means we

don't have to pay any business tax for revenue under $3,500.

I went to the bank for the first time since the freeze on funds was removed. I deposited some money, paid the electric and phone bills, and cashed eighty-nine Social Security checks.[27] In the afternoon today, I worked on our books for the first time in a month. Because of the recent turmoil, there's a huge discrepancy between the books and the cash. The revenue is recorded properly, but it's hard to tell what we've paid out. We kept some receipts but we lost so many others.

January 10 (Sat.)

The evening edition of the *North American Times* today has headlines such as "Imminent Danger in Singapore: Citizens Already Preparing to Take Refuge," and "Enemy (which means the Japanese army) Has Advanced 50 Miles Within 24 hours; Kuala Lumpur Is Abandoned." But they still have 240 miles to go before they reach Singapore. The paper says that the American and Philippine armies retreated 15 miles and reconfigured themselves into a firm new defense formation, and that a full-scale Japanese attack is expected to take place soon. The paper doesn't tell us anywhere, however, where they are fighting after retreating those 15 miles. I don't know if they haven't received any reports or don't wish to announce it publicly. Either way, we don't know the exact location.

Other interesting news is that the Chinese army is said to have become very strong in the past few days. They say that the Chinese army is forcefully pushing the Japanese army back. The Chinese surrounded 30,000 Japanese, chased 50,000 Japanese away to the north, killed 7,000 Japanese and so forth. Those stories sound a bit exaggerated. Although it's apparently true that the Royal Air Force and the American Air Force are participating in the battle of Chungking, I still wonder how reliable these reports are.

The *Post-Intelligencer* released some communications from Tokyo, the Allies, and the Japanese government. According to those reports, what the Japanese claimed they lost sounded far too low. According to the war results from the U.S. Army and Navy published in the *North American Times* this evening, they certainly downed 16 enemy battleships, 68 aircraft, and 5 troop transport ships.

January 11 (Sun.)

I visited Masae Maeno-sama around 1:30 p.m. I hadn't heard that Mr. Maeno was sent to a camp, but I assumed that he must have been taken to the camp because most people associated with the Japanese Association, especially those who served as board members, had been taken away.[28] Just as I had thought, Masae-sama told me that her husband was arrested on the night of the 7th. He had thought he would be back in a day or two.

Maeno-sama's business as a beer wholesaler has been suspended, which causes them great financial trouble. Masae-sama has been working outside so there's some income still coming in. Yet what she earns is barely enough to feed the family, and definitely not enough to pay for her other expenses, including the rent. Masae-sama wakes up their youngest daughter, who is four years old, and gives the children breakfast before she goes to work. The older children stay with the youngest until the school bus from the preschool comes to pick her up. They go to their schools after they make sure she gets on the bus.

Through my conversation with Masae-sama, I discovered that Nagamatsu-sama had also been arrested. We suspected that, but kept telling ourselves that the authorities wouldn't arrest someone like Nagamatsu-sama, who is nothing but a good-natured person. I didn't think Nagamatsu-sama was heavily involved in the Japanese Association, but he may have had some ties with the Association lately. That incident has really made it clear that the Japanese Association was near the top of the authorities' blacklist. Almost everyone on the board there was arrested. It didn't matter what kind of people they were. If you had a strong relationship with the Japanese Association you were taken away. All trading businesses that have transactions with Japan, regardless of size, have been shut down. Furuya Company, Tsutakawa & Co., North Coast Importing Company, and

Chihara Jewelers all import general merchandise from Japan. I heard that among them only Chihara Jewelers received permission to resume business on Friday, the day before yesterday. There is a rumor that sometime this week the others may be allowed to resume business as well.

The Photo Studio was closed down around the time I deposited my cameras at the police station.[29] But the paper said that the studio reopened a few days ago.

The President and other high ranking officials say earnestly that Americans shouldn't lay off goodhearted people, even if they are Enemy Aliens, as long as the businesses concerned aren't in wartime industries or government offices. They also point out that some of the descendants of those immigrants are fighting for the United States as soldiers. Some stores with Japanese workers, however, are being given a hard time because of their Enemy Alien employees. Some store owners don't want to keep Japanese workers if it means risking the loss of customers. In some cases, therefore, they hire Filipino workers instead. Here and there, Japanese people are beginning to lose their jobs. Once they lose a job, absolutely nobody wants to hire any new Japanese workers.

January 12 (Mon.)

While the general public in Seattle is already experiencing shortages, there's a large influx of people into the city due to the rise of wartime industries. That in turn leads to more shortages. The purchasing agent for hotel supplies keeps telling us to purchase more toilet paper because there isn't much left, or soap for the guests because there are only two boxes left, or brooms because their price will rise. But when we get around to ordering them, it doesn't seem like any of these items is in short supply.

They recently stopped supplying tires except for use by the military and public transportation. This evening's newspaper has an article reporting on protests by taxi companies, which change tires on their cabs every four months. The trains are already overcrowded, so the taxis are the only alternative form of public transportation, and if the taxi companies can't get tires the public as well as the taxi companies will be in trouble, the article says.

In regard to the automobile tire supply problems, I suppose the government has to pay close attention to their allocation. These days we can't imagine our lives without cars. What's most puzzling is the fact that people living in the west side of the city often have businesses in the north, while people in the east side have stores in the west. Thanks to cars, they can choose where they want to live. It's also very common for people to live three to four miles away in the suburbs, or even ten or fifteen miles outside the city. The suburbs keep spreading in all directions regardless of

access to public transportation systems such as trains and buses.

If people lose their cars for commuting, we're going to be in big trouble. I would almost go so far as to say that people's daily lives will be shaken to their foundations. The only way to cope with this disastrous situation would be for people to sell their houses and move to more convenient locations that are closer to train stations or bus stops, or to neighborhoods within walking distance of their place of business. If people actually choose this option, most of the households in Seattle would have to move from east to west, from north to south, from suburbs to inside the city—a major influx from inconvenient locations to convenient ones would have to take place. What can we do about it? The government will have to relax the controls over the use of rubber tires. But if the government yields a bit, everyone will want to get their hands on tires. Then the government will be forced to find other ways to obtain rubber.

January 13 (Tues.)

This morning was just gorgeous. Haruko and Yuzo took a walk with Yoshiko riding in the stroller and did some shopping. The world appears to be very calm. If it weren't for the war news in the newspapers and on the radio, things would seem to be just the way they would have been in peacetime.

But new rules and regulations keep pouring out one after another. So many of them are coming out that we hardly have time to respond to them. Since they are all important for the citizens and for us in particular, we have had no time to relax.

They are issuing federal license stickers through the end of February. We are required to purchase the sticker at the post office for $2.09 and place it on the windshield. Any car without one will be fined $30 to $50. Moreover, the sticker is for the first half of the year, so we'll have to pay an additional $5 sometime after May.

Also, those who were born after February 1897 and are older than twenty will have to complete their draft registration by February 16. Americans and foreigners alike. Since I was born in July 1897, I should not forget that.

The newspaper reminded the hotels again of the need to cover skylights during the blackouts. We are also required to place a piece of paper with the name of the person in charge of the household and the phone number in front of the house, and file the same information at the police station.

The Red Cross sent us a letter demanding a donation. The letter said that we have to send money as soon as possible because it's our duty to do so. We also have to file our income tax returns by March 15.

It feels like there's always something that must be done. I have to take care of

things one at a time, which keeps my brain extremely busy. What we do about our regular hotel work has been pared to the bare minimum. Both old and new government offices come up with abundant new rules and regulations, and much of our time is occupied in trying to abide by them, which leaves us no time to do anything else.

January 14 (Wed.)

I went to the JACL office this afternoon and asked them to prepare our business asset report for the last year. I donated $2 to the Red Cross at the JACL, and obtained a business registration card.

As to the draft registration for those who are forty-four or younger, where and how we are supposed to register haven't been made clear yet. They continue to enact new laws, but they haven't decided how to implement them, even if the deadlines are approaching fast.

Just as I'm thinking that it seems some pressing matters have been taken care of and others have been postponed, this evening's paper now tells us to appear at the post office between February 2 and 7. For the "Re-registration of the Enemy Aliens," they are creating something similar to the alien registration cards we obtained a year ago. This time fingerprints are required only for the index fingers, but photos will need to be submitted as well. Yet the size or number of pictures required has not been decided. They say that further details will be posted at a later date.

According to the regulations under the General License Law 66-A, individuals who hold general business licenses with assets exceeding $1,000 have to file a TFR-300.[30] Businesses with assets exceeding $5,000 have to file a TFBE-1 at Federal Reserve Banks by the 15th, which is tomorrow. But we haven't received the TFR form in this city yet, and the due date for filing the reports has been postponed in the meantime. This is merely another example of a law that has been enacted without having proper forms prepared. Federal Reserve Banks finally have received the TFBE form, according to the newspaper, and those with assets of $5,000 or over will have to file the form even after the 15th. The due date is tomorrow, but they don't have any forms today.

The problems we are facing are minor, though. Under a headline saying, "The Ottawa government officially announced that Canada is moving her Japanese residents to the interior: Sympathy for 23,000 fellow countrymen," an article reports that everyone, except for those who obtained permission to stay from the police, will be moved to the interior. People with permission to stay will have to join the Canadian-Japanese volunteer army. Even if they become volunteer soldiers, they can't fish because their fishing boats have been confiscated. I wonder how

they are going to live. I suppose the volunteer soldiers themselves can somehow manage, but what about their families? I doubt that the authorities will offer benefits for the rest of their families to live on. So the Japanese people in Canada are being treated much more severely than us. Over one thousand fishing boats have been taken away, and fishing itself has been prohibited. Since most people are being moved to the interior, it might be better to all go off together after all.

Of course, in the United States, too, similar issues are being heavily discussed. One-third of the population of Hawai'i is Issei or Nisei, and they are debating what to do about them. They may be thinking about relocating them somewhere else. I seriously doubt that we will be able to remain in Seattle until peace returns.

January 15 (Thurs.)

Despite all the rules and regulations being continuously imposed on us, our lives so far have been relatively unaffected. I think there are two main reasons for this. One is that Japanese people are very deeply rooted here in Seattle. And the other is that the Niseis' pro-American movement is affecting the authorities. I've written before that 80 percent of the vegetable supplies to Seattle come from Japanese farmers living on the outskirts of the city. This is another financial reason why the citizens in Seattle rely on the Japanese.

Japanese people operate 250 or more hotels and apartment buildings in Seattle. Almost all the hotels and apartments, mostly located south of Yesler Way, are operated by Japanese. In addition Japanese-run hotels are clustered in a few other areas. Near the center of the city there are several hotels here and there operated by Japanese. Most seniors living solely on Social Security income ($40 per month) live in hotels owned by Japanese.

If they try to get rid of the Japanese by replacing the operators of such hotels and apartments, it will certainly mean a hike in rent. The price of food and other items will follow the trend and go up. If that happens, the $40 from Social Security will not be enough for all those elderly people to live on. King County offers $8 rental support as an unemployment benefit and the Veterans office also offers $8 rental support for unemployed veterans. If living expenses become higher, what they are offering will not be enough. Those offices will have to come up with new budgets for their relief efforts.

I have been in the hotel business for six years now. Ten guests have trusted me enough to deposit their money here at the hotel rather than at a bank. This is a growing trend every year. I would assume that Japanese people, like me, who have been operating hotels for the past few decades must have had many more such trusting guests.

January 16 (Fri.)

Up until today, I've been writing this diary driven simply by my desire to write. Now that I look back, though, I noticed that sometimes I have been writing emotionally, and sometimes I have been writing mainly to record a series of events. I'm beginning to think that I should refine my strategy. If I am to write something interesting to read, then I should try to be entertaining. And if I am to record events, I should try to be precise. I realize that I should set my objectives and write accordingly. But that's quite difficult for a nonprofessional writer like me. If I'm writing something for other people to read in the future, the way this diary is now is unsatisfactory as either entertainment or a record. If I try to satisfy one of these needs fully, however, I would have to spend much more time writing. Spending more time is impossible for me at the moment. I guess I will just continue doing what I've been doing as time permits. Inconsistent as it is, I'll continue with this diary. Sometimes it's emotional, and sometimes it's more factual. I suppose I just can't help it.

I've been writing about the various rules and regulations that keep cropping up. I'm curious how all of these rules, regulations, and controls will develop. They will inevitably ease up some of the rules, and they will enforce other rules much more strictly than they do now.

Among these rules, I'm most keenly interested in the tire issue. I think it's the most significant problem of all. The way things are now doesn't allow people to get tires when they need to. Dissatisfied people will explode. It's only a matter of time. How to handle this situation should be a major concern for the government.

January 17 (Sat.)

When the Japanese army was reported to have come within one hundred miles of Singapore, it caused an uproar. They now say that the Australian army has joined the fight and stopped the Japanese army from advancing any further. That news was received with enthusiasm. That was yesterday. The paper also reported that the Australian army forced the Japanese leading units to retreat by blowing up ten tanks and three armored vehicles. The Australian army was reportedly in very high spirits heading for the battle line. The Australian commanding officer's quotes sounded almost boastful.

I was telling Haruko that people going to the front lines should refrain from bragging like that. Just as I suspected, today's paper says that the Australian army was defeated. One news source says that the Japanese army has closed to within fifty miles of Singapore. This report may not have a solid foundation, but it's probably true that the Japanese army is now within seventy to eighty miles at most

of Singapore. I hear that the string of defeats on the Malaya Peninsula is a very big issue in Australia and Great Britain. There seem to be a lot of comments in the newspapers suggesting the need for a reassessment of the strength of the Japanese army.

Yesterday and the day before yesterday, the paper said that the only person who could overcome this difficult situation and save the Philippines and Singapore from their peril is Chiang Kai-shek. It seems as if they are trying to position the British and Chinese armies closer to Burma to pose a threat to the Japanese army in Thailand, thereby forcing the Japanese army to split their forces, which in turn will ease the pressure on the Philippines and Singapore. Yesterday's evening paper, however, reported that Japan got the jump on the situation and began attacking Burma from the Thai side. Japan's taking such initiative must have caused great distress to the Allies. Also, according to a statement released by the Japanese army, the American and Philippine armies led by General MacArthur in the Philippines are being held at bay and are expected to retreat to Corregidor Fortress or to the opposite shore of the Bataan Peninsula. At any rate, it certainly appears that the American and Philippine armies won't last very long.

All these developments over the past week or so make me feel suffocated. I can't concentrate on anything. After finishing our routine cleaning of the hotel's hallway, I am lost in thought. And my thoughts focus only on the war.

January 18 (Sun.)

I heard that both the father and mother of Shokichi's schoolmate, Fred, have become bedridden due to heart problems. So we made some sushi to bring along and visited them in the afternoon. Fred's mother, as it turned out, was feeling better and had gone to work.

I also visited the Nagamatsus. Nagamatsu-sama was arrested. Since they have so many children, his wife is having a hard time taking care of their family by herself. If someone is taken by the authorities, his family is allowed to withdraw only $100 a month. If the family has a business and earns, say, $50 a month, the amount allowed to be withdrawn is limited to $50 from the bank. No matter what you do, living expenses are limited to $100 a month per household. Families like the Nagamatsus, who have many children and have been enjoying a relatively luxurious lifestyle, can't live on $100 a month. I worry about their future.

Those who had most of their money in Sumitomo Bank in Seattle are in a lot of trouble because of the war. Even if they have money in the bank, they can't do anything with it because the bank has been closed down by the U.S. government.

January 19 (Mon.)

The situation in Hawai'i seems to be causing major headaches for the American government—not only because one-third of their population is Japanese Issei and Nisei, but also because there are many Nisei in the defense forces in Hawai'i.

I read a story told by a Hawai'ian officer today. The officer said that Hawai'i's economy would be in total chaos if they decide to move the Japanese population someplace else. If they decide to keep the Japanese population there, on the other hand, they might be taking a great risk. If one or two people in the defense forces rebel, the defenses could fall apart. They have no real choice, however, other than to place their trust in the Japanese residents of Hawai'i. As a partial solution, they have created some defense units consisting only of white people.

The battle situation in Malaya is unclear. Some say that the Japanese have advanced to within 25 miles, 35 miles, or 90 miles. Others say that the Australian army is fighting 100 to 110 miles away from Singapore. It's hard to know what to believe. The battle for the Philippines is also murky. According to the Japanese military, the situation was so chaotic that the U.S. artillery abandoned their weapons and retreated. According to American reports, however, the U.S. forces are still standing firm and have retreated only 20 miles. But as to where that 20-mile retreat started or where

it ended, or how much of the defensive line remains intact, nothing is forthcoming. The gap between the reports from Japan and the United States is widening.

I went over to the JACL and donated $10 today. I also went to the *North American Times* to pay for our subscription for November, December, and January.

January 20 (Tues.)

The boards we ordered yesterday were delivered. I will start working on the cover for our skylights. I was surprised to see that the boards cost $32.75. When we are finished with this project, it will have cost us at least $67.

The war has spread widely. In addition to Malaya and the Philippines, battles are going on in Burma and the Dutch East Indies. Another naval port in Australia is said to have been bombed today. I know I'm repeating myself, but it's truly amazing that it has been only a month and a half since the war broke out. To us, the past month and a half seems like a few years. For the past month and a half, ordinary notions of time do not apply to us. If the war continues for a year, we will probably age ten years both mentally and physically.

The *Count of Monte Cristo* by Dumas contains a scene where his hair turns white overnight.[31] Our current situation is somewhat similar to that, except that we're not locked up in a cliff-side prison. We can drive, visit our

friends on Sundays, and conduct our business. But an invisible thread is being wrapped around our waists. It doesn't appear to be there, but it is there. Somebody or something is pulling on it from somewhere. It looks weak but it's actually very strong. Even if we know we are innocent, they don't trust us one bit. Such is the mercilessness of the thread.

The higher authorities keep telling the nation that people have to protect good-hearted Enemy Aliens. Their words bring joy to our ears but little more. Those who have become most keenly aware of this invisible thread are the people who have been arrested. We hear that they had turkey for Christmas; that they had *sake* and wine in addition to *mochi*; and that they are enjoying a Japanese-style bathtub they made themselves. All those things must have been wonderful treats they hadn't expected. I would assume, though, that those things could satisfy their eyes and senses but not touch them deep inside. Once they look inward, they probably don't know what to do with the bleakness they feel.

If you are a manager with Shokin or an employee on a merchant vessel from Japan, you might feel the treatment you received was understandable.[32] Most people sent to the camps, however, are immigrants who have decided to make this country their burying ground. Now that they are old and their children are grown up and independent, they would rather stay here than go back to Japan. Many of them are well over fifty, and there

are even those who are in their sixties or seventies. The immigrants benefited Japan during peacetime and have also greatly benefited the United States.

When there was peace, how could people have realized that this invisible thread was wrapped around their waists? At this critical time, they expected to be among the first recruited.[33] They thought they would be asked to contribute to America's national defense and be assigned to vital roles even if they were Japanese. But things turned out to be completely different. I'm not complaining about it. I suppose this is the way the world is. This situation is too significant to complain about a lack of trust. People think that all Japanese are somehow dangerous.

With the nation in such grave need, I believe that the Nisei will display the most magnificent courage on behalf of their homeland (America). For they are of Japanese descent. Thoroughbreds are a must in horse-racing. Like their parents who would be brave for their country, the children must have the same traits. If they are born in America, they will certainly fight for America and be the bravest of the brave. I believe that the Niseis' loyalty to this country is stronger than that of any other immigrants.

January 21 (Wed.)

We are beginning to see some oppression of Japanese businesses. This was only a matter of

time. Today I heard that the Japanese Express shipping company had their license revoked. They had some trouble with a union before, when the union wanted the Japanese Express to stop their service. This time they are taking advantage of the situation, since Japanese as Enemy Aliens have lost all their legal rights.

An official from the City Department of Health paid us a visit this afternoon and asked us if we're using a central heating system for our rooms. I replied that we don't use a central heating system but that each room has a small heater guests can use of their own accord. Then the official said that the hotels using radiator systems must have the heater on all day during the winter. As reasonable as this may sound, it's an indication that they are beginning to put indirect pressure on the Japanese hotels. Most Japanese hotel owners run economy hotels. Even if they do have some heating equipment in the rooms, they normally limit the hours when the central heater is turned on because of the relatively cheap rents. For example, they have the heat on between six and nine or ten in the morning, and from six to about ten in the evening. Only the lobbies, which serve as entertainment centers for the guests, have the heat on all day long. If we're required to keep the heat on all day every day during winter, economy hotels like ours wouldn't be able to make any profit at all.

"The hotels on Yesler Way are using their central heating systems and charging their guests $5 a week. If you start using yours, you can charge $4 to $5 a week, too," the official said. It seemed like the official wasn't able to differentiate economy hotels from the hotels downtown. Hotels like ours, whose guests are elderly people receiving $40 a month from their Social Security benefits, can't charge $4 or $5 a week for the heaters. Our guests wouldn't have any money left for food. At a hotel like ours, it's also kind of dishonest to charge that much merely for steam heat.

I am quite sure that the officials are aware of all this. We will probably receive a visit from the Fire Department too. Among all the Japanese businesses, hotels are the only ones doing well. Perhaps they are going to send one official after another from departments that have some kind of authority over the hotel owners. "It's like we're in the midst of a war ourselves," I said to Haruko today.

By the time this war is over, all Japanese will be left penniless—this is what I told Kuromiya-sama just as soon as the war began.[34] I have also said this to other people from time to time. It seems like my prediction is slowly but surely coming true. To record the process of this transition may be the real purpose of this diary.

January 22 (Thurs.)

Yoshiko, born on December 17, started walking just before her thirteenth month and was walking rather well today. She must be very

happy with herself. She kept taking steps for a short distance. Sometimes she even walked longer, about twelve feet.

Today's *North American Times* had a quotation from the Secretary of the Navy, Frank Knox. It read, "Especially in Honolulu and Oahu where Pearl Harbor is, the Issei and Nisei population is concentrated, making up 37 percent of the total. This is a very significant matter. In the near future, we have to determine what to do with the 37,353 resident aliens born in Japan. But the decision has to be made by the military authorities." Knox may haunt the Japanese for the rest of his life.

The Japanese government has expressed their concern regarding Issei living in Hawai'i. They said that if Issei people were detained due to false accusations, they hope the United States would ensure that justice is fully served after the war. This matter is relevant not only to Japanese immigrants in the United States, but also to immigrants of other countries as well. I admit that Japanese people feel an attachment to their home country. But I don't think there are any ungrateful Japanese immigrants who would act with malice against the country they immigrated to. I hope they check into this matter as thoroughly as possible and apologize if this treatment turns out to be baseless.

In regard to the Japanese immigrants in South America, I truly hope that they will never be treated as we are, viewed with suspicion and oppressed. When I look at Japanese immigrants, I see that the Japanese are model immigrants.

January 24 (Sat.)

"Presently in Sacramento, the capital of California, a state legislative meeting is being held. State senators and legislators are heatedly discussing the necessity of conducting a study regarding the current land lease situation with Japanese immigrants and of instituting harsher restrictions and punishments on lease transactions."[35]

The exclusion of Japanese farmers has always been an issue inseparable from land law.[36] But now that many of the Issei are reaching retirement age, most lease transactions are handled between Nisei and their landlords. There are also many cases in which Issei are giving the orders but the properties are leased under Niseis' names.

I wonder if they are trying to say that this violates the rules and use it as an excuse for legal action. When the war broke out and transactions with the Japanese were temporarily suspended, many Japanese businesspeople here in Seattle transferred their businesses into their sons' or daughters' names, thinking the businesses should be under Niseis' names. They may eventually say it's illegal for Issei to conduct businesses this way, by merely borrowing Niseis' names.

They can't take businesses or properties away from Japanese by force. They can, however, scrutinize the legality of a situation from various angles and then take away our properties and businesses, claiming that we have been breaking the law. These methods are legal on their surface. The Japanese government won't have any grounds on which to raise objections after the war. I think the authorities will start using many tactics like this to find any slight flaws in legality and then confiscate our businesses and properties. As of now, I am operating this hotel. But if they start giving me a hard time, I will be forced to give it up.

January 25 (Sun.)

Today was Sunday and sunny, which is very rare this time of year, but we didn't have anywhere to go. Government officials have told us not to go to parks. We have been ordered not to go to the beach. There are no places for us to take our children so that they can jump around to their hearts' content. We also have been ordered not to leave the city limits. To go outside the city, we need to file an application form stating the nature of our business and obtain official permission. There isn't much we can do about the situation. Today we didn't have any options other than to go to a neighborhood with a lot of Japanese residents and find a relatively quiet spot to let our children play.

My hotel is in Skid Row and all we can see from there are buildings with no greenery anywhere. On top of that, the building across the street from our hotel is very tall and blocks the sun from mid-October through mid-February. Since we rarely go out due to the war, Yoshiko, who was born in December the year before last, has been brought up only in the shade. She is so pale. I feel sorry for her. I have never felt this eager to see the sunshine in February.

In addition to filing our income tax return, we're now required to submit an inventory of our property if the total value is over $1,000 and a different form if the value is over $5,000. We have to include everything from our insurance to the certificates of deposit we own in Japan. I thought our assets would be lower than $5,000. But, after some calculation, it looks like they will exceed that amount. I don't understand the purpose of this kind of survey, but I imagine they must have some plan. Although I'm already convinced that they are eventually going to squeeze every last penny from us, this kind of treatment still bothers me.

January 27 (Tues.)

Kawaguchi-sama called around seven in the evening to tell us that Sawada-sama suddenly passed away. So we immediately went to visit his widow to offer our condolences. Since walking outside at night is unsafe, I took a

taxi with my father-in-law. A lot of Sawada-sama's friends from the Congregational Church and other acquaintances were already there. He was fifty-six, still young.

It must be unbearable for Mrs. Sawada to lose her husband at a time like this. All four of their children are grown up already. She can at least feel reassured on that account. Even their youngest daughter is already in high school. Their two boys are wonderful sons and their first daughter, I hear, is attending a beauty college. They will soon be able to help their mother. The Sawadas acted as go-betweens on Haruko's side when we got married.

January 28 (Wed.)

Many young Japanese men have been drafted. And many of their mothers are grieving, not knowing what has happened to their sons because not a single letter has arrived from them. According to today's newspaper, one unit is being sent to Ireland. Some drafted Japanese men may have been in that unit.

I wonder if their letters have been confiscated because their parents are Enemy Aliens. I feel deep sympathy for the mothers. I believe that the authorities should at least find some way to let the families know their sons are safe. The children who were drafted went off to war, sacrificing themselves for the sake of the safety of their parents and siblings as well as for the nation. The parents

are oppressed as Enemy Aliens, while the children are drafted as American citizens. No matter how their parents are treated, if the authorities say, "It's for the country," the children do not have any choice. But the authorities could take a different stance. For instance, they could have told the children to do a great job for the nation because the authorities were going to take good care of their parents and siblings, so that they could rest assured. I wish they could have received such a commitment from the authorities. I wish the authorities could have shown that much kindness.

There are parents who haven't heard from their children in six months. I don't mean to seem biased about the matter, but I think that's a bit too much. If sending a letter isn't allowed, why not allow them at least to send home pictures of themselves in uniform? The authorities repeatedly tell the nation to treat Enemy Aliens equally, but the reality in this society is quite opposite.

There was a story in today's *North American Times* about three Japanese railroad workers in Auburn. The American workers there issued an ultimatum saying they would quit unless the Japanese workers were fired.

January 29 (Thurs.)

The matter of three Japanese workers at the Great Northern Railway in Auburn was settled by layoffs. Similar incidents occurred

at other yards, and were also settled by lay-offs. They say, "It was settled," but they don't say, "It was solved." Once you are laid off, you never go back to work. I have seen several such examples. All of those who are in the railroad industry have been working there for a long time, twenty to twenty-five years. If they could stay with the railroad only a little bit longer, they would be eligible to receive pensions. That is the thing I feel most sorry about. They are supposed to receive pensions and have been looking forward to it. I know someone working at a roundhouse in Everett. In twelve more years, he will receive his full pension. If he is laid off during the war and thrown out forever, what will happen to him? He is almost sixty now.

The Los Angeles County Board of Supervisors unanimously decided to pass a bill requesting that the 13,391 residents of Japanese ancestry be moved out of LA County. At the same time, on the 28th, Los Angeles Mayor Fletcher Bowron announced that the city would dismiss all thirty-nine Japanese American citizens who were serving as city officials. Mayor Bowron said, "We will allow Japanese-American citizens to return to their jobs once the war is over. Even though they are American citizens, it is rather difficult now to determine whether they have dual citizenship."

I have written about four Japanese American citizens arrested here in Seattle. Today's *North American Times* said that all four of them were charged by a federal judge. Mr. Takahashi and Mr. Osawa were charged with the intent to illegally exporting military equipment to Japan, while Mr. Masuda and Mr. Ito were charged with illegally acting as Japanese agents without registering with the State Department. In addition, there are twenty-two additional charges against Mr. Takahashi and Mr. Osawa, eleven additional charges against Mr. Masuda, and twenty-four additional charges against Mr. Ito.

January 30 (Fri.)

The Attorney General issued an order saying that out of all the immigrants living in the eight coastal states, those Enemy Aliens residing in certain specified areas are to be relocated. Attorney General Francis Biddle today held an emergency press conference and ordered the wholesale eviction of the three classes of Enemy Aliens (Japanese, Germans, and Italians) currently living in specified areas of the cities of San Francisco and Los Angeles, by February 24. (The newspaper had a list of areas specified.) The areas listed are predominantly populated by Japanese. The number of Japanese people forced to move would be a lot, probably many thousands. Where they would be moved hasn't been made clear yet. Only if there were immigrants in need of specific assistance would such aid be provided by the government, the newspaper said. It also said that the agents

from the Department of Justice and the U.S. Army would patrol those specified areas.

The city of Portland determined that they wouldn't issue any business licenses to Japanese. A public hearing was held at 1:00 p.m. during the City Council meeting about granting the various business licenses to Enemy Aliens living in Portland. The lawyer Bernard Kariya and Mr. Masaoka, who is National Field Secretary of the National JACL, among others, attended this hearing, representing the Japanese people's side.[37] They really tried hard to defend our position, but the representatives from the American Legion were furious in their opposition. The Council decided not to grant any business licenses to Enemy Aliens. Therefore, all the laundries, hotels, restaurants, and other businesses run by Issei are now being forced to turn over the management of their businesses to American citizens. These are the things written in the *North American Times* today. We in Seattle will be in the same predicament. Sooner or later, the same thing will happen to us.

There was a funeral for Sawada-sama in the Congregational Church at 7:00 p.m. It lasted about an hour. There weren't too many memorial addresses and it was a fine and pleasant funeral. Sawada-sama would have been pleased with the service. Nearly two hundred people attended the funeral, which filled up the Congregational Church.

February 1 (Sun.)

Although it was Sunday, I stayed home all day. Since the sun was out occasionally in the morning, Haruko let the children play by the building across the way on the sunny side of the street. They came back shortly after noon. Yoshiko was extremely cranky because she was sleepy as well as hungry. But after having some milk with lunch she fell asleep easily. Since the children were acting strangely, we let them all take naps.

I went over to the JACL before 1:00 to ask them about the Enemy Alien Registration form, which we have to file sometime between tomorrow and Saturday. After filling this out, I have to bring three pictures along with my alien registration card to the post office to complete the registration process.

Enemy Aliens living in the eight states along the Pacific Coast, which according to the U.S. military may become battlegrounds, are broken down as follows: 70,000 or more Germans, 60,000 or more Italians, and 30,000 or more Japanese (excluding Japanese-American Nisei). These people all have to register between February 2 and 7. Enemy Aliens living in other states are given a little bit more leeway and are required to register between the 8th and the 20th or something like that.

What I have to do at the moment is this: Enemy Alien Registration and the Asset Inventory Report (whose form is still unavail-

able) by February 15, plus a draft registration, which I assume is related to military service, for those forty-five and under. And all these must be done in three days, February 14, 15, and 16. Since I always have a few crucial things to do on my mind, I can't stay focused on what I should do at my hotel. All I can do is the daily cleaning and some of the more pressing matters.

Yoshiko started walking around January 14 or 15. I suppose we didn't really teach her how to walk at all because of all this commotion, but she must have been ready. Her physical development is quite apparent. When Haruko was giving Yoshiko a bath tonight, I was amazed to see how big she has gotten. Being a fifth child as she is, Yoshiko is starting to show signs of intelligence early on. Despite her young age, she knows how to play all sorts of tricks and this surprises me.

Our third child, Yasuo, has become a big boy now. Our fourth one, Yuzo, has expanded his vocabulary and is capable of expressing himself fairly freely. Even Yoshiko will become a big sister this coming July. Although I worry about the current crisis, I forget about the war more than half the time while I keep myself busy with the children. I feel truly grateful for that.

February 2 (Mon.)

After finishing the hotel cleaning in the morning, I went over to the main post office to take care of the Enemy Alien Registration. I got there after ten, but the post office wasn't open yet. Japanese, Germans, and Italians (mostly Japanese) crowded the entrance to the basement. I suppose there were nearly a hundred people there. I waited for a while but they didn't show any sign of opening the iron grill leading down to the basement anytime soon. At first I thought they were limiting the number of people going in at any one time. So I waited there for quite a while but the line wasn't moving at all. I asked someone ahead of me and found out that nobody had gone in yet. So I gave up and came home.

It had been some time since I had walked downtown. There were things I wanted to stop and look at, but that was just a feeling. My legs kept moving forward mechanically. It was as though something in the back of my head was telling me not to stop and look into the display windows like other people.

We have a window on the fire escape, with the possibility of light leaking from either side of the window shades during blackouts. So after I went home I hammered boards about four inches wide on both sides of the window so that the edges of the shades were covered. This solution seemed to be satisfactory. I painted the window shades black too. "When these kinds of measures actually become necessary, we probably won't be able to stay in this hotel anymore. We'll be locked up some place else by then." We joked about our quick fix and laughed out loud. To

us, the blackout inspectors are one hundred times as scary as Japanese bombers. Thanks to the quick fix, we're now well prepared for the inspectors.

Since we have been choosy about which guests to take in, the feeling between the guests and ourselves hasn't changed a bit since the war started. Sometimes I even find myself forgetting about the war going on between Japan and America. I feel grateful.

February 3 (Tues.)

Opinion is growing strong demanding the evacuation of Japanese from coastal areas and their confinement to a certain place. Some demand that both Issei and Nisei, Japanese resident aliens and Japanese American citizens alike, should be evacuated. If we're going to be removed anyway, we'd rather be in one place all together. I think it's going to be interesting to see how this issue develops. They are not going to starve us to death or anything, so we don't need to worry too much. We can just watch how all this unfolds.

They say that the Department of Justice is completing a plan to remove Enemy Aliens from vital defense areas in Washington and is going to announce the finalized plan in a few days. There's no way of telling what kind of fate awaits us. If they issue an order that forces us to evacuate, that would be really disastrous. The purpose of the plan is

to remove Japanese people at least from vital defense areas. To remove Japanese people everywhere would be too costly. Those who unfortunately live in these particular areas just have to take it.

Our hotel is located about two-tenths of a mile from the beach and is very close to public transportation. I think the hotel is really in a danger zone. We might have to move when the plan is announced.

February 5 (Thurs.)

Today's paper reported that fifteen Japanese people on Bainbridge Island were arrested. The charges against them are possession of shortwave radios, binoculars, gunpowder, and so forth, which Enemy Aliens are not allowed to have during wartime. I suspect that the arrested people are Nisei. Since Nisei people are U.S. citizens, it's okay for them to possess those things unless they live with Issei. The newspaper probably knows all this, but it sensationally reports it as though a fifth column consisting of Japanese Issei was lurking sneakily around. The results of the investigation will eventually be printed in the paper.

They announced seven Prohibited Zones in the state of Washington. There must be some Japanese people living in those areas, but the number can't be very high.

February 6 (Fri.)

The problem for Japanese people here in Seattle is that the authorities will eventually announce more Prohibited Zones because this city is a seaport. When that happens, Nikkei people living in the cities close to the coast might have to evacuate. In Seattle, the north-south street closest to the ocean is called Waterfront. The numbered avenues follow, First, Second, Third, and so on, with the numbers going up as you head east. Some people say that from Waterfront to Third or Fourth Avenue will be designated as a Prohibited Zone. Others say that everything from the shoreline to Twelfth Avenue will become a Prohibited Area. If the latter is the case, most of the Japanese people in Seattle would be affected. People are already panicking before disaster strikes. We all know that it does no good to worry about it now, but we can't help talking about it.

The Nisei have been treated as Americans up until now. They consider themselves Americans but they are beginning to be oppressed. Someone's son has one year left before graduating from college, but he now says that he doesn't want to go to school anymore. When they asked him the reason, he said, "There's no hope even if I do graduate." They said to him, "As long as you graduate, you might be able to get a job in Japan after the war is over." His response was that it was even harder for him to imagine going over

to Japan and successfully making a good living. According to the son, a Nisei person got promoted in the military, but the American soldiers working under him refused to obey him, and because the military couldn't see any other alternative they demoted him. Nisei people are beginning to be oppressed just like Issei. It's a pity but this may be a good test for them.

February 7 (Sat.)

Last evening's *North American Times* said that the federal welfare program has launched relief efforts for the remaining family members of the internees and for those who are hard-pressed by the evacuation order. Kiyo-chan's husband will finally be sent to an internment camp tomorrow. About forty people will be sent away this time. Since Kiyo-chan called, I told her about the relief offered by the federal welfare program. She said that she wouldn't take food or other aid from the JACL, but would gladly accept help from the government. The people who are in trouble because of the war didn't do anything wrong. By all means, I think people should try to avail themselves of help offered by the government.

A group of war veterans in a naval port on Bremerton, an island just off Seattle, passed a resolution to remove all Japanese residents from the island.[38] On the other hand, some people in inland America are requesting

referrals of Japanese farmers who need to be relocated. They say they have a shortage of agricultural manpower.

It is said that some Japanese people in Vancouver, Canada, will be put to work in the coal mines. This is a bit much, I think. I hear there are many Japanese fishermen in Vancouver, so perhaps they intend to send only very fit and strong fishermen to mines. Still, coal mines are not attractive destinations to anyone.

February 8 (Sun.)

In the Maryknoll hall today at 2:00 in the afternoon, a welcoming reception was held for Bishop James Walsh.[39] The Bishop visited in an attempt to ease the oppression of Japanese people. They say that Father Tibesar has made tremendous efforts on this matter, too.[40] The problem we're facing in Seattle is relatively mild when compared with the problems in other areas. These peoples' behind-the-scene efforts may be one of the reasons why we have had it easier here.

After the reception, the board had a meeting. Because of inflation, they said it would be impossible to keep serving lunch to the children for just five cents a person. The Father, however, didn't want to raise the fee beyond five cents. He asked us if it was possible for the parents organization to donate about $30 a month. There are more than a hundred households enrolled at the

school, but the parents organization has fewer than fifty members. We discussed the matter and decided to persuade more parents to join the group and to collect a minimum of a twenty-five cent membership fee each, preferably more than the minimum. Then we will be able to make up the balance needed to continue offering lunch to children. It was after six by the time I came home. It was so late that Haruko was worried about me. It's not necessarily safe to walk outside even with the streetlights on.

February 9 (Mon.)

They say that a plan to move Japanese people to the interior, some five hundred miles away from the Pacific coast, is now almost finalized in the House of Representatives (the Dies Committee).[41] We may be relocated before too long. Last night, Haruko and I talked about the need to start double-checking and organizing things around the house.

Living among suspicious people during wartime versus moving to a place that the American people consider secure—the latter may be the best for both groups. I'd be willing to go anywhere if only the government guaranteed living conditions of a minimum level. With as many children as we have, the most important thing is to have a safe place to live. Money comes second or third. We have lived in Seattle for quite a long time. It

may not be such a bad idea to get to know some other place for a while.

February 11 (Wed.)

First, there was some talk of removing Japanese Issei from the Pacific coast. Then they started talking about creating some Prohibited Zones to exclude foreign citizens. And now there's a rumor saying that they are tentatively evacuating Nisei as well as Issei from the coast, and that they will issue licenses only to specially selected people to allow them to return and resume their businesses.

Once they decide on a course of action, the Americans will move swiftly. We may be caught off-guard. Especially with the military in charge, I don't think they will waste any time in evacuating us. Tomorrow we'll start getting ready for it little by little. I think we should prepare ourselves for three different scenarios.

1. Pack the bare necessities: This is preparation in case we are driven away with nothing but the clothes on our backs.
2. Pack a little more than the bare necessities: This is in case we are given a little bit of time before leaving and are allowed to carry some luggage.
3. The third scenario is where we are given a week to two weeks advance notice before evacuating. This would be similar to packing for moving.

With these varying possibilities in mind, we have to determine what to bring in the first case, how much we would carry in the second case, and what to discard for the third case. As for the stuff we don't need in the meantime, we can put it into the basement for now. If the time comes when we need some of our things, I think we can write a letter to the lady in the restaurant below and ask her to send them to us.

February 12 (Thurs.)

Japan claims that Singapore fell on February 11, whereas the United States claims that Singapore hasn't fallen as long as some resistance remains. From the Japanese point of view, it is true that Singapore has fallen. From the American point of view, however, it can also be said that Singapore hasn't completely fallen yet. If reinforcements arrive, potentially they could resume fighting. So Singapore seems to be barely holding on. The front pages of the newspapers are pretty much filled with Singapore-related stories.

February 13 (Fri.)

Most Japanese people here are in constant fear because the Prohibited Zones around the city of Seattle and Puget Sound will be announced in a day or two. Some think that everyone will have to be evacuated. Others think that only the unfortunate people living

in the designated Prohibited Zones will be evacuated. If the latter is the case, everyone hopes to be exempted from evacuation.

As far as I can see, Seattle doesn't have many areas that are likely to be designated as Prohibited Zones since the city is so far inside Puget Sound. There will be very few, if any, Japanese residents that will need to be relocated. Most people share my view. For now, the treatment of Japanese residents is a bigger issue near the coast.

February 14 (Sat.)

There is a lot of talk about the possible evacuation of Japanese residents. Many people have had their belongings confiscated because they were in possession of prohibited items. We're not even allowed to have maps. All maps of the United States are prohibited, including road maps and maps of Seattle, so yesterday we burned every map we had in the boiler. But we can't be sure whether we have another one hidden somewhere unexpected. I will have to double-check more closely as we slowly begin to organize things around the house. It would indeed be a shame to be arrested because of a trifling thing like the possession of a map.

Since the Prohibited Zones haven't been announced yet, everybody is extremely worried. I wouldn't be surprised if some people are driven to despair. We're going through the agony of being squeezed from various

directions and the anticipation of more pressure to come.

On the 12th, the Union Pacific Railroad laid off all its Japanese workers. They had about one hundred Japanese workers and most of them were stationed in Wyoming. Our artist friend, Horiuchi-kun, was, I believe, working for the railroad in Wyoming.[42] I suppose he must be among the laid-off workers. I feel very sorry for him. As far as I know, he has two little children. He may even have three by now.

Mr. Kosai's barn in Auburn burned down and two cows were killed. The paper says that arson is suspected. There are actually countless incidents reported in the newspapers very similar to this one.

February 15 (Sun.)

They are conducting draft registration at three different locations in Seattle. Anyone who turned twenty on or before December 31 and hadn't yet turned forty-five on or before February 16 is required to register from February 14 through 16. There are a couple of Caucasian guests at the hotel besides me who needed to register, so we all went together in my car this morning.

Registration took place at an armory and there were about one hundred fifty clerks. The procedures weren't as complicated as the Enemy Alien Registration I had to do the other day, plus there were so many clerks

that the line kept moving at a good pace even though more and more people came to register. When we were done, we received a card from the clerk, which we were supposed to carry at all times. This card contained all the information we gave them. The front side of the card has my name, address, today's date, name of the clerk, the district number of my address (tenth district), and my signature. On the back side, the following information was recorded in addition to my height and weight: Race (White, Negro, Oriental—I checked here, Indian or Filipino); Color of Eyes (Blue, Gray, Hazel, Brown—checked here or Black); Color of Hair (Blonde, Red, Brown, Black—checked here, Gray or Bald); and Complexion (Sallow, light, Ruddy, Dark, Freckled, Light—checked here, Brown, Dark Brown or Black). Under additional physical characteristics, my card noted that I had a little scar on my right cheek.

Around 1:30 in the afternoon, we visited Teramoto-kun. The weather turned fair around 3:30 so we went to the Collins Playfield, in the Japanese residential area, to let the children play. Yoshiko had never been to a place like that since she started walking. At first, she just watched the other children on the swings for a while in amazement. She eventually got acclimated and started playing cheerfully, forgetting all about how sleepy she was. She really looked like she was having fun. Yoshiko walked on real earth and played in the sand for the very first time. Watching

Yoshiko joyfully play under the sun made me feel sorry for her. Even if it's because of the war situation, I feel guilty for not going on this kind of outing more often.

When we returned home, while I was putting my car into a garage shortly before 5:00, I heard that all the defending troops in Singapore had surrendered.[43] My heart is full of deep emotion.

The pressure on us may become even more intense. We have to be well prepared for that. I thought it was odd that some hotel guests, who were normally very friendly and chatty, didn't even want to say "Hi" this morning. Now I know why. It was not just me. Haruko also mentioned the strange mood among the guests before I said anything about it.

February 17 (Tues.)

Yesterday's newspaper had an article reporting that all Japanese residents in coastal areas will be moved east of the Rocky Mountains. Because Seattle falls into the Defense Zone "No. A" category, we have to worry about the future of Nisei people as well as Issei.

Although we didn't go outside and meet other Japanese people or see anybody's reactions firsthand, the astonishment among all the Japanese people must have been beyond imagination. I could hardly focus on any work yesterday. The article said that we'll have to move within two weeks after the

announcement is made in the papers. That means we don't have much time to waste. I finished cleaning in the morning, and started to pack some linen from our linen room into boxes. This is my seventh year running this hotel. Packing up is not an easy task. If we were going back to Japan, I would probably like to take as many things as possible. But I have to select only what is necessary this time. I can't help but notice things that I don't want to leave behind. There are so many things I just can't throw away. Organizing these things is going to be difficult.

There are different rumors going around as to the details. Today some people say that women and children will be allowed to remain. Others say that Nisei people will certainly be able to remain where they are.

I thought about asking Takei-kun's wife, who is Nisei, to take over the Cadillac Hotel if she were willing. So I called them last night. Takei-kun came over around noon. We talked about the benefits of hotels and so forth over lunch. He told me that his wife is willing to run the hotel but is worried whether she can manage things with only women and children to help. Particularly in a place like the Cadillac Hotel, where most of the guests are laborers, I think it's only natural for her to be a bit scared beforehand. It must be hard to imagine what it's like to run a hotel like mine. I believe people would be surprised how easy it is once they try it.

February 18 (Wed.)

Continuing the organizing process from yesterday, I began to pack some things we don't need very much, things we use once or twice a year (such as the dolls for Boy's Day and Girl's Day), and those we can normally get by without. Once we determined that we had to discard some of our things, surprisingly there were quite a few we could throw away. At the same time, we were also surprised to see how many we couldn't part with. Nevertheless, we basically cleared out the storeroom today.

On the first try, we started to set aside some of the things we thought were necessary, but we didn't have a clear idea as to what we would need. So we changed our tactics and began packing up what we didn't think we needed. That method worked out rather well. Of course, I'm sure that the fact we worked on this project all day today helped too. Since we were busy sorting, Yoshiko was restless. She was cranky all day. The younger children are, the better they sense what is going on in our minds.

February 19 (Thurs.)

As soon as we finished cleaning, we started in again on the packing today. We just packed things randomly. We put whatever we thought we wouldn't need during the war into boxes one after another. Everything from

the kitchen, except for the rice bowls, plates, and other things we use on a daily basis, went into boxes. More drawers and cupboards became empty. We found things from a decade or a couple of decades ago in the least expected places.

I can't predict what they'll decide about the treatment of Enemy Aliens. Some papers say the Issei will certainly be relocated but whether the Nisei will have to go along remains in question. Other papers use very mild tones.

The office of Representative Tolan, who is the chairperson of the House Select Committee Investigating National Defense Migration, announced that hearing dates are set for the 21st and 23rd in San Francisco regarding the relocation issue of Japanese living on the Pacific coast, the 27th and 28th in Portland, March 2 and 3 in Seattle, and March 6 and 7 in Los Angeles. The final review will be held back in San Francisco on March 9 and 10. Based on their findings, each region will determine whether they will evacuate and the extent of it. The Japanese-language paper was telling us not to make much noise in the meantime and to be prepared for the worst.

A lot of Japanese people are being taken into custody in California and Oregon. The paper says that two hundred people were taken into custody in California.

February 21 (Sat.)

This morning the President charged army headquarters with deciding the fate of the Japanese people as well as Nisei people living in coastal areas. Until now, various rumors have said that the relocation issue was relevant only to male Issei, or to all Issei, or to Issei and returning Japanese Americans (born in the United States but educated in Japan). But this now seems to have been settled. They intend to include all citizens of Japanese ancestry as well as Issei. Our only hope is that the President's order states that they will not inconvenience us in terms of food, clothing, and shelter. This stance, however, could be altered in any way depending on the attitude of the people executing the plan.

All the Japanese people have totally lost their spirit, just as they did on December 7. The nearby states where Japanese people can potentially take refuge have begun to raise their voices trying to prevent an influx. In fact, about one hundred fifty Japanese left California for New Mexico, only to find that the governor of New Mexico didn't allow them to stay. The governor said the state has a labor surplus. Neither Texas nor Colorado want to take any Japanese in either. Those one hundred fifty people may have made it worse by moving before the President's order came out this morning. Then again, no one can tell what is going to happen to us at any moment.

Washington Governor Arthur B. Langlie is said to have designated the state of Washington a Protective Area. What this means in essence is that Japanese Issei and Nisei are not allowed to have any explosives or firearms. They say this is different from what the army calls Prohibited Zones.

Today was George Washington's birthday. It's a holiday but the schools were in session. We started packing up the things from our bedrooms. There are a lot of worn-out children's clothes. Some are usable if mended, some are usable as they are, and others are beyond repair. There are tons of old clothes. We mercilessly threw away a big boxful, but there's still quite a bit left. I have no idea whether we will have time to sort things out once we are relocated. I also have no idea how much we will be allowed to bring with us. This is very frustrating.

Last Saturday, 101 people were arrested in Seattle. They were all taken to the Immigration Office for questioning. They said that the people would be released if their offenses turn out to be minor, but nobody has been released as of now. I heard that the husband of Hidaka-san, our chambermaid, was taken into custody, too. Some say it was because Mr. Hidaka was a member of the *Hinomarukai* (war veterans' association), but the truth is not known.[44]

Maybe all of us will be arrested eventu- ally, leaving only women, children, and Nisei behind. This certainly is not good for us, but it may well be the best solution. Other states are not welcoming Japanese people. If we can avoid being arrested by the FBI, areas in eastern Washington such as Yakima or Spokane may be the only places where we can flee with our families. There are many young Nisei women working in the public schools, but people are beginning to protest their presence. The Japanese railway porters were all laid off a few days ago. Taking all these situations into consideration, being relocated and fed by the government may be the safest and most carefree fate for us.

The most frustrating thing to me now is having everything up in the air and all the various rumors floating around. We are starting to see some unpleasantness caused by this uncertainty.

February 25 (Wed.)

"(Washington, February 24) The Dies Committee claimed to have confiscated a detailed map, prepared by a Japanese spy, that allegedly indicated an invasion route through Alaska and Northwestern Canada into the United States. According to claims made by the Committee, they confiscated the map from a Japanese person after the U.S. joined the war. This document will be photographed and included in the report on Japanese actions to be released this week."

I don't know what the Dies Committee really is. But no one with common sense would believe such a foolish story. Wartime must have a strange effect on people to make them believe such outlandish stories. I think the map must have been planted by someone in order to intentionally harm Japanese people, or someone must have made it up to oppress Japanese people further. Suppose there was a Japanese spy. What good would it do him to have such a map? At first glance, even I can see how stupid that is. And if there was a Japanese who had such a map, I don't think he could be considered a good spy. No spy anywhere in the world could be that stupid.

Some mothers of students at the Gatewood Elementary School are demanding the firing of Japanese American secretaries working at public schools. They have collected 250 signatures from supporters and have decided to submit their petition to the Defense Command rather than to the School Board. The lady leading this movement is named Mrs. Esther M. Sekor. This is just as ridiculous as, or even more ridiculous, than the Dies Committee. They claim that removal of workers of Japanese ancestry is necessary for the safety of the children, should anything happen. How dangerous could it be for children to have a single Japanese American secretary at their school? It's utterly ridiculous to fear their presence at school, but there are some serious issues

there. All the Japanese American secretaries submitted their resignations to the School Board.

When considering their future, I'm happy for the Nisei people that they have a chance to endure such oppression. The younger generation will eventually learn how to overcome all these obstacles and move forward.

February 27 (Fri.)

A council meeting will be held on February 28 and March 2 in Seattle. They will discuss how to relocate Japanese people and whether they should include Nisei in the relocation project. The general public and we share the view that they will probably send only male Issei to the interior at first. They'll put them to work through the spring and summer, while they try to find or create relocation sites. Once they have relocation sites, they will try to send the Nisei, women, and children to the interior as soon as possible.

The problem is that no one is willing to accept Japanese people. Yakima and Spokane have already begun to voice their opposition to sending Japanese people there. I wonder how the War Relocation Authority will resolve this issue. There may be some areas willing to accept Japanese under the condition that Japanese aren't allowed to work there. That means we can live without having to work. I don't know if we can actually live

lazily, but it may take some time for them to come up with a solution before the actual relocation takes place.

We sorted out most of the stuff on the top floor today.

Japanese and Italians make up most of the workforce in agriculture in this area. Due to the uncertainty and anxiety regarding relocation, shipments of produce are down and people are planting less. We may face a produce crisis. In fact, celery that used to be ten cents now costs twenty cents, whereas a bunch of carrots, which used to be five cents, now costs six and a half cents. Produce dealers are saying that celery could eventually reach as high as fifty cents. U.S. agriculture in general is suffering a labor shortfall of almost a million people because young people are being drafted and moved into munitions industries.

Haruko is worried about childbirth. The new baby may come sometime in late June or early July, and we don't know if we'll be here or somewhere in the interior. In the past, good things have always happened to us every time we had a new child. Although this may sound superstitious, I truly believe it. Good things have miraculously happened at the time of the births of our children. One time we were saved by unexpected income during the midst of the depression. I believe this time will be no different.

I sometimes think that these good things are gifts from heaven—given to honor childbirth, which is the work of heaven or the work of God. When we bear a child, we give birth to it peacefully. God somehow supports our endeavor. Thus, I have no worries about the childbirth. We are raising five little children. Soon we'll have six. I believe we will be rewarded accordingly.

March 1 (Sun.)

I read about the ongoing hearing here in Seattle in last evening's *North American Times* and the *Great Northern Daily News*. Three representatives were sent by the government to investigate the local situation. The people who stated their opinions in front of these representatives were as follows:

Washington Governor Arthur B. Langlie
Seattle Mayor Earl Millikin
Tacoma Mayor Harry P. Cain
Mr. J. W. Spangler, vice president of
 the First National Bank, Seattle
Mr. Floyd Oles, representative
 of the Washington State Pro-
 duce Shippers Association
James Y. Sakamoto, represen-
 tative of the JACL

Seattle Mayor Millikin took a position for the removal of all Japanese Issei and Nisei; he would like to avoid another Pearl Harbor happening to Seattle. Governor Langlie opposed the plan to set up relocation

camps in eastern Washington, saying that the eastern part of the state has facilities just as important as those in the coastal areas, such as forests, dams, irrigation canals, farming fields, and so forth. The time might come, the Governor continued, when we have to evacuate all the civilian population into the eastern part of the state.

Tacoma Mayor Cain presented the most moderate opinion of all. Mayor Cain didn't think it was necessary to evacuate the Japanese because suspicious people have already been arrested by the FBI, and, in the general public's opinion, it's impossible to separate loyal Japanese people from disloyal ones (which is the fundamental concept that led to the argument for the removal of all Japanese). But as far as Mayor Cain could see, it wouldn't be impossible to differentiate them; we could learn a lot by checking the background and the current occupation of a person. Besides, we should leave such matters to the FBI. He thought that Japanese farmers in and around Tacoma should be allowed to continue farming under supervision.

Mr. Spangler presented some stats. There are 181 hotels run by Japanese, with about 10,550 rooms. Mr. Spangler thought it wouldn't be difficult to find non-Japanese people to keep them running.

Mr. Oles was opposed to the idea of evacuating all Japanese people from the standpoint of the produce market. About a half, or even more, of the shipments come from Japanese farmers. The impact on the produce market would be too big to handle if all Japanese people were evacuated.

Mr. Orville E. Robertson, Executive Secretary of the Family Society of Seattle, was against wholesale evacuation. There were suspicious characters in all groups of our population besides Japanese; therefore, he thought the individualized evacuation only of suspicious people was preferable.

March 2 (Mon.)

Lt. General DeWitt, military commander of the Western Defense Command, made the following statement: "By order of the President of the United States, I am endowed with certain authority. No one has the right to speak for me. Therefore, announcements or forecasts coming from other sources should be ignored. The relevant authorities of the central government are preparing a grand plan, in hopes of resolving the relocation issue. Methods of protection of property, relocation and resettlement of those who are affected by the decision are being continuously studied. Preparation includes plans to protect the property and rights of people, to minimize the losses caused by the sale of the property at giveaway prices, as well as to lessen the financial effects that may occur in the future. As soon as this research is completed, those who are to be affected by the plan will be announced."

The hearing started on Saturday here. Today's speakers were as follows:

Mr. Robert Bridges (Auburn Valley Protective Association): He was for the removal of all Enemy Aliens but didn't object to their return to the valley once the war is over.

Mr. Floyd W. Schmoe, an instructor at the University of Washington (the American Friends Service Committee): Evacuation of Japanese people should be a last resort. If the decision is made to carry out an evacuation plan, protections and occupations would need to be provided. Japanese people are anxious to remain engaged in constructive and productive work.

Mr. Bernard G. Waring (the American Friends Service Committee): These people should not be considered sheep to be driven out. That would not be the American way. That would be the European method. If we have to move them, we should be careful not to terrify them, and we should keep family members together and provide them with some means for living in the future.[45]

In addition to the people above, Mr. Miller and Mr. Freeman both expressed their approval of the evacuation plan.[46] Rev. Thomas Gill emphasized the importance of how the resettlement was to be carried out

and any suffering minimized.[47] Washington Attorney General Smith Troy stated that any evacuation should be left in the hands of the military. He also claimed that loyal citizens of Japanese ancestry could be brought back for use on public projects.

I have previously written that these hearings have been taking place in Los Angeles, San Francisco, Portland, and Seattle. The main purpose of these hearings, I believe, is to hear public opinion and, at the same time, to investigate the best methods of evacuation for each respective region. The army in turn is probably intending to assign Prohibited Zones and Restricted Zones depending on the views of the public.

This afternoon, I removed all of my oil paintings from their frames. I decided to keep fourteen or fifteen paintings. As to the frames, I can discard them if it becomes necessary.

March 3 (Tues.)

There have been a lot of false reports and various rumors going around. We couldn't bring ourselves to do any hotel work while we didn't know what to believe. But this morning we heard on the radio that our fate had been determined.

Lt. General DeWitt, the military commander of the Western Defense Command, made a public announcement for the first time. According to his statement, all Pacific

coastal areas are designated as Prohibited Zones, and the western half of the state of Washington is going to be a Military Area. Therefore, Japanese Nisei as well as Issei will all have to move out of these Prohibited Zones.

The day before yesterday, I told Teramoto-kun I would need his help, so he came to help with the packing up process at 9:30 in the morning. We decided to do the hotel cleaning later and brought out the stuff we had packed. Thanks to the goodwill of the people running the restaurant downstairs, we put our belongings into the storage room of the restaurant. We were pretty much finished by 3:00 in the afternoon.

I read the *Star* over dinner and found out for the first time the details of Lt. General DeWitt's statement that came out on the radio this morning. Now that we know we have to evacuate, what we have to do becomes clear. The only question that remains is how much luggage we will be able to bring along. As for the furniture, we will keep it all in the storage room of the restaurant after emptying out its contents. And we will tentatively put our clothes and everything else from the furniture into boxes. We will then take whatever is necessary out of the boxes up to the limit we are allowed.

The families with children attending the Maryknoll School can feel at ease because the Father is going to see to it that our relocation site is safe and that we will have sufficient food. Somebody said that there are a lot of Catholics in Missouri. People associated with Maryknoll School may be sent to that area. One way to look at it is that we will be able to see the Midwest at the government's expense.

We spent the last few days organizing things, dusting my oil paintings, putting some of my old drawings up on the walls again, and so forth. When I think of the possibility of our going to Missouri, I feel the inspiration and motivation to draw scenery I haven't seen yet. If we end up settling down there, I should be able to work on sketches or something like in the old days. That's something I can look forward to.

According to the announcement made by Japanese Imperial Headquarters, the results of the naval battle in Java last week were as follows: A total of 23 ships from the Allied forces were sunk—6 cruisers, 8 destroyers, 7 submarines, 1 gunboat, and 1 minesweeper. On the other hand, Japan only lost 1 minesweeper, and 1 destroyer was said to have received very minor damage. On the contrary, the forces in the Dutch East Indies announced that they destroyed and sank 32 Japanese ships, whereas the Allied forces lost only 2 cruisers and 2 destroyers. Is it that naval battles are so chaotic that the damage the enemy receives is uncertain? Or is it that the both sides are lying? Or could one side be telling us the truth? Readers of these news stories have no idea what to believe.

March 4 (Wed.)

According to today's paper, 2,500 Issei and 3,500 Nisei will be relocated from the state of Washington to the interior. They are planning to move us somewhere in the central or western states. As soon as everything is approved by the military, they will execute their plan. That must mean that the relocation sites are ready. Some say that we'll go to Missouri. The paper says that they will complete the relocation process within sixty days, which leaves us only about a month or so in Seattle. A Sister told Shokichi's class today that the relocation would take place in April.

Today I searched the linen room thoroughly one more time only to find more and more things I would like to save. I also organized the closets. It is indeed annoying not to know how much we can take. I suspect that my old car, a 1929 Ford, may not make it to Missouri.

March 5 (Thurs.)

There has been speculation that the people associated with Maryknoll School will be relocated to St. Louis, Missouri, but there has been other speculation depending on whom you talk to, so we don't know what will actually happen. As for the baggage, some say we will be allowed to carry up to two hundred pounds. If that's the case, we'll practically have to leave with nothing but the clothes on our backs.

I was going to talk directly to Sakamoto-kun about this rather than wondering whose story to believe when I received a phone call from Mr. Partridge of the Henry Broderick real estate agency asking me to come over and discuss some matters. We set up a time for our meeting. When I went over to his office, he told me that there are three ways to handle the hotel I own now. One is to sell it. One is to sublease it to someone. Another is to hire someone to run it.

I said to him: "Since I can't seem to find a person suited to run the hotel for me, I don't think hiring someone is an option. But if there were a buyer, I'd consider selling. As to the subleasing option, I don't like the idea in general. But if I were to sublease it, the hotel still belongs to the landlord whereas the furniture inside belongs to me. We could probably lease the hotel at a little higher price as a furnished hotel. The lease has been $65 a month. Maybe we can set the lease at $80 or $85 a month, pay the landlord $65, and I could keep the balance of $15 or $20. Would it be possible to set up such a deal?" Mr. Partridge said that the subleasing system I suggested may be possible and that he would look into it further.

I went home, then went to visit Sakamoto-kun at the *Japanese American Courier*. Mrs. Sakamoto's understanding in regard to the relocation plan for the people associated

with Maryknoll School was pretty much the same as the rumor we had been hearing. We would be sent to St. Louis. We could carry only our personal belongings. The plan is that we'll bring a little bit of baggage to Maryknoll School and the school will get one or two freight containers to transport it.

According to a notice the children brought home in the evening from school, however, we will have to pay transportation fees. Train tickets, food, and transportation fees for our luggage all together will be quite a bit. Considering that we will have no income at all from now on, or at least we'll have nothing coming in for a while, this will be a problem. The notice had a provisory clause as follows:

> As I finished writing this notice, we received a telegram from the New York headquarters of Maryknoll. The telegram said that Bishop Walsh was in the middle of negotiations with the government and the military regarding the relocation site for all the Japanese people currently living in Seattle. Once matters are settled, we will make an announcement in the Japanese language paper. So please inform your friends of this plan.

There are about four to five hundred Japanese people associated with Maryknoll School. I imagine that Bishop Walsh must be trying to convince the military and the government that they should relocate all the Japanese people from Seattle to somewhere closer than St. Louis. If he succeeds in persuading the authorities, we won't have to move so far away at our own expense and will be together in one place.

In southern California, they have already begun constructing a one hundred thousand-acre city in the Owens Valley (an area that the city of Los Angeles purchased for their water supply) as a relocation site for the Japanese evacuees.[48] They say the site will accommodate five to ten thousand people with schools, churches, and even factories within the premises (source: *Great Northern Daily News*). The English-language newspaper, on the other hand, reports that this city will accommodate fifty to one hundred thousand people. If this report is accurate, almost all of the Japanese people in California will be fortunate enough to live there. I'm happy for them.

March 7 (Sat.)

Our relocation site doesn't seem to have been determined yet. But people have begun to see that the authorities will work something out as long as we sit tight patiently. The fear of simply being forced out without anywhere to go to has subsided. They are developing some plan for us. Even though there has been no announcement of the final decision, we can sense that much, at least, from various

peoples' statements in the English language papers. The decision to open up the one hundred thousand acres of land in the Owens Valley in California for Japanese people is one of these indications.

Now that it has been determined that we will be evacuated, I don't hesitate to show myself in public places anymore. It's kind of strange but I feel quite at ease walking on the street now. This emotional shift is very hard to explain. We have been in a state of suspense, not knowing how and when the relocation will take place. But now at least we're certain that we will be relocated. I feel more comfortable being clear on that point than having things up in the air with people feeling sorry for us.

I wouldn't say that I'm not anxious. Wherever we go, I'll have to find some work. Even if I find a job, I don't know whether I can earn enough to live on. At the same time, though, I have hopes for some kind of new horizons opening up before us. I enjoy thinking about it. It's like the pleasant imaginings I have on the night before I go on a sketching trip. It's fun to think of building a town in America with only Japanese residents. From the bottom of my heart, I feel a surging desire arising from all corners to handle the situation well.

The Kuromiya-sans and my parents-in-law are twelve or more years older than our generation. Their age may have something to do with the fact that they seem to

be extremely anxious. In addition to their unbearable anxiety, they don't seem to have even a shred of hope. Kuromiya-san was desperately hoping they could stay in Seattle even if they had to resort to bribery.

March 10 (Tues.)

As the situation gradually unfolds, there have been no communications or negotiations between the states and the central government regarding the removal order by the military.

Upon hearing about the military removal order, Japanese people started panicking. Some hasty people ran away to other states, which triggered boycott movements everywhere. This led to the Midwestern governors' unanimous rejection of Japanese people moving into their states. Surprised by these reactions, the Pacific coastal states and the federal government finally realized the gravity of the situation. As they started to consider the best course of action, the military didn't have a choice other than assisting with the removal program.

The state of Washington does not have a concrete plan for where they will send us. According to this evening's *Star*, the governor of Washington will soon invite military and county officials to a meeting to discuss the possibility of finding a collective relocation site somewhere east of the Cascade Range. If that is the case, the slightly less than ten

thousand Japanese living in the Prohibited Zones in Washington may be moved to the eastern part of the state.

March 11 (Wed.)

My mission is not to keep a record of war-related articles, but to record the events among our countrymen living in the United States during the war. I refer occasionally to some war-related news, writing brief descriptions about what was going on where at a given time. I chose this method so that people who read this diary in the future will have a clearer idea about the kind of situation we were in at a particular time.

There's nothing stranger than the battle results announced by each country. Based on announcements made by the United States, Japan has already lost considerably more than 150 ships. But when we look at the Japanese announcements, their losses are surprisingly small, whereas the U.S. Navy has suffered extremely high losses. When we see the statements from both sides, we end up totally puzzled. It is indeed very strange. Especially confusing are the announcements of naval battle results.

What really bothers us as the war develops is that people are badmouthing Japanese people regardless of the truth, writing stories saying how barbaric Japanese are, and how they don't follow the ethics of war or anything. Yesterday, British Foreign Secretary

Anthony Eden claimed that without apparent reason the Japanese military had executed about fifty Englishmen, whose arms and legs were tied. But I think it was rather strange that there were no Japanese prisoners when Singapore fell. The battle stretched from the Malay Peninsula to Singapore, until it finally fell. How could anyone believe that no Japanese soldier was taken prisoner throughout that long campaign?

March 13 (Fri.)

Japanese people living in America are being driven into a dire situation. Most people who worked for American businesses have now been fired. Businesses run by Japanese are having an increasingly difficult time. Grocery businesses aren't doing well. Dry cleaners and florists aren't doing so well, either. The only businesses that haven't seen much change are hotels and restaurants, thanks to the influx of workers due to the rise of the armaments industry.

Our chambermaid Hidaka-san's husband was arrested by the FBI. Her elder son has been hospitalized at the lung disease hospital, while her younger son was drafted and left today by train for an unknown destination. Only Mrs. Hidaka and her eighteen-year-old daughter are left. Hundreds of Japanese people from this area have already been taken into custody by the FBI. With their husbands arrested and their sons drafted, unfortunate

families with only women and children left are quite common.

On top of that, the relocation process is about to take place. The government says that they will protect our property after relocation. (The government has set up consultation offices for that specific purpose.) Hotels like ours, located on the outskirts with fifty to sixty rooms, can't hire white people as managers. The numbers just don't add up.

March 14 (Sat.)

Per government order, the *North American Times* has ceased publication as of yesterday. The only Japanese-language paper available now is the *Great Northern Daily News*, which is kind of sad. After the President, Mr. Arima, was taken into custody, the *North American Times* had its assets frozen. They had been issuing papers by obtaining permission on a day-to-day basis. In its final issue, the paper expressed regret for being unable to continue publication until the day of the Japanese people's relocation.

Today's *Post-Intelligencer* reported that more than two hundred people in California were detained by the FBI. Several weeks ago in Seattle, more than one hundred people were taken into custody. They were mainly from the *Hinomaru-kai* (war veterans' association) and subscribers to a magazine called *Sokoku* (Motherland). Although I don't know much about *Sokoku*, the magazine has had a negative impact on Japanese immigrants in wartime. A salesman came to me about eight or nine years ago, asking me to subscribe to this magazine. In order to decline, I said that I'd think about it. I didn't like the attitude of that salesman.

Many people in Japantown became subscribers to be sociable, and now many have been arrested because of it. If you are a subscriber to *Sokoku*, you are considered a member of the *Sokoku-kai* (the Motherland Association). The *Sokoku-kai* in turn is regarded to be tied to the *Kokuryu-kai* and is therefore closely watched.[49] At times like this, when we need as many men as possible, it would be intolerable if you were taken by the FBI just because of a magazine subscription. The negative impact it has had on our society is not negligible.

March 15 (Sun.)

It was gloomy all day today. I didn't feel like going anywhere, but the children played hard jumping all around the house.

My hotel is an old one. There's a large hall in the middle that's surrounded by rooms on all four sides. At the center of the hall we have a heater. Some guests prefer to hang out around this heater rather than spend time in the lobby. There are always several elderly men sitting around the heater. Since they have a regular group, our children have known them for a long time. It's been more

than six years since we started this hotel. Three of our children were born here: Yasuo, the third one; Yuzo, the fourth one; and Yoshiko, the fifth one. For some reason, the three children who were born at this hotel seem to be dearer to those elderly men than the two older children are. They have begun to call Yasuo "Jacky" and Yuzo "Mickey."

"Jacky" Yasuo will be four in May, whereas "Mickey" Yuzo will be three in September. Our oldest one, Shokichi, who's turning eight this month, doesn't seem to have a clear idea about the Japan–U.S. war. Our second oldest, Shizuko, and the younger ones have no idea at all. "Jacky" and "Mickey" repeat whatever they have learned at preschool when they come home. They take out wooden toy guns and aim at those elderly men, saying "Pow! Pow!"

When I walk on the street with them, they may start yelling in Japanese without reservation, *Heitai-san, heitai-san* ["Soldiers, soldiers"]. Or they say very loudly, "Army car! Army car!" Shizuko received a warning from her teacher immediately after the war broke out. The teacher told her, "You must never say, 'I hope Japan wins the war.' Say, 'America will win the war.' " We have been repeatedly telling the children to never mention the war.

The newspapers have the word "Japs" written all over the place on every single page. The radio incessantly repeats "Japs," "Japs," day in and day out.

In my hotel, however, I have not heard the word "Japs" since the war started. We don't even hear about the war either. The guests apparently discuss the war all the time, but they also try to make sure we don't hear. We don't accept customers who have excessive drinking habits. That practice of selecting our guests probably contributes to the pleasant atmosphere inside the hotel. Another thing is that we don't particularly think of our guests as Americans. They probably don't think of us as Japanese either. I feel that there's a warm friendliness and sense of connection between us that goes beyond our nationalities as Japanese or Americans.

In regard to the current relocation program, everyone tells us to stay until we're forced to move out. When I was moving some packages with Teramoto-kun's help yesterday, for instance, someone asked me if we were moving. "No, we aren't," I answered. Then he said, "Stay here until the last minute." To that I replied, "Yes, we're going to hang in for as long as we can."

March 16 (Mon.)

Wherever we end up going, we will have to obtain travel permits. Since we need to submit two photos each for the permits, I went over to Takano Photo Studio to order them. Miyake-kun, the owner of the Takano Photo Studio, was among those who were arrested the other day. They say it was because of his association

with the *Sokoku-kai*. A chambermaid lady told me today that the people arrested so far would be sent to Montana the day after tomorrow.

According to the *Great Northern Daily News* this evening, Attorney General Biddle completed hearings on the 9th. The total number of Enemy Aliens arrested was 1,632, including Japanese, Germans, and Italians. The Department of Justice obtained reports submitted by the regional hearing committees and announced the results: 666 of them would be sent to an internment camp; 270 would be released unconditionally; and 587 would be pardoned if guaranteed by U.S. citizens. In addition, the total number of Enemy Aliens arrested by the FBI was 5,856: 3,536 Japanese, 1,798 Germans, and 522 Italians. Some people from the legislature are said to be complaining that Attorney General Biddle's decision was too lenient. The paper says that they will conduct an investigation into the fairness of the judgment.

As I heard from Jimmy Sakamoto today, there's a plan to develop agricultural land by constructing irrigation systems along the Columbia River where it flows southeast through Washington. They are trying to convince them to hire Japanese people for the construction work in order to create an area where we can be permanently settled. I heard that the area is about a million acres, so that's fairly large. The plan is to establish an irrigation system in this barren land to provide for Japanese towns and Japanese farms. It would be convenient for us to have a place we can settle down to start with, as is the case with the Owens Valley in California, rather than moving to a temporary evacuation site. Some people in the state government, however, would like to save the irrigation system construction project for a recession period during peacetime. Others would rather build a dam to generate additional power to make up for the power shortage caused by the increased munitions industry usage. The bottom line is that the state of Washington hasn't yet decided on a relocation site for us.

March 18 (Wed.)

In order to protect the property people leave behind after relocation, the government has set up consultation offices in different regions. Kuromiya-sama visited yesterday and told us that he had sent his daughter to one of those offices. She went only to hear them say, "The government will manage immovable properties such as land or buildings until they are sold. The government will, however, use local real estate agents to manage such properties. Therefore, it would be to your benefit to sell them now if you can find a buyer. Just make sure you don't sell them at a giveaway price." As for the hotel managers like us who own only the furniture inside, they said that there's no good way to protect it. So they thought it would be wise to sell it or have some white people run the hotel. "We

were well aware of that much on our own," we said to ourselves as we laughed out loud. As it turned out, the consultation offices were virtually useless.

At my hotel, the value of the furniture itself can be estimated at approximately $800 to $900. But the hotel is leased until October next year in this wartime business climate. So it would be quite possible to sell the business for $3,000 or more under normal circumstances. When a real estate agent called me today, however, he said, "You told me the furniture is worth about $800. There's a potential buyer of the hotel for that much. Would you like to sell?"

For the past few months, my hotel has generated a profit of $250 a month. Even if we deduct $70 to $100 a month for living expenses, we still have $150 to $170 or $180 a month left. If someone buys my hotel for $800, that person will get that amount back within six months. What a great deal! Since I will be leaving, I might as well get $800 rather than simply abandoning the hotel. That way, I won't have to worry about our financial situation for a while. It's a shame to sell, but it's too ridiculous to throw it all away. Other people in the hotel business must also be being driven into similar situations that require them to give their businesses away at bargain prices. Is it a plan to uproot all the Japanese businesses while they can? With things going the way they are now, we may not be able to conduct business even

after we return when the war is over.

A bill has been introduced to strip Nisei of their citizenship. A hearing will be held on March 23. It will be under the U.S. Senate Immigration Section Committee with Senator A. Tom Stewart (D-Tennessee) as chairman. The paper said that the Committee would request that governors from the western states as well as senators and legislators attend the hearing.

March 19 (Thurs.)

The relocation plan is relevant not only to Japanese and Nisei, but also to Germans and Italians. But there's a big difference in terms of the way we're being treated. First of all, Japanese and Nisei will be the first to be removed. Needless to say, Nisei were born in the United States and therefore are legally Americans. Secondly, Germans and Italians don't have to relocate if they have someone in their family serving in the army, or if they are seventy or older.

It's true that the Pacific coastal areas don't have to worry about an invasion by Germany or Italy. Consequently, it's understandable that the Germans and Italians can be treated more generously. But the gap in treatment is not pleasant to us. Some Japanese families have sons in military service. Why can't they let them stay where they are and continue doing their business? The explanation we've heard so far is that they would like to protect

Japanese people by relocating us, because no one knows what unforeseen calamity could befall us.

Then why do they have to relocate the Nisei who are Americans? The explanation in response to this question is that it's particularly difficult with the Japanese to determine whether they are loyal to the United States or not, although they do believe that Nisei are loyal to this country.

The general Issei opinion on this matter is that it's okay if they want the Issei to move. It can't be helped if the authorities would like to relocate Nisei as well. But isn't it too hypocritical for the government to draft our sons because they need them in the military? Whenever we get together and the talk touches on this subject, I hear the same complaints. The government has on one hand been taking Japanese youths for military service without hesitation, while the FBI has been ruthlessly taking Japanese people into custody.

Just yesterday, seventeen or eighteen more people were arrested. This time they were mainly a group of people associated with the Buddhist Church, and Japanese Language School teachers, I heard. But I thought the teachers at Japanese language schools are normally women. Since this is all hearsay, I'm not quite sure how reliable the news is. When the truth becomes clearer, I'll write more.

March 20 (Fri.)

There have always been complaints within the Japanese/Japanese-American community that the Nisei are too Americanized. Nisei, on the other hand, have thought it natural to deliberately act like Americans because the times are different. "It can't be helped because they were born in America"—this is the Isseis' criticism of the Nisei. Mothers say to one another, "What's going to become of our children if they don't change?" The mothers' lament is shared by all the Issei. Even though our eldest child is still only seven, I worry about whether our children will become like the Nisei youth we see today. How can we establish a Japanese-style relationship between parents and children? The Issei have tried all kinds of methods and worked extremely hard to try and seize every opportunity to achieve that goal. Instead of fulfilling our desires, our efforts have only helped increase the distance between Issei and Nisei.

In the midst of that crisis, the war broke out and intensified the relationship between the Issei and Nisei. The number of Nisei from age eighteen to twenty-five or twenty-six is increasing. We have begun to see conflicts between these Nisei and their parents due to different ways of thinking and views about finances. We have heard more and more about conflicts since the war began.

In some sense, it was a gift from God.

The Nisei have suddenly come to their senses. They have become aware that they are, in fact, Japs themselves. This realization is not something that money can buy. The financial basis of the Japanese immigrant community is being destroyed. For that very reason, though, Issei and Nisei can now embrace each other truly for the first time ever. I feel indeed grateful. The Nisei have suddenly become very dependable. Eighteen- or nineteen-year-old sons are taking care of businesses after their fathers are taken into custody. I can see that they are trying so hard to do better than their fathers. It's very touching. Besides that, all of them have been cooperating willingly with us. Upon seeing their attitude, all Issei must think, "I may be old but I feel like I can do anything"—this is what I strongly believe.

Just before noon today, an officer from the IRS came to collect income taxes. We've already paid the amount due by May this year, but the officer said it was for January 1 through the end of the year. I thought it was okay. Since I've managed the hotel under my name for three to four months this year, I thought I should pay. But the bill listed $2.75 as a lien notice fee in addition to around $12 in tax. As far as I can remember, a lien notice is issued as a warning about foreclosure when you have failed to pay taxes, so this must be the fee to process such a notice. But I haven't defaulted on any payment. I didn't think it was fair to issue a lien notice for the taxes

due by May of next year, so I had to voice my objections.

I immediately called the JACL. They said that it is extremely difficult during wartime to reason with the authorities about even such a simple matter. Many people had voiced their complaints and Sakamoto-kun had promptly contacted the IRS regarding this matter, but the IRS hadn't responded yet. They should have said, "We're very sorry about this but you will be relocated to an unknown destination. Would you please pay the tax now which is actually not due until next year?" Instead of pleading like this, they've issued a lien notice and even charged us a fee to process it. Going so far as to issue a lien notice in order to force us to pay taxes in advance doesn't seem to be the American way at all. Are they beginning to lose their minds?

March 21 (Sat.)

On December 7th, when the Japanese military attacked Pearl Harbor, there was a rumor that a fifth column consisting of local Japanese people went out onto the streets to try to obstruct police activities. Today W. A. Gabrielson, the Chief of Police in Honolulu, made it clear in his official report to Congress that the above rumor had no basis in fact whatsoever.

I believe that no one among the Japanese immigrants in this country has ill intentions

toward the United States. Even now, we hope the day will come as soon as possible when peace returns between Japan and the U.S. If there were some Japanese people who truly deserved the FBI's attention, they must be long gone. Considering how open this country was before the war, they could have easily entered the U.S. without going to the trouble of pretending to be immigrants.

March 23 (Mon.)

I leaped up the stairs to the third floor! Something was awfully wrong! I heard a chambermaid's voice. I also heard Haruko screaming. "Go to Room 31, please," was what I heard as I ran up the stairs. "Something is not right with him—"

At the top of the stairs, I turned left. I ran like I was flying past the chambermaid with her mouth moving. I was thinking to myself, he might have had it. Many thoughts were running through my head. I pictured the old man's face, which had been looking quite pale for some time. I opened the door. The bed was empty. I hurriedly looked around the room. I didn't see anything unusual. I took a step inside. The old man's legs were on the floor by my feet. He was lying sideways, with his head in front of the chest of drawers behind the door. At a glance, I could tell he was already dead.

I was upset and my heart didn't stop pounding until two police officers rushed over. The procedure went smoothly and everything was over within about an hour. An ambulance came. The old man's body was wrapped in a white cloth and wheeled away on a stretcher. His name was John Skuse. He was eighty-three. He was a good person. Although he was a little stubborn, he was a good old man. He came here shortly after we started this hotel six years ago and has lived here ever since.

This incident reminded me of Johnson. He was a nice old man, too. After he got sick, he came back to this hotel half-senile. He sometimes couldn't remember his room number and went around knocking on doors with his cane. We thought to ourselves, "We've got a terrible troublemaker here." The day he came, I put a plaster on his back, and he remembered that until he died. His mind recovered and he was back to normal in about a week. He was a cheerful and open-minded person. I believe he was born in Norway. He lived with us for three or four years.

Green was also a nice old man. He was extremely stingy but he was always well dressed. He repeatedly said, "I'm gonna get out of here. This place is too expensive. I'll be out of here," but he stayed with us until his death. Even a stingy old man like Green, when he had some money in his pocket, would give away spare change when pressed. He would loan money, too. When Green couldn't get his money back from some of the residents in our hotel, he would come to

Haruko complaining. Haruko reluctantly went to the person who had borrowed money from him to get his money back. "Don't loan anybody money any more," she would tell him. But he kept making the same mistake.

Americans, particularly American laborers with some money in their pockets, can't say "No" when pressed. It's rather strange but everybody seems to have the same tendency. Even when they know they'll need money to buy something, these good-natured men still loan some to others. Afterward they grumble, saying, "What to do? What to do?" But they may sometimes borrow money from someone else themselves. Sometimes they can pay it back, other times they can't. So they don't hold a grudge when someone doesn't pay them back. Their attitude is, "He must be in a tight situation now," or something like that.

Occasionally we get sly young men who borrow as much money as they can from our residents and then disappear. We can sometimes immediately identify men like that. Some people may think it's meddling, but we kick out such people when we see them.

March 24 (Tues.)

There is a lake called Moses Lake between Yakima and Spokane east of the Cascades. This evening's *Star* was saying that the Japanese and Nisei might be sent somewhere near there. Judging from the fact that this evening's *Great Northern Daily News* didn't mention this, they must have decided on this late yesterday afternoon. Tomorrow's paper will probably have more details. As far as I can see from a map, the lake is situated about 200 miles from Seattle. If that's the case, we perhaps could bring all kinds of things with us, which would be very convenient. I heard, however, that the area is like a desert and quite dreary, with low shrubs dotting a sandy plain.

March 25 (Wed.)

It has been determined that the forty-plus Japanese families on Bainbridge (across the water from Seattle), some 280 people, have to move within the week. The destination for the people from Bainbridge is the Owens Valley. This is a total surprise to me. They are telling those people to go all the way to Southern California, which is about 2,000 miles away. They won't be able to bring anything if they have to go so far away.

It is said that the farmers in Tacoma and vicinity will soon be ordered to move as well. Where will they order them to go, I wonder? If everyone from Washington has to go to Owens Valley, it will be a disaster. But they haven't announced a relocation destination inside the state of Washington yet. Sakamoto-kun sent a petition directly to the President asking for reconsideration of this matter. I suppose that is our last resort.

The people on Bainbridge still haven't moved. It's not that they won't, but they can't. They probably don't even know where to begin after being told to relocate all the way to the Owens Valley. The government is guaranteeing a place to live and food to eat, but it doesn't seem like we can rely on them from the way things are going now. In fact, they are telling us that we will have to live on our own means unless we promise to join the Relocation Labor Group, which travels around to farms in different areas looking for work.

They say that a relocation camp like the one in the Owens Valley will be built in Idaho as well. According to the paper, this new camp will accommodate one hundred twenty thousand people. Either way, it will cause new headaches for the people in Washington and Oregon.

March 26 (Thurs.)

I received a phone call telling me to come to John Skuse's funeral, which would be held at Butterworth's at 9:30. So this morning I asked Charley Smith and Claire to come along to the funeral. We went in my car. The three of us were the only mourners. It was a very lonely and quiet funeral.

March 31 (Tues.)

I haven't written in this diary since the 26th.[50] I wasn't being lazy or anything but

I have been reviewing the diary from the beginning. I have made a clean copy of some portions, and I have rewritten other portions. I have a feeling that I may have to rewrite the whole thing one more time. When I get better at writing so that I can express myself more clearly, I will probably have to rewrite this diary. Otherwise, it is simply pointless.

The biggest event over the past several days was the imposition of a curfew. They've also said that a couple will have to manage a business that needs three people to run; a couple plus an employee will have to manage a business that needs four or five people; and a family with many children has will have to manage a business that normally requires a lot of workers. So our businesses will not survive unless we can do it ourselves. Even if the government attempts to protect or manage our businesses, they probably won't know where to start. To us, therefore, relocation means that we have to throw away virtually everything we have worked for. We won't even be able to earn a penny once we move. There will be no way to find a job either. Everywhere we go, Japanese are boycotted. After all is said and done, the only possibility left is for the government to take care of us.

April 3 (Fri.)

It appears to be true that we will be temporarily housed in Puyallup. We will be allowed to bring only bed linen, clothes, some

kitchenware, and nothing else. They say that we'll be in this temporary location less than three months, which means they'll move us again sometime in July. This appears to be a reliable story.

The prospect of having to move twice is making everyone anxious. Building a camp in Puyallup to accommodate 8,000 people and building another one someplace else to move us to must be an ordeal for those who are executing the relocation plan. It's no less troublesome for us. Since we don't even know whether we will end up going north or south the second time around, we can't determine how to prepare. If we knew for sure that we were going to Moses Lake, as we once thought, we could make sure to be well-prepared for a severe winter. If we move with a lot of winter clothes only to find out that our final destination is Colorado, it'll be too late to fetch the things we left behind. This is rather frustrating for us especially because we have five small children. "We can get what we need from the government," I try to joke about things, but it's understandable that Haruko feels at a loss.

One thing that is clear now is that the housewives won't have to cook in Puyallup. They say they will be serving us three meals a day. Some say we can bring no more than $25 with us when we move, while others say the limit is $50. Again, some are going so far as to say that everything we leave in our bank accounts will be confiscated by the govern-

ment. (Many people actually believe this to be true.) I don't think it's true. Talk like this is amusing but at the same time troublesome.

April 5 (Sun.)

I hear that most of us, after spending some time in Puyallup, will be moved to Toppenish, which is 20 or 30 miles south of Yakima. We'd better wait and see what they decide before putting too much stock in this story.

April 9 (Thurs.)

It's a pity that I tend to skip days making diary entries because I'm spending a lot of time making a clean copy of what I have already written. Since time is limited, it can't be helped. I skipped the diary for three days since the 6th. Things to note are as follows:

They say that Japanese Americans serving in the military will be dismissed after three months of boot camp. Some people lately have received rejection letters even before they join the military, and others have received a phone call saying that it's not necessary for them to report. I don't know the reason. Either the government has realized that it's too selfish to draft young Japanese men into the military while they send the rest of their families to camps as if they were prisoners, or the government has begun to think that all Japs, including Nisei, are dangerous. I don't know the true intentions of the army,

but it's a fact that they are not accepting Nisei any more. The navy has never taken Nisei.

It looks like Bataan has fallen. Corregidor and other forts probably won't last much longer. Since we don't have detailed information, I don't know the number of deaths or injuries or how many have been captured. The English-language newspapers don't seem to know the details yet, either. It must have been a difficult campaign for the Japanese military because the Filipinos were in favor of the United States.

There are a lot of Filipinos along the Pacific coast in this country. When the Japanese landed in the Philippines, Filipinos became very agitated. There were many incidents in which Japanese people here were hurt or killed by Filipinos. The Filipinos from certain areas of the Philippines are still quite barbaric. Even white workers are afraid of their wild natures.

Hotels like ours that serve workers have the lowest rating. Even so, we try not to take Filipinos or black people as guests. We never take them in at the Cadillac Hotel. They cause trouble by exhibiting their wild sides whenever something happens. American workers are by far the easiest to handle. The next easiest are immigrants from Scandinavia and from the big countries in Europe such as Great Britain and Germany. French and Italians are a bit sly. People from the smaller countries in Europe tend to be extremely cunning.

April 11 (Sat.)

Lt. General John L. DeWitt announced in the paper that they intend to complete the removal process of Japanese immigrants and Japanese American citizens by May 20. Stores owned by Japanese have started desperately selling goods at giveaway prices.

April 15 (Wed.)

With the announcement from Lt. General John L. DeWitt about the removal date, our relocation will finally happen soon.

People from this region will go to the Puyallup fairgrounds, which has been designated as an assembly center.[51] But we can't help worrying because our final destination hasn't been decided.

In order to determine how we should prepare for our move, we have seen pictures and read stories about the people who were sent to the reception center in the Owens Valley. About three or four days ago, however, the paper reported that we wouldn't be allowed to move in our own cars. We were extremely distressed by this news. The only things we will be allowed to take are eating utensils, clothes, and some bedding. Even though they say they are going to feed us, these things alone won't be sufficient.

So I sent Haruko over to the consultation office (they deal with inquiries regarding sale of property and so forth necessitated by the

relocation program) located at 808 Second Avenue to get more details. We found out the following:

1. We can take a crib. We're allowed to take some necessities for the baby such as a bathtub, kiddy car, stroller, etc.
2. Although we don't know the exact location of our final reception center, they know we'll go somewhere south. (This helps us figure out what kinds of clothes to bring for our children.)
3. The government may bring some washing machines, sewing machines, refrigerators, etc., to the reception center (for families with many children).
4. As long as we keep luggage within a size we can carry ourselves, there's no limit as to the number of suitcases.
5. Pregnant women and sick people can rest assured that they will receive special care. Families with many little children will also receive extra attention to avoid difficulties.

Haruko's visit to the consultation office was worthwhile. Now we feel slightly more reassured. We also have a clearer idea about how to prepare our luggage.

April 16 (Thurs.)

I received a card from the main post office on the 14th telling me to come by. They said it was about my alien registration. The dates are from the 16th through the 25th, and the hours are between 9:00 am and 4:00 pm. I was supposed to visit Room 423. Judging from what it said on the card, it didn't look like anything serious. Since I had other business to take care of downtown anyway, I decided to stop by the post office. "Could it be a periodical inspection?" I wondered as I climbed up the worn marble stairs at the post office. But it turned out to be no big deal.

When I filed my alien registration form two summers back, they took all my fingerprints from both hands. They said that it wasn't done properly and the fingerprints weren't clear, and they would like to redo it. So they took my fingerprints again. My fingers got stained with black ink from the process. I cleaned my fingertips with coal oil and wiped them very carefully using a piece of paper that was provided. I tossed that dirty paper into a wastebasket like I was throwing away something impure, then I left the post office.

I went directly to Sun Life Insurance Company to pay Haruko's premium. On my way back, I stopped by the Red Cross to entrust them with my words. I wanted to let my big brother in Japan know that we're okay. The limit was twenty-five words in English.

Family all well, business as usual.
We will soon live in the camp under
 protection of the army.
Expect new baby born later part June.

April 18 (Sat.)

The *Post-Intelligencer* this morning had a big headline with letters about 4 to 5 inches tall: "Bombs Hit Tokyo." "Finally, here they come," the Japanese people must have felt. I can almost feel the tension rising among all the Japanese people. No matter how many times the country gets bombed, they don't have to worry about losing territory. "We're not afraid of bombs," the Japanese army in Burma must be thinking. The people in Japan will now start to have the same mind-set. In some ways, this bombing may help the Japanese people unite. According to the paper, Tokyo, Yokohama, Nagoya, and Kobe were bombed.

Since the day of relocation was approaching and we had found a good buyer, we decided to sell the hotel for $1,500. This buyer is a naturalized citizen from Italy named Jimmy Minelli. I know him very well. He had been working at a mine in Bellingham, but he hurt his leg. He popped up at the hotel about two weeks ago, hoping to find a decent job in town. We had known each other from before and he was looking for a job. So I told him about my situation and he immediately showed interest in buying the hotel. He brought $500 yesterday. We decided that he will pay $500 in cash now, and he'll make monthly payments of $100 for the balance of the $1,000.

This morning I went to Henry Broderick, the real estate agent for my landlord, to switch the names on the contract. Then I went to the lawyer to take care of the transference procedures. The legal transfer will be completed next Saturday.

I felt that part of the load on my shoulders had been lifted. On my way back, though, I felt as though I was a vagabond because the load on my shoulders was too light. It was a strange feeling. I wouldn't have felt that way if I had sold the hotel because I thought it was the right time to sell. Right now, I feel as if my clothes have been stripped off by force or something.

April 21 (Tues.)

The Exclusion Order was finally issued to 2,000 people in Seattle. In short, the area covered by this order is between Roosevelt Way and the waterfront on the north, and between Fifth Avenue and the waterfront south of downtown. Our hotel is situated within the boundary specified. That means we're included in the first group to be removed from the city. Since we have already sold the hotel, there aren't many remaining obstacles to our move. Maybe it's better to move sooner, only I worry a little bit about the fact we don't yet know where the final reception center will be. But there's nothing we can do about that.

April 22 (Wed.)

I'll have to go to the lawyer's office on Saturday to handle the transference of the hotel. Those like us who are in the assigned area have to go to 2100 Second Avenue on either Saturday or Sunday to start relocation procedures. The paper says that the head of the family has to appear in person. On Monday I also have to go to 808 Second Avenue to report the sale of the hotel.

That leaves only four more days, Thursday, Friday, Sunday, and Tuesday, to pack for relocation. We're going to be quite busy. We worked all day today, but we've packed only a little.

They stopped delivering the *Great Northern Daily News* today. McCarthy came tonight and left $35 to buy my car.

April 26 (Sun.)

I went to 2100 Second Avenue to register for the relocation. Too many people were there, so they told me to come back at 10:05 a.m. tomorrow. I went home and worked on packing all day. I got so tired that I fell asleep from early evening until 11:30 at night.

Recently, we've been filling up in the morning, and it's rare for someone to ring the bell at night.

April 27 (Mon.)

I went to the office at 10:05 as I was instructed yesterday, but it was so crowded that didn't I start the registration process until 11:00. After the procedures were completed, they gave me a notice telling us to be at the corner of Eighth Avenue and Lane Street by 8:00 a.m. on May 1 with all our luggage.

Inside the office at 2100 Second, there was a man from the Federal Reserve Bank. He was a most unkind person. He didn't seem to have any sympathy or even any emotion. His only purpose was to keep records indicating that they were fair in the disposing of Japanese people's possessions. He looked like a statistics-loving American working to attain a higher percentage of "satisfactory" answers from us.

I told him that I sold the hotel and received $500 in cash and financed the remaining balance for $100 monthly payments. He wrote that information down and asked, to my surprise, "Is that satisfactory?" I wasn't ready for that. I didn't see it coming. Just as soon as I involuntarily said, "Yes," I regretted it. Then again, Japanese people tend to be good losers. I must subconsciously have been trying to feel satisfied that the hotel was sold for something, which was why I instantly replied, "Yes."

I watched this man writing about me in his report with a notation saying, "Satisfac-

tory." I almost told him to add the phrase saying, "Hate this situation," but I didn't. The man probably wanted to proudly present a report on the handling of Japanese people's assets with an 80 or 90 percent satisfactory rating. His only goal seemed to be to get as many "satisfactory" answers as possible, and it showed. I heard a lot of stories from people. All of them agreed that the man from the Federal Reserve Bank didn't look sincere for a consultant who was trying to help Japanese people dispose properly of their assets.

April 28 (Tues.)

I haven't had time to read the paper the past several days. I have put aside the war and everything else.

There was a doctor's examination yesterday and I took everyone to 2100 Second Avenue. Since I had told them that Haruko was seven months pregnant, they sent a doctor to examine her today. The doctor thought that it would be okay for her to travel.

We started packing in the morning and kept working on it all day. A lot of boxes scattered around were 80 percent full. We packed things into the remaining spaces one box after another.

[The diary contains no entries from the Puyallup Assembly Center. It resumes at the Minidoka Relocation Center in Idaho.—ed.]

September 12 (Sat.)

There was a bit of rain last night. We are a little troubled that we don't have a heater because it's so cold in the morning. Across the main street in the row designated for single people, they made a fire outside yesterday and today. But after we began to see the sun peeking through the clouds around 10:00, it quickly warmed up.

Haruko went shopping and got some newspapers from town. I read the war-related news for the first time in many days. Japan claims that they sank some twenty ships. The United States, on the other hand, claims that they are still fighting on the island they took over while we were in Puyallup and are gradually expanding the territory under their control.[52] Basically, Japan claims victory because they sank many U.S. ships, whereas the U.S. claims victory because they landed on three islands. If we assume both claims are true, the losses the U.S. has suffered are greater than their gains. In the meantime, the United States should be happy about the success of their advances on the three islands. The radio news reported that the Japanese army in New Guinea had advanced and had only forty miles to go before reaching Port Moresby. When we were still in Puyallup, the Japanese army was sixty miles away from Port Moresby.

We received the three remaining packages we had sent by train. Now we have everything we intended to bring. Our radio

was inside of one of the three packages. We turned it on right away and found out that the reception from a station in Salt Lake City was pretty good. In a remote place like Minidoka, news is very valuable.

September 13 (Sun.)

We visited Haruko's parents, who are living in Block 14. It was so far away that I got really tired. Haruko was holding the baby while I pushed the kiddy car. I felt so beaten down on our way. After forty minutes of struggle, we finally got there. We had lunch and dinner at the mess hall in their block and came home.

While we were in Block 14, they told us about the news that was on a shortwave program from Japan. (A white person who understands Japanese must have caught the shortwave program and told them about it.)[53] According to that program, all the air bases in Alaska have been destroyed. The United States also suffered much greater damage in the Solomon Islands than we had heard. Although the Marines have landed on those islands, the U.S. doesn't have any way to resupply them because the Japanese defenses are too firm.

September 14 (Mon.)

I did carpentry work all day today. I cut down a board and carved it into a rounded

stick to use as a mop handle. I also made a towel hanger and a dustpan. The boards we used for packing have come in handy. I enjoy making this place look more like home little by little.

I was stunned to see what was for dinner: rice, *udon* noodles, a little bit of canned peas and two tomato slices. No milk. No sugar either. At first I thought they had run out of food because we went to the mess hall about ten minutes late. As it turned out, they hadn't received any food supplies.

People are growing worried about the possibility of not having enough to eat if the trains get tied up during the winter. Haruko and I talked about the precautions we could take and decided to make dried rice from the leftovers and save some coal once rationing starts.

September 15 (Tues.)

With almost everything in its place, our barracks has started to look like home. We should be thankful for this. It's not too much to say that this is the first time since the end of last year, when the war started, that we have a place to settle down. There are a lot of flaws in this place and it's in a barren desert area. Nevertheless, we find it somehow reassuring, because we know we can stay here until the end of the war.

It was the third day in a row that the inside of our house got sandy even with our windows

tightly closed. When I found so much dust on the radio I set up a few days ago that I could make dust piles, I was utterly amazed.

September 16 (Wed.)

I found a board that was about 12 or 13 feet long among the rafters. I used that and some of the boards we used for packing to make a cupboard. I created the cupboard by putting junk boards together, which made me happy and gave me a great sense of accomplishment. It's too bad we can't start using it yet because we don't have any shelves, but I look forward to the day we put this piece into use. I'm thinking about looking around to gather enough material to create doors for it, too.

September 17 (Thurs.)

It was so cold this morning. I started on my carpentry early and made a sturdy piece that could be used as a work table or bench.

Yoshiko has a little bit of a cold. She was cranky all day but she felt better and started playing in the evening. It rained for about half an hour shortly after 5:30 in the evening. The rain helped calm down the worst sandstorm we have had so far, but the temperature dropped quite a bit, too. It's almost like winter. Since we don't have a heater yet, it feels all the more cold inside ourselves as well.

The sandstorms around here are irritating. It was blowing almost all day today. If I looked up when the wind stopped momentarily, a fine blue sky seemed to be above us. The sandstorm, however, left the impression that it was cloudy all day long. To protect us from the cold and sandstorms, we have all our doors and windows shut tightly. Despite that, sand gets everywhere. We had to completely seal up two windows that we weren't using much.

September 20 (Sun.)

I have been feeling rather chilly from the waist down for the last three days. I got sick, just as I expected, in the afternoon yesterday and last night I was groaning all night long. My whole body ached and I couldn't find a comfortable sleeping position. By the time I finally dozed off, it was already dawn. So I slept by the sunny window from morning until 3:00 in the afternoon.

I haven't heard any radio news for the past two days. I listened to various stations but didn't catch any news. Lately I feel the need to find out what's going on with the war, at least once a day like before. It may be an indication that we're becoming much more used to living in this place.

September 22 (Tues.)

They set up a heater for us this evening specifically because we have a baby. It's a huge heater from the U.S. Army. Just by putting in

a little bit of wood, it keeps us warm for over an hour. If we can get a large enough coal ration, the winter cold will be bearable.

September 23 (Wed.)

As of today, breakfast is served between 7:30 and 8:00 a.m. It feels early because that's just when the sun finally rises above the horizon. When the moon rises in the evening, the sky is still blue. When the large moon appears above the horizon in an indigo sky, it looks just like a drawing from the Ten-Cent Store. The color scheme looks quite similar to the drawings at the Ten-Cent Store but the actual beauty is beyond what you can imagine. I'm thinking about trying to capture this beauty once I get my art supply box. I look forward to that, but it'll probably be more difficult to draw than I anticipate. If I could recreate that color without making it look like a drawing from the Ten-Cent Store, that would be a great accomplishment. I've had a hard time finding scenery in our camp that inspires me to draw, except for a couple of unique spots I found the other day.

We requested two more blankets for the baby. We have borrowed a total of sixteen blankets (two blankets each) so far.

September 24 (Thurs.)

The weather changes drastically in the interior, which is difficult for physically weak people. My family is generally healthy. Even so, I got sick a few days ago, Yuzo was sick last night, and Yasuo and Haruko are sick today. Since everyone's symptoms are different, I don't know if all of us are suffering from the same cold or not. It's hard to determine what to wear or what to put on our children. It's cold as winter in the morning, during the daytime it gets so hot that we sweat, and it becomes fall-like in the evening. There's no one here who can teach us how to cope with this weather.

September 25 (Fri.)

The war consumes people's lives and material resources. Even the United States, which normally enjoys abundant natural resources, is now desperately appealing to the public to donate scrap metal. It looks like we're experiencing shortages in everything. Farmers are requesting price increases for their produce by some percentage. The President is trying frantically to keep inflation under control.

They say the camp will implement self-governance by the residents. We will select two representatives from each block so that we'll have a total of seventy-two representatives from the thirty-six blocks. Only people with U.S. citizenship are eligible to become representatives. Although Issei will have the right to vote, we don't have the right to become candidates.[54]

The American people in charge of this camp tell us that they are running the camp democratically. I think that's false. I believe they have a labor shortage because of the war, which is why they would like to use Nisei to run the camp. They say "election," "right to vote," and "democracy." We don't understand what kind of democracy they are talking about. This is an internment camp. They want to make a distinction between citizens and non-citizens among the internees even though they put us all in here. That's absurd and inconceivable. I absolutely don't want to spend any of my time on this ridiculous so-called democracy. I want things to be the way they have been so far. I will be content as long as they give us a little food to eat, a place to sleep, and some clothes to wear during the war.

September 26 (Sat.)

The east wind, which started blowing yesterday evening, continued to blow all day long today. I had thought that the dust storms always come with the west wind, but the east wind is pretty bad, too. In this wide-open area with nothing to block the wind, the wind can blow in any direction it wants to. But, as one who is being blasted by the wind, I can't help but study its tendencies. Every day we're getting gradually used to our lives here. I'm a little worried about how cold it can get in winter, but during the day it was just as hot as summer.

Today is Saturday and there's some dancing going on in the mess hall. There's a large crowd of young people gathering there. I can hear the music going as I write this diary. I wonder how the young people in this internment camp view the war. They may never know what war is really like, for better or worse.

September 27 (Sun.)

Shiho-san's husband, who had been suffering from stomach cancer and was mainly on a liquid diet, got very weak after traveling the seven hundred miles from Puyallup. I just heard he died two weeks ago.

Even if we don't have any specific physical problems and think that life here isn't that bad, we really have to take good care of ourselves. Since we're living in such a dry area, we will have to keep a close watch on our health during the first year.

September 28 (Mon.)

As long as I'm reading American newspapers or listening to American radio stations exclusively, it sounds like American planes are the only ones in the world that are making an impact. Neither the Japanese Zero fighters nor the German planes seem to be active at all. I think that's bizarre but it gives me an eerie feeling. As for the battle over the Solomon Islands, they only talk about Japanese warships and merchant ships being sunk every day.

We dug a furrow in the street to get water from upstream to the camp. The street consequently became like a muddy field. The children were very happy with that turn of events. They played in the mud all day. Our plan seems to be to plant rye to help keep down the dust.

September 29 (Tues.)

In the afternoon before dinner, the American named Heike visited us and suggested that we move to a bigger place. He said that they could offer us two rooms instead of one. Since one room for a family of eight is a bit too crowded, we decided to take up the offer. We will now have 8E and 8F in the same block. Best of all, we'll be closer to the laundry room and the latrine.

October 1 (Thurs.)

We waited and waited for the car that was supposed to help us move but nobody came. Now our house is a mess. When it was time to go to bed, we had to plug all the appliances back in, dig through boxes to find our pajamas, take stuff out in order to give the baby a bath, etc. We had to pull out many things before we were finally ready to go to bed.

I had to visit the latrine four or five times today. Some say it must be because of the water. Others say it must be from some kind of cold.

In the dim light of dusk, I sat on a stool shivering in the latrine, into which the west wind was howling. Someone else came in to urinate. "We will be in trouble if this lasts too long," he said as he was leaving. It suddenly occurred to me that it would be hard to bear up if the war lasted two or three years. That fear swiftly seeped into my mind. In a way, my family may be more carefree than anybody else because we're so busy with the children day in and day out. For families without children or with grown children, life here may be five to ten times harder and more unbearable than it is for us. "How long will this war last?" If you start thinking too much about it, you could suffer a nervous breakdown. Who knows? Sensitive people may not even be able to keep their sanity.

October 2 (Fri.)

One of our new rooms is 8E in Block 38. The size is about the same as our old place, but the new place is much brighter, with six windows—one more than before. 8F is still occupied but they'll move someplace else within a week or two. Then we will have two whole units to ourselves.

October 3 (Sat.)

It's been exactly one month since we came to the camp. A nice dinner was served at the mess hall.

About 1,000 people from our camp have found jobs outside the camp (such as picking apples, digging potatoes, and harvesting sugar beets), which has caused a sudden labor shortage inside the camp. They are in a panic trying to get more people to work. I was asked to work as a handyman for our block. A handyman's role is to do simple repair work, I suppose. Since it sounded interesting, I decided to take the job. I thought not having to commute a long distance to work would be convenient.

October 4 (Sun.)

We finished organizing most of the things in our new place today. We put up a clothesline to dry laundry.

The camp is coming together, too. There are shops in Blocks 6, 30, and 40, from which we can purchase daily necessities. I hear there are also a barbershop, a shoe repair place, and a radio repair shop in Block 12 or somewhere. The government said that they would provide winter clothes for us, but they haven't done so yet. It's getting colder each day, so I'm getting anxious.

Uncle, who visited me from Block 28, told me that all the people, including Issei, around Block 28 have taken jobs.[55] Even the wives are working at the mess hall. I think it's for the best to take on a light load of work like that. The worst thing to do is to complain about our situation without working to improve it.

October 5 (Mon.)

I went to camp headquarters with a letter from our block manager to get some utility man work. I was told that I had to go to the Employment Office in Building 11, Block 22, to obtain four copies of a paper that verifies my name and that I filled out the job description. I walked over to Block 22, but they told me to come back tomorrow because they hadn't received a requisition from headquarters indicating they had in fact hired me.

I thought it would be a lot of trouble to go to the Employment Office again tomorrow and then back to headquarters to report. So I went back to headquarters and asked them to do something about it. They took pity on me and said that they would take care of all the necessary procedures at headquarters and that I would be allowed to work. From the start I was thinking, "If I get the job, great. If not, that's okay." To me, the whole thing was no big deal. But for those who desperately need a job, these procedures would be such an ordeal. I left home about nine, and I barely made it back in time for lunch. The young female Japanese secretary told me that she was sick and tired of the regulations requiring a signature from a white person for every single thing. The procedures are complicated, and headquarters and the Employment Office are about six or seven hundred yards apart. There's no telephone or car. It's highly inefficient.

I don't know how much I actually walked, but I was very tired by the time I got home. Anyhow, it was good exercise for my legs. When I returned, I told Tajima-kun, the block manager, about what happened. He laughed and said, "Sounds like you did get the job, though, after all." So I replied, "I guess I did," and we both laughed about it.

There were a lot of white people at camp headquarters. It seemed like they had one white supervisor for every section. Headquarters seems like the most unpleasant place in camp. Various notices are posted everywhere saying, "No talking while filling out forms," or "Be as quiet as possible." One would get dispirited by looking at those notices all the time.

October 6 (Tues.)

The newspapers are really depressing to read. With a headline saying, "Assuming a new offensive position from three directions," they report that American forces advanced toward the Aleutian Islands and have 250 miles to go and that they are within 400 miles of Kiska Island, which is occupied by Japan. The Marines are increasingly expanding the area in their possession around the Solomon Islands and driven the Japanese army to the mountaintops of the Owen Stanley Range in New Guinea.

The Japanese military has been quiet lately. It makes me feel uneasy not to know

what they are up to. The lack of action from Japan makes me feel a bit irritated. The local paper is even assuming that Japan may give up on Milne Bay. Although I don't think that will ever happen, what I hear on the radio every day really gets me down.

October 7 (Wed.)

They brought in large loads of supplies to camp today. Since I thought the thick cardboard they used for packaging might come in handy, I stood there hoping to get some. Several people came swiftly over and started a tug of war over the cardboard. I became ashamed and went home without even trying to put my hands on any of it.

October 8 (Thurs.)

The newspaper said that, judging from the aerial photographs, it didn't look like the Japanese army was in Attu and Agattu in the Aleutian Islands and that they assumed the Japanese army must have retreated to Kiska. The paper also said that the United States had bombed Kiska twelve times over the last eleven days. It said that the Japanese army in New Guinea was continuing to retreat further. The newspaper didn't say anything about Guadalcanal in the Solomon Islands. There aren't many new developments to write about, but still I feel compelled to write.

Haruko took Shokichi and Shizuko to a bath in Block 36 tonight, but they were told that there was no hot water because they didn't have any coal there. The camp actually received a lot of coal but no one delivered it to the bathhouse. Nobody wants to carry coal for $16 a month.

October 9 (Fri.)

A lot of Issei and Nisei seem to have gone outside to work. We can earn at least $4 to $5 a day when we work outside. Besides, this state is suffering from a labor shortage and they welcome anyone willing to work, even Japanese or other nationalities. The farmers growing beets, apples, potatoes, and onions, who have been barely surviving due to the labor shortage, are greatly helped by such a workforce. It's good for the workers, too. Those who work outside can go shopping, see movies, and have fun. It's only natural for internees to feel like seeing the world outside. Young people especially must be fed up with life in the camp. We have been confined for more than five months already, from May through September.

On my way home from work, I met a policeman. He said, "Since it's you, I want to tell you something," and confided his thoughts to me. "No matter what happens, I will never ever go outside to work. No matter how good the wages may be, I never will." I thought he was being quite stubborn but he sounded reasonable. I was about to agree with

the man. Then I had second thoughts and decided to wait patiently until I heard the rest of his story. My assumption was that he was going to tell me that he doesn't want to work outside during war because that would help American industry. Contrary to my assumption, he told me about the Germans living in the States during World War I, who were sent to camps just like us now. Those Germans who didn't go outside to work at all during the war received compensation of $3,500 when the war was over, even though the Germans lost. Therefore, he told me, I should never get a job outside camp.

I was utterly speechless and stunned for a while after hearing this. I also thought it was both pathetic and laughable. I saw that this man was small and trifling. He believes he's smart and is puffed up with the idea. To see a man like this made me feel miserable. The number of people who've lost their Japaneseness despite being Japanese is not small. It doesn't feel good to become aware of this. Some people get jobs outside the camp just so that they can drink, since a little bit of drinking, with restrictions, is allowed outside.

Someone I was talking with in front of the boiler room told me that there are many complicated issues for Issei working outside the camps. When switching hotels, for instance, they have to notify the authorities of their change of address a week in advance, along with the immigration office in Philadelphia and one other office, even after they

receive permission to do so. They are required to follow the same procedures and get permission to switch jobs, too.

The man I was talking to has been in and out of camp often. The FBI agent inside the camp finally sent for him and gave him a thorough questioning. They urge us to go outside and get jobs. Once we step outside, however, an invisible string is wrapped around our waist so that the FBI has total control over us.

October 11 (Sun.)

I was surprised to see ham and eggs plus mashed potato on the menu this morning. We said to one another, "What's going on?" or "This is the first time we've had ham and eggs since we entered Puyallup." Then our block manager told us that it was because they were expecting Director Dillon S. Myer to visit. "No wonder," I thought.

Our block manager told us that there were always piles of food, including eggs and such, in storage. The lunch menu again surprised me with roast pork, spinach, mashed potato, and pie on a plate. We laughed together saying, "We should have these people visit us more often if this is what we get to eat."

October 13 (Tues.)

Between our camp and the river below there is an area filled with debris from when they built the camp. For some reason we're not allowed to go down there, and the Japanese police guard the spot. Since it's been getting fairly cold the last few days due to the rain, some scavengers have started picking up woodchips from the dump. We've picked some up ourselves, too, while the police were looking the other way. But no one could stand it any longer. People swarmed over the dump after dinner, although the police warned them. Before nightfall, there were more than a hundred people there. The huge dump was very crowded, and we all collected woodchips until dark.

October 14 (Wed.)

I went down to the dump this morning and picked up more wood all day. Since there were two to three hundred people there, all of the wood in the 240 square yards was gone by afternoon. We didn't leave even one tiny piece of wood anywhere. Since we collected quite a bit of firewood, we're going to be fine for a while. There's still a lot of fiberboard, tarpaper for roofs, and cardboard left in the dump. I'm sure it will disappear without a trace.

October 15 (Thurs.)

It looks like the battle in the Solomon Islands has finally gotten serious. The newspaper says that U.S. Army troops have landed as

reinforcements, in addition to the Marines. Japan, on the other hand, is reported to have dispatched warships, cruisers, and torpedo boats to begin attacking the U.S. airfield.

I was at the dump again after lunch when Shizuko came running over with a note. The note said to come to the Employment Office in Block 22. When I got there, they asked me to work as a sign man. They said that the camp needed an extra hand because most of the sign men at the camp had gone outside to dig potatoes or pick apples.

Working under a Nisei was the last thing I wanted to do, so I declined. I added that I would be willing to continue working as a utility man. They then asked me if I had applied for work in camp. When I said "No," they said they wouldn't be able to give me a job unless I filed an official request first. I was beginning to think it wasn't worth the trouble. They must have sensed my irritation because they said, "The procedures are not that complicated. Just come with us." They made me fill out some brief background information and gave me a paper that allows me to work as a utility man.

October 18 (Sun.)

After people started to go to the dump openly, they also began to go beyond to the riverbank. Now it seems like we're permitted to go down to the river, so everyone goes there. We see quite a few people fishing now.

Because North America is a big continent, the fish in this river are good-sized too. The fish we catch is shaped like a carp but doesn't have whiskers. Its body aside from its head is about one and a half to two feet long, and its scales are shaped like those of carp. We ate it salted and broiled, and it was pretty good. Its bones are very hard, and its fine bones are hard and sharp like needles. It tastes simple and doesn't have the strong taste freshwater fish often have. Haruko sliced it up into sashimi, and she thought it was rather good. The other day, the newspaper circulated inside the camp warned us not to eat raw freshwater fish because of worms, so I didn't eat any sashimi. But the fish broiled with salt wasn't bad. It tasted plain and we found it to our liking.

Having recreation such as fishing is a nice consolation for the internees in this camp. The river isn't really clean, but it's not cloudy either. It smells muddy when we go down to the riverbank. It doesn't seem to be a good river to swim in because the water runs quite fast and there are a lot of weeds.

The river is about sixty yards wide. They call it a canal. The water must have been drawn from the Snake River for irrigation a long time ago because the river is well-established now and the greenery in the surrounding area is nurtured by this river. On all accounts, the river is a gift to us. Even in the midst of the desert, we see some greenery thanks to this river. When they drew water

into camp the other day, they dammed up the upper stream of the river to divert it. Today I noticed many green sprouts here and there in the camp compound as a result of those efforts.

October 19 (Mon.)

Looking up at a totally clear sky, someone said, "It's nice to have such a warm day in October, isn't it?" These words reflect the deep feeling of many people here. "Fall in Japan is decorated with Chinese bellflowers and patrinia." "In Seattle, we'd be having *matsutake* mushroom around this time of year." "Oh yeah, right now *matsutake* is in season in Seattle." People think of Seattle and in turn remember distant Japan. We reminisced while standing in line in front of the mess hall before lunch.

Since coming here, people have become extremely indifferent to the war. Everybody seems to be keenly focused on putting their living quarters together. Maybe it's because people are happy to finally have a place to settle down for the first time since the war broke out. I talked to four or five people when the big battle for the Solomon Islands was imminent, but their response was simply, "Is that right?" I strike up conversations hoping to get more news, but I'm disappointed every time. I've decided not to talk about the war anymore.

October 20 (Tues.)

Everyone needs wood. We were laughing out loud earlier in the mess hall, saying that we feel like stealing whenever we see some wood. We want to make cupboards or shelves. There are a lot of things we'd like to make but there's no wood. Takei-kun went to the lumberyard in the camp to steal some wood and lost his eyeglasses there. It almost sounds like the plot for a comedy. Since the police are Japanese Issei, they overlook most things. But I don't think I'll get a chance to take any wood from the lumberyard because it's so far away from our place.

October 21 (Wed.)

I brought the requisition paper from the Housing Office to the Clothing Department and received some work clothes. I got five items: a hat, a pair of gloves, a pair of pants, socks, and a mackinaw coat. On my way home, I stopped by the canteen to buy a pair of shoes. I was amazed to have to pay $5.75 for them, but they seem quite sturdy.

The United States is said to be continuously expanding its control of the air from the Aleutian Islands in the north to New Guinea and the Solomon Islands in the south. That in turn is said to be delaying the Japanese army's offensive. Honestly, probably nobody knows the exact status of the war.

October 25 (Sun.)

When I woke up this morning, the sky was cloudy and it was quite windy. I didn't like the looks of the day. The weather got better but the wind remained strong. They say that the really cold days here are from late December through January and February. We're tense with anticipation because it would be unbearable to have this kind of strong wind when the temperature really drops. In fact, we're being told that it could get to minus 20 or 25 degrees. We ordered thick undershirts for the children from Sears today.

October 28 (Wed.)

A newspaper critic named Raymond Clapper said that the U.S. military always delays announcements regarding its losses. This sound like the kind of complaint we hear from the side with the upper hand. We probably don't hear this kind of complaints from Japan very much because the people there have absolute trust in their army and navy.

October 29 (Thurs.)

The delay announcing the damage received and the multiple commanders for one area have become issues. This indicates perhaps that the battle for the Solomon Islands is not going well. The newspaper says that the authorities don't know the situation in the Solomon Islands yet. They may in fact not know. The newspaper does tell us that the battle has expanded to areas such as Fiji and New Hebrides.

October 30 (Fri.)

The evening edition of today's newspaper said that the U.S. Army destroyed twelve small Japanese tanks in the battle of Guadalcanal, there was a temporary cease-fire, and the U.S. Army didn't lose any ground. Twenty thousand Japanese soldiers are said to have landed on the island.

The west wind has been blowing hard through the camp lately and it's been quite cold. The temporary latrine is exposed to the wind, so the whole body gets cold while using it. Just as soon as I see the coal coming, I rush to the mess hall to get a bucketful. The water we spray to keep the dust down stays frozen all morning.

October 31 (Sat.)

Today is Halloween. Normally we'd dance at night. The children would carve pumpkins to make jack-o'-lanterns and would go around playing tricks. In the city, they play tricks like marking windows of houses or cars with candles and soap, knocking on doors and running away, or knocking down garbage cans. But I don't think we will see much of that tonight.

November 1 (Sun.)

Matsumoto-kun, a carpenter from Block 8, was supposed to give me some boards today. I was going to take a bus and waited at the bus stop but it didn't come. I waited for about an hour and a half before I lost patience and came home. As it turned out, I wasted my Sunday morning.

Boards are hard to come by in camp. I'd like to have a couple of cabinets plus a shoe cupboard. A better table would be nice too. I'd like to have this and that, but we can't get our hands on wood very easily. It seems like those who work as carpenters can take advantage of their position, but it's not as if they have extra to give away. So everyone feels like grabbing whenever they see some boards. They say wood from the lumberyard gets stolen often, but I don't think this can be helped.

November 2 (Mon.)

I went to visit Matsumoto-kun in Block 8 to get some wood. I put as many boards as I could carry on my shoulders. By the time I reached Block 14, however, I couldn't go on any longer. So I thought about stopping by the Suzukis' to take a break. Just as I turned toward their house, I saw Koichi, the Suzukis' eldest son, drive up in his truck.[56] He gave me a lift from Block 14 to Block 28. After that, I could walk back to our place in Block 38

easily. When I got home, however, I realized that I only had eight boards that ranged from about 3 to 4 feet long by 7 or 8 inches to 1.5 feet wide. I was disappointed to see how little I could carry on my shoulders.

When we came home after dinner, there were two people waiting for us. One was Hidaka-san, who worked for us until we were relocated to the camp in Puyallup. The other was a man, over seventy years old but in good health, who had been sent to a faraway federal camp because he had been in the Japanese military during the Sino-Japanese and Russo-Japanese wars, but was sent back to join us when we left Puyallup. We were very surprised to hear from them that my father-in-law had been hospitalized. We went to see him immediately. The doctors don't know what it is yet but recommended hospitalization because of his chronic high blood pressure. He told us he went into the hospital yesterday but was feeling much better today. When we finally got home, it was a little before nine.

November 6 (Fri.)

They started erecting a barbed-wire fence between our camp and the dump I frequent. Our path to the river is now closed off again. Why aren't we allowed to go down to the river? One possible reason occurred to me today. The river Los Angeles uses as a water source runs through the Owens Valley.

Because of that, the general public at one point opposed the idea of setting up a Japanese camp in the Owens Valley. Likewise, it's possible that they don't want us to go to the river because of opposition from people living downstream. This may be the most likely explanation.

November 8 (Sun.)

They removed all the sentries and Japanese policemen who have been guarding the lumberyard and at the same time declared that anyone can take wood. We have been desperate for lumber so this was great news. Everyone went to the lumberyard to take whatever they could lay their hands on. Everyone, including women and children, started bringing out wood like ants carrying food. The announcement was made the day before yesterday. Unfortunately, we just heard the news yesterday because we live far away from the lumberyard. We couldn't bear the thought of missing out on this opportunity, so I took my wife, the neighbor across the street, and her two daughters to the lumberyard to fetch some wood. I took five boards (about 9 1/2 inches wide and 8 to 10 feet long), Haruko took three, our neighbors took six altogether, and we carried them home on our backs. Since today was Sunday, I started working on the *tansu* my family has long been asking for.

I went to the scrap-yard twice by truck to collect some more woodchips today. I was

amazed to see that more than half of the wood was gone. On Saturday, the woodpile was about 7 to 10 feet high covering approximately 7,400 square yards. Today, the pile was considerably smaller and reduced to only a few feet high. The scrap-yard was crowded, like a picnic ground, with people picking out wood and trucks parked everywhere. I'd say there were two to three hundred people there. If they are not sending us any coal because they want us to clean up the scrap-yard at no cost, they have some nerve. They must be elated that the scrap-yard is getting cleaned up for free.

We have a nice latrine but are still using the temporary one because the sewage pipe for the nicer one hasn't been completed yet. The drafty latrine is unbearable in this cold weather, so we removed some boards from the exterior of the latrine, closed up the gap, and put on a door to block the wind. It'll be somewhat better, I think. I worked on this project with one other person this morning.

November 10 (Tues.)

Since the septic tank for the temporary latrine got full, we moved the women's latrine about ten feet, which ended up taking all day. Since it was still cold, we patched some gaps near the top with boards and put on a door.

The U.S. Army landed in French Algeria and was preparing to attack General Rom-

mel from two directions. This drove General Rommel away in retreat. It was quite unusual not to have any stories in the newspaper related to the war situation in the Western Pacific. This is very peculiar.

November 11 (Wed.)

Since we aren't expecting any coal deliveries for a while, each block requested a truck to collect woodchips from the scrap-yard in the northern part of Block 8. The truck came to our block about 1:00 in the afternoon and made two woodchip runs. In order to distribute this huge amount of woodchips to the seventy-plus households, we divided it into smaller piles between the mess hall and the laundry room. We started distributing the woodchips to Barracks 1 through 12. If a household didn't have any men capable of physical labor, we carried the woodchips for them. We took what was left to the boiler room in the laundry area. When all the woodchips were cleared away, it was already after sunset. They then said they were giving out one bucketful of coal per household, so I went to get our ration.

November 13 (Fri.)

Tajima-san, our block manager, is troubled by the coal rationing issue. When we get a delivery, one or two bucketfuls per household are allowed. But Japanese people tend to worry about potential coal shortages before they actually happen—which is one of the best as well as the worst characteristics of the Japanese—and they get excessively greedy. Although the ration is determined by bucketfuls, some people bring a big box with the excuse that their buckets are being used for some other purpose. We pre-scoop coal to distribute in the standard-sized buckets, but some people selfishly insist on filling up their own containers. Even if the ration is announced to be two bucketfuls, there are people who would take three. I have sympathy for those people. I can understand that kind of mindset. As one of the people assigned to shovel coal for distribution, however, it's extremely irritating.

It's very interesting that those who are greedy for coal are also greedy about everything else. Since I believed that few can match me in greediness, it's enlightening to see how other people's minds work.

November 16 (Mon.)

I finished the bureau I started on the 8th. After paint and everything, we now have something that resembles a *tansu*. I feel like I've fulfilled my responsibility and delivered what has long been asked for. Perhaps Haruko will be busy tomorrow organizing her kimonos.

November 17 (Tues.)

There was a report on the four-day naval battle in the Solomon Islands, which said that 23 Japanese ships sank: 1 warship, 5 cruisers, 5 destroyers, and 12 other military ships. The damage America suffered, on the other hand, was only 2 light cruisers and 6 destroyers. The President even gave a speech on this topic at 8:30 tonight. The newspaper said that the Japanese aircraft carriers might have been much more severely damaged than the United States had imagined, judging from the fact that not even a single aircraft carrier was deployed by the Japanese forces. It also said that Japanese ships carrying between twenty to forty thousand men intended as reinforcements had been sunk and that the Japanese objective of recapturing Guadalcanal had essentially been thwarted.

When I went over to the lumberyard in Block 17, a white guard told me it was okay to pick up any boards shorter than about four feet. So I collected ten boards in that range and carried them home. Walking from Block 17 back to Block 38 wasn't that easy, but it was nice to have more boards for our house.

November 18 (Wed.)

U.S. Army Intelligence is trying to gather some Japanese in the appropriate age range with Japanese language ability. Examiners are visiting our camp for recruiting purposes. Since anyone joining this group will be excused from military service, parents of eligible youths are quite keen on it. It would be very hard indeed for the internees to have to serve in the military in this war. I hear that they already have about two hundred applicants.

November 21 (Sat.)

The United States has been celebrating their victory so much that I find it difficult to read the newspapers or to listen to the radio. Yesterday's newspaper said that the U.S. sank twenty-eight Japanese ships in the naval battle around the Solomon Islands. It also said that Buna in New Guinea was about to fall. But from other sources, we hear that Japan is claiming in a broadcast announcement to have inflicted considerable damage on the U.S. fleet. I wonder which claim is true. It makes me really depressed to read only American newspapers.

The Tanakas, who had been our next-door neighbors, moved to 3D today. Thanks to the fact that we got their room, our house has become considerably bigger. We put all the junk into the closet of the new room, put up a clothesline, and moved all the equipment for carpentry and painting into the new space. Our current room finally looks something like a real living space. Haruko and I were elated and said to each other,

"With this kind of space, we can finally get motivated to decorate."

November 25 (Wed.)

Every day, we have been hearing and reading stories about how well the U.S. forces are doing. I'm getting so depressed that I'm not in the mood for writing in my diary.

Aside from the actions by the United States, the newspapers don't seem to regard the Solomon Islands as an important issue. According to the newspaper, some Japanese troops penetrated deep into the area between Buna and Gona. Buna is now surrounded on three sides and the only way for the Japanese to escape is toward the ocean. The focal point now, they say, is on Timor Island, which serves as a base for Japanese air forces. Reading something like this every day in the newspaper and listening to the same stories on the radio a few times a day, one can't help but get depressed.

Someone, probably a white person who understands Japanese, catches the news aired in Japan and passes it on. According to that source, Japanese citizens are being told to rest assured not only because the Japanese military was overwhelmingly victorious in the Solomon Islands but also because Japan had captured many soldiers and ships around Alaska. Admitting that Japan had suffered some damage to their ships in the naval battle for the Solomon Islands, the news gave listen-

ers reassurance that everyone retreated safely. Hearing news like this, I suppose people from both countries feel encouraged to fight. But we're totally confused.

I've been pondering all day today. Has Japan actually lost all of their aircraft carriers? Or is it that Japan doesn't think aircraft carriers are necessary? I wonder if the story was true that some Japanese warships, which spread out into three groups to approach Guadalcanal Island, attacked one another by mistake in the darkness of the night. I have to put question marks on these points until the details become clear.

Since we put the kimonos into the *tansu* today, the closet has become empty. So we put some of the boxes scattered around the house into the closet. The house looks so much neater now. It's hard to believe it's the same place. But the news about the naval battle for the Solomon Islands kept me feeling down all day.

November 26 (Thurs.)

Today is Thanksgiving Day. This is a big holiday in the United States. I was wondering if there would be turkey, and then turkey was served for dinner tonight. They asked all the men to remain in the mess hall after dinner. They told us that the camp had received eighty freight cars of coal, but the cars would have to leave on Monday. They wanted us to unload all the coal in just three days and said

we needed fifteen volunteers from each block per day. We have forty-two blocks in all. If we have fifteen volunteers from each block, that's over six hundred people.

Tule Lake camp received forty freight cars of coal but they couldn't finish unloading it because they didn't have enough workers or volunteers. The rest was taken away when the freight cars had to leave. As a result, our block manager told us, the Tule Lake internees are facing inconveniences such as being able to take a bath only once a week. So we each picked a date we could volunteer and signed up. Since Sunday had the least number of volunteers, I signed up for that day.

I don't know the situation for the American people in general, but it seems like we're increasingly suffering from material shortages. The newspaper says that there are restrictions even on coffee. When we order merchandise from Sears, Roebuck and Co., we receive less than half of the order. For instance, I ordered two thick winter stockinet shirts per child, but I have received only a few of them so far. My order was for $15, but I received a $10 check back because many of the products were out of stock. Sometimes I ask someone going to a nearby town to get us something, but the stores often don't have what we want. I hear that trying to get an electric iron or an electric heater is absolutely hopeless. I wanted to get rubber boots for our children. So I looked through the catalogues from Sears and Montgomery Ward, but I couldn't find any. Maybe rubber boots have been discontinued.

November 29 (Sun.)

This morning I went to unload coal from the freight cars. I was in a light mood because I heard that we only needed to unload twenty-three cars. But when I saw the freight cars, I was very disappointed. We didn't have very many people on Sunday. The freight cars were all big ones, each of which would hold forty to fifty tons. Imagine how hard it was to scoop all that coal out with small shovels. We had about twenty people on each car scooping out the coal. It took two hours to dig two feet deep about six feet around oneself. I felt helpless. Nevertheless, I went back to work after lunch and came home after 4:00.

When I got home, the road was a muddy field. For each meal, we have to carry Shizuko, Yasuo, Yuzo, and Yoshiko on our backs to the mess hall because we can't let them walk in such conditions. Even my work shoes get uncomfortably wet from all the water seeping in. Now I'm dying for those boots in the boxes we left at Maryknoll, which would supposedly be shipped to us. We must have put Haruko's overshoes in one of those boxes, too. We would rather have the streets remain frozen like in the morning. That would be so much easier to handle. Haruko and I talked about it and agreed that we should finish our

errands in the morning while the streets are still frozen and stay inside once the ice starts melting.

December 1 (Tues.)

Kuromiya-sama visited me after lunch and told me about the people working on farms outside the camp and the situation in the town of Twin Falls. It's not too much to say that the farms in Idaho have been saved from possible catastrophe thanks to the Japanese laborers. The money Japanese people spend in Twin Falls is not trifling either. The Japanese people's popularity has done a complete turnaround. The camp's paper had a story the other day about a thank-you letter the governor sent to the camp, saying that Japanese workers had helped the state tremendously this fall.

Those who didn't have any money all went outside to work. It is Japanese people's nature to work diligently once they have a job to do. It may not be beneficial to Japan because those workers in a way are helping U.S. industry. But there are a lot of people who have no choice, other than working outside the camp, to earn money. And when they work, they work in accordance with their diligent nature. People in many states regarded the Japanese as worse than animals and boycotted them. After actually employing some Japanese, people here seem to have realized that Japanese workers can be useful.

But if the Japanese start purchasing or leasing land to engage in agriculture, a different kind of oppression might follow.

I have no idea what's going on in the Solomon Islands and New Guinea. The news we occasionally receive is written as though the annihilation of the Japanese military is imminent. Since that is in the back of my head, I feel uncomfortable. Even with my diary set in front of me, I find it hard to write. I'm dying to know the truth.

December 2 (Wed.)

There are trees growing among the sagebrush that are similar to sagebrush but somewhat different. If we peel the bark off and polish the wood, I can make fairly tasteful carved ornaments. Their shapes and hues are very elegant. It's starting to be a popular hobby among us to go collect these branches, although we can't find decent ones unless we go three to five miles out into the brush.

Just the other day, a couple of people were rescued and escorted back to the camp by a search party after having gotten lost in the brush. The day before yesterday, one person named Abe-san from Block 4 went into the brush and never returned. A search party was sent out and two planes joined the effort, but he hasn't been found yet. I heard that 300 people went out looking for him today.

With all this mud, we can't let our children play outside. Rubber boots aren't

available either. About four or five days ago, I ventured to wear my *getas* to the bath because I didn't feel like wearing my muddy shoes.[57] After taking one step, however, my foot got trapped in the mud and couldn't move. I managed to make it to the bath although I came close to falling a few times. On my way back, my *getas* got totally stuck in the mud. With no other choice, I took a few steps barefoot. It was so cold that I almost fainted. I hurried home, which was about twenty yards away, like I was dancing. By the time I got home, I was chilled to the marrow. What an awful feeling it was! After sitting very close to the heater for a while, my feet became burning hot.

December 5 (Sat.)

I copied a poem by "Red Dragonfly," who is an internee at Fort Missoula, onto a board and brought it to Sano-san's place. It reads,

> Binding what's unjustified together
> with what's justified, I pack
> my traveling bag.

> Muri mo ri mo, tomo ni
> karagete tabi kaban.

This must have been composed when the author was taken into custody. In an attempt to see how it would sound, I changed the word order from "what's unjustified together

with what's justified" to "what's justified together with what's unjustified." I think the reverse order works slightly better.

Putting myself in the author's shoes, I tried to write some poems. I found it very difficult but I eventually managed to compose the two that follow:

> Traveling bag, don't open
> yourself up too much.

> Tabi kaban, ōkina kuchi wa akemai zo.

> Please come with me, traveling bag,
> although this is not
> an ordinary journey.

> Ryokō naranedo otomo shi-
> tekure tabi kaban.

December 7 (Mon.)

It's been exactly one year. When I look back, everything has gone so quickly. It feels like it was just the other day when Pearl Harbor was attacked.

It's no wonder that time seems to have flown. Although we have seen the seasons change, we haven't had the chance to savor the beauty of the transitions between spring, summer, and fall before the earth has come around again. We have spent the whole year not even knowing the accurate situation of the war.

Today, I heard that the Japanese people in Manzanar rioted and some were shot dead.[58] According to follow-up stories I heard tonight, some internees at Manzanar were upset because they hadn't gotten paid for the work they had done, but they had to keep buying things.

In fact, I started working in October, but I haven't gotten paid for October or November. Nevertheless, I have to get ready for winter by buying some winter clothes for the children. I've been spending $5 here, $10 there, and the expenses have been accumulating. The packages containing most of our winter clothes haven't arrived from Maryknoll yet. I heard on several occasions that we were entitled to receive so many dollars for per person as family benefits. We have seen articles in the camp newspaper about that too. But we haven't yet received one penny. It's no wonder people are getting frustrated.

I used the sled that I made for the children to carry coal. It works really well. To walk sixty yards five or six times carrying a bucketful of coal in each hand is not easy, but to carry two bucketfuls of coal on the sled is just as easy as walking empty-handed. I was amazed to see how effortless it became with the sled and was deeply impressed with the wonders that snow can bring.

December 8 (Tues.)

I'm not sure whether that riot had any effect, but our block manager distributed some sort of application form for family benefits today. After we put the names and ages of the head of the family, spouse, and children and send it in, we will be eligible to receive clothing benefits of $3.75 for adults, $3.25 for children between the ages of eight and eighteen, and $2.25 for children under eight. If they are only getting around to doing this paperwork now, who knows when we will actually receive these benefits.

December 9 (Wed.)

About a week ago, they made a Japanese style bathtub for our Block 38. The tub is about 7 by 5 feet and is quite comfortable. There's no comparison how warm our bodies can get when compared with a western-style bathtub. It even feels nice to walk home in the snow afterward. I'm very thankful for this new addition. We'll probably feel its benefits even more as the weather becomes more severe.

December 10 (Fri.)

With the melting snow, the streets have become like a muddy swamp again. The coal is near our place, but we're unable to fetch it because of the poor condition of the street. Because people are edgy, any trifling thing triggers an argument. Maybe we have too much free time. Since we have many small children to keep ourselves occupied every day, we don't have time to worry about little things.

December 11 (Fri.)

The Japanese forces that had retreated to Gona in New Guinea have retreated even further to Buna to dig in, yesterday's newspaper reported. I don't know what they are planning to do. Is Japan intending to give up New Guinea? No, that is inconceivable. Is it some kind of mistake? From today's newspaper, it seems that the Japanese military has advanced from Burma into southern China.

I spent all day today making a lid for the iron pot in the mess hall, using a wooden board I got from Miyake-kun yesterday. Since it was a nice board, the lid I made turned out better than I expected.

Our baby has been coughing due to a cold. We used a poultice last night but the coughing hasn't stopped yet, but at least it's not accompanied by a fever.

December 13 (Sun.)

Today's newspaper reports that the Japanese military set up an airfield 150 miles from Guadalcanal in the Solomon Islands. This indicates that the battle for Guadalcanal may be becoming more and more problematic for the United States. The war situation is becoming more interesting now. Japan will not be cornered and discouraged so easily in New Guinea, either.

After lunch I went to collect sagebrush to use for Christmas decorations. It was the first time I walked out into the sagebrush field. One step out of our camp's gate, there is sagebrush as far as the eye can see. The height and shape of the branches reminded me of a tea plantation in my hometown, Shizuoka Prefecture. I almost forgot that I was in America, so far away from Shizuoka. Sagebrush, however, doesn't have leaves. When I took a closer look, I found that sagebrush, despite its small size, has the dignified look of huge trees. Every one had lichen covering its surface. They must all be hundreds of years old. The sagebrush are about four to five feet high. They live in the desert, suffering from a lack of water as well as severe windstorms. Since they have survived such odds, they have great shapes, like bonsai. I was utterly stunned.

When I cut the sagebrush, the scent coming from it was quite wonderful. It has a strong smell like pine trees with a gentle touch to it.

December 15 (Tues.)

We were told that we would receive our wages for the month of October, so I went to headquarters yesterday. Since I started working on October 5, I received $13.87, which was just short of the full monthly payment of $16. It's the first money I have received since we were sent to the camp in Puyallup last May. I appreciate any money I can get with Christmas just around the corner.

I'm planning to make some things out of greasewood and send them to a couple of Caucasian people who took good care of us while we were in Seattle.

December 16 (Wed.)

Each block is contributing $35 to hold a Christmas celebration. I already made my contribution about a week ago to the person collecting donations. So they sent me a few sheets of red, white, and green crepe paper, a few of silver paper, four sheets of cardboard, and some red, yellow, and green paper for decorations. These are not nearly enough, but I started to decorate the mess hall anyway. Although they were just ordinary decorations, they did bring a livelier atmosphere to the place.

Mrs. McRea sent us some Christmas presents. Some for our children, and even some for my wife and me.[59] Thanks to such generosity, we can now celebrate Christmas in a real Christmas mood. I feel very grateful. If we can add some small things to her gifts, our children will be extremely happy.

I'm also happy to report that they say we are likely to receive our clothing allowance as well as our wages for the month of November before Christmas.

December 19 (Sat.)

I went to headquarters to mail some Christmas presents to Mr. and Mrs. Scavatto and Mr. and Mrs. Lowell.[60] I had to walk more than a mile to mail these packages. I stopped at a different building on my way back and received my November salary in cash. I thought the wages might be ready and got lucky.

December 22 (Tues.)

We decided to decorate our Block 38 mess hall with the decorative paper and Christmas trees they distributed to help celebrate Christmas. Since I have one of the most flexible schedules, I started working on this project with a few other people. As we were decorating, the Nisei people started to complain about the way we were doing it and decided to take over. The younger generation had their own ideas and the outcome looked pretty good. They left untouched only the decorations we had done for the ceiling and reworked everything else. When it comes to a job like this, we should just hand it over to the young people. They didn't seem to mind spending a lot of time on the project and didn't lose their enthusiasm. The older generation can't really get into it as much as they can, nor are we as patient. Apparently, we have been defeated by the younger generation on this matter. It's probably for the best this way.

Some sugar has spilled onto
 the saucer under the coffee cup,
(I move my fingers toward it,
 but there's not even a pinch)
I miserly try to pinch some nevertheless.

Kōhī no sara ni koboreta satō ari,
(Yubi mote ikedo tsumamu
 hodo mo nashi)
Kokoro mazushiku tsumandemo miru.

During the Christmas party,
 our child on my lap
suddenly reminds me of reality
 when he urinates.

Kōtansai, iwai no en ni hiza no ko ni,
Oshikko sarete futo ima wo omou.

My pants are wet with the urine
 from the child on my lap,
I can't stir or the scent might
 start drifting off.

Hiza no ko no oshikko ni
 nureta waga pantsu,
Nioi mo yurete miugoki dekizu.

I've handed over the wet child,
but the party seems to have lost its appeal.

Shikko shita hiza no ko wa watashitaga,
Shukuga no en wa samegachi ni miru.

Holding our wet child,
my wife watches the celebration,
 standing by the window alone.

Shikko shita kodomo wo daite tsuma hitori,
Shukuga no en wo madogiwa de miru.

December 26 (Sat.)

As I worked on my project for the mess hall, I overheard some people saying that it was the most relaxing Christmas they had had since they came to America over twenty years ago. Returning home from the Christmas party at the mess hall last night, we said the same thing. It's funny that other people share the same feeling about this.

December 28 (Mon.)

Bathed, dressed in pajamas
 and all tucked in,
The children start demanding water.

Yu ni irete nemaki wo kisete nekasarete,
Mizu nomitai to kora wa iidasu.

On some days peace seems
 within our reach,
On other days it still seems far away.

Heiwa no hi chikayottari to omou hi to,
Mada tōkaran to omou hi to ari.

We were told it would hardly
 ever rain in our camp,
But we've had a lot of rain
 and snow this December.

Ame nashi to kikasarete
 kita kono kyanpu,
Ame yuki ōki jūnigatsu nari.

When evening comes, not having
 hot or cold water or a latrine inside,
Means I can't even take off
 my shoes and relax.

Yu mo mizu mo benjo sae
 naku yoi kureba,
Yukkuri shitaku mo kutsu sae nugezu.

December 30 (Wed.)

Our Block 38 meeting was held last night. These items were on our agenda.

1. It's not likely that we will receive enough *mochi* rice by New Year's Day. How about postponing the New Year's celebration until the 7th?
2. We have a ration of one teaspoonful of sugar per person for coffee in the morning. Why don't we refrain from using sugar in our coffee and save it for mak-ing *yōkan* for a part of our New Year's food?[61]
3. How about establishing a women's auxiliary for Block 38?
4. Get male volunteers for pounding *mochi* and female volunteers for cooking *zoni*.

Some people complained about Item 2, saying that a teaspoonful of sugar in the morning was not enough to begin with. They don't think it's worth not using sugar in their coffee for a week just to have a slice of *yōkan*. Basically there were two groups of people. One group says: "We're in a war. This is not a time for celebrating New Year. What's the point of celebrating? We're in camp." The other group says: "Because we're in a war and have been put into camp, we don't have any other consolation. For that very reason, we at least have to celebrate New Year's Day." It'll be hard to reach a consensus because both groups have good points.

Kuromiya-sama suggested that we should go into the sagebrush together to collect some greasewood, so we went there this morning. It took us an hour and forty-five minutes to get to the greasewood. We left that spot just after 3:00 and returned home at 4:25 p.m. If you go through the Block 44's gate, situated on the southern edge of camp, and keep heading south through the sagebrush follow-ing the power lines for about fifty minutes, you come to the point where the power lines curve eastward. If you continue following

those power lines for a while, you see more and more greasewood among the sagebrush. I find it interesting that we see greasewood only on rocky hillsides.

All the high and undulating hills around here are rocky. Eons ago, this must have been a huge field covered with nothing but rocks. Over many, many years, dust blown by the wind probably began to cover the lower ground, and the tall hills have retained the same rocky formation from time immemorial. Many are huge solid rocks. Some of those huge rocks have cracks that remind me of the stone walls surrounding a castle. All the rocks are horizontally separated like flat *mochi*, and they have vertical cracks as well. They look like *senbei* that are squashed down.[62] Some are about a foot thick. It seems like there are a lot of rabbits. Even during the daytime, I see them running through the sagebrush. "If only there were no rattlesnakes, this would be a perfect spot for a field trip in spring and summer," we said to each other. The air is clean, the view is good, and the landscape is quite graceful.

1943 (SHOWA 18)

January 1 (Fri.)

I helped with the *mochitsuki* until eleven o'clock last night.[63] Since two bags of *mochi* rice were distributed to each block, we decided to use half for *zoni* on New Year's

Day and the other half for *zoni* on the 10th, when we will have our New Year's party.

We had only two meals today. Breakfast at 10:30 am, and dinner at 4:30 pm. We gave all the workers in the mess halls a day off, so all the wives from Block 38 worked in the mess hall. We had *zoni*, tuna sashimi, and a bowl of soup. Since we hadn't been expecting anything like this, it was such a treat. After *mochitsuki* last night, we even had *udon* instead of the traditional *soba* for New Year's Eve at Sano-san's place. That was something.

Now that a new year has begun, the question that remains is whether or not the war will end this year. I think I'll let fate run its course and just try to enjoy each and every day.

January 2 (Sat.)

Even having had *zoni*, sashimi,
 and a bowl of soup,
it still doesn't feel like New Year.

Zōni mochi sashimi suimono tabe oete,
Sate shōgatsu to iu ki okorazu.

January 6 (Wed.)

A poll was taken about whether the Japanese Issei and Nisei should be allowed to return to the Pacific Coast area after the war. According to the Gallup survey, the results are as follows:

Oppose return = 31%
Favor return = 29%
Favor citizens' return = 24%
Undecided = 16%

January 15 (Fri.)

We started cleaning the chimneys in Block 38 yesterday. We have three chimneys per barrack, which makes a total of thirty-six chimneys. Every two households share one chimney and we have seventy-two heating stoves. We also have four chimneys in the laundry room, five or six in the kitchen, and some more in the recreation hall. That's quite a few chimneys altogether. We took care of three barracks yesterday and did three more today. So half of the living quarters are finished. I didn't like the idea of cleaning chimneys at first. But once I tried it, it wasn't as bad as I had feared. People can do pretty much anything if they are willing to try.

January 20 (Wed.)

Yesterday and the day before yesterday were the coldest days yet with the temperature dropping down to the low 20s. I went to headquarters in that cold to receive our clothing allowance check in the amount of $85.75 for July through October. I cashed it in Block 23 on my way home. When I stopped at Haruko's parents' place in Block 14, the cold finally got to me and I felt ill. I lay down

for about half an hour to gather the strength to make it home. It was too cold for only a leather jacket over a sweater.

The cold is very severe. It's not as bad as Manchuria, where my runny nose would freeze inside the nostrils and start crunching, but it's close. The water in the basin, set in the hallway between our front door and the door to our room, was frozen at the top and bottom. I was amazed to see the fish inside the basin was still swimming sandwiched by sheets of ice. "It has finally come," we say to each other instead of saying "Hello." But the severe cold was gone today, replaced by a snow and water mixture, sort of like the shaved ice we used to eat in the summer. The way to and from the children's school was arduous.

> Water in a puddle freezes and separates
> from the ground.
> As it shatters, it sounds like
> breaking glass.

> Mizutamari mizu wa kōtte chi wo hanare,
> Gurasu no gotoki oto shite warenu.

January 22 (Fri.)

For a while, they have been encouraging us to work outside the camp. "They threw us into this camp just as they pleased. We won't go out now just because they ask us to." This is an opinion shared by the majority of Japanese

people. Having had our businesses and every-thing else taken away, we can't make a living in an unfamiliar place now.

The criticism of Mr. Ogawa, the Chief Cook, is finally taking concrete shape. The women in Block 38 have decided to sign a petition demanding that he reflect upon his shortcomings. The representative of this women's group came to our door tonight to get our signatures. Since we're discontented with the food given to our children, we agreed to sign. It'll probably be good if Mr. Ogawa gets severely rebuked.

January 29 (Fri.)

Over the past week, the mess hall reform movement has become a big issue in our block. As I wrote on the 22nd, people were going door to door collecting signatures for a petition, and that information leaked out to the mess hall workers. Last Tuesday night, all the workers declared they would resign and give us the key to the mess hall. We needed to examine the food situation, so Mr. Kibe, Mr. Kakefuji, and I went into the pantry to write down everything stored there.

Eventually the women came over and started talking about the preparation of the next day's breakfast. We fired up the kitchen stoves and got down to work right away. Since then, the women and a handful of men have managed to handle the cooking

for three days—Wednesday, Thursday, and Friday.

Meanwhile, there was a meeting last night at 7:00 in our mess hall. We decided to elect two committee members from each block and to entrust them with settling the issues. The original objective of this reform move-ment was to demand from Mr. Ogawa the following:

1. No gambling in the kitchen.
2. Serve everyone equally.
3. Don't remove things from the mess hall.
4. Don't force the women on laundry duty to help in the mess hall. Hire more cooks if necessary.
5. Persuade the head waiter to take stock of himself, or lay him off.

There was one more item, but I can't remember what it was. According to my memory, though, we heard only the top three items from the person who came to our door collecting signatures for the petition.

In response to these demands, the mess hall's counter-demands are as follows:

1. All mess hall workers be allowed to return to work.
2. The main activists of this protest move-ment have to move somewhere else.

They are insisting on these two. And there was one more thing. The mess hall workers

apparently want an apology from the people who started this reform movement. These demands will be presented from the mess hall side at the block committee meeting tonight. I'm very interested to see how this will be resolved in the end.

It seems to be quite common for there to be issues between block residents and their mess halls. We hear the voices of dissatisfaction everywhere. I hear that the youth group in Block 28 is holding a meeting to discuss suggestions to improve their mess hall services.

An extra edition of the camp's newspaper *Minidoka Irrigator* was issued today, telling us that the U.S. military is forming a unit by recruiting eligible Japanese Nisei. They are giving the Nisei a chance to show their loyalty to the United States. I feel really grateful for that.

February 9 (Tues.)

The mess hall workers are still on strike. The women's group took the issue to Stafford, and Stafford assigned George Takigawa of the Fair Labor Committee to handle the matter. I heard that someone came from the Steward's Division today and told us that they were planning to settle this matter within a couple of days. Mr. Ichikawa, Mr. Fujimura, and Mr. Uchida are considered to be on the cooks' side.

February 13 (Sat.)

I spent half the day flying kites with the children.

Since the day before yesterday, the former cooks have been back. They came with George Takigawa, and pretty much forced their way back into the mess hall. I was fed up with working to serve our block. So, yesterday morning, I told Tajima-kun, our block manager, that I would quit. He said he was also thinking about quitting in the near future and would like for us to quit together. I said "Okay," so I'm in an in-between stage right now.

March 2 (Tues.)

I haven't written in this diary for a long time. When I write, there are things to write about, and when I don't, there doesn't seem to be much going on. Mr. Ogawa, the Chief Cook at our mess hall, had left work for about a week, but now he's back again. I'm stunned to see him back showing no remorse after causing such a huge commotion. The mess hall has the same people working there as before. Nothing has changed except that they have two new women from our block working as dishwashers.

Calling on the spirits to perform divination about the war has been popular in the camp for quite some time. It's not just in our camp, but it's also popular in other camps

as well. According to these spirits' fortune-telling, the war will come to an end in four months. It will be over by June and we will be able to go back to Seattle, they say. It's too good to be true. But if it is true, it calls for rejoicing. Even unreliable news like this is enough to gladden our hearts. It may well be that there are signs in heaven indicating the war on earth will end in four months, as said by *Seicho-No-Ie*, and that the spirits are informing us of these signs.[64]

Since we were able to buy shoes today, Haruko went to Block 23 to obtain a permit, and she bought five pairs, for Yoshiko, Yuzo, Yasuo, Shizuko, and me. Now I don't think I'll need to worry about new shoes until the end of the year.

The situation inside the country is quite a mess. Price controls on agricultural products were voted down by the Senate overwhelmingly, and people are now worried about the inflation that is sure to come. The demands for higher wages from railroad workers are not going anywhere. There seems to be trouble at aircraft factories along the Pacific Coast. The labor shortage in agriculture is getting serious. The domestic situation is really complicated. Unless the war ends sometime this year, this domestic turmoil will get even worse. Our meals have become poor compared with when we first came. The butter is now artificial, the bread is now potato bread, and the meat comes in extremely small portions.

March 5 (Fri.)

A Japanese transport convoy of twenty-two ships going from Rabaul, New Britain, to Lae, New Guinea, was completely destroyed by the U.S.–Australian aerial forces. Fifteen thousand Japanese soldiers and several thousands marines were swallowed up by the sea, the newspaper said.

When I think about this, there's something strange about it. As I wrote in my March 2 entry, to announce or to print in the newspaper that "The U.S. and Australian aerial units are waiting for the weather to clear, and getting ready to strike because they have spotted a Japanese transport convoy," is very strange to begin with. That sort of information should be classified by the military until everything is said and done. No matter how you slice it, announcing before their attack that the U.S.– Australian aerial units are getting ready to strike just as soon as the weather clears is odd. This could be a phony story. It stinks. It's fishy. Although I think the story is unreliable, I still can't help feeling somewhat apprehensive.

March 23 (Tues.)

Clear and sunny. Spring has come.

At dinner, we gave a send-off party for those who have volunteered for military service from this camp. There were six enlisted soldiers from Block 38. A turkey dinner was

served. The newly enlisted soldiers were seated in front and we celebrated them going to war. There were over three hundred volunteer soldiers from this camp.

March 30 (Tues.)

Mr. Osawa, Mr. Kinomoto, Mr. Kamei, and Mr. Yamauchi were reelected at the Chief Cook Meeting last week as supervisors of the Steward's Division. So long as they are in those positions, mess hall reform in Block 38 will not happen. They seem to be prouder of their titles as supervisors of the Steward's Division than anything else. And they try to have it their way by siding with the Chief Cooks on everything, without considering whether the Chief Cooks' behavior is right or wrong. They don't seem to have any Japanese consciousness left at all. Chief Cook Ogawa and the others in Block 38 don't seem to have the slightest sense that they are entrusted with the well-being of over three hundred of their countrymen. They know they have four people in the Steward's Division backing them, and they don't think they will get fired no matter what they do. So they are getting carried away. They are pathetic, but there's nothing we can do about it.

What can we do to cultivate Japanese awareness in them? They are gambling in the mess hall between meals just like before. They seem to be distributing the rationed soy sauce and eggs to Mr. Eiichi Uchida's

and some other families. It is not acceptable behavior to take advantage of their position to steal supplies. We now live in safety ultimately because of Japan. Thanks to Japan, we can eat. Although the food is supplied by the U.S. government, we owe it to the Japanese government all the same. Those people have an important responsibility to protect Japanese internees' health for Japan. But that thought probably doesn't cross their minds. Even if they don't think that far ahead, I think it's common sense to be fair when we're all living under similar conditions in this camp. Young people are after all void of humaneness.

March 31 (Wed.)

A shortwave broadcast originating from Japan reported that the Japanese forces that landed in Australia were steadily advancing and that 45 Japanese planes had pressed on ahead with a major bombing raid over Sydney.

The American newspaper, however, doesn't even have a single line mentioning a Japanese landing in Australia. Rather, today's paper reports that three Japanese destroyers were spotted near the eastern edge of Huon Peninsula in New Guinea, where the Japanese forces are based, and that the largest one was hit by a bomb in the stern while the two others ran away. It said that the destroyer hit by the bomb probably went to the bottom of the ocean.

In addition, the paper went on to say that if the destroyers were being used to supply food and ammunition, this would mean that Japan could no longer use the slower merchant vessels for that purpose due to the increased threat coming from the U.S.–Australian aerial forces. The Japanese military in New Guinea is getting into an increasingly tighter spot, the paper says. With all this conflicting information, we don't really know what is going on with the battle in the South Pacific.

If the news from the Japanese shortwave broadcast were true, the United States and Australia wouldn't be able to focus on the battle for New Guinea. For the moment, I really don't know what to believe. I think the truth will eventually be revealed.

[The entries from March 31 to September 24, 1943, are solely accounts of the war and have been omitted from this publication. Two with personal interpretations of the news appear below. The diary stops or the pages are lost from September 1943 to June 1944.—ed.]

June 5 (Sat.)

After Haruko fell asleep with the children around 10, I've been thinking about Japan's lost battle for Attu.[65] Strange as it may seem, it suddenly occurred to me that the whole thing might have been just made up by the United States. I don't have any plausible proof of anything now. But the way the Attu battle developed was too perfect for the U.S. From beginning to end, everything worked to the advantage of the U.S. military. Even if the U.S. brought huge forces of twenty to thirty thousand troops against Japan's defense of two thousand men in Attu and caught Japan off guard, everything sounded too good to be true. If that was how it actually happened, it makes the Japanese soldiers seem too weak.

I have extensive knowledge about Japan and the Japanese military. I just don't understand it. Even though Japan wasn't prepared for the U.S. attack, I can't see how Japan could be so utterly humiliated by the U.S. forces, just because the U.S. forces were five or ten times bigger than theirs. Someone told me that the Japanese shortwave broadcast claimed that all U.S. soldiers on Attu were completely wiped out as of the 21st. Now I'm beginning to think that story may be true. The photos of the Attu battle in the paper from Twin Falls raise a lot of questions I don't have answers to.

The main reason I began to doubt the credibility of the media coverage was an article reporting that Prime Minister Tōjō offered his prayers at the Yasukuni Shinto Shrine to comfort the spirits of the two thousand soldiers who died defending Attu.[66] The U.S. media says that there are still some Japanese soldiers remaining in the moun-

tains on Attu. It may be one hundred, two hundred, or fifty soldiers. No matter how few there may be, they are still fighting. If so, why did Prime Minister Tōjō have to go to the Yasukuni Shrine to console the spirits of the two thousand defending soldiers? Even if there's only one soldier left fighting against the U.S. forces, we can't say that there's absolutely no hope of reclaiming Attu. The Prime Minister wouldn't go to Yasukuni Shrine in that case either.

The Attu battle will be over only when the last soldier falls. And the Prime Minister shouldn't go and pray at Yasukuni Shrine until that happens. Prime Minister Tōjō can't be so stupid as to visit Yasukuni Shrine while there are still some Japanese soldiers fighting. Such behavior is simply not permissible for Japanese warriors. If you lose your weapon, you bite your enemies if you must, or do anything else to fight on until your last breath, never losing hope of victory until the final moment. That's the Japanese philosophy and that's common sense among Japanese military men. I believe the two thousand soldiers defending Attu must have been a selected elite. Because of my belief, I will leave a question mark on the U.S. media coverage for a while.

July 18 (Sun.)

Although I don't know whether it was about the Kwantung army or not, but I'm putting this information down.[67] The Japanese mili-

tary today said that they are holding more than 870,000 British and American soldiers prisoner. Can this be true? From which battles did Japan obtain so many prisoners anyway? The American newspapers are too one-sided toward America. The news from Japan is too favorable toward Japan.

[The July 18 entry then reiterates war news and is the last for eleven months.—ed.]

1944 (SHOWA 19)

June 18 (Sun.)

I'm beginning to think that Russia may play a role as a mediator between Japan and the United States to achieve peace after all. I think there may be a closer relationship between Japan and Russia than people believe. Or is it just my imagination as an outsider? Am I taking a side and trying to interpret things favorably for Japan? I just have to wait and see what happens later.

July 14 (Fri.)

We haven't been able to listen to the news from Japan. But judging from what we read in the American newspaper and what has been going on lately, Japan seems to be facing a dead end. U.S. airplanes are currently bombing Rota Island and Guam. The U.S. military is proud of these tactics, which they

claim to be contrary to what Japan may have foreseen. I wonder if that's true. Isn't Japan supposed to be good at appearing in unexpected places? Or is Japan totally helpless because of the operations of U.S. Navy Task Force 58? Just as we all worried about the Attu battle, everyone is really discouraged about the current war situation.

July 20 (Thurs.)

With Saipan captured by the United States, Japan has now suffered a significant blow to its defenses. Prime Minister Tōjō, perhaps taking the responsibility on himself, resigned.

[Final entry.—ed.]

ORANGE

Kamekichi Tokita
Translation and Romanization by Michiyo Morioka

Don't know when
an orange
rolled under the bed.
Shriveling day by day,
leaning slightly like the earth with its tilting axis.
And, shriveling day by day,
mountains form, valleys deepen.
Remembering after four or five days,
take a peek.
It is still there, quietly,
near old shoes covered by dirt.
Dirt? Dust?
. ?
Oh, it's mold!
Look closely,

fine layer all over the surface.
Another peek after several days,
now pure white.
On the light-gray floor board.
Faint but like drops,
green dots are there!
Malachite green . . . !
It's mold! Green mold!
Another peek after several days,
green mold has colored almost everywhere.
And, look carefully,
something moves
barely, barely.
Pale worms, worms have bred.
If touched, the orange will fall apart.

Grasses and trees veiling the earth like green mold,
humans with pale faces looking like worms,
the earth is already rotten.
If touched by God's hand,
it will break.

Looked under the bed the next day,
the orange was gone, the old shoes were gone.
Even the gray dust.
Everything.
Thrown into a garbage can?

The rotting earth, too,
may be thrown into the garbage
by God's hand.
It's
about time.

ORENJI

KT sei

(This romanized version of the Japanese original retains Tokita's use of lines and dots)

Itsu no maniyara
beddo no shita ni, korogekonda,
orenji hitotsu.
Hini hini, shinabite iku.
Ryōkyoku wo yaya keisha saseteiru chikyū no yōni,
sukoshi naname ni natta mama.
Soshite, hini hini shinabite iku.
Yama ga dekiru. Tani ga fukaku naru.
Shigonichi shite, omoidasu mama,
nozoite mitara,
mada aru. Shizukani.
Chiri ni mamireta furugutsu no soba ni.
Chirikashira? . . . hokorikana?
. ?
Aa, kabida!

Yoku mireba, usuku ichimen ni.
Nisannichi shite, mata, nozoitara,
masshirodatta.
Usunezumiiro no yuka no ue ni.
Kasukanagara, pottsuri to
aoi tenten ga mieruzo!
Rokushōiro no ?
Kabida! Aokabida!
Mata nisannichi shite mitara,
aokabi wa, daibubun wo someteita.
Soshite,
yoku mireba,
ugoku mono ga aru.
Kasukani, kasukani,
aojiroi mushida. Mushi ga waitanoda.
Te wo furetara, orenji wa kuzureyō.

Chikyū wo outa aokabi no kusa ya ki yo,
aojiroi kao shita mushi no yōna ningen yo,
chikyū wa mō kusarete iru.
Kami no te ga furetara kowarerudarō.

Tsugi no hi nimo, beddo no shita wo, nozokikondara,
orenji wa nakatta. Furugutsu mo nakatta.
Haiiro no chiri saemo.
minna.
Gyabējikan ni suteraretakana?

Kusarekakatta chikyū mo,
kami no te de,
gyabēji no naka ni suteraretemo,
mō.
Yoi jibundana.

EXHIBITION HISTORY

The following list includes only those exhibitions for which English documentation exists.

17th Exhibition of Northwest Artists,
 Seattle Art Institute; *Street*, second
 prize in oil
First Annual Exhibition of Western Watercolor
 Painting, California Palace of the Legion
 of Honor, San Francisco
First Annual Exhibition, Bay Region Art
 Association, Oakland Art Gallery

1932

18th Annual Exhibition of Northwest Artists,
 Seattle Art Institute
Washington State tour of selected works from
 18th Annual Exhibition of Northwest Artists

1933

Inaugural exhibition of paintings by Seattle
 artists, opening of Seattle Art Museum
Selected paintings to complement American
 Federation of Art traveling exhibition,
 Young Americans, Seattle Art Museum
Selected paintings from the collection, Seattle
 Art Museum
19th Annual Exhibition of Northwest Artists,
 Seattle Art Museum; *Drug Store*, third
 prize in oil

1934

National Exhibition of Work Produced under
 the Public Works of Art Project, Corcoran
 Gallery of Art, Washington, D.C.
Selected work by Washington artists in the
 Public Works of Art Project, Seattle Art
 Museum

Oil Paintings by Four Japanese of the Pacific
 Coast, co-organized by Seattle Art
 Museum and California Palace of the
 Legion of Honor exhibited at both venues

1935

55th Annual Exhibition, San Francisco
 Art Association
21st Annual Exhibition of Northwest Artists,
 Seattle Art Museum
Group of Twelve (rotating exhibitions),
 Penthouse Gallery, Seattle
Bay Region Art Association First Annual
 Exhibition, Oakland Art Gallery
Solo exhibition, Seattle Art Museum,
 December 11, 1935–January 5, 1936

1936

Group of Twelve (rotating exhibitions),
 Penthouse Gallery
Group of Twelve (oil paintings), Tacoma
 Art Association, Tacoma, Washington
Group of Twelve (watercolors), Tacoma
 Art Association
Group of Twelve, Seattle Art Museum
First National Exhibition of American Art,
 Rockefeller Center Gallery, Municipal
 Art Committee, City of New York
22nd Annual Exhibition of Northwest Artists,
 Seattle Art Museum

1937

American Artists' Congress, Inc., Portland
 Branch, National Membership Exhibition;

Portland Art Museum, Portland, Oregon;
traveled to Seattle Art Museum

1938

Drawings by the Group of Twelve,
Seattle Art Museum

1943

Art Exhibit, Minidoka Relocation Center,
Jerome County, Idaho

1948

34th Annual Exhibition of Northwest Artists,
Seattle Art Museum

1972

Art of the Thirties: The Pacific Northwest,
Henry Art Gallery, University
of Washington, Seattle; traveled
to Portland Art Museum

1989

100 Years of Washington Art: New Perspectives,
Tacoma Art Museum

1990

Views and Visions of the Pacific Northwest,
Seattle Art Museum

1994

*They Painted from Their Hearts: Pioneer
Asian American Artists*, Wing Luke
Asian Museum, Seattle

*The View from Within: Japanese American Art
from the Internment Camps, 1942–1945*,
Japanese American National Museum,
Los Angeles, California

1995

*Japanese and Japanese American Painters
in the United States, 1896–1945: A Half
Century of Hope and Suffering*, Tokyo
Metropolitan Teien Art Museum, Tokyo;
traveled to Oita Prefectural Art Hall
and Hiroshima Museum of Art

2011

Kamekichi Tokita and Kenjiro Nomura,
Seattle Art Museum

NOTES

ABBREVIATIONS

AAA Archives of American Art,
 Smithsonian Institution
SCUW Special Collections,
 University of Washington Libraries

BIOGRAPHY

1 Marius B. Jansen, "Cultural Change in Nine-teenth-Century Japan," in *Challenging Past and Present: The Metamorphosis of Nineteenth Century Japan*, ed. Ellen P. Conant (Honolulu: University of Hawai'i Press, 2006), 31–32. For the Imperial Rescript on Education, see http://www.japanorama.com/zz_ebook/eb_IROE_1890.pdf; http://www.bookrags.com/history/imperial-rescript-on-education-ema-03 (accessed 8/26/09).

2 See Ezra R. Vogel, "Kinship Structure, Migration to the City, and Modernization," in *Aspects of Social Change in Modern Japan*, ed. R. P. Dore (Princeton, NJ: Princeton University Press, 1967). I thank S. Frank Miyamoto for the reference; personal communication, June 18, 2009.

3 Whether or not the Tokitas were truly of samurai lineage is unknown; family composition in Japan was fluid, based more upon practical need than blood-kinship, and it was customary for families within a powerful samurai's domain to adopt the name honorifically.

Much of the personal information in this chapter comes from communications in 2008–9 with Shokichi Tokita, the artist's eldest son.

4 The Tokitas later had a baby boy of their own, but because they had an adopted son, they respected tradition by giving their birth son to another family. Francis Fukuyama describes nonkinship-based relationships in feudal Japan and the resultant fluidity of family ties, in *Trust: The Social Virtues and the Creation of Prosperity* (New York: The Free Press, 1995), 171–83. The reference is from Miyamoto, personal communication, June 18, 2009.

5 Wahei Tokita worked in his father's company until the firebombing of Shizuoka in 1945, which destroyed their factory and two-thirds of the city. After the war, their business changed from brewing to retailing of soy products.

6 Two sons died in infancy, one in 1896, another in 1903. After Shin Kato's death, Juhei married twice more: his second wife died within a month of their marriage in 1917, and in 1918 he married

Kuma Ohsawa. Masaki Norizuki (Wahei's grandson), personal communication, October 14, 2009.

7 Tokita recited the story in his article, "Jew Them Down," *Town Crier*, December 5, 1931, 66.

8 Tokita attended Shogyogakko Shizuokaken from 1910–15. *Shogyogakko* were commercial vocational schools, part of the formalized levels of education established by the 1880 Education Orders and strengthened by additional regulations in 1884. They were a part of a two-level middle-school education for students aged fourteen to nineteen. The first level of middle schools, typically four years, prepared students for upper- and middle-class careers; the second level of vocational schools, typically two years, provided specialized commercial, agricultural, or technical training, while academically focused middle schools prepared students for university. Either level could be shortened by one year; Tokita completed the course in five years. For the educational system and vocational schools, see "The Formation of the Modern Educational System," http://www.mext.go.jp/b_menu/hakusho/html/hpbz198103 (accessed 9/10/09). For Tokita, Family #11048 Evacuee Case File, U.W. War Relocation Authority, U.S. National Archives and Records Administration, 31. File in possession of Yoshiko Tokita-Schroder.

9 Tokita did not serve in the military. Despite the two years' mandatory military duty and heightened tensions in Manchuria at the time because of Japanese expansion, Tokita was sent to Manchuria for business purposes only. This was confirmed by his brother-in-law, Warren Suzuki, personal communication, September 15, 2009, and stories told to his eldest son, Shokichi, by his widow, Haruko.

10 Told to Ken Tokita by Katuichi Katayama, ca. 1960. Ken Tokita, personal communication, September 25, 2009. For more on Katayama, see Louis Fiset, *Imprisoned Apart: The World War II Correspondence of an Issei Couple* (Seattle: University of Washington Press, 1997), 7, 9, 10.

11 Masaki Norizuki recalled a family story of Tokita's drawing sketches of performances after attending the theater. Personal communication, October 14, 2009.

12 This account was told to Ken Tokita by Katuichi Katayama and Paul Horiuchi, both of whom had heard the story from Tokita. Ken Tokita, personal communication, September 25, 2009. Warren Suzuki learned from Tokita about his studies in Manchuria. Personal communication, September 15, 2009.

An alternate story tells of Tokita's returning to Shizuoka from Manchuria to teach English and his desire to go to the United States to further his knowledge of English. The details of Tokita's rebellion and their father's calling Wahei home were told by Wahei's family to Shokichi Tokita. I have combined the elements of both stories traceable to original sources.

13 Of 7,874 Nikkei in Seattle in 1920, 6,011, or 76 percent, were Issei. See S. Frank Miyamoto, *Social Solidarity among the Japanese in Seattle* (Seattle: University of Washington Press, in cooperation with the Asian American Studies Program, University of Washington, 1984), 14. First published in 1939.

14 Miyamoto, *Social Solidarity*, 11.

15 Cited in Doug Blair, "The 1920 Anti-Japanese Crusade and Congressional Hearings," in the Seattle Civil Rights and History Project, http://depts.washington.edu/civilr/Japanese_restriction.htm#_edn9 (accessed 3/17/09). Blair's article examines the role of Washington Congressman Albert Johnson, who called the 1920 hearings and co-authored the 1924 Immigration Act.

16 The constitutional prohibition was directed to "aliens without rights in citizenship," which pertained only to immigrants from Asia. See Nicole Grant, "White Supremacy and the Alien Land Laws of Washington State," Seattle Civil Rights and Labor History Project, http://depts.washington.edu/civilr/alien_land_laws.htm (accessed 9/10/09).

17 Cited in the United States Supreme Court Case *Ozawa v. United States*, 260 U.S. 178 (1922),

http://www.multiracial.com/government/ozawa.
html (accessed 6/30/09).

18 Some of these notes are among his personal
 papers.

19 Tacoma also had a substantial community,
 although it was largely destroyed by wartime
 internment and did not revive. There were small
 communities in Spokane and Yakima.

20 I thank Roger Daniels for emphasizing this
 point. Personal communication, November 6,
 2009. For the relationship between the Japanese
 associations and consulates, see Daniels, *Asian
 America: Chinese and Japanese in the United
 States since 1850* (Seattle: University of Washing-
 ton Press, 1988), 128–33.

21 Miyamoto describes this formalized interdepen-
 dence in Seattle in *Social Solidarity among the
 Japanese in Seattle*. See also Theodore C. Bestor,
 Neighborhood Tokyo (Stanford, CA: Stanford
 University Press, 1989), 261–68, on the "old
 middle class" in Japan. The reference is from
 Miyamoto, who pointed out Japan's distinctive
 middle-class character. Personal communica-
 tions, June 16 and 18, 2009.

22 Diary, December 10, 1941.

23 Kansuo Ito, *Issei: A History of Japanese Immi-
 grants in North America*, trans. Shinichiro Naka-
 mura and Jean S. Gerard (Seattle: Executive
 Committee for publication of *Issei: A History of
 Japanese Immigrants in North America*, Japanese
 Community Service, 1973), 729–30.

24 Ito, *Issei*, 834. Ito notes that Kayo Tankakai
 lasted until World War II and after the war,
 reorganized as Seattle Tankakai.

25 Mayumi Tsutakawa, editor, *They Painted from
 Their Hearts: Pioneer Asian American Artists*
 (Seattle: Wing Luke Asian Museum, 1994),
 23–24.

26 On Shigetoshi Horiuchi, see Barbara Johns,
 Paul Horiuchi: East and West (Seattle: Univer-
 sity of Washington Press in association with
 the Museum of Northwest Art, La Conner,
 Washington, 2008), 4–9. The antique shop is
 described in Sally Todd, "The Horiuchi Collec-
 tion," *Town Crier*, Christmas 1930, 39; dates of

operation are unknown. Seattle city directories
list Shigetoshi Horiuchi as business manager
of *The North American Daily News* from 1917 to
1934.

27 His collection was featured in a major exhibi-
 tion of Japanese art at the Seattle Art Institute
 in March 1930 and, at year-end, was placed there
 on long-term loan. The loan was hailed as the
 prestigious beginning of the Art Institute's col-
 lection. Seattle Art Institute, Director's Report,
 December 20, 1930. Seattle Art Museum,
 UWSC, Acc. 2636-001, Box 33/22.

28 They were S. Haigiuda, Azu Nakagawa, S.
 Oishi, Toshi Shimizu, and Yasushi Tanaka.
 With the exception of the Fourteenth North-
 west Annual in fall 1928, Nikkei artists were
 represented in the juried exhibitions every year
 to 1942.

29 Adele M. Ballards, "With the Fine Art Folk,"
 Town Crier, October 7, 1916, 12–13. For Ballards's
 role, see Anne H. Calhoun, *A Seattle Heritage:
 The Fine Arts Society* (Seattle: Lowman and
 Hanford, 1942), 42. *Town Crier* was published in
 Seattle from 1910 to 1937.

30 Tanaka to Frederic C. Torrey, February 9, 1920.
 Yasushi Tanaka Papers, AAA, reel 5474.

31 The fullest biographical account of Nomura is in
 June Mukai McKivor, ed., *Kenjiro Nomura: An
 Artist's View of the Japanese American Intern-
 ment* (Seattle: Wing Luke Asian Museum, 1991),
 55–81.

32 Olivia Malstrom Carl (1903–1988), a Tadama
 student about this time, recalled her classmates
 as nearly all Japanese American. Carl to David
 F. Martin of Martin-Zambito Fine Arts, ca.
 1989–90. Martin, personal communication,
 December 17, 2008. See also Kazuko Nakane,
 "Facing the Pacific: Asian American Artists in
 Seattle, 1900–1970," in *Asian American Art: A
 History, 1850–1970*, Gordon H. Chang, Mark
 Johnson, and Paul Kerlstrom, eds. (Stanford,
 CA: Stanford University Press, 2008), 57.

33 Nomura's study with Tadama, 1919–24, was
 likely only occasional. Tokita's study with
 Nomura is dated in one source as 1924. Both

described themselves as largely self-taught. Seattle Art Museum exhibition notes, ca. September 1934. Seattle Art Museum, SCUW Acc. 2636-1, Box 23/Publicity Materials for Exhibitions Already Shown 1935–36.

34 Seattle City Directory, vols. 1919, 1920, 1921 (Seattle: R. L. Polk).

35 Seattle City Directory, 1922. Toda exhibited in the Northwest Annual in 1925 and 1926. He was also a founding member of the Seattle Camera Club in 1925. *Notan* 9 (February 13, 1925), SCUW.

36 George Tsutakawa, quoted in Martha Kingsbury, *George Tsutakawa* (Seattle: University of Washington Press and Bellevue Art Museum, 1990), 29.

37 My thanks to Tetsuden Kashima for pointing out the importance of poetry as one of the few means of emotional expression available to Issei men of Tokita's generation. See his introduction to Keiho Soga, *Life Behind Barbed Wire: The World War II Internment Memoirs of a Hawai'i Issei* (Honolulu: University of Hawai'i Press, 2008).

38 The translation is by Naomi Kusunoki-Martin.

39 "Specification and Claims for U.S. Patent, Executed by Kamekichi Tokita, August 1st, 1928." Tokita, AAA. For Tokita's registered patents, see http://www.freepatentsonline.com/1712485.html and http://www.freepatentsonline.com/1762430.html.

40 Fujii exhibited in Northwest Annuals regularly from 1930 to 1941. There is little record of his artistic activity in Chicago, although he is listed among Illinois artists, http://www.illinoisart.org/artists_list.html.

41 Kibei refers to Japanese Americans born in the United States and educated in Japan. For monographs of the artists, see Martha Kingsbury, *George Tsutakawa*, and Barbara Johns, *Paul Horiuchi*.

42 George Tsutakawa, oral history interview by Martha Kingsbury, September 8 and 13, 1983, AAA.

43 For the Seattle Camera Club, see Carol Zabilski, "Dr. Kyō Koike, 1878–1947," *Pacific Northwest*

Quarterly 68 (April 1977), 72–79; Susan Shumaker, "Untold Stories from America's National Parks: Mount Rainier and the Seattle Camera Club." http://www.pbs.org/nationalparks/media/tnp-abi-untold-stories-pt-08-mt-rainier.pdf. Published as this book was in production: David Martin and Nicolette Bromberg's book about the Seattle Camera Club, *Shadows of a Fleeting World* (Seattle: University of Washington Press and Henry Art Gallery, 2011).

44 Kyō Koike, "Introducing the City of Seattle," *Notan* 16 (September 11, 1925), unpaginated.

45 Hoshin Kuroda, "Historical Review of Japanese Art," translated by K. Koike, *Notan* 35 (April 8, 1927), unpaginated.

46 Margaret Bundy [Callahan], "About It and About," *Town Crier*, January 18, 1930, 5–6; "Some Seattle Streets," *Town Crier*, Christmas 1930, 31–32.

47 George Tsutakawa, quoted in Kingsbury, *George Tsutakawa*, 36

48 [Carl F. Gould], President's Report, Art Institute of Seattle, 1927. Seattle Art Museum, Accession 2636, Box 33/23.

49 Quoted in Calhoun, *Seattle Heritage*, 80.

50 The 1926 date accounts only for English-language newspapers and is the earliest noted in Tokita's personal scrapbook. Tokita, AAA. In 1931, Tokita was said to have been exhibiting for seven years. "Gifted Nippon Artist," *Seattle Post-Intelligencer*, October 16, 1931.

51 Clipping, no author, no title, *Seattle Sunday Times*, December 21, 1930. Tokita, AAA.

52 The Salon was held under the Seattle Fine Arts Society's sponsorship at the Renfro-Wadestein Galleries. See Calhoun, *Seattle Heritage*, 86–88. A second Annual opened in September 1928. This time separate juries were assigned for conservative and modern art, following the example of some regional exhibitions such as those in Oakland.

53 Dorothy V. Morrison, Acting Director, Henry Gallery, to Tokita, August 9, 1928. Tokita, AAA. Tokita to Morrison, August 13, 1928, W.U. Henry Gallery, SCUW, Accession 75.6, Box 1/4.

54 Henry Gallery records do not list such an exhibition. W.U. Henry Gallery, scuw, Accession 75.6, Box 6/Exhibitions 1928–30.

55 Savery to Tokita, October 10, 1932. David Schultz, Henry Gallery, wrote Tokita of the terminated project. Tokita, AAA. There is no record of Tokita's ever exhibiting at the Henry Gallery.

56 On Gould's role in the Seattle Art Institute and the design of the Seattle Art Museum, see T. William Booth and William H. Wilson, *Carl F. Gould: A Life in Architecture and the Arts* (Seattle: University of Washington Press, 1995).

57 "Civil Works Administration to employ artists on Public Works of Art," news release, Federal Emergency Relief Administration, December 11, 1933. W.U. Henry Gallery, scuw Acc. 75-6, Box 2/1.

58 Instructions Regarding Public Works of Art Project. WPA Federal Art Project scrapbook, Seattle Public Library.

59 Burt Brown Barker of Portland was appointed project head of District 16, which encompassed Oregon, Washington, Idaho, and Montana. The Washington State committee was comprised of Charles Alden, Seattle architect and committee chair; Clara Reynolds, Supervisor of Art, Seattle Public Schools; May von Puhl, manager of the Northwest Art Galleries; Richard E. Fuller, president and director, Seattle Art Museum; Lea Puymbroeck, University of Washington art instructor; Mrs. A. M. Young, educational director, Seattle Art Museum; George Gove, Tacoma architect; Henry C. Bertelsen, Spokane architect. Kenneth Callahan, "You Buy Some Art," *Town Crier*, April 7, 1934, 6.

60 The ranks were Group I, Group II, and Art Laborers, whose weekly salaries were $38.24, $23.85, and $13.50 respectively. Over sixty artists in Washington State participated overall. "Artists Employed for Public Works of Art" and "Number at Work," WPA Federal Art Project scrapbook, Seattle Public Library. A news article by Margaret Prosser states that three Japanese American artists participated, but the statement is not corroborated by records of enrollment or artistic production. Margaret Prosser, "Needy Artists Greatly Aided by Government," *Seattle Times*, ca. May 1934, WPA scrapbook. The scrapbook contains records of state enrollment.

Had the PWAP provided more than four weeks' employment, Group I's annualized rate of about $1,900 would have exceeded the 1934–36 average household income of $1,524. U.S. Bureau of Labor Statistics, http://www.bls.gov/opub/uscs/1934-36.pdf.

61 Edward Bruce to Tokita, April 11, 1934. Tokita, AAA.

62 Diary, January 15, 1942. By 1940, 63 percent of the city's hotels and apartments were operated by Japanese Americans. David Takami, *Executive Order 9066: Fifty Years Before and Fifty Years After* (Seattle: Wing Luke Asian Museum, 1992), 20.

63 Diary, February 17, 1942.

64 As of 1941 he held shares in American Airlines. American Airlines to Tokita, November 16, 1944. Tokita, AAA.

65 Diary, January 21, 1942.

66 Yasuo Tokita, personal communication, March 1, 2009.

67 Undated poems, Tokita. AAA.

68 Report of interview June 5, 1944. Family #11048, War Relocation Authority, 24.

69 Undated poems, Tokita. AAA.

70 John Okada, *No-No Boy* (Seattle: University of Washington Press, 1976), vii. First printed by Charles E. Tuttle, Rutherford Vermont, and Tokyo, Japan, 1957.

71 Diary, December 7, 1941.

72 Diary, January 19, 1942.

73 Diary, March 2 and 3, 1942.

74 Diary, April 18, 1942.

75 Most of the Nikkei in Seattle and the valley to the south were sent to Puyallup and then to Minidoka. Those on Bainbridge Island were sent to Manzanar in southern California; those in Bellevue to Tule Lake in northern California.

76 I use the official names of the sites and use "incarceration" rather than "internment," with the latter referring specifically to civilian enemy

nationals arrested by the FBI and detained under different rules from the War Relocation Authority. See Denshō on terminology, www.densho.org/causes/default.asp; also Tetsuden Kashima, *Judgment without Trial: Japanese American Imprisonment during World War II* (Seattle: University of Washington Press, 2003), 8–9.

77 Cited in Audrie Girdner and Anne Loftis, *The Great Betrayal: The Evacuation of Japanese-Americans during World War II* (London: MacMillan Company, 1969), 154. The description of the Puyallup site is from Girdner and Loftis, 154–55. For a study of the Puyallup assembly center, see Louis Fiset, *Camp Harmony: Seattle's Japanese Americans and the Puyallup Assembly Center* (Champaign: University of Illinois Press, 2009).

78 Shokichi Tokita, in unpublished biographical notes by Shokichi Tokita and Yoshiko Tokita-Schroder, 2008, 31.

79 War Relocation Authority, "Relocation Communities for Wartime Evacuees," September 1942. James Y. Sakamoto papers, SCUW, Accession 1609, Box 10/38.

80 In May 1943 the fence was removed, and the posts and barbed wired were quickly salvaged for clotheslines and garden fences—the subject of one of Tokita's poems. Incarcerees could move around the area without immediate confinement.

81 Diary, October 20, 1942.

82 Diary, December 5, 1943.

83 Undated poem, Tokita papers, AAA. I thank Naomi Kusunoki-Martin for pointing out this poem as exemplary of Tokita's attitude. Personal communication, May 4, 2010.

84 Illustrated in McKivor, 40; also National Park Service, U.S. Department of the Interior. *Minidoka Internment National Monument: General Management Plan* (Seattle: U.S. Department of the Interior, National Park Service, Pacific West Region, Seattle, 2006), 38, where the sign but not Tokita is identified.

85 Diary, October 1, 1942.

86 Undated poem, Tokita papers, AAA.

87 Diary, January 30, 1943, and December 1, 1942.

88 Diary, December 19, 1942.

89 Diary, June 5, 1943.

90 Diary, October 19, 1942.

91 Undated poem, Tokita papers, AAA.

92 "Project Artistic Talent on Display Next Week," *Minidoka Irrigator*, November 29, 1943, 1. The "ten best" very likely refers to the Washington painters selected for the *First Annual Municipal Art Exhibition* in New York in 1936, in which Tokita, Nomura, and Fujii were represented.

93 Diary, September 23, 1942.

94 Undated poem, Tokita papers, AAA.

95 Diary, December 13, 1942.

96 Report of interview with Tokitas on July 19, 1945. Family #11048, War Relocation Authority, 25.

97 Family #11048, 23. "It was necessary to reject this application as they have $500."

98 Kenneth Callahan, "Northwest Artists Show Local Scene," *Seattle Times*, October 31, 1948, S-9.

99 In 1957, she was the first recipient of the Japanese American Citizens League's "Mother of the Year" award. See "Mother of the Year: Widow with 8 Never Quit," *Pacific Citizen* (Los Angeles), May 19, 1967, 3.

PAINTING

1 Only forty-one paintings remain as evidence of Tokita's accomplishment. Most are oil paintings; two are watercolors. Although he produced drawings for exhibition, none remain. The remaining visual record consists of black and white photographs of paintings and a few sketches. Six paintings are in the collection of the Seattle Art Museum; all others, several in Tokita's handmade frames, are in the possession of family members. While the complete record is sparse, given his experience during the war and its aftermath, that as many paintings survive is testimony to the value he attached to the work.

2 Margaret Bundy, "Art in the Northwest," *Town Crier*, October 8, 1930, 17.

3 George Tsutakawa, "A Conversation on Life and Fountains," *Journal of Ethnic Studies* 4 (Spring 1976), 12. The event described is ca. 1929–30.

4 Kenneth Callahan, "Tokita's Paintings Exhibited," *Town Crier*, December 31, 1930, 15.

5 *Japanese American Courier*, undated clipping, ca. December 1934, Tokita, AAA.

6 "Seattle's highways and byways pose for a local artist: Kamekichi Tokita," *Seattle Times Rotogravure*, January 18, 1931, 8.

7 Mrs. Reginald Parsons also acquired a painting, but neither has been located. Evelyn Walbeland [?], Seattle Art Museum, to Tokita, February 18, 1931; Parsons to Tokita, November 24, 1931, Tokita, AAA.

8 Richard E. Fuller to Tokita, January 30, 1931. Tokita, AAA.

9 *Town Crier*, March 19, 1936. See also [John Davis Hatch, Jr.], Director's Report, December 10, 1930. Seattle Art Museum, Accession 2636-1, Box 33/22; *Quarterly Bulletin of the Art Institute of Seattle* 1 (November 1931), 14.

10 Fuller to Tokita, October 9, 1931. Tokita, AAA.

11 Margaret Bundy, "About It and About," *Town Crier*, January 18, 1930, 5.

12 "Mr. Tokita's goal is to express in oil a phase of the older life of the city which is rapidly passing." *Quarterly Bulletin of the Art Institute of Seattle* (1931), 5.

13 Kenneth Callahan, "Tokita's Paintings Exhibited," 15.

14 M[argaret] Bundy, "Art Institute of Seattle," *Town Crier*, September 28, 1929, 9.

15 Kenneth Callahan, "The Northwest Annual," *Town Crier*, December 5, 1931, 35.

16 The museum presented simultaneous solo exhibitions of his and Steichen's work in late 1935, although Tokita's most striking views precede this date.

17 Cited in Erika Doss, "Coming Home to the American Scene: Realist Paintings," in *Coming Home: American Paintings, 1930–1950, from the Schoen Collection* (Athens, GA: Georgia Museum of Art, University of Georgia), 2003, 20.

18 Holger Cahill, "New Horizons in American Art," in the introduction to the catalogue of the same name (New York: Museum of Modern Art, 1936), 9–41.

19 Martha Candler Cheney, *Modern Art in America* (New York: McGraw-Hill, 1939), 70, 167–68. See also her letter to Ambrose Patterson, ca. February 1938, Ambrose Patterson Papers, SCUW, Acc. 2563-1, Box 1/6.

20 Thomas Handforth, quoted in Bundy, "Art Institute of Seattle," 9.

21 Recent scholarship has reevaluated Japan's modern artistic production. For background, see Ellen P. Conant, "Introduction," in *Challenging Past and Present: The Metamorphosis of Nineteenth Century Japanese Art*, ed. Ellen P. Conant (Honolulu: University of Hawai'i Press, 2006), 1–27.

22 Kenneth Callahan, "Tokita's Paintings Exhibited," 15.

23 "Gifted Nippon Artist Paints Local Scenes." *Seattle Post-Intelligencer*, October 16, 1931, part 2, 1.

24 Diary, December 19, 1942.

25 Richard E. Fuller (1897–1976) joined the Board of the Directors of the Art Institute of Seattle in 1928, became first vice president in 1929, and served as president of the board beginning in 1930. In 1933 he assumed the dual role of president and director. He led the museum until his retirement in 1973.

26 Fuller, typescript of notes for the opening of the Seattle Art Museum, June 28, 1933. Seattle Art Museum, SCUW Acc. 2636, Box 23/Writings re Museum Opening 1933.

27 Fuller to Tokita, November 13, 1932. Tokita, AAA. The third of three Artist Life Members at the time of the museum's opening was George Fischer, whose work is not represented in the collection.

28 Richard E. Fuller, *A Gift to the City: A History of the Seattle Art Museum and the Fuller Family* (Seattle: Seattle Art Museum, 1993), 8.

29 *Japanese American Courier* (title and date not available). Tokita, AAA.

30 Larry Cross, *Seattle Times* (title and date not available). Tokita, AAA.

31 Nomura was the only Nikkei included in the Museum of Modern Art's *Sixteen American Cities* in 1933. In 1934, Tokita and Nomura were the only two Nikkei represented in the national exhibitions of the federally funded Public Works of Art Project (PWAP); none from California were included. Again in 1936, they and Fujii were among the eleven Washington State artists in New York City's *First Annual Exhibition of American Art*, where the only other Nikkei was sculptor Yoshimatsu Onaga from Pennsylvania.

32 Nomura won the top prize, the Katherine B. Baker Memorial Award, at the 1932 Northwest Annual and was given a solo exhibition in 1933. Callahan wrote that "except for his annual entries in [the] past ten Northwest Annuals, [he] has been practically unheard of," but concluded that he "will sometime achieve the recognition that is due him in other parts of America." Kenneth Callahan, "The Art Situation: Nomura Exhibition," *Town Crier*, July 15, 1933, 9–10.

33 Nomura's painting is in the collection of the Wing Luke Asian Museum; Fujii's is in a private collection in Seattle.

34 Nomura was represented in both exhibitions.

35 Burt Brown Barker, Regional Director, PWAP, Portland, to Tokita, September 6, 1934. Disposition of the six paintings: *Fifth and Cherry Streets* and *Seattle Street Scene* to unspecified venues in Washington, D.C.; *Auto Parking Grounds* to Washington State College (now University); *12th and King Streets* to State Normal School, Cheney (now Eastern Washington University); *Sidestreet* to Seattle Public Schools; and *Backyard* to Seattle Art Museum. Tokita, AAA. Only the one at the Seattle Art Museum can be located today.

36 Fuku Matsuda Nakatani's dance school was the subject of an extensive photography session for *Life* magazine in 1957, although the feature was never published. Eileen Tokita (Nakatani's granddaughter), personal communications, May 16 and June 30, 2009. The masks today are in the possession of Goro and Eileen Tokita.

37 Previously Oakland had shown the annuals organized by the San Francisco Art Association.

38 Kenneth Callahan, "Seattle Art Museum," *Seattle Times*, December 29, 1935. Tokita Papers. AAA.

39 Kenneth Callahan to Tokita, October 12, 1935. Tokita, AAA.

40 Brian Tobey Callahan, ed., comp., *Margaret Callahan: Mother of Northwest Art* (Victoria, BC: Trafford Publishing, 2009), 110.

41 Brian Tobey Callahan, *Margaret Callahan*, 56–57.

42 Callahan called a meeting at his home on November 12, 1935, in advance of an exhibition at the Penthouse Gallery. Callahan to Tokita, November 7, 1935. Tokita, AAA.

43 "Penthouse Art Gallery Plans to Show Work," *Seattle Daily Times*, October 5, 1935. Tokita, AAA. The others were Kenneth Callahan, Margaret Gove Camfferman, Peter Camfferman, Elizabeth Cooper, Earl Fields, Morris Graves, Walter Issacs, Ambrose Patterson, and Viola Patterson.

44 The Textile Tower, today called Seattle Tower, was built in 1929 at Seventh and Olive streets. The Penthouse Gallery was operated from 1935 to 1937 by Julia Caskey and Jean Fay, sister-in-law of architect Carl F. Gould. Their letter to Tokita, October 9, 1935, invited him to join the gallery as a member of a twelve-person cooperative. Tokita, AAA.

45 Kenneth Callahan, "Pacific Northwest Painters," *Art and Artists of Today* 1 (September-October 1937), 7.

46 *Some Work of the Group of Twelve* (Seattle: Frank McCaffrey, 1937). Martha Kingsbury describes it as the first self-published artists' catalogue in Seattle. Martha Kingsbury, *George Tsutakawa* (Seattle: University of Washington Press and Bellevue Art Museum, Bellevue, WA, 1990), 30.

47 The Group of Twelve held an exhibition of self-portraits at the Penthouse Gallery in February 1936. "Paintings to be Shown at Tacoma by Seattle Group," *Seattle Times*, February 9, 1936, Tacoma Art Museum Records, Scrapbook 1, Washington State Historical Society.

48 The painting has a label from the 1948 Annual with Tokita's name and Horiuchi's address at the time. After the war Horiuchi searched for paintings by the Issei artists among donations to St. Vincent de Paul's thrift store, many left behind as families left for relocation camps. He remembered having seen this one at an earlier Northwest Annual and later gave it to Ken Tokita. Ken Tokita, personal communication, September 25, 2009.

49 Fujii, in *Some Work of the Group of Twelve*, unpaginated.

50 Nomura, in *Some Work of the Group of Twelve*, unpaginated.

51 Tokita, in *Some Work of the Group of Twelve*, unpaginated.

52 Fuller recounted discussions with Tokita to Ken Tokita, ca. early 1960s. Ken Tokita, personal communication, September 25, 2009.

53 Jan Gardner, *Modern French Masters* (New York: Dodd, Mead, and Company, 1923), 32, 36, 37. Tokita inscribed his copy, "Kame Tokita June 14th.24." Tokita, AAA.

54 The characterization of Sesshū's work is taken from Joan Baker-Stanley, *Japanese Art*, rev. ed. (London: Thames & Hudson, 2000), 134–37.

55 Before contact with the West, one-point perspective was introduced to Japan by way of Western-influenced painting in China. Michiyo Morioka noted the similarity of Tokita's paintings to *uki-e*, or "perspective pictures" of theater interiors, in the heightened sense of spatial depth based on linear perspective. Personal communication, September 18, 2009.

56 Tokita, AAA, and papers in the possession of family members.

57 Nomura, by contrast, left a sizable body of work illustrating camp life. See June Mukai McKivor, ed., *Kenjiro Nomura: An Artist's View of the Japanese American Internment* (Seattle: Wing Luke Asian Museum, 1991).

58 The drawings are undated. One is the image of Daruma identical to his painted version, and, on this basis, I have dated the drawings as a group to the Minidoka years. Tokita, AAA.

59 When used with the artist's signature in Asian painting, "mountain man" also conveys "hermit" or "recluse." I thank Michiyo Morioka for pointing out the significance of the inscription. Michiyo Morioka, personal communications, September 18, 2009 and April 6, 2010.

60 See Barbara Johns, *Paul Horiuchi: East and West* (Seattle, University of Washington Press in association with Museum of Northwest Art, La Conner, WA, 2008), 31–32, 36–37.

61 Nomura's postwar work was shown by gallerist Zoe Dusanne, whose support was critical to his and others' success. His culminating achievement was inclusion in the 1955 São Paolo International Biennial. McKivor, 13.

62 Typescript review of the Northwest Annual, September 27, 1936. Seattle Art Museum, SCUW, Acc. 2636-1, Box 24/Transient shows 1936–38 (2).

63 Kenneth Callahan, "The Art Situation: Paintings Reflect Region," *Town Crier*, October 21, 1933, 10.

64 Ibid.

65 Viola Patterson, oral history by William Hoppe, July 10, 1972, Viola Patterson Papers, SCUW, Acc. 2563-2, v.f. 1396B.

66 Kenneth Callahan, "Pacific Northwest Painters," 6.

67 The major texts are Martha Kingsbury, "Seattle and the Puget Sound," in *Art of the Pacific Northwest: From the 1930s to the Present* (Washington, D.C.: Smithsonian Institution Press for the National Collection of Fine Arts, 1974), 39–92; Martha Kingsbury in *Northwest Traditions* (Seattle: Seattle Art Museum, 1978), 9–60; and Sheryl Conkelton and Laura Landau, *Northwest Mythologies: The Interactions of Mark Tobey, Morris Graves, Kenneth Callahan, and Guy Anderson* (Tacoma: Tacoma Art Museum in association with University of Washington Press, Seattle, 2003).

68 Kenneth Callahan, "Pacific Northwest," *Artnews* 45 (July 1946):22–27, 53–56.

69 Ibid., 24.

70 Once again, Margaret Callahan was the one to call attention to the Isseis' achievement. In

a 1954 article about the recognition recently achieved by Tsutakawa, Horiuchi, Nomura, and John Matsudaira, she looked back to the Isseis' prewar contribution. Margaret B. Callahan, "Seattle's Japanese Painters," *Seattle Times*, August 1, 1954, Sunday Magazine, 7.

71 Bundy, "About It and About," 6.

PREFACE TO THE DIARY

1 The description is from Haruo Takasugi, "Important Historical Material of Japan-America War," 2005, in an unpublished translation of the diary prepared for the Tokita family.

2 Joseph T. Okimoto, MD, provided this insight. Personal communications, November 25, 2008, and September 18, 2009.

3 Poems, ca. 1943–45, Tokita papers, Archives of American Art, Smithsonian Institution.

4 The *haiku* form has a pattern of 5-7-5 syllables; the *tanka* has thirty-one syllables in two clusters, 5-7-5 and 7-7. Tokita sometimes deviates from the precise form. The poems in this book appear in extended lines as they do in Japanese, rather than with line breaks to indicate the syllabic rhythms as they commonly appear in translation in the West.

DIARY

1 On the night of December 7, 1941, the FBI began arresting Issei community and business leaders. Most were imprisoned in internment camps solely for Japanese nationals for the duration of the war. For an account of the interagency planning that enabled such immediate action, see Tetsuden Kashima, *Judgment Without Trial: Japanese American Imprisonment during World War II* (Seattle: University of Washington Press, 2002).

2 Many suffixes, or honorifics, are used to convey a level of politeness or familiarity among the Japanese. For acquaintances, *san* is used much like mister; *sama* adds a level of familiarity and is used for friends; *kun* is usually reserved for

the closest of friends. Naomi Kusunoki-Martin, 2005.

3 The use of ellipses and parentheses in the diary is Tokita's. Insertions by the editor are in brackets.

4 Poem by Matsuo Bashō (1644–1694). From Matsuo Bashō, *The Narrow Road to Oku,* trans. Donald Keene (Tokyo: Kodansha International, 1996).

5 The news articles to which he refers are not among his personal papers.

6 Miyamoto Musashi (1584?–1645) was a famed swordsman, samurai, and author of an influential book on swordsmanship, *Gorin no shô* (The Book of Five Rings). Matsubara, now a suburb of Ōsaka, was the site of some of his legendary but unsubstantiated victories. His book is still widely read in Japan and appears frequently in forms of popular culture.

7 Mr. and Mrs. Leo Scavatto ran the Italian restaurant in the building that housed the Cadillac Hotel. They stored the Tokitas' possessions during relocation and shipped several boxes to them at Minidoka.

8 Tokita refers to three newspapers produced in Seattle's Nikkei community: the Japanese-language *Hokubei Jiji* (*North American Times*) and *Taihoku Nippo* (*Great Northern Daily News*) and the English-language *Japanese-American Courier.*

9 M. Furuya Company was the largest Nikkei-owned business in Seattle and had branches in Tacoma, Portland, Vancouver, BC, and Kobe, Japan. Tsutakawa and Co. was an import and grocery business founded by Shuzo Tsutakawa, father of the artist George Tsutakawa.

10 James Y. Sakamoto (1903–1955) was the founding editor and publisher of the English-language *Japanese American Courier*, published from 1928 to 1942. He was also a founder of the Seattle Progressive Citizens' League and its successor, the Japanese American Citizens League (JACL).

11 Based on the Consumer Price Index, $1,480 in 2009 dollars. Sumimoto Bank of Seattle, whose parent organization was in Japan, was closed by federal authorities on December 7, 1941.

12　Translator Kusunoki-Martin notes the similarity to the Biblical passage: "So do not be anxious about tomorrow; tomorrow will look after itself" (Matthew 6:34) and suggests Tokita's reference may be to this verse in a different version of the Bible. Personal communication, October 18, 2008.

13　Tokita refers to the Issei and Nisei communities.

14　The leading mainstream English-language newspapers in Seattle were the *Seattle Times*, *Seattle Post-Intelligencer*, and *Seattle Star*.

15　Given Tokita's mention of a ten-year span, the "China Incident" to which he refers is likely the Mukden or Manchurian Incident of September 1931, when Japan invaded Manchuria in reaction to rising Chinese nationalism. These events were the prelude to the China Incident of 1937, the beginning of full-scale war between Japan and China.

16　The Ft. Missoula camp of the Civilian Conservation Corps, a Depression-era federal work project.

17　State Political Directorate or political police.

18　Ishida Mitsunari (1560–1600) was a samurai and a leading government administrator in the service of Toyotomi Hideyoshi, who stabilized the newly unified Japan. After Hideyoshi's death, conflicting political loyalties resulted in the Battle of Sekigahara, in which Mitsunari was defeated and executed.

19　Dry cleaners were known as dye works.

20　Tokita added this postscript while reviewing the diary at a later date.

21　Kenjiro Nomura was Tokita's painting colleague and business partner (see Biography and Painting in this book).

22　*Noshi-mochi*, pounded and flatted rice cakes.

23　*Kagami-mochi*, round, stacked rice cake.

24　*Zoni*, rice cake soup; *kamaboko*, fish cake; *kinton*, mashed sweet potato; *kanten*, agar; *kuromame*, black soybeans; *kazunoko*, herring eggs; *nishime*, vegetables cooked in soy-based soup.

25　The Wilson Hotel was managed by Haruko's parents (see Biography).

26　Tōjō Hideki (1884–1948) was prime minister of Japan from October 16, 1941, until his resignation on July 19, 1944.

27　Tokita's resident customers typically paid in Social Security checks.

28　The Japanese Association was closely allied with the Japanese consulate and played a leading role in arguing for the rights of Japanese nationals.

29　The Takano Photography Studio opened in 1921 and was owned in the 1930s by Henry Miyake (see March 16, 1942, entry).

30　The office of Foreign Assets Control, Department of Treasury, froze the assets of Enemy Aliens who had left the United States for a period of time since June 17, 1940. Those who had not left had to register their assets but could retain them. Once relocation was ordered, assets of Enemy Aliens were transferred to the Alien Property Custodian. Under forced circumstances, owners sold physical assets for a fraction of their value.

31　The hero of *The Count of Monte Cristo*, published by Alexandre Dumas in 1844–45, is falsely imprisoned, spends years seeking revenge, and ultimately finds redemption.

32　The imperially chartered Yokohama Shokin Bank. Tokita refers to Japanese nationals arrested by the FBI.

33　Tokita's original text is ambiguous but he appears to be continuing his line of thought and referring to the Issei.

34　Mr. and Mrs. Shotaro Kuromiya were close friends of the Tokita and Suzuki families (see figure 30 in this book).

35　Unattributed newspaper report.

36　The California Alien Land Law of 1913 prohibited "aliens ineligible for citizenship" from owning land. It was followed in 1921 by a similar law in Washington State, which reinforced and strengthened a constitutional prohibition of 1889. "Aliens ineligible for citizenship" applied to all immigrants from Asia.

37　Serving as national spokesman of the JACL, Mike M. Masaoka (1915–1991) argued for the Nikkei community's cooperation with the federal government in the belief that resistance would only bring retribution.

38 Tokita mistakenly identifies Bremerton, a port city on the Kitsap Peninsula, as an island.

39 James Walsh (1891–1981) served as bishop of the U.S. Maryknoll Mission from 1936 to 1948.

40 Father Leopold Tibesar (1898–1968) was the Maryknoll priest serving the Nikkei community in Seattle from 1935 to 1946 (see Biography).

41 Known as the Dies Committee for its chair, Martin Dies, Jr. (Democrat from Texas), the special investigating committee was formally established in 1938 as the House Committee on Un-American Activities.

42 Chikamasa Paul Horiuchi (1906–1999), who became a renowned Seattle artist, worked for the Union Pacific Railroad near Rock Springs, Wyoming, until the railroad's firing of all Japanese Americans in February 1942.

43 British Commonwealth forces, assisted by Chinese irregulars.

44 The Rising Sun Flag Society.

45 Although this statement was attributed to Mr. Waring, the record of the hearing shows that these words were uttered by Mr. Schmoe.

The record search and correction in endnotes 45 and 46 were made by translator Kusumoki-Martin, 2005.

46 Although Tokita lists Mr. Miller and Mr. Freeman, the record shows that Mr. Miller Freeman was present at the hearing.

Freeman (1876–1955) was a newspaper publisher, civic activist, and former Washington State legislator. As a legislator and president of the Anti-Japanese League of Washington, he had actively supported the passage of Washington's Alien Land Law in 1921. A Bellevue resident since 1938, he began the development of Bellevue Square in 1946 on property formerly farmed by Japanese Americans.

47 Rev. Thomas Gill (1908–1973) was pastor of St. James Cathedral in Seattle.

48 Manzanar Relocation Center, which at its peak held 10,046 people.

49 The *Kokuryū-kai* or Black Dragon Society, founded in Japan in 1901, was an ultranationalist association with a small but powerfully connected membership.

50 Tokita's entry reads "the 27th," although none appears from that date.

51 Western Washington State Fairgrounds in Puyallup, Washington.

52 The U.S. Marines landed on Guadalcanal on August 7, 1942, beginning an eight-month battle to retake it from Japanese forces. Tokita refers to three islands, Tulagi, Wake, and Guadalcanal, occupied by the Japanese.

53 Nikkeis' possession of shortwave radios was banned in December 1941.

54 Tokita refers to camp governance. Isseis, barred from naturalized citizenship, had no voting rights outside camp.

55 Manzo Tokita (1877–ca. 1964), a paternal uncle, immigrated to the United States in 1907. He lived in Seattle, except for wartime incarceration, until returning to Japan in 1956.

56 Warren Koiche Suzuki, Haruko's younger brother. A Kibei, he returned to Seattle from Japan in January 1941 and was a freshman at the University of Washington at the time of Pearl Harbor. The Suzukis were transferred to Tule Lake Relocation Center because he answered "no" to two key questions on the WRA loyalty questionnaire.

57 *Getas*, elevated wooden sandals.

58 Strife broke out at Manzanar Relocation Center, fueled by conflict between JACL supporters of administration policies and a number of Issei and Kibei.

59 Reverend and Mrs. McRea did not know the Tokitas personally but volunteered to correspond with them during the war.

60 For Mr. and Mrs. Scavatto, see note 7.

61 *Yōkan*, sweet jellied bean paste.

62 *Senbei*, round flat rice crackers.

63 *Mochitsuki*, pounding the rice cake. In paragraph following, *udon*, wheat noodle; *soba*, buckwheat noodle.

64 A syncretic, nondenominational religion founded in Japan in 1930. The organization translates the name as "The Home of Infinite

Life, Wisdom, and Abundance." http://www.snitruth.org (accessed 10/18/08).

65 U.S. forces had been engaged in the Aleutian Islands since January 1942 but could not prevent Japan's invasion. Their retaking the island of Attu in May 1943 ended Japan's occupation of American territory.

66 Yasukuni Shrine was designated by the Meiji emperor in 1879 to commemorate those who died in the service of the emperor and became the primary national shrine to honor the war dead. In Shintō belief, it houses the spirits of the dead.

67 The Kwantung army, established in 1919, was a Japanese force based in Manchuria and Korea.

REFERENCES

Tokita is mentioned by name only in works marked with an asterisk. Works published only in Japanese and sources about World War II battlefronts are not included in the References.

TOKITA

"A Word about Art." *Town Crier*, August 15, 1934, 17, 23.

American Artists' Congress, Inc. "National Membership Exhibition, Portland Branch. Portland, Ore., 1937 (exhibition brochure).

"Art Exhibit Here Feb. 16." *Tacoma Times*, February 8, 1936.*

Art of the Pacific Northwest: From the 1930s to the Present. Essays by Rachel Griffin and Martha Kingsbury. Washington, D.C.: Smithsonian Institution Press for the National Collection of Fine Arts, 1974.

"Artists' Yule Sale Exhibit Stirs Interest." *Seattle Times*, December 12, 1935, 3.

Berner, Richard C. *Seattle in the 20th Century*, vol. 3: *Seattle Transformed: World War II to Cold War*. Seattle: Charles Press, 1999.

Bundy, M[argaret]. "Art Institute of Seattle." *Town Crier*, September 28, 1929, 9–10.

Bundy, Margaret. "Northwest Art." *Town Crier,* December 28, 1929, 8.

———. *Town Crier*, March 19, 1930, 10; cover illustration.

———. [Bundy, Margaret.] "Art in the Northwest." *Town Crier*, April 9, 1930, 12–13.

———. "Art in the Northwest." *Town Crier*, October 8, 1930, 17.

Callahan, Brian Tobey, comp., ed. *Margaret Callahan: Mother of Northwest Art*. Victoria, B.C.: Trafford Publishing, 2009.

Callahan, Kenneth. "Tokita's Paintings Exhibited." *Town Crier*, December 31, 1930, 2, 15.

———. "Northwest Annual Opens." *Town Crier*, September 26, 1931, 7.

———. "The Northwest Annual." *Town Crier*, December 5, 1931, 35; illus. 36–38.

———. "San Francisco Annual." *Town Crier*, May 14, 1932, 8.

———. "The Galleries: Northwest Annual Opens." *Town Crier*, October 8, 1932, 9.

———. "The Art Situation: Nomura Exhibition." *Town Crier*, July 15, 1933, 9–10.

———. "The Art Situation: From Permanent Collection." *Town Crier*, September 16, 1933, 9.

———. "The Art Situation: Nineteenth Annual Opens." *Town Crier*, October 7, 1933, 9.

———. "The Art Situation: Paintings Reflect Region." *Town Crier*, October 21, 1933, 9–10.

———. "You Buy Some Art." *Town Crier*, April 2, 1934, 6.*

———. "The Art Situation." *Town Crier*, May 12, 1934, 14.

———. "Seattle Art Museum." *Seattle Times*, December 22, 1935, 8.

———. "Seattle Art Museum." *Seattle Times*, December 29, 1935, sec. 3, 3.

———. "Pacific Northwest Painters." *Art and Artists of Today* 1 (September–October 1937): 6–7, 17.

———. "Letters to the Editor." *Life*, June 20, 1938, 6.*

———. "Northwest Artists Show Local Scene." *Seattle Times*, October 31, 1948, S-9.

Callahan, Margaret B[undy]. "Seattle's Japanese Artists." *Seattle Times*, August 1, 1954, Sunday Magazine, 7.

Chang, Gordon H., Mark Johnson, and Paul Karlstrom, eds. *Asian American Art: A History, 1850–1970.* Palo Alto, Calif.: Stanford University Press, 2008.

Chantler, Evelyn. "Art Show Preview Arranged." *Tacoma Daily Ledger*, February 14, 1936.*

Cohen, Aubrey. "Japanese Center Holds Memories of Hunt Hotel." *Seattle Post-Intelligencer*, June 8, 2007.

Cross, Larry. "Seattle Art Museum." *Seattle Times*, July 29, 1934.*

———. [Untitled article.] *Seattle Times* [ca. August 1934]. Tokita, Archives of American Art.

First National Exhibition of American Art. Rockefeller Center Gallery, Municipal Art Committee, 1936. City of New York (exhibition brochure).

"Gifted Nippon Artist Paints Local Scenes." *Seattle Post-Intelligencer*, October 16, 1931, part 2, 1.

Hackett, Regina. "Pride amid Prejudice: Despite Internment, Japanese-American 'Visions' Survived." *Seattle Post-Intelligencer*, August 9, 1990, C1, C8.

———. "East Meets Northwest at the Wing Luke." *Seattle Post-Intelligencer*, September 8, 1994, C1, C7.

Harmon, Kitty, ed. *The Pacific Northwest Landscape: A Painted History.* Introduction by Jonathan Raban. Seattle: Sasquatch Books, 2001.

Henry Art Gallery. Special Collections, University of Washington Libraries, Accession 75-6.

Higa, Karin M. *The View from Within: Japanese American Art from the Internment Camps, 1942–1945.* Los Angeles: Japanese American National Museum, UCLA Wight Art Gallery, and UCLA Asian American Studies Center, 1994.

———. "Japanese American Art from the Internment Camps." In *Japanese and Japanese American Painters in the United States, 1896–1945: A Half Century of Hope and Suffering*, edited by the Tokyo Metropolitan Teien Art Museum, 133–37. Tokyo: Nippon Television Network Corporation, 1995.

"Interesting Art Exhibit Held at College." *Tacoma Times*, February 17, 1936.*

Ito, Kazuo. *Issei: A History of Japanese Immigrants in North America*, translated by Shinichiro Nakamura and Jean S. Gerard. Seattle: Executive Committee for publication of *Issei: A History of Japanese Immigrants in North America*, Japanese Community Service, 1973.

"Japanese Artist Displays Work at Seattle Institute." *Seattle Times*, Sunday, December 21, 1930.

Johns, Barbara. *Modern Art from the Pacific Northwest in the Collection of the Seattle Art Museum.* Seattle: Seattle Art Museum, 1990.

———. *Paul Horiuchi: East and West.* Seattle: University of Washington Press in association with Museum of Northwest Art, La Conner, WA, 2008.

Kingsbury, Martha. *Art of the Thirties: The Pacific Northwest.* Seattle: University of Washington Press for the Henry Art Gallery, 1972.

———. "Seattle and the Puget Sound." In *Art of the Pacific Northwest: From the 1930s to the Present*, 39–92. Washington, D.C.: Smithsonian Institution Press for the National Collection of Fine Arts, 1974.

———. "Celebrating Washington's Art: An Essay on 100 Years of Art in Washington." In *Celebrating Washington's Art*, 1–29. Olympia: Washington Centennial Commission, 1989.

———. *George Tsutakawa*. Seattle: University of Washington Press and Bellevue Art Museum, 1990.

McKivor, June Mukai, ed. *Kenjiro Nomura: An Artist's View of the Japanese American Internment*. Seattle: Wing Luke Asian Museum, 1991.

Minidoka Interlude: September 1942–October 1943. Hunt, Idaho: Minidoka Relocation Center, 1943. Privately reprinted by Thomas Takeuchi, Gresham, Oregon, 1989.

Mochizuki, Ken. "Japanese Americans Remember Living in Language School after Leaving Camps." *International Examiner* 34: 12; www.iexaminer.org/archives/"p=979 (accessed 8/14/09).

"Mother of the Year: Widow with 8 Never Quit." *Pacific Citizen* (Los Angeles), May 19, 1967, 3.

National Park Service, U.S. Department of the Interior. *Minidoka Internment National Monument: General Management Plan*. Seattle: U.S. Department of the Interior, National Park Service, Pacific West Region, Seattle, 2006. Tokita is pictured but not identified on page 38.

"Paintings by Tokita Shown at Institute." *Japanese American Courier*, December 20, 1930, 4.

"Paintings to be Shown at Tacoma by Seattle Group." *Seattle Times*, February 9, 1936.*

Patterson, Ambrose. Special Collections, University of Washington Libraries, Accession 2563-3.

Patterson, Viola. Oral history interview by William Hoppe, July 10, 1972. Viola Patterson, Special Collections, University of Washington Libraries, Accession 2563-2.

———. Oral history interview by Martha Kingsbury, October 22 and 29, 1982. Archives of American Art, Smithsonian Institution.

"Penthouse Art Gallery Plans to Show Work." *Seattle Daily Times*, October 5, 1935.

"Penthouse Sale of Paintings Will Continue" [no source, no date]. Ambrose Patterson, Special Collections, University of Washington Libraries, Box 3/11.*

"Project Artistic Talent on Display Next Week." *Minidoka Irrigator*, November 29, 1943, 1.

Seattle Art Museum. Special Collections, University of Washington Libraries, Accession 2636-1.

"Seattle's Highways and Byways Pose for a Local Artist: Kamekichi Tokita." *Seattle Times Rotogravure*, January 18, 1931, 8.

Sharylen, Maria. "Where Eagles Fly: Artists of the Pacific Northwest." Reprint in Resource Library, March 23, 2009, http://www.tfaoi.com/aa/8aa/8aa487.htm.

"Some Facts Appropos . . ." *Town Crier*, June 24, 1933, 6.

Some Work of the Group of Twelve. Seattle: Frank McCaffrey, 1937.

Tacoma Art Museum, records. Washington State Historical Society.

Takasugi, Haruo. "Important Historical Material of Japan-America War." Saitama, Japan, 2005. Manuscript of English translation of Tokita's diary. © Tokita Family (Shokichi Tokita), 2006.

"To Present Art Exhibit." *Tacoma Times*, February 27, 1936.*

Todd, Sally. "Art Display Is Ultra Modern." *Seattle Post-Intelligencer*, November 10, 1930, 3.

———. "Northwest Annual." *Town Crier*, October 3, 1931, 11.

Tokita, [Kamekichi], and [Kenjiro] Nomura. "Seattle's Japanese Artists." *Town Crier*, May 28, 1932, 9.

Tokita, Kamekichi. "'Jew Them Down.'" *Town Crier*, December 5, 1931, 66.

———. Papers, ca. 1900–48. Archives of American Art, Smithsonian Institution.

Tokita, Shokichi, and Elsie Tokita. "A Biographic Resume and Artistic History of Kamekichi Tokita, 1897–1948." Manuscript, 1992.

Tokyo Metropolitan Teien Art Museum, ed. *Japanese and Japanese American Painters in the United States, 1896–1945: A Half Century of Hope and Suffering*, translated by Kikuko Ogawa. Tokyo: Nippon Television Network Corporation, 1995.

Tsutakawa, George. "A Conversation on Life and Fountains." *Journal of Ethnic Studies* 4 (Spring 1976): 4–36.

———. Oral history interview by Martha Kingsbury, September 8 and 13, 1983. Archives of American Art, Smithsonian Institution.

Tsutakawa, Mayumi, ed. *They Painted from Their Hearts: Pioneer Asian American Artists.* Includes *Asian American Artists Directory,* compiled by Alan Lau and Kazuko Nakane for the Archives of American Art, Smithsonian Institution. Seattle: Wing Luke Asian Museum, 1994.

U.S. Department of Justice. "Records about Japanese Americans Relocated during World War II." National Archives and Records Administration, http://aad.archives.gov/aad/fielded-search.jsp?dt=2003&tf=F&cat=WR26&bc=,sl.

U.S. Patent, vehicle lift, http://www.freepatentsonline.com/1712485.html.

U.S. Patent, syringe, http://www.freepatentsonline.com/1762430.html.

U.S. War Relocation Authority. Kamekichi Tokita, Family No. 11048 Evacuee case file. U.S. National Archives and Records Administration, Washington, D.C. File in possession of Yoshito Tokita-Schroder.

Wong, Shawn. "Introduction." *The Seattle Review* 11 (1) (Spring/Summer 1988): 5–7; cover illustration.

W.P.A. Federal Art Project scrapbook. Assembled by Clara P. Reynolds. Seattle Public Library.

ART

Alexander, Jane. *Portrait of an Artist: Ambrose Patterson (1877–1966), from the Latin Quarter to the Pot Pourri of Palamadom.* Melbourne, Aus.: Jimaringle Publications, 1992.

Artists Against War and Fascism: Papers of the First American Artists' Congress. Introduction by Matthew Baigell and Julia Williams. New Brunswick, N.J.: Rutgers University Press, 1986.

Baigell, Matthew. *The American Scene: American Painting of the 1930s.* New York: Praeger Publishers, 1974.

Ballards, Adele M. "With the Fine Art Folk." *Town Crier,* October 7, 1916, 12–13.

Booth, T. William, and William H. Wilson. *Carl F. Gould: A Life in Architecture and the Arts.* Seattle: University of Washington Press, 1995.

Cahill, Holger. "New Horizons in American Art." In *New Horizons in American Art,* 9–41. New York: Museum of Modern Art, 1936.

Calhoun, Anne H. *A Seattle Heritage: The Fine Arts Society.* Seattle: Lowman and Hanford, 1942.

Callahan, Kenneth. "Northwest Art." *Town Crier,* December 10, 1930, 12.

———. "Art in the Northwest: Painting or Personality?" *Town Crier,* February 7, 1931, 16.

———. "You Buy Some Art." *Town Crier,* April 7, 1934, 6.

———. "The Art Situation." *Town Crier,* May 19, 1934, 14.

———. "Pacific Northwest." *Artnews* 45 (July 1946): 22–27, 53–55.

———. "Northwest Artists Show Local Scene." *Seattle Times,* October 31, 1948, S-9.

———. Oral history interview by Sue Ann Kendall, October 27, November 21, and December 19, 1982. Archives of American Art, Smithsonian Institution.

Cheney, Martha Candler. *Modern Art in America.* New York: McGraw-Hill, 1939.

Conkelton, Sheryl. *What It Meant to Be Modern: Seattle Art at Mid-Century.* Seattle: Henry Art Gallery, University of Washington, 1999.

Conkelton, Sheryl, and Laura Landau. *Northwest Mythologies: The Interactions of Mark Tobey, Morris Graves, Kenneth Callahan, and Guy Anderson.* Tacoma, Wash.: Tacoma Art Museum in association with University of Washington Press, 2003.

Corn, Wanda M. *The Great American Thing: Modern Art and National Identity 1915–1935.* Berkeley: University of California Press, 1999.

Cornish, Nellie Centennial. *Miss Aunt Nellie: The Autobiography of Nellie C. Cornish.* Seattle: University of Washington Press, 1964.

Doss, Erika. "Coming Home to the American Scene: Realist Paintings." In *Coming Home: American Paintings, 1930–1950, from the Schoen Collection,* 19–35. Athens: Georgia Museum of Art, University of Georgia, 2003.

Fuller, Richard E. *A Gift to the City: A History of the Seattle Art Museum and the Fuller Family.* Seattle: Seattle Art Museum, 1993.

Gardner, Jan. *Modern French Masters*. New York: Dodd, Mead, and Company, 1923.

Illinois Historical Art Project. List of Illinois Artists. http://www.illinoisart.org/artists_list.html.

Mark Tobey. Madrid: Museo Nacional Centro de Arte Reina Sofía and Àmbit Servicios Editoriales, Barcelona, 1997.

Martin, David F., and Nicolette Bromberg. *Shadows of a Fleeting World: Pictorial Photography and the Seattle Camera Club*. Seattle: University of Washington Press and Henry Art Gallery, 2011.

Northwest Traditions. Essay by Martha Kingsbury. Seattle: Seattle Art Museum, 1978.

Tanaka, Yasushi. Papers, 1913–24. Archives of American Art, Smithsonian Institution.

Todd, Sally. "Art Institute—A Resume." *Town Crier*, December 31, 1930, 62.

———. "The Horiuchi Collection. *Town Crier*, December 31, 1930, 39.

Watson, Forbes. "The Public Works of Art Project: Federal, Republican, or Democratic?" *American Magazine of Art* 27 (1) (January 1934): 6–9.

———. "A Steady Job." *American Magazine of Art* 27 (4) (April 1934): 168–81.

Wechsler, Jeffrey, ed. *Asian Traditions, Modern Expressions: Asian American Artists and Abstraction, 1945–1970*. New York: Harry N. Abrams, Inc., in association with the Jane Voorhees Zimmerli Art Museum, Rutgers, The State University of New Jersey, 1997.

JAPANESE AND JAPANESE AMERICAN HISTORY AND CULTURE[†]

Baker-Stanley, Joan. *Japanese Art*. Rev. ed. London: Thames & Hudson, 2000.

Bashō, Matsuo. *The Narrow Road to Oku*, translated by Donald Keene. Tokyo: Kodansha International, 1996.

Bestor, Theodore C. *Neighborhood Tokyo*. Stanford, Calif.: Stanford University Press, 1989.

Blair, Doug. "The Anti-Japanese Crusade and Congressional Hearings." Seattle Civil Rights and Labor History Project. http://depts.washington.edu/civilr/Japanese_restriction.htm.

Bundy, Margaret. "About It and About." *Town Crier*, January 18, 1930, 5–6.

———. "Some Seattle Streets." *Town Crier*, Christmas 1930, 31–32.

Burton, Jeffry F., Mary M. Farrell, Florence B. Lord, and Richard W. Lord. "Confinement and Ethnicity: An Overview of World War II Japanese American Relocation Sites." National Parks Service, Publications in Anthropology 74, rev. 2000. http://www.nps.gov/history/history/online_books/anthropology74/index.htm.

Chang, Gordon H. *Morning Glory, Evening Shadow: Yamato Ichihashi and His Internment Writings, 1942–1945*. Stanford, Calif.: Stanford University Press, 1997.

Chin, Doug. *Seattle's International District: The Making of a Pan-Asian American Community*. Seattle: International Examiner Press, 2001.

Conant, Ellen P., ed. *Challenging Past and Present: The Metamorphosis of Nineteenth Century Japanese Art*. Honolulu: University of Hawai'i Press, 2006.

Daniels, Roger, Sandra C. Taylor, and Harry H. L. Kitano, eds. *Japanese Americans: From Relocation to Redress*. Rev. ed. Seattle: University of Washington Press, 1991.

Daniels, Roger. *Asian America: Chinese and Japanese in the United States since 1850*. Seattle: University of Washington Press, 1988.

———. *Prisoners without Trial: Japanese Americans in World War II*. New York: Hill and Wang, 1993

Denshō: The Japanese American Legacy Project. www.densho.org.

Fiset, Louis. *Imprisoned Apart: The World War II Correspondence of an Issei Couple*. Foreword by Roger Daniels. Seattle: University of Washington Press, 1997.

———. *Camp Harmony: Seattle's Japanese Americans and the Puyallup Assembly Center*. Champaign: University of Illinois Press, 2009.

Formation of the Modern Educational System. http://www.mext.go.jp/b_menu/hakusho/html/hpbz198103.

Fukuyama, Francis. *Trust: The Social Virtues and the Creation of Prosperity*. New York: The Free Press, 1995.

Gesensway, Deborah, and Mindy Roseman. *Beyond Words: Images from America's Concentration Camps.* Ithaca, N.Y.: Cornell University Press, 1987.

Girdner, Audrie, and Anne Loftis. *The Great Betrayal: The Evacuation of Japanese-Americans during World War II.* London: Macmillan Company, 1969.

Grant, Nicole. "White Supremacy and the Alien Land Laws of Washington State." Seattle Civil Rights and Labor History Project, http://depts.washington.edu/civilr/alien_land_laws.htm.

Hirasuna, Delphine. *The Art of Gaman: Arts and Crafts from the Japanese American Internment Camps, 1942–1946.* Berkeley, Calif.: Ten Speed Press, 2005.

Ichihashi, Yamato. *Japanese in the United States: A Critical Study of the Problems of the Japanese Immigrants and Their Children.* Stanford, Calif.: Stanford University Press; London: Humphrey Milford, Oxford University Press, 1932.

Ichioka, Yuki. *The Issei: The World of the First Generation Japanese Immigrants, 1885–1924.* New York: The Free Press, 1988.

———. *Before Internment: Essays in Prewar Japanese American History,* edited by Gordon H. Chang and Eiichiro Azuma. Stanford, Calif.: Stanford University Press, 2006.

Jansen, Marius B. "Cultural Change in Nineteenth-Century Japan." In *Challenging Past and Present: The Metamorphosis of Nineteenth Century Japanese Art,* edited by Ellen P. Conant, 31–55. Honolulu: University of Hawai'i Press, 2006.

Kashima, Tetsuden. *Judgment without Trial: Japanese American Imprisonment during World War II.* Seattle: University of Washington Press, 2003.

———. "Introduction." In Keiho Soga, *Life Behind Barbed Wire: The World War II Internment Memoirs of a Hawai'i Issei,* translated by Kihei Hirai, 1–16. Honolulu: University of Hawai'i Press, 2008.

King, Melanie B. "'Dust Days, Sweat Days, Yellow People, Exiles': Japanese American Visual Memories of Wartime Incarceration." M.A. thesis, University of Washington, 2008.

Koike, Kyō. "Introducing the City of Seattle." *Notan* 16 (September 11, 1925), unpaginated.

Kuroda, Hoshin. "Historical Review of Japanese Art," translated by K. Koike. *Notan* 35 (April 8, 1927), unpaginated.

MacIntosh, Heather. "A Brief History of the Cadillac Hotel." http://www.historicseattle.org/projects/cadillachotelbriefh.aspx.

Miyamoto, S. Frank. *Social Solidarity among the Japanese in Seattle.* Seattle: University of Washington Press, in cooperation with the Asian American Studies Program, University of Washington, 1984. First published in 1939.

Minichiello, Sharon A. "Greater Taishō Japan 1900–1930." In *Taishō Chic: Japanese Modernity, Nostalgia, and Deco,* 9–15. Honolulu: Honolulu Academy of Arts, 2001.

Ministry of Education, Culture, Sports, Science and Technology, Japan. "Japan's Modern Educational System." http://www.mext.go.jp/b_menu/hakusho/html/hpbz198103/index.html.

Nakane, Kazuko. "Facing the Pacific: Asian American Artists in Seattle, 1900–1970." In *Asian American Art: A History, 1850–1970,* edited by Gordon H. Chang, Mark Johnson, and Paul Karlstrom, 55–81. Stanford, Calif.: Stanford University Press, 2008.

Personal Justice Denied: Report of the Commission on Wartime Relocation and Internment of Civilians. Foreword by Tetsuden Kashima. Washington, D.C: The Civil Liberties Public Education Fund; Seattle: University of Washington Press, 1997.

Okada, John. *No-No Boy.* Seattle: University of Washington Press, 1976. First published in 1957.

Sakamoto, James Y. Special Collections, University of Washington Libraries, Accession 1609.

Seattle Camera Club. *Notan* 9–35 (February 13, 1925–October 11, 1929). Special Collections, University of Washington Libraries.

Seattle City Directory, vols. 1919–1941. Seattle: R. L. Polk.

Shirai, Noboru. *Tule Lake: An Issei Memoir,* translated by Ray Hosoda, edited by Eucaly Shirai and Valerie Samson. Sacramento, Calif.: Muteki Press, 2001. First published in Japan in 1981.

Shumaker, Susan. "Untold Stories from America's National Parks: Mount Rainier and the Seattle Camera Club." http://www.pbs.org/national-parks/media/pdfs/tnp-abi-untold-stories-pt-08-mt-ranier.pdf.

Sone, Monica. *Nisei Daughter*. Seattle: University of Washington Press, 1979. First published in 1953.

Speidel, Jennifer. "After Internment: Seattle's Debate over Japanese Americans' Right to Return." Seattle Civil Rights and Labor History Project. http://depts.washington.edu/civilr/after_internment.htm.

Sumida, Stephen H. "Hawaii, the Northwest, and Asia: Localism and Local Literary Developments in the Creation of an Asian Immigrants' Sensibility." *The Seattle Review* 11 (2) (1988): 9–18.

———. "The More Things Change: Paradigm Shifts in Asian American Studies." *American Studies International* 38 (2) (June 2000): 97–114.

Takami, David. *Executive Order 9066: Fifty Years Before and Fifty Years After, A History of Japanese Americans in Seattle*. Seattle: Wing Luke Asian Museum, 1992.

Takashina, Shūji, and J. Thomas Rimer, with Gerald D. Bolas. *Paris in Japan: The Japanese Encounter with European Painting*. Tokyo: The Japan Foundation and Washington University in St. Louis, 1987.

Tsutakawa, Mayumi. "The Political Conservatism of James Sakamoto's *Japanese American Courier*." M.A. thesis, University of Washington, 1976.

U.S. Bureau of Labor Statistics. "1934–36" in "100 Years of U.S. Consumer Spending." http://www.bls.gov/opub/uscs/1934-36.pdf.

Vogel, Ezra R. "Kinship Structure, Migration to the City, and Modernization." In *Aspects of Social Change in Modern Japan*, edited by R. P. Dore, 91–111. Princeton, N.J.: Princeton University Press, 1967.

Zabilski, Carol. "Dr. Kyō Koike, 1878–1947." *Pacific Northwest Quarterly* 68 (April 1977): 72–79.

† This section in particular is selective. Twenty years ago, Roger Daniels noted that wartime incarceration was the most thoroughly documented aspect of Japanese American history, and since then the research has grown significantly. Daniels, "Bibliographic Note," in *Japanese Americans: From Relocation to Redress*, edited by Roger Daniels, Sandra C. Taylor, and Harry H. L. Kitano, 24. Rev. ed. Seattle: University of Washington Press, 1991.

INDEX

Illustrations are indicated in boldface type.
Diary entries mention many Nikkei by the family name only; these are included in the index.

blackout, 111, 114, 115, 131, 147–48
Borneo, 119. *See also* war in the Pacific
Bowron, Fletcher (mayor, Los Angeles), 145
Bremerton, Wash., 149, 234n38
Bridge, 66, **88**, 89, 93–94
Bridges, Robert, 160
Broderick, Henry. *See* Henry Broderick, Inc.
Brooks, Van Wyck, 71–72
Brown, Burt Barker, 227n59, 230n35
Bruce, Edward, 35–37
Buddhism, Buddhist Church, 170; inspiration from, 90; Tokita's beliefs, 42, 108, 127; Zen, 86, 90
Buna, 196, 197, 202. *See also* New Guinea

C

Cadillac Hotel, Seattle, **36**, 37, 42, 148, 166–67; and banking, 38, 136; and blackout regulations, 115, 131, 134; crisis policy of, 128, 130; custodianship of, 114, 154; daily running of, 111, 133, 135; guests of, 114–17, 121–22, 126, 136, 153–54, 167, 172–73, 176; sale of, 45, 143, 162, 168–69, 178–80; taxes on, 171
Cahill, Holger, 72
Cain, Harry P. (mayor, Tacoma), 158–59
California: Issei custody in, 155, 166; discrimination in, 13, 14, 15, 142, 233n36; and Manzanar Relocation Center, 201, 227n75, 234n48, 234n58; relocation site in, 163–64, 173, 227n75; and Tule Lake Relocation Center, 198, 227n75, 233n36. *See also* Owens Valley
California Palace of the Legion of Honor, 75, 220
Callahan, Kenneth, 30, **72**, 74; and Group of Twelve, 81; and Northwest artists, 96; remarks on Tokita, 55, 58–59, 66, 73, 80, 92–95, 97, 230n32, 230n42; *Stump Landscape*, **97**
Callahan, Margaret Bundy, 30, 63, 80, 231n70
calligraphy, **10**, 11, 67, 89
Canada, 135–36, 150
Catholic Church, Catholicism, 41–42. *See also* Maryknoll Mission
Cézanne, Paul, 82–85, 89; *Mont Sainte-Victoire and the Viaduct of the Arc River Valley*, **84**
Cheney, Martha Candler, 72
Chihara Jewelers, 133

China, 11, 84, 89, 231n55
China Incident, 119, 233n15
Chinese ink painting. *See* ink painting
Chinese military, 132, 138, 234n43
Chungking (Chongqing), 132
citizenship: frustrations with, 19, 90–92, 183–84, laws, 15–16, 224n16, 233n36; Nissei and, 148, 169; perspectives on, 44, 129; rights, 108, 114
Columbia River, 168
Congregational Church, 42, 144, 146
Congress, congressional. *See* U.S. Congress
controls, price, 137, 183, 210; on rubber, 133–34, 137
cooks, at Minidoka, 208–9, 211
Corcoran Art Gallery, 19, 76–78, 220
Crocker, Anna B., 32
Cross, Larry, 75

D

Daruma, 90–92, **92**, 231n58
December 7, 1941, 4, 101; events of, 104, 109–10, 171, 232n1; reflections on, 34, 109, 100–111, 118, 200
Depression, the, 32–33, 34–37, 72, 93–94
DeWitt, Lt. General John L., 45, 159–61, 176
Dies Committee. *See* House Committee on Un-American Activities
Drug Store (Edward Hopper), **73**
Drugstore (Tokita), 67–68, **69**, 70
Dumas, Alexandre, *Count of Monte Cristo*, 139–40, 233n31
Dusanne, Zoe, 231n61
Dutch East Indies, 118, 139, 161. *See also* war in the Pacific

E

Eden, Anthony (foreign secretary, Great Britain), 165
Enemy Aliens: arrests of, 140, 148, 168; business licenses for, 146, 151; registration of, 135, 146–47; and relocation, 44–45, 145, 148, 155, 160; Tokita's reflections on, 102, 107–8; treatment of, 133, 144, 233n30
evacuation, 96–97, 148–71 passim, 173–80; relocation hearings and, 155, 158–59, 160, 234nn45,46
Evans, Walker, 70; *Outdoor Advertisements*, **69**

poetry, 18, 110, 200; forms of (*haiku, tanka*), 22, 103, 232n4; of Matsuo Bashō, 110, 232n4; as means of expression, 18, 22, 226n37; "Orange" (Tokita), 215–18; poem by "Red Dragonfly," 200; Tokita's untitled poems, 39–40, 42, 49, 50–53, 103, 200, 204–7

Poland, Reginald, 66

Portland, Ore., 107, 131, 146, 220–21

Post-Intelligencer. See Seattle Post-Intelligencer

Prefontaine Street, 62, **63**

Prohibited Zones, 148–49, 151–52, 156, 160–61, 164–65

Public Works of Art Project (PWAP), 35–37, 76, 78, 220, 227n60, 230n31

Puyallup, Wash., 45, 176, 234n51

Puyallup Assembly Center, 46–47, **46**, 101, 174–75, 180, 234n51

PWAP. *See* Public Works of Art Project (PWAP)

R

railroad, railroad industry, railroad workers, 12, 144, 210; Great Northern Railway, 144–45; Union Pacific Railroad, 152, 234n42

Red Cross, 134–35, 177

"Red Dragonfly," 200

Regina Hotel, 113

registration, forms of: Asset Inventory Report, 143, 146–47, 233n30; auto license stickers, 122, 134; business, 135, 142–43; draft, 120, 134, 135, 146–47, 152–53; Enemy Alien, 135, 146–47, 177; income tax, 119, 131, 135, 143

relocation. *See* evacuation

Relocation Labor Group, 174, 186, 188–89, 199, 207–8

Robertson, Orville E., 159

Rommel, General Erwin, 194–95

Roosevelt, Franklin D., 44, 133, 155, 173, 183; speeches by, 112, 196

Rota, 213–14. *See also* war in the Pacific

rubber, rubber tires: control of, 133–34, 137

Russia, 127, 213

Russo-Japanese War, 9, 193

S

Sagamiya Confectionary, 126

Saipan, 214. *See also* war in the Pacific

Sakamoto, James Y., 44, 116–17, 232n10; advice, 114, 115, 118, 171; conversations, 117; news from, 119, 168; protests by, 158, 173 *See also* Japanese American Citizens League (JACL); *Japanese American Courier*

samurai, 8, 9, 39, 52, 223n3. *See also* Ishida, Mitsunari; Miyamoto, Musashi

San Francisco, 75, 145, 155, 219–20

San Francisco Art Association, 78, 219–20

Savery, Halley, 31, 32

Sawada, Mr. and Mrs., 113–14, 143–44, 146

Scavatto, Leo, family, 45, 48, 203, 232n7

Schmoe, Floyd W., 160, 234n45

schools, Seattle public, 33, 156, 157

Seattle, city of, 11–12; and Department of Health, 141; and Fire Department, 130–31, 141. *See also* schools, Seattle public

Seattle Anti-Japanese League, 13–14, 234n46

Seattle Art Institute, 31–33, 58, 60, 219–20, 225n27

Seattle Art Museum, 31–33, 55, 74–75, 80, 220–21

Seattle Camera Club, 25–27, 226n43

Seattle Fine Arts Society, 30–31, 219, 226n52

Seattle Post-Intelligencer, 31, 100, 118, 132, 178

Seattle Scene, 66, **67**

Seattle Star, 161, 164, 173, 234n14

Seattle Times, 31–32, 60, 75, 80, 233n14

Seicho-No-Ie, 210, 234n64

Sekor, Esther M., 157

Select Committee Investigating National Defense Migration, 155, 158–59, 160

Self-Portrait (Tanaka), **19**

Self-Portrait (Tokita), **2**, 18, 230n47

Senate Immigration Section Committee, 169

Sesshū, Tōyō, 82–86; *Winter Landscape*, **85**

Shiho, 184

Shizuoka City, 9, 10

Shizuoka Prefecture, 9–10, 202, 223n5, 224n12

shortages, wartime: Minidoka, 183, 184, 188, 195, 210; Seattle, 133, 149–50, 168

Singapore, 131, 139, 151; attack of, 118–19; and Japanese advances, 120, 137–38; and Japanese losses,

THE SCOTT AND LAURIE OKI SERIES IN ASIAN AMERICAN STUDIES